Art Museums PLUS

Art Museums

Cultural Excursions in New England

PLUS

Traute M. Marshall

University Press of New England HANOVER AND LONDON

Published by University Press of New England,
One Court Street, Lebanon, NH 03766
www.upne.com

© 2009 by University Press of New England
Printed in the United States of America
5 4 3 2 1

Every attempt has been made to verify the accuracy of
schedules, prices, and other details included in this book.
Because changes can occur, please consider calling ahead to
confirm any information that is crucial to your plans. The
author invites comments, corrections, updates, and suggestions
to be sent to trautemar@hotmail.com.

Library of Congress Cataloging-in-Publication Data
Marshall, Traute M., 1942–
Art museums plus : cultural excursions in New England /
Traute M. Marshall. — 1st ed.
 p. cm.
Includes index.
ISBN 978–1–58465–621–0 (pbk. : alk. paper)
 1. Art museums—New England—Guidebooks. 2. Art—
New England—Guidebooks. 3. New England—Guidebooks.
I. Title.
N510.5.N4M37 2009
708.14—dc22 2008049860

Cover illustrations: (Top) George Bellows (1882–1925), *the Big Dory,*
1913. Oil on wood panel, 29 × 32½ inches. New Britain Museum of
American Art, Harriet Russell Stanley Fund, 1944.21. *(Bottom)* Exterior
of Provincetown Art Association and Museum. Machado and Silvetti
Associates, Boston, architects. Photograph © Anton Grassl/Esto.

 University Press of New England is a member of the
Green Press Initiative. The paper used in this book
meets their minimum requirement for recycled paper.

TO MY HUSBAND, ROBERT,
companion in art, music, and life

Contents

Introduction 1

CONNECTICUT

Bridgeport
Housatonic Museum of Art 15
PLUS: Barnum Museum 16

Farmington
Hill-Stead Museum 17
PLUS: Avon Old Farms School (Avon) 20

Greenwich
Bruce Museum 20
PLUS: Bush-Holley Historic Site (Cos Cob) 22

Groton
Alexey von Schlippe Gallery of Art,
 University of Connecticut 23
PLUS: Connecticut College outdoor sculpture
 (New London) 25

Hartford
Wadsworth Atheneum Museum of Art 26
PLUS: Chick Austin House and biography 31

Middletown
Davison Art Center, Wesleyan University 32
PLUS: Campus architecture 34

New Britain
New Britain Museum of American Art 35
PLUS: Walnut Hill Park 39

New Haven
Yale Center for British Art 40
PLUS: Louis Kahn building; *My Architect* (film) 43

Yale University Art Gallery 43
PLUS: Modernist campus architecture 48

New London
Lyman Allyn Art Museum 49
PLUS: New London architecture; Eugene O'Neill sites 52

Norwich
Slater Memorial Museum 53
PLUS: Walking tour of historic district 56

Old Lyme
Florence Griswold Museum 56
PLUS: Lyme Art Association Gallery; First Congregational
 Church 59

Stamford
Stamford Museum and Nature Center 60
PLUS: Sculptures by Reuben Nakian 62

Storrs
William Benton Museum of Art, University of Connecticut 62
PLUS: Ballard Institute and Museum of Puppetry 65

Waterbury
Mattatuck Museum 65
PLUS: Cass Gilbert District 67

Wilton
Weir Farm National Historic Site 68
PLUS: Aldrich Contemporary Art Museum 70

RHODE ISLAND

Newport
National Museum of American Illustration 73
PLUS: Campus of Salve Regina University 75

Newport Art Museum and Art Association 77
PLUS: Tennis Hall of Fame 79

Providence
Annmary Brown Memorial, Brown University 79
PLUS: Nightingale Brown House; John Brown House 81

Rhode Island School of Design (RISD) Museum of Art 82
PLUS: First Baptist Church 87

MASSACHUSETTS

Amherst
Eric Carle Museum of Picture Book Art 91
PLUS: Atkins Farm Country Market 93

Mead Art Museum, Amherst College 93
PLUS: Emily Dickinson Museum 99

Andover
Addison Gallery of American Art, Phillips Academy 99
PLUS: Stevens-Coolidge Place 103

Arlington
Cyrus E. Dallin Art Museum 104
PLUS: Robbins Garden bronze sculptures 105

Boston
Institute of Contemporary Art (ICA)/Boston 106
PLUS: Harbor Walk; Moakley Courthouse 109

Isabella Stewart Gardner Museum 109
PLUS: Biography of Isabella Stewart Gardner 114

Museum of Fine Arts, Boston 115
PLUS: Back Bay Fens and Olmsted's Emerald Necklace 124

Trinity Church 125
PLUS: Boston Public Library 127

Brockton
Fuller Craft Museum 131
PLUS: Buildings by H. H. Richardson in North Easton 132

Cambridge
Harvard Art Museum
 Fogg Museum 134
 PLUS: Corbusier's Carpenter Center for the Visual Arts 138

 Busch-Reisinger Museum 138
 PLUS: Adolphus Busch Hall organ concerts 141

Arthur M. Sackler Museum 141
PLUS: Peabody Museum of Archaeology and Ethnology 143

Canton
Milton Art Museum 144
PLUS: Forbes House Museum (Milton) 145

Clinton
Museum of Russian Icons 146
PLUS: National Plastics Center and Museum
 (Leominster) 148

Cotuit
Cahoon Museum of American Art 149
PLUS: Historical Society of Santuit and Cotuit 151

Dennis
Cape Cod Museum of Art 151
PLUS: Rockwell Kent mural 154

Duxbury
Art Complex Museum 155
PLUS: John Alden House 158

Essex
Cogswell's Grant 158
PLUS: Essex Shipbuilding Museum 161

Fitchburg
Fitchburg Art Museum 161
PLUS: Bulfinch Church in Lancaster 163

Framingham
Danforth Museum of Art 164
PLUS: N. C. Wyeth in the Needham
 Free Public Library 167

Gloucester
Beauport (Sleeper–McCann House) 168
PLUS: Hammond Castle Museum 170

Cape Ann Museum 171
PLUS: Art-related sites on Cape Ann 174

Harvard
Fruitlands Museum 175
PLUS: Harvard Shaker Village Historic District 178

Ipswich
Ipswich Historical Society and Museums 178
PLUS: Arthur Wesley Dow walking tour 180

Lenox
Frelinghuysen Morris House & Studio 181
PLUS: Morris Elementary School 182

Lincoln
DeCordova Museum and Sculpture Park 182
PLUS: Walter Gropius House 186

Lowell
New England Quilt Museum 187
PLUS: Brush Art Gallery and Studios 189

Whistler House Museum of Art 190
PLUS: Lowell National Historical Park 192

Newton
McMullen Museum of Art, Boston College 192
PLUS: Bapst Library, Boston College 194

North Adams
Mass MoCA (Massachusetts Museum of Contemporary Art) 195
PLUS: Hallmark Museum of Contemporary Photography
(Turners Falls) 197

Northampton
Smith College Museum of Art 198
PLUS: Campus Center 202

Pittsfield
Berkshire Museum 203
PLUS: Arrowhead, Herman Melville's home 206

Provincetown
Provincetown Art Association and Museum 206
PLUS: *The Mayflower Compact*; Unitarian Universalist
Meeting House 210

Salem
Peabody Essex Museum 210
PLUS: McIntire Historic District, Chestnut Street 216

South Hadley
Mount Holyoke College Art Museum 216
PLUS: Wistariahurst and Mt. Holyoke 220

Springfield
Springfield Museums 221
 George Walter Vincent Smith Art Museum 223
 Museum of Fine Arts 224
PLUS: Two courthouses 228

Stockbridge
Chesterwood, the Studio of Daniel Chester French 229
PLUS: St. Paul's Episcopal Church 231

Norman Rockwell Museum 232
PLUS: Naumkeag 234

Waltham
Rose Art Museum, Brandeis University 235
PLUS: Stonehurst, the Robert Treat Paine Estate 238

Wellesley
Davis Museum and Cultural Center, Wellesley College 239
PLUS: Elm Bank Horticultural Center 242

Williamstown
Sterling and Francine Clark Art Institute 243
PLUS: Williamstown Theatre 247

Williams College Museum of Art 248
PLUS: River Bend Farm 253

Winchester
Griffin Museum of Photography 254
PLUS: Richardson Library in Woburn 256

Worcester
Higgins Armory Museum 257
PLUS: Tower Hill Botanic Garden (Boylston) 259

Worcester Art Museum 260
PLUS: American Antiquarian Society 265

NEW HAMPSHIRE

Cornish
Saint-Gaudens National Historic Site 269
PLUS: *Glory*: Robert Shaw and the Fifty-fourth Regiment 271

Hanover
Hood Museum of Art, Dartmouth College 272
PLUS: Hopkins Center for the Performing Arts 277

Manchester
Currier Museum of Art 277
PLUS: Zimmerman House by Frank Lloyd Wright 281

VERMONT

Bennington
Bennington Museum 285
PLUS: Old Bennington and Robert Frost Gravesite 287

Burlington
Robert Hull Fleming Museum, University of Vermont 288
PLUS: Billings Student Center by H. H. Richardson 291

Manchester
Southern Vermont Arts Center 292
PLUS: Equinox hiking trails 293

Middlebury
Middlebury College Museum of Art 294
PLUS: Campus sculpture 297

Montpelier
T. W. Wood Gallery and Arts Center, Vermont College 297
PLUS: Athenwood and the Thomas W. Wood Studio 299

Shelburne
Shelburne Museum 299
PLUS: Shelburne Farms 304

St. Johnsbury
St. Johnsbury Athenaeum and Art Gallery 305
PLUS: Town Architecture 308

Windsor
Cornish Colony Museum 309
PLUS: Cornish-Windsor Covered Bridge 310

Woodstock
Marsh-Billings-Rockefeller National Historical Park 311
PLUS: Billings Farm & Museum; Woodstock 313

MAINE

Bangor
University of Maine Museum of Art 317
PLUS: Hudson Museum, Orono Campus 318

Brunswick
Bowdoin College Museum of Art 319
PLUS: Peary-MacMillan Arctic Museum 323

Lewiston
Bates College Museum of Art 323
PLUS: Lewiston Public Library 325

Ogunquit
Ogunquit Museum of American Art 326
PLUS: Marginal Walk 328

Portland
Portland Museum of Art 329
PLUS: The Art Gallery at the University of New England
 (Westbrook College Campus) 333

Rockland
Farnsworth Museum and Wyeth Center 334
PLUS: Olson House 338

Waterville
Colby College Museum of Art 339
PLUS: Skowhegan Lecture Archive 343

Resources 345

Index 349

Color plates follow page 174

Art Museums PLUS

The experience of traveling to see a fine object becomes part of the experience the object itself can provide.

S. LANE FAISON, JR.

This book is the outgrowth of a project my husband and I embarked upon after our retirements. We decided to make it a habit to visit a museum or art show once a week. As residents of Boston, we were surrounded by many fine art institutions, and once we had visited the obvious ones, I started researching lesser-known museums and galleries via travel books and the internet. It occurred to me that there ought to be a guide to the art museums of New England, and since none could be found in bookstores, I would write it myself. Then I learned that such a book had existed, published in 1982 and long out of print, but available in the antiquarian book market. S. Lane Faison, Jr. (1908–2006), beloved art historian and inspired teacher at Williams College, from whose seminars whole generations of museum directors, curators, art historians, and art lovers had sprung forth, was the author of *The Art Museums of New England*. His book was conceived as an "an excursion into art criticism and art history based on the vast treasure available to the public in New England." Faison chose about 550 works from the permanent collections of over 100 museums, historical societies, and public libraries, supplied small reproductions, and with wisdom, wit, and learning he created a printed cicerone for a tour of New England art museums.

When I contacted Professor Faison, then in his mid-nineties, he was excited about a proposed update and revision, but it soon became clear that so much had changed in

the intervening years that this undertaking was not feasible. *Art Museums PLUS* has benefited from Faison's book, from its many original insights, and from its organization, which I have adopted. In addition, following his encouragement to do so, here and there I have quoted from it verbatim, followed by the parenthetical (Faison).

This book is a guide to the art museums of New England, but some definitions are in order.

In this book, the term *art* includes objects that owe their existence to high skill, aesthetic quality, and expressive intent. They may or may not have an additional, practical purpose. Therefore, I have included museums devoted to craft, prints, illustration, and photography.

Craft with artistic aspirations means especially contemporary craft (Fuller Craft Museum), and historic crafts collected and displayed primarily for their aesthetic value (New England Quilt Museum, Beauport [Sleeper McCann House], Cogswell's Grant, Shelburne Museum, Higgins Armory Museum). I have not included collections of historic tools, furniture, clothing, etc., that are typically the province of historical societies. Many historical societies, however, do have sizable collections of paintings, especially portraits done by itinerant painters. I decided not to include these institutions when the emphasis was clearly on history rather than art, and when the art was not on regular display. A reader interested in Colonial portraiture and Primitive art should check out state and regional historical societies. Furniture is treated as part of museum collections, and the astute reader will notice that the Colonial Revival movement forms a recurrent theme, inasmuch as it led to the reevaluation of America's past, including early "folk" painters, and the appreciation of folk art as collectible art.

Prints, which by their nature are not one-of-a-kind artworks, have been included. Collections of prints are often the only way that small, young institutions, especially college museums, can provide their students with the tangible experience of an artist's output (for example, University of Maine Museum of Art, or Davison Art Center at Wesleyan University). The renewed flourishing in the twentieth century of various print techniques as forms

of artistic expression, rather than as copies of or substitutes for original art, seemed to argue even more urgently for the inclusion of prints as "works of art."

Illustration for many art lovers would be outside of the definition of art. If "true" art is done primarily for its own sake, illustration always has some ulterior motive, be it to embellish, to illuminate, to clarify, to sell, to persuade, to inform. Yet, the same is true for much of fine art; for example, religious art during the age of widespread illiteracy. Many artists started out as illustrators and became bona-fide artists, the most striking American example being Winslow Homer. Others needed to do illustrations for much of their careers in order to put bread on the table. While there is no denying that art and illustration are separate things, there is also no denying that illustration can rise to a level of craftsmanship, originality, and wit, and can provide emotional and aesthetic experiences of the quality that we readily associate with art. Think of the posters of Toulouse-Lautrec. New England boasts three outstanding museums entirely dedicated to illustration: the National Museum of American Illustration, the Eric Carle Museum of Picture Book Art, and the Norman Rockwell Museum. The New Britain Museum of American Art has a comprehensive collection of illustration and mounts regular shows of that genre. The Cornish Museum includes a large collection of works by Maxfield Parrish, one of the Cornish colony artists, while the Farnsworth Museum and Wyeth Center documents the work of N. C. Wyeth in depth. Finally, the Springfield Museum of Fine Arts boasts the largest museum collection of Currier & Ives tinted prints.

Photography, too, has had to fight for recognition as an art form, but by now almost every art museum avidly collects photography; two museums in New England are dedicated entirely to it, the Griffin Museum of Photography and the Hallmark Museum of Photography.

My definition of *museum* is equally liberal. Included are, of course, the encyclopedic civic and academic art museums, of which New England is blessed with an abundance not seen elsewhere in the country. For the rest, one condition was that the institution own a permanent collection, part of which would al-

ways be on display. This excluded many university galleries that exist to show changing exhibitions only; it also excluded some venerable art centers or noncommercial galleries that are dedicated to showcasing regional artists. Certain institutions are not, strictly speaking, museums, but definitely of high interest to the art lover; namely, artists' homes and studios that retain some or much of their owners' work. The number and variety of such artists' residences in New England open to the public is astounding: the country estates of sculptors Augustus Saint-Gaudens and Daniel Chester French; the Connecticut farm of Alden Weir; the Colonial farmhouse in which the Cahoons lived, painted, and ran their shop; the upscale summer home of patrician artists Suzie Freylinghuysen and George Morris; and the studio of Norman Rockwell, which was moved to the museum complex. These places reveal that artists had a fine instinct for locating picturesque settings, often designed themselves beautiful houses and grounds, and bequeathed to us destinations for delightful summer excursions.

The New England coast and countryside was, indeed, the summer destination for many New York artists. Farms were easy to come by, as New England became industrialized and the railroads transformed the Midwest into the bread basket and meat larder of the East Coast. Once one artist had found a place, others soon followed, and art colonies sprang up along the coast from Connecticut to Maine, and in Vermont, the Berkshires, the White Mountains of New Hampshire. Some evolved into art schools, some organized art associations to exhibit and sell their work. Several art associations in time found themselves in possession of works donated by participating artists or local collectors. These are the antecedents of many museums in this guide: the Florence Griswold Museum, the Provincetown Art Association and Museum, the Ogunquit Museum of American Art, the Cape Ann Historical Museum, the Cape Cod Museum of Art, and many others.

The earliest museums in New England were established by colleges. Almost without exception, they began as cabinets of curiosities, interesting objects found locally or brought back by sea captains or missionaries from exotic locales. Artistic, historic, and

scientific specimens, and just plain oddities were mingled, and often located within the library. Just as frequently, college presidents and distinguished professors had their likenesses painted and displayed on campus. Eventually, science and art were separated, gallery space was freed up in some building, and a dedicated museum building was erected (often named for the donor). Today an art museum or at least an art gallery is a sine qua non even for public colleges. The venerable private colleges have outstanding museums, supported and enriched by generations of loyal alumni: Amherst, Bowdoin, Dartmouth, Harvard, Mount Holyoke, Smith, Wellesley, Williams, and Yale. Other institutions of higher learning developed notable museums somewhat later: the Rhode Island School of Design, the University of Vermont, Colby College, and Middlebury College.

When one considers the origins of nonacademic museums, certain patterns emerge. The majority of the civic museums came into being in the second half of the nineteenth century, when New England towns and cities reaped the financial rewards of rapid industrialization and Yankee inventiveness. The industrial hubs of Springfield, Fitchburg, Pittsfield, and Worcester in Massachusetts; of Manchester, New Hampshire; of Hartford, New Britain, and Norwich in Connecticut; of St. Johnsbury in Vermont—all founded comprehensive museums, whether owing to the instigation of a single mover or the concerted efforts of enlightened citizens, whether concerned about the spiritual and intellectual enrichment of their fellow citizens or the eventual assimilation into American culture of the thousands of newly arrived immigrants. Industrialists' zeal for improving the minds of their workers may seem touchingly quaint to us now, but we owe these benefactors a tremendous debt. The Wadsworth Atheneum, the oldest continuously operating museum in North America, may stand as a prototype of this enlightened paternalism and engaged philanthropy. Often these museums started out as combinations of lending libraries, scientific museums, and art galleries. The most successful tended to branch apart into specialized collections as they grew, but a few, such as the Bruce Museum in Greenwich and the Berkshire Museum in Pittsfield, still combine science and art.

A number of museums founded in the twentieth century were committed from the beginning to the exclusive collecting of American art. Given limited resources, this proved to be an excellent decision, for first-rate American art was still widely and cheaply available at a time when the market in European art was already beyond the means of most museum acquisition budgets and would become ever more prohibitive. Thus we have comprehensive collections of American art at the Addison Gallery in Andover (an outstanding collection assembled by a prep school), as well as at the New Britain Museum of American Art, Colby College, the Farnsworth Art Museum and Wyeth Center, the Danforth Museum in Framingham, and the DeCordova Museum, in addition to the collections mentioned above that grew out of art colonies and associations.

We owe some of the most interesting and unique museums to individual collectors, forceful personalities who often were the first to specialize in an area not deemed fashionable or even proper, or who just pursued a personal dream and eventually found their collections crowding them out of their homes. Electra Havemeyer, who at age eighteen defiantly bought a cigar-store Indian, gave us the incomparable Shelburne Museum collection of American folk art in Vermont. John Higgins, steel manufacturer, became enamored of medieval armor; the result is the Higgins Armory Museum in Worcester. The founders of the National Museum of American Illustration, Judy and Laurence Cutler, were collectors and dealers in this neglected genre and helped put it on the map as a bona-fide collectible. Sterling and Francine Clark, with wealth inherited from the Singer sewing machine fortune, spent their lives acquiring the best in European and American fine art; they oversaw the building of a marble temple to house their glorious collection in quiet Williamstown, safely tucked away from any danger. Isabella Stewart Gardner not only collected art of superb quality, she built a Venetian palazzo in Boston to give her collection an equally superb setting. Paul Mellon's infatuation with all things British resulted in the Yale Center for British Art. Two very recent examples are the Museum of Russian Icons, founded by Gordon Lankton, and the Griffin Museum of Photography, named for its founder.

During the research and writing of this guide it was sometimes hard to keep up with all the new building, renovating, and expanding of the physical plants. There is, of course, a museum-building boom nationwide—indeed, worldwide at this time— and New England has its share of that growth. As this book goes to press, the Museum of Fine Arts in Boston and the Harvard Art Museum in Cambridge are in the middle of major expansions and renovations. The Currier and New Britain museums just finished theirs (both, incidentally, designed by the same architect team, Ann Beha Architects of Boston), and Bowdoin College saw its exquisite Beaux Arts building radically but sensitively renovated (by the firm of Machado and Silvetti, who are also responsible for the clean clapboard-and-glass addition to the Provincetown Art Association and Museum). The Institute for Contemporary Art has a new, daring construction on Boston's waterfront, and the Griffin Museum of Photography, while made to look like an old New England mill, is just as new. From the 1950s through the 1990s, museum buildings and additions were typically designed by famous architects who saw in these commissions an opportunity to show their most original side. The museums described here can be read as a short history of architectural styles of the last half of the twentieth century, from Bauhaus influences to Postmodernism, and I have seen fit to identify the architects in the individual entries for the same reason one would provide the name of the painter when referring to a canvass. Here is an overview of important recent architectural work to be seen in museums of the New England region.

Paul Rudolph (Jewett Arts Center, Wellesley College)

Louis Kahn (Yale University Art Gallery; Yale Center for British Art)

Cesar Pelli (Mattatuck Museum)

Kevin Roche, John Dinkeloo and Associates (Davison Art Center, Wesleyan University)

Charles Moore (Hood Museum, Dartmouth College; Williams College Museum of Art)

Robert A. M. Stern (Norman Rockwell Museum)

Hardy Holzman Pfeiffer Associates (Middlebury College Center for the Arts)

Gwathmey Siegel & Associates Architects (Werner Otto Hall, Busch-Reisinger Museum, Harvard)

Rafael Moneo (Davis Museum, Wellesley College)

James Stirling (Arthur M. Sackler Museum, Harvard)

Foster + Partners (Museum of Fine Arts, Boston, expansion)

I. M. Pei Partners (Charles Shipman Payson Building, Portland Museum of Art)

Polshek Partnership Architects (Smith College Museum of Art; Yale University Art Gallery renovation)

Kallman McKinnell & Wood (DeCordova Museum; Asian Export Wing, Peabody Essex Museum)

Moshe Safdie (Peabody Essex Museum)

Machado & Silvetti (Provincetown Art Association and Museum, addition; Bowdoin College Museum of Art renovation)

Diller, Scofidio + Renfro (Institute for Contemporary Art, Boston)

The adaptive reuse of existing buildings for museum purposes is often coupled with the hope and expectation that a museum will help spawn a cultural and economic revival. The outstanding, and highly successful, example of this trend is MASS MoCA, but there are others, big and small, as well: notably, two former gyms (Slater Memorial Museum, William Benton Museum of Art), a Masonic temple (Mattatuck Museum), a firehouse (Cornish Colony Museum), a department store (University of Maine Museum of Art). Even more common are museums that began as private homes, were donated for public use (with or without ar-

tistic content), and were expanded later, often completely eclipsing the original house (New Britain Museum, Southern Vermont Arts Center, Newport Art Museum).

Lastly, we should recognize the important architects of the nineteenth and early twentieth centuries who left us a legacy of dedicated museum buildings whose elegance and splendor are a welcome relic of the Gilded Age: Bowdoin College's Walker Art Center by Charles Follen McKim (also responsible for the Boston Public Library), the Currier Museum of Art by Edward Tilton, the Fleming Museum by the firm of McKim, Mead and White, the Addison Gallery and the Lyman Allyn Art Museum by Charles A. Platt. While not intended as a museum, a gorgeous Newport mansion, Vernon Court by Carrère and Hastings (who also built the Frick mansion on Fifth Avenue in New York), now houses the National Museum of American Illustration; and the Tudor mansion that is home to the Alexey von Schlippe Gallery of Art is another prime example of Gilded Age architecture.

A word about the PLUS feature. This book is not addressed to art historians or museum professionals, but to art lovers, cultural tourists, eager travelers, and people who cherish new experiences and enjoy learning more about their surroundings, its history, its treasures. I conceived of a museum visit as the central experience to an outing that might last a few days and include other activities, such as hiking, antiquing, visiting historical houses, exploring local history and its manifestations in buildings and townscapes. The PLUS feature is intended to supplement a museum visit, especially a second visit or an extended stay. I was looking for anything that was not commercial, not too well known, and that would have a visually satisfying element to it. Many times it turned out to be a public building, a church, a library that had particular architectural merit (H. H. Richardson is thus featured several times). Other times I found small collecting institutions that did not quite warrant their own entry but had a relationship to the main entry or were in themselves intriguing. Often I just try to entice you to walk around the area, the campus, the town, so you can experience the museum in context or explore a historic district. At times I cite a book or a film, a mural, a collection

of outdoor sculpture. A few historic houses are included, but so are museums of anthropology, polar exploration, industrial history, even tennis. Writers' homes (Herman Melville, Emily Dickinson) are part of the mix. I hope you will be surprised by some of the choices and will enjoy them all.

The organization of this book is simple. The six New England states appear in order, south to north, and the section for each state opens with a map identifying all towns that harbor a museum noted in this book. Within each state, towns and cities are listed alphabetically, and within each town or city, museums are listed alphabetically.

I have provided directions to each destination from the nearest interstate; more detailed directions can easily be found on each museum's Web site. Directions to a PLUS feature are typically given starting from the location of the main entry. Opening times may change, especially in the case of academic museums during semester breaks and in the case of small museums during installations of new shows. It is always advisable to double-check the Web site. This symbol ❀ indicates a seasonal museum, and this one 🛒 denotes a museum with superior facilities, programs, and spaces for children.

Admission prices are accurate as of early 2008; increases are likely to be proportional. Many museums have days or hours of free admission, and public libraries often let you borrow free museum passes. Twelve smaller regional museums offer reciprocal free admission to their members (Connecticut: New Britain Museum of American Art, Lyman Allyn Art Museum, Mattatuck Museum; Rhode Island: Newport Art Museum; Massachusetts: Cape Cod Museum of Art, Provincetown Art Association and Museum, Art Complex Museum, Danforth Museum of Art, Fitchburg Art Museum, Fruitlands Museum; Vermont: Bennington Museum; Maine: Farnsworth Art Museum).

Under "catalog," I list just one or two readily available and affordable general guidebooks; the major museums publish many detailed catalogs and studies, and even smaller museums often have ambitious publishing programs and scholarly catalogs tied to temporary exhibitions. Unattributed quotations within the entry

are taken either from the museum's Web site and other promotional material or from the source item listed for that museum.

I would like to thank the staff members of the various museums who have helped me by answering queries, showing me around, pointing me to overlooked information, and providing me with images to illustrate this guide: Melanie Anderson, Hill-Stead Museum; Maud Ayson, Fruitlands Museum; Janie Cohen and Chris Dissinger, Robert Hull Fleming Museum; Connie Colom, New England Quilt Museum; Sharon Corwin and Patricia King, Colby College Art Museum; Laurence Cutler and Eric Brocklehurst, National Museum of American Illustration; Ronda Faloon, Cape Ann Museum; Suzie Fateh, Mattatuck Museum; Katherine French, Danforth Museum; Janice Goodrow, Fitchburg Art Museum; Wendy Hansen, St. Johnsbury Athenæum; Elizabeth Ives Hunter and Christy J. King, Cape Cod Museum of Art; Douglas Hyland and Abigail Runyan, New Britain Museum of American Art; Gordon B. Lankton and Jesse Rives, Museum of Russian Icons; Diane Lewis, William Benton Museum of Art; Chris McCarthy, Provincetown Art Association and Museum; Melissa MacPhee, DeCordova Museum and Sculpture Park; Wally Mason, University of Maine Museum of Art; Ellyn Moeller, Milton Art Museum; Nancy Netzer, McMullen Museum of Art; Cindy Nickerson, Cahoon Museum of American Art; Julia M. Pavone, Alexey von Schlippe Gallery of Art; Rosa Portell, Stamford Museum and Nature Center; Nancy Stula, Lyman Allyn Museum; Charles Weyerhaeuser, Art Complex Museum; Robbin Zella, Housatonic Museum; Anne Zill, Art Gallery at the University of New England; and Vivian Zoe, Slater Memorial Museum.

Sam and Sheila Robbins, collectors extraordinaires, provided advice and help with images; Leslie Cohen was the copy editor one wishes for; Richard Pult and the staff at University Press of New England thoughtfully and expertly guided the book through the publishing process. Professor Faison's grace and humor were a special gift. But foremost I would like to thank my husband for his shared enthusiasm for the project, for his willingness to undertake our visits even in winter snowstorms, for his thoughtful editing, and, above all, for the joy of his companionship.

Connecticut

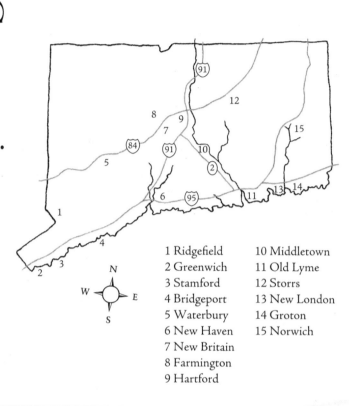

1 Ridgefield
2 Greenwich
3 Stamford
4 Bridgeport
5 Waterbury
6 New Haven
7 New Britain
8 Farmington
9 Hartford

10 Middletown
11 Old Lyme
12 Storrs
13 New London
14 Groton
15 Norwich

Bridgeport

HOUSATONIC MUSEUM OF ART

900 Lafayette Boulevard, Bridgeport, CT 06604; Tel. 978-598-5000, www.hcc.commnet.edu/artmuseum.

Directions: From I-95, take Exit 27. Coming from north: At exit ramp take right onto Lafayette Boulevard. Coming from south: Make second left onto Lafayette Boulevard and go under I-95. The parking garage (free) is on your right.

Hours: Monday through Friday, 8:30 A.M. to 5:30 P.M., Thursday until 7 P.M.; Saturday, 9 A.M. to 3 P.M.; Sunday, 12 to 4 P.M.

Admission: Free.

Catalog: Housatonic Museum of Art: Selections from a Growing Permanent Collection, foreword by Burt Chernow, Bridgeport, 1980.

You have heard of a "museum without walls," but here every available wall functions as a museum. This one-building community college (soon to double in size) of about five thousand students has made the arts ubiquitous—in fact, inescapable. The typical college museum has its own space, possibly its own building, and—aside from student guards and group visits led by a professor—often very few students visiting. Here, however, the moment you enter the atrium hall with its surrounding balconies, you see art everywhere. Next, you notice that the most prominent feature of the atrium is the entrance to the Burt Chernow Galleries, two connected spaces for temporary exhibitions. But even these dedicated spaces are porous, as doors open onto the surrounding corridors and students cross through the galleries to reach their classrooms. Those very corridors, and in fact all corridors on both levels of the building, are hung with Modern art. Even the copier room had paintings on the wall!

The rationale is explained thus: "Just as the college understands the necessity of providing books through a library, Housa-

tonic Community College believes that an equally important component of its educational mission is to provide an opportunity to experience original works of art, in essence, a visual library." The collection was assembled under the guiding hands and eyes of the former museum director Burt Chernow, art teacher and historian, who over forty-five years cultivated many artists and collectors and installed the art when the college moved to this new building in 1997. The collection now numbers over five thousand items, mostly nineteenth- and twentieth-century European and American art. As you explore the building (and don't be shy!) you will discover a dramatic array of African sculpture and groups of landscapes, portraits, and semiabstract paintings, supplemented by Western sculpture (by Auguste Renoir, Alexander Archipenko, Isamu Noguchi, Lee Bontecou), as well as some Asian pieces and even a Greek krater. Chernow seems to have favored a not-so-abstract Expressionism, but almost all schools and movements of twentieth-century art are represented. He was a close friend of Gabor Peterdi's (1915–2001), painter and innovative printmaker and teacher, about whom he published a book. Peterdi is very well represented, and so is Christo, famous for creating large-scale installations, such as buildings wrapped in fabric. He and his wife and collaborator, Jeanne-Claude, were also good friends of Chernow's and the object of a study by the latter, published posthumously. During my visit I was particularly impressed by the large *Family Group* by Elaine de Kooning (see color insert), *The Alcove* by Boston Expressionist Bernard Chaet, and the commanding *Seated Man* by Michael Hafftka. Temporary shows draw on the permanent collection, especially the works on paper, which cannot be on permanent exhibit. Among these are works by Chagall, Picasso, Miró, Klimt, de Chirico, Reginald Marsh, Milton Avery, Philip Guston, Robert Rauschenberg, Sol LeWitt, and many regional artists and illustrators.

+ PLUS

Barnum Museum 🛒

Just a few blocks away is the Barnum Museum, founded by Connecticut-born Phineas Taylor Barnum as the Barnum Insti-

tute of Science and History and bequeathed to his adopted town. A striking Byzantine/Romanesque Revival building, it declares its dedication to American history in elaborate relief panels across the top of the building. Inside are exhibits tracing Bridgeport's industrial and social history, of which Barnum was a vital part as real estate developer and mayor. But Barnum the showman—the man who probably never said "there's a sucker born every minute," but who did say "the people like to be humbugged"—is at the center of the museum now. Through artifacts, memorabilia, and documents, his life story and feats of promotion are brought to life. It came as a surprise to me that he was over sixty years old before he started his circus venture. A detailed miniature model of his five-ring circus, with over three thousand carved figures, is the highlight of the museum.

Tel. 203-331-0079; www.barnum-museum.org.

Directions: At HCC side exit, turn right onto State Street, go two blocks to Main Street, turn right. The museum is at 820 Main Street.

Hours: Tuesday through Saturday, 10 A.M. to 4:30 P.M.; Sunday, 12 to 4:30 P.M.

Admission: Adults $5, students and seniors $4, children 4–17 $3.

Farmington

HILL-STEAD MUSEUM

35 Mountain Road, Farmington, CT 06032; Tel. 860-677-4787; www.hillstead.org.

Directions: From I-84 East or West, take Exit 39 (not 39A!). Continue straight onto Route 4 West. At the second traffic light turn left onto Route 10 South (Main Street). You will pass Miss Porter's School, the famous girls' boarding school. At the next light, turn left onto Mountain Road. The museum is a half mile on the left.

Hours: May through October: Tuesday through Sunday, 10 A.M. to 5 P.M.; November through April: Tuesday through Sunday, 11 A.M. to 4 P.M.

Admission: Adults $9, seniors $8, children 6–12 $4, free for children under 6. Guided tours only.

No museum in the traditional sense, Hill-Stead is rather the Colonial Revival retirement estate of a Cleveland iron magnate, designed by his daughter, the architect Theodate Pope. The thirty-six-room main house is filled with a connoisseur's collection of French Impressionist paintings, Japanese woodblock prints, Chinese porcelains, and the original furnishings. Formerly a working farm, it is set within 152 acres of land, with trails to explore, and features a lovely sunken formal flower garden.

After graduating from Miss Porter's, Theodate was taken on the grand tour of Europe by her parents in 1888–89 to finish her education and help clarify her future professional plans. She was one of those searching young women of the suffragette generation, who, keenly aware of her privileged upbringing, ruminated in her diary on how she could "make the world I touch a little better." In addition to the typical sightseeing program in France, Spain, Italy, and England, her art-loving father took her to galleries and exhibitions and visited artists' studios with an eye to buy art for his home in Cleveland. Typical for his class and age, he fancied the Barbizon painters, but he—and Theodate—quickly became enamored of the then cutting-edge Impressionists. His daughter, seeing one of Claude Monet's haystack paintings in an exhibit, urged him to buy it. He obliged and added another Monet, *Rocks at Belle-Île.*

Her love of the Connecticut landscape around Farmington (near Hartford) made her settle there. She bought, redesigned, and ran a farm in Farmington, which allowed her to pursue her charitable interests by teaching village children, while also keeping her in touch with her teachers at Miss Porter's School and the intellectual life of New York. She eventually chose a site near her original farm for her parents' estate, which she designed on an opulent scale but in New England farmhouse style (with allusions to George Washington's Mount Vernon).

The interior could be described as a light-filled Colonial-Victorian mixture in a rather open floor plan. Theodate planned the exact location of the pictures, with two horizontal pictures by

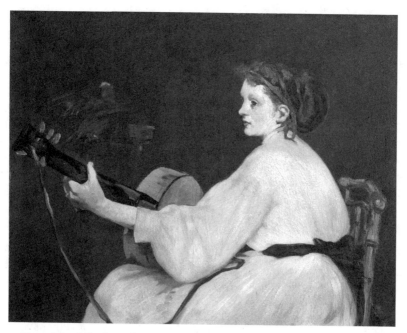

Edouard Manet, *The Guitar Player*, 1867. Oil on canvas, 25 × 31.5 in. Alfred Atmore Pope Collection, Hill-Stead Museum, Farmington, CT.

Degas and Monet hanging over the fireplaces, and created a gradual procession from the entry hall through a number of more intimate rooms into the splendid salon, which displays the artistic jewels of the collection.

Pride of place is given to *The Guitar Player* by Edouard Manet (1832–83), a stunning early work that uses the same model as his *Street Singer* in the Boston Museum of Fine Arts. The large white shapes of the woman's dress against the dark background, and the glowing orange of the guitar, fairly command one's eyes across the room. At a similarly high level is Edgar Degas' pastel *The Tub*, a nude bending to wash herself against a background of delicate blues and greens. Another Degas, *Dancers in Pink*, delights with the bold, almost scarlet color of the tutus, tight framing, and lively interplay of light and shadow. Rounding out the list of highlights are James A. McNeill Whistler's *Blue Wave* and a lovely family scene by Mary Cassatt. There are more works by Manet, Degas, and Monet, many etchings by Whistler, as well as other prints and paintings filling the walls of the stately staircase and the upstairs

bedrooms. The tour we took was led by an excellent docent and moved at a leisurely pace, giving one plenty of time to take in all the beauty and imagine oneself to be living in such splendid surroundings.

+ PLUS

Avon Old Farms School (Avon)
While Theodate Pope's architectural output is not large, she founded, designed, and built the campus of the Avon Old Farms School in nearby Avon, Connecticut, against many odds and over ten years, 1919–29. It is well worth the fifteen-minute trip to see this enchanting ensemble of red-sandstone, brick, and half-timber buildings, which combine features of a college quadrangle and a time-worn Cotswold village. The slate roofs have a built-in sag and slight flare to make them look aged: right angles are eschewed, and many details reflect Theodate's love of English vernacular architecture and the Arts and Crafts movement of the late nineteenth century. A particularly impressive interior is the Pope refectory, the communal dining room that echoes Medieval banquet halls. (A biography of Theodate Pope by Sharon Dunlop Smith, which provides a detailed history of the building of Hill-Stead and Avon Old Farms, can be found at www.valinet .com/~smithash/theodate/TOC.html.)

Directions: From Hill-Stead turn right on Mountain Road, then right onto High Street. Turn right onto CT-10/Main Street and continue on CT-10 for 3.5 miles. Turn left onto Old Farms Road (landmark is the village church on your right). Go for 1.5 miles; www.avonoldfarms.com.

Greenwich

BRUCE MUSEUM

1 Museum Drive, Greenwich, CT 06830; Tel. 203-869-0376; www.brucemuseum.org.

Directions: From I-95 North (or South), take Exit 3. At bottom

of ramp turn right (if going north) or left (if going south) onto Arch Street. Go through next intersection (Steamboat Road); the road becomes Museum Drive, with the museum on the left.

Parking: Ample parking around museum.

Hours: Tuesday through Saturday, 10 A.M. to 4:30 P.M.; Sunday, 1 to 4:30 P.M. Some exhibitions are in the Bantle Lecture Gallery, which may be used for events and therefore closed to viewing. Call ahead.

Admission: Adults $7, students and seniors $6, children under 5 free.

Catalog: The Bruce Museum: A Century of Change, published by the Greenwich Library Oral History Project and the museum, 2007. For Cos Cob, see Susan G. Larkin, *The Cos Cob Art Colony: Impressionists on the Connecticut Shore,* New Haven, 2001.

The Bruce Museum began in 1908 with the donation of a Victorian mansion set on a hundred acres of land, and a stipulation that it be used "as a Natural History, Historical and Art Museum, for the use and benefit of the public." One hundred years later, the mansion is almost engulfed by lavish and tasteful additions that provide space for the presentation of about sixteen exhibitions per year, as well as more permanent natural-science exhibits. The majority of exhibitions are art related, and photography has found an especially hospitable embrace.

The rather small permanent collection is not always on view, but at regular intervals there will be topical exhibitions that showcase works from the permanent collection. Its main focus is Connecticut art, and especially art related to the Cos Cob artists colony (see below); in addition to paintings and watercolors, the museum also owns sketchbooks and notebooks of Cos Cob–related artists.

When the Bruce Museum held its first exhibition in 1912, it featured the works of members of the Greenwich Society of Artists, some of whom overlapped with the Cos Cob colony. Thereafter, the society held annual exhibitions at the museum through 1926. The early acquisitions tended to be conservative and pleasant, including works by Emil Carlsen, Edward Henry Potthast, Carl

Rungius, and John Frederick Kensett. Recent acquisitions and gifts have added works by William Merritt Chase, Childe Hassam (*The Mill Pond, Cos Cob*), and Theodore Robinson.

The Bruce continues to collect and is expanding into both contemporary art and photography. There are regular exhibitions of photographs, drawn from outside sources or from the museum's own collection. Occasionally there will be tandem art and science exhibitions covering one theme; for example, "The Nature of Dogs" paired with "Dogs in Art from the Renaissance to the Present."

The land bequeathed by Robert M. Bruce is now a public park with a playground, some outdoor sculpture, lavish plantings, jogging trails, a baseball diamond, a lawn bowling green, and picnic facilities. The area is particularly pretty in the spring when azaleas, tulips, and dogwoods bloom. The Bruce Museum also hosts two major outdoor events, a crafts festival on Memorial Day weekend, and an arts festival on Columbus Day weekend.

+ PLUS

Bush-Holley Historic Site (Cos Cob)

Just a few miles north of Greenwich, the Bush-Holley Historic Site provides a tangible link to the oldest artist colony in Connecticut, Cos Cob. From 1890 until the 1920s, the old inn and boardinghouse run by the Holley family welcomed artists and writers, who were escaping to the quiet of the small harbor town of Cos Cob, newly linked to New York by rail. Such New York Impressionists as Childe Hassam, John H. Twachtman, Ernest Lawson, and many others sought out the landscape and light of this still-rural part of the Connecticut coast. Theodore Robinson provided a living link with Monet, having studied in Giverny for many years. One of the artists, Elmer MacRae, married the innkeeper's daughter, and the house stayed in the family until 1957, when the Greenwich Historical Society bought it. Guided tours of the inn let you step back in time to experience what it must have been like when art students and their teachers ate communal meals and spurred each other on. They captured the coastal landscape in the various seasons, the harbor and boats, the clapboard

houses, and made lovely portraits of their wives, daughters, and girlfriends. Some of these pictures hang in the rooms where they were painted or which they depict. Now a national historic site, it was barely saved when I-95 was built. While the site is intact, it takes some effort to visually subtract the intrusive, looming viaduct above and imagine the tranquility of the nineteenth-century setting. There is a small gallery, which mounts exhibits related to the Cos Cob art colony.

39 Strickland Road, Cos Cob, CT 06807, Tel. 203-869-6899; www.hstg.org.

Directions: From I-95 southbound: Take Exit 4, make immediate right U-turn onto Sound Shore Drive, follow to end; turn right onto Strickland Road; parking lot on left under I-95 overpass.

From I-95 northbound: Take Exit 4, make left over I-95, make immediate right onto Sound Shore Drive, turn right onto Strickland Road.

Hours: The visitor center is open Tuesday through Sunday, 12 A.M. to 4 P.M., with tours of the Bush-Holley House at 12:15, 1:15, 2:15, and 3:15. In January and February the site is open on Saturday and Sunday only.

Admission: Adults $6, seniors and students $4, children under 6 free.

Groton

ALEXEY VON SCHLIPPE GALLERY OF ART, UNIVERSITY OF CONNECTICUT

1084 Shennecossett Road, Groton, CT 06340; Tel. 860-405-9052; www.averypointarts.uconn.edu.

Directions: Take I-95 North or South to Exit 87; take Clarence Sharp Highway (Route 349). Turn right at second traffic light, then left at second light (still 349) onto Eastern Point Road. Proceed for 1.5 miles to the entrance of the Avery Point Campus. The gallery is in the Branford House mansion near the waterfront.

Hours: Wednesday through Sunday, 12 to 4 P.M. Call ahead to
 make sure there is no wedding reception, in which case ac-
 cess may be limited.
Admission: Free.

This is a small, young, and ambitious gallery housed in a stately
Tudor-style mansion (built of locally quarried granite) that could
not be exceeded for dramatic location and vistas. Morton Free-
man Plant, a railroad heir, playboy, and yachtsman, built him-
self, in 1903, a $3 million "summer cottage" across from New
London, on a granite promontory at the mouth of the Thames,
with sweeping views of Long Island Sound and various islands
and lighthouses. At the time the estate included a working farm,
elaborate Italian gardens, marble statuary, a wharf, greenhouses,
etc., on over three hundred acres. Nowadays, only a gatehouse
and the mansion survive. A checkered history found the mansion
sold at auction for $55,000, the gardens bulldozed during WWII,
and the property bouncing between the U.S. Coast Guard and
the State of Connecticut. It was finally turned over to the Univer-
sity of Connecticut in the late 1960s to be used as a branch cam-
pus, with concentration in marine sciences.

The university has been a good warden of the spectacular
mansion, allocating space to both the art gallery and an experi-
mental theater. The ground floor, with a grand hall dominated
by a two-storey fireplace and elaborately carved woodwork, is
often rented for weddings and functions. (On summer weekends
it's advisable to call ahead to make sure the gallery will be open.)
Do explore the ground-floor suite of rooms and the charming lit-
tle veranda and garden if you can. Hundreds of European carvers
were brought here for the woodwork; marble, onyx, bronze, and
even Italian topsoil were imported.

Once you have ascended the elegant staircase, you will be
entering the intimate Alexey von Schlippe Gallery. Founded in
1992, it is named for the Russian-born painter (1915–1988) and
professor of art at Connecticut College from 1963 to 1982. At the
core of the holdings are five hundred paintings by von Schlippe.
He painted figures, landscapes, and still lifes, which are informed
by subtle allusions to earlier periods and techniques (such as Early

Renaissance paintings or Byzantine icons), a certain level of abstraction and simplification, and often a gentle surrealism. A number of his works are always on view. Beyond that, the gallery functions as an exhibition space for living artists—local, national, and international—in a hybrid not-for-profit/commercial format, in which all artwork is for sale and the exhibitors return a portion of the sales price as a donation to the gallery. There are about twelve exhibits annually, complemented by gallery talks and lectures; poetry readings, films, concerts, and new theater works are offered through the associated Avery Point Playhouse, also housed in the mansion.

The greatest attraction for many art and nature lovers may well be the Sculpture Path by the Sea. A good dozen large sculptures in various media are placed along a curving brick path that hugs the shore in front of the Branford House and ends at the lighthouse. The exhibit is expected to increase over the years. On a sunny day, this combination of art, architecture, land, and sea is hard to beat. A pamphlet with detailed information on the works and artists is available at the gallery; some works are for sale, others belong to the permanent collection (see color insert).

+ PLUS

Connecticut College outdoor sculpture (New London)
If your appetite for outdoor sculpture has been whetted, proceed to nearby Connecticut College and view its collection on the south campus, near the Cummings Art Center. About a dozen pieces are on view, including works by Sol LeWitt and Louise Nevelson. See www.conncoll.edu/visual/campus-sculpture/SouthCampus. htm for a little plan and further information on the individual pieces. (Incidentally, the impressive Wetmore Print Collection at Connecticut College is not on view, but made completely accessible and downloadable online at www.conncoll.edu/visual.)

Directions: From Avery Point, take I-95 South to New London. Just after the bridge, take Exit 84 to Route 32 North. The college entrance is 1 mile on the left. Park in the south lot and proceed to Cummings Center.

Hartford

WADSWORTH ATHENEUM MUSEUM OF ART

600 Main Street, Hartford, CT 06103; Tel. 860-278-2670; www.wadsworthatheneum.org.

Directions: From 1-91 North or South: Take Exit 29A. Take the Prospect Street exit, turning right onto Prospect. The back of the museum is on the left, one block up, the parking lot on the right.

From Boston and points east: Take 1-84 West to Exit 54 (left exit, Downtown Hartford). After crossing Founders Bridge, turn left at the first light (Columbus Boulevard) to Arch Street. Turn right onto Arch. Go one block to Prospect Street, turning right onto Prospect. See above.

From New York and points west: Take 1-84 East to Exit 48B (Capitol Avenue), turn left onto Capitol Avenue and when it ends, turn right onto Main Street. The museum is on the right, two blocks up. For parking, go past the museum and turn right at the light. At the stop sign, turn right onto Prospect Street. The parking lot is on your left.

Hours: Tuesday through Friday, 11 A.M. to 5 P.M.; Saturday and Sunday, 10 A.M. to 5 P.M.; first Thursday to 8 P.M.

Admission: Adults $10, seniors $8, students with ID $5, children under 12 free; first Thursday, 5 to 8 P.M. $5.

Catalog: Numerous specialized catalogs available in bookstore.

The Wadsworth Atheneum rightly prides itself on a number of accomplishments: Founded in 1842, it is the oldest public art museum in the United States, and was from the start a leading advocate and collector of American art; it houses the largest collection of Colonial American furniture in the country; it assembled an outstanding collection of European Baroque art, and, last but not least, it played a pivotal role in bringing twentieth-century European art, including dance, music, and film, to the United States.

Aside from these unique strengths, the museum is also a full-

fledged civic art museum, the biggest between New York and Boston, devoted to covering the (mostly Western) arts from Antiquity to the twenty-first century. Its very structure tells its history and that of its devoted donors; additions in various styles and dating from 1910 to 1969 (with more on the drawing board) make the space difficult to grasp and navigate, thus the museum thoughtfully provides you with a map, updated every time a new temporary exhibit opens.

You enter what is the oldest part, the Neo-Gothic original Atheneum, a temple devoted to art and learning, built to house the art collection of founder Daniel Wadsworth. Nowadays this gothic fortress houses visitor services (library, information desk, bookstore) on the first floor and exhibition space on the second floor of the heavily modernized entry space, which also boasts a huge mural by Sol LeWitt (1928–2007), a Hartford native.

Daniel Wadsworth (1771–1848) came from an influential Hartford family that traced its origins to the Hooker Party, the secessionist Puritans who left the Massachusetts Bay Colony to found Hartford in 1636. Daniel's father, Colonel Jeremiah Wadsworth, was a wealthy mover and shaker in colonial Connecticut and hosted George Washington repeatedly while the latter was assembling his army (see the historical marker on the exterior left wall of the original building). Son Daniel was a friend and related by marriage to John Trumbull, the "painter of the American Revolution," who painted the murals of the rotunda in the Capitol in Washington, D.C., of which half-size copies by Trumbull are at the Atheneum. It was Trumbull who in 1825 introduced Wadsworth to Thomas Cole (1801–1848), the founder of the so-called Hudson River School; Wadsworth was to become one of Cole's major patrons. Later, it was Wadsworth who prevailed upon Cole to take on seventeen-year-old Frederic Church (1826–1900) as a student—his only one. Church followed his teacher in painting "a higher style of landscape"; i.e., a grand, idealized evocation of pristine nature, before the intrusion of modernity. It comes as no surprise that Trumbull, Cole, and Church, as well as their American contemporaries, are amply represented at the Atheneum.

The first big expansion embodies the wealth and the munificence of the Gilded Age: the Morgan Memorial, an elegant

Renaissance Revival structure to the right of the original Atheneum, and, functioning as a bracket between the two, the Neo-Tudor Colt Memorial. The great financier John Pierpont Morgan, another Hartford native, funded this memorial to his father, and eventually bequeathed to the museum some 1,300 items—antique bronzes, Italian majolica, silver-gilt works, Venetian glass, and an outstanding collection of German and French porcelain. The gorgeous, two-storey vaulted Morgan Great Hall, painted in a deep burgundy red, is dominated by large-scale American and European oils. The side naves contain smaller paintings and artifacts of the Late Medieval and Renaissance eras on one side and Asian art, as well as Classical antiquities, on the other. The opulent double staircase leading to the second floor galleries is unfortunately marred by a bright red, blue, and yellow geometric mural by Sol LeWitt, which is painful to look at in this context. The upper-floor galleries typically house temporary exhibits, as well as a permanent gallery for the important collection of European porcelain.

The Colt Memorial was given by the widow of the inventor of the revolver, Samuel Colt, whose large manufacturing plant, topped by a blue onion-dome, can still be seen from the back of the museum on the other side of the Connecticut River. Both an important collection of American art, assembled under the tutelage of Frederic Church, and a large collection of historical firearms came to the museum through this Hartford connection. Currently the Colt Memorial houses nineteenth-century paintings both academic and Impressionist.

The Avery wing of 1934 might as well be called the Chick Austin wing. A. Everett "Chick" Austin, Jr., became director of the Atheneum at age twenty-seven, in 1927, and led it from musty obscurity into the vanguard of all that was modern, first-rate, and exciting, until he left in 1944. When funds were available for a major expansion, he fought tenaciously against the donor's wishes for something in the "general architectural effect" of the Morgan Memorial; Austin was determined to make the new wing the first modern museum building in the United States. What Austin achieved is a Bauhaus-style interior, for which he made the design decisions down to the shape of the radiator grilles. In a stroke of

genius—or eccentricity—Austin placed a marble fountain in the middle of it, a Mannerist, twisting *Venus with Nymph and Satyr* by Pietro Francavilla (1548–1615).

The Avery wing contains a fully equipped theater with orchestra pit, cyclorama, and state-of-the-art film projection equipment. Theater, ballet, concerts, film, and lecture series complemented the exhibitions and acquisitions that from the start brought the hottest European and American developments to the relative backwater of Hartford. Austin mounted the first Surrealism show (1931) and the first Picasso retrospective (1933) in this country. He sponsored the immigration of choreographer George Balanchine to the United States; Balanchine's first public American dance production was mounted in the Avery Theater, long before his New York City Ballet came into being. Exhibitions featuring modern architecture, concerts of contemporary music, and the American premiere of Virgil Thomson's opera *Four Saints in Three Acts*, with text by Gertrude Stein, all took place at the Atheneum. Austin's frequent exhibitions of contemporary European and American artists led to the acquisition of many works of art within a few years of their creation (Dali, Miró, Mondrian, Magritte, Calder, and many others).

At the same time, Chick Austin was a Harvard-trained art historian and connoisseur with an uncanny eye for the highest quality in Old Master painting. He acquired masterworks by such Renaissance and Baroque artists as Fra Angelico, Piero di Cosimo, Strozzi, Tintoretto, Claude Lorrain, Jusepe Ribera, Zurbarán, Frans Hals, and Van Dyck. Chick Austin loved the Baroque; since it was then out of fashion, he was able to assemble an outstanding collection in a relatively short time and, due to the war, at relatively low prices. Caravaggio's *St. Francis in Ecstasy* cost the museum all of $17,000 in 1943!

The Avery wing's central, skylit courtyard is surrounded by balconies on two levels. The second-floor galleries nowadays house American decorative arts and the Nutting Collection of Pilgrim Furniture, acquired in 1926 by John Pierpont Morgan, Jr., for the Hartford Atheneum. Wallace Nutting (1861–1941) was an authority on Colonial furniture and had used these historical pieces as models and inspiration for his thriving business in

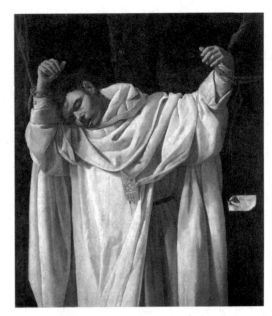

Francisco de Zurbarán, *Saint Serapion*, 1628. Oil on canvas, 47⅝ × 41 in. Wadsworth Atheneum Museum of Art, Hartford, CT. The Ella Gallup Sumner and Mary Catlin Sumner Collection Fund, 1951.40.

reproduction domestic furniture and paraphernalia. If you sit on a Windsor chair today, or have a hooked rug on the floor, it's Nutting's legacy. His motto was "whatever is new, is bad."

The third floor houses American art of the nineteenth and twentieth centuries—an impressive collection that also includes sculpture and decorative arts. All the major names are represented: Thomas Eakins, Winslow Homer, John Singer Sargent, Childe Hassam, the Ashcan School (John Sloan, George Bellows), Early Modernists such as Stuart Davis, Marsden Hartley, Georgia O'Keeffe, and many others. The ground-floor galleries are available for special exhibits, and the interior courtyard walls usually present major European paintings of the twentieth century, many purchased during the Austin reign, among them a particularly rich selection of Surrealist paintings.

Filling in the space between the Avery wing and the original Wadsworth Atheneum building is the unassuming Goodwin wing from the late 1960s. It contains the largest uninterrupted

space and usually houses the large-scale masterworks of European painting or other selections from the permanent collection.

Let me finally just mention that there is also an extensive Costume and Textile Division, which mounts two exhibits per year. A large collection of drawings and costumes related to the Ballets Russes came to the museum through the dancer Serge Lifar.

The museum has plans underway to add yet another building, the massive Greek-style former office of the now-defunct *Hartford Times*, for which it holds a long-term lease. Situated diagonally behind the museum on Prospect Street, it overlooks a small park that can barely contain the huge orange Calder steel sculpture *Stegosaurus*. Eventually the building will house the administrative offices for the Wadsworth Atheneum, thus freeing up approximately thirty thousand square feet of exhibition space in the existing array of buildings. Stay tuned for the next chapter in the Wadsworth Atheneum's rich history.

+ PLUS

Chick Austin House and biography

It is hard to capture the excitement of the Austin years at the Hartford Atheneum in a short entry. Fortunately, there is an excellent biography that does just that: *Magician of the Modern: Chick Austin and the Transformation of the Arts in America*, New York (Alfred R. Knopf), 2000. The author, Eugene R. Gaddis, is the curator and archivist at the Austin House, the Palladio-inspired private residence Chick Austin built for himself and which he furnished with Baroque and Bauhaus furniture. It has recently undergone extensive restoration and is on the National Register of Historic Places.

The house is located at 130 Scarborough Street, Hartford, CT 06103. Tours are available by appointment only, with a $20 contribution to the Sarah Goodwin Austin Memorial Fund. For more information call 860-278-2670, ext. 3049.

Middletown

DAVISON ART CENTER, WESLEYAN UNIVERSITY ❁

301 High Street, Middletown, CT 06459; Tel. 860-685-2500;
www.wesleyan.edu/dac.

Directions: From points north: take I-91 South to Exit 22, to
Route 9 South. At Exit 15, turn right onto Route 66 West
(Washington Street). At third light turn left onto High
Street. The art center is in a pink building on the right. From
points south: Take I-91 North to Exit 18, to Route 691/66
East. Route 66 becomes Washington Street in Middletown.
Turn right onto High Street. Park along High Street.

Hours: September through May only: Tuesday through Sun-
day, 12 to 4 P.M.

Admission: Free.

The Davison Art Center owns one of the two or three most im-
portant collections of prints at any university. The numbers alone
are impressive: nearly eighteen thousand European and Ameri-
can prints dating from the Renaissance to today, more than six
thousand photographs, and over six hundred Japanese prints. The
Davison is the legacy of George Willets Davison (1872–1953), a
banker and avid collector, who, beginning in the 1930s, gave his
collection of about six thousand prints to his alma mater. In 1950
he provided funds to buy the historic Alsop House, to renovate it
and build a wing that would house the growing collection. There
are now plans under way to build a "university museum" to house
this and other scattered collections, but for the time being, the
Davison Art Center at Alsop House is the primary location for art
on the Wesleyan campus.

It is supplemented by the Ezra and Cecile Zilkha Gallery,
housed in the nearby Center for the Arts complex and dedicated
to exhibitions of contemporary art (as well as student works),
which fits well with the 1973 building, a pair of connected, stark,
limestone-clad cubes, designed by Kevin Roche, John Dinkeloo
and Associates.

The contrast with Alsop House (built 1838–40), with its delicate, pale pink exterior, Classicistic murals, and light, filigree-iron porch supports, is striking indeed. The ground floor and the stairwell of the house are open to visitors. You will be given a printed handout to guide you through the various rooms, which boast an elaborate program of mural painting. Executed in oil on plaster, the murals are a delicate amalgam of Raphaelesque, Empire, and Pompeian influences, executed by an unknown artist, who added charming birds, butterflies, and some trompe l'oeil effects for good measure. The description "Romantic Classicism" that has been applied to the house does make sense once you have seen it.

The exhibition space, in an annex, hosts four to six exhibitions per academic year. They are in some way tied to prints and photographs, and draw on the collection as well as on loans. There is, however, no display of the permanent collection per se, which is quite understandable given the fragile nature of prints. To make up for that, the Web site is elaborate and well organized, and provides more detailed breakdowns of the holdings; it also has a search function, but only a fraction of the holdings are accessible in this way.

Some highlights of the collection include nineteenth-century photographs, especially travel photos; 222 prints by Goya, including a complete set of *Los Caprichos*; nearly the entire etching output of Piranesi, close to 1,000 pieces; 50 Rembrandt works, including variant versions of the same plate; 73 woodcuts and engravings by Dürer. The nineteenth-century collection is particularly rich in French works, but also English and German. Outstanding selections include Manet (35), Odilon Redon (39), Corot (29), Daumier (211, including the entire set of illustrations of Goethe's *Faust*, viewable online).

The twentieth century is well covered in terms of European works. Let me just cite the twenty-six Picassos, eleven Rouaults, nine Kokoschkas, thirteen Beckmanns, twenty-one Barlachs, fifteen Kandinskys. In fact, almost every artist of renown who worked in print is represented by a few works, and seeing the listings makes one sad that so little is readily accessible.

When we come to the twentieth and twenty-first centuries,

the Americans certainly take the lead, from the etching revival of the late nineteenth century, the Ashcan School, the Early Modernists, Pop Art, Abstract Expressionism, to Color Field Painting: whatever the school or movement, there is a sizable print presence. And the growth of the collection seems to be particularly pronounced in contemporary art. Several hundred pieces are added to the collection every year.

One artist needs to be singled out, and that is Jim Dine (b. 1935). He is an eclectic both in his aesthetics and his media (painting, sculpture, printing, photography, and performance art). The museum owns about 150 of his prints, dating from 1965 to the present, thus spanning his entire development as an experimental printmaker. In the 1990s Dine turned to photogravure, a process in which a photographic negative is used to prepare a printing plate; in his case, a copper plate. He donated 192 of his photogravures to the Davison in 2000, with the promise that one exemplar of every future photogravure would go to the museum.

+ PLUS

Campus architecture
In addition to the Davison Art Center, there are two other venues for art you should check out: the abovementioned Ezra and Cecile Zilkha Gallery, easily reached by walking past the Alsop House away from High Street and toward the many cube-shaped buildings of the Center for the Arts. Walking beyond the Zhilka Gallery toward Washington Terrace, you will find, at No. 343, the Mansfield Freeman Center for East Asian Studies. Here small exhibits of Asian art are held in a simple, large space; the center also has a lovely traditional Japanese room, which overlooks the small Japanese garden in the back. After the overwhelming scale of the Center for the Arts, these intimate spaces are a welcome relief. Last but not least, a walk up and down High Street reveals many stylish and imposing residences from the nineteenth century, now often used for academic purposes, of which the Alsop House is but one.

New Britain

NEW BRITAIN MUSEUM OF AMERICAN ART

56 Lexington Street, New Britain, CT 06052; Tel. 860-229-0257; www.nbmaa.org.

Directions: From I-84: Take Exit 35 (left exit) to Route 72E. Follow signs to New Britain and take Exit 8, Columbus Boulevard. At the exit light turn right and proceed to next light. Take a right onto West Main Street, and immediately take a left (before Bank of America) onto Lexington Street. The museum is the last building on the left.

From I-91: Take Exit 22N, follow Route 9 to Exit 28. Follow 72W to Exit 7, Corbin Avenue. At exit light turn right, proceed to next light and turn right onto West Main Street. One block after the third light, turn right onto Lexington Street.

Hours: Tuesday, Wednesday, Friday, 11 A.M. to 5 P.M.; Thursday, 11 A.M. to 8 P.M.; Saturday, 10 A.M. to 5 P.M.; Sunday, 12 to 5 P.M.

Admission: Adults $9, seniors $8, students $7, children under 12 free. Free admission for all on Saturday, 10 A.M. to 12 P.M.

Catalog: New Britain Museum of American Art: Highlights of the Collection, vols. 1 and 2, New York, 1999 and 2004.

Founded in 1903, the museum is the first, and thus oldest, institution devoted exclusively to American art. But the building housing its five-thousand-piece collection is one of the newest, having opened in 2006 (Ann Beha Architects). The history of the NBMAA reflects the history of its town, also known as "Hardware City": booming industries (particularly the Stanley Works, producers to this day of hand tools and metal fittings) attracted thousands of immigrants, who worked in the large brick factories still visible near the center of town. Great fortunes were made and the civic spirit thrived. One manifestation was the founding, in 1858, of the New Britain Institute, a public library and reading

room meant to help immigrants participate in the cultural life of their new homeland.

An art room was established in 1901; the first purchases were made possible by the gift, from a local tycoon, of twenty New York Central and Hudson Railroad Company coupon gold bonds (what a Victorian mouthful!), worth $20,000. Other money gifts followed, and soon a committee of earnest citizens sought the advice of the director of the Metropolitan Museum on how to spend the income. The advice was to buy contemporary art, and specifically American art, since it was less expensive. They were steered to the Macbeth Gallery in New York City, which specialized in American art, and were advised to collect "backward and forward" from their point in time. (The Addison Gallery of American Art in Andover, Massachusetts, was another major client of Macbeth's.)

Slow beginnings almost came to a halt during the Depression, but for a propitious donation by philanthropist Grace Judd Landers, who bequeathed money and her turn-of-the-century mansion as a permanent home for the art collection. It opened in 1937 as the Art Museum of the New Britain Museum Institute, and Sanford B. D. (Sandy) Low, an artist and illustrator, became its first, part-time director in 1940. With the help of funds donated by Alix W. Stanley, of the Stanley Works, Low was able systematically to enlarge the collection. As an illustrator himself, he was keenly interested in illustration as an art form and collected widely in that field, often urging his friends and colleagues to donate their work. As a result, the museum has almost 1,500 illustrations dating from the nineteenth century to the present, making it the first museum to boast an illustration collection.

The ongoing program of loan exhibitions included a controversial showing in 1929 of Picasso, Matisse, Derain, and Modigliani, as well as an annual presentation of emerging local artists. In 1949 the exhibition "Young Talent" showcased the work of twenty-one-year-old Sol LeWitt, who grew up in New Britain. LeWitt did not forget this early encouragement; today NBMAA has 1,500 lithographs, silk screens, and engravings as a promised gift by the artist.

As you enter the Chase Family Building—dubbed an "ex-

pansion," but really a full-fledged new museum adjacent and connected via a glass passageway to the original Landers House facility—the first thing you see is another Sol LeWitt, a huge mural composed of dark and light bands of swirling pencil markings. A Sol LeWitt mural has almost become de rigueur for new museum buildings; the Sackler Museum, the Williams College Museum of Art, and the Currier Museum of Art each have one, the Wadsworth Atheneum in Hartford, even two. This one is unusual for being in black and white only, but it fills the large lobby space effectively and unobtrusively and is enhanced by the warm wood paneling of the book shop, the boldly sculpted reception desk, and the vistas of the adjacent park one glimpses.

"With this new space, we aim to have twice as many visitors as we had before. But we hope to satisfy them in a way that they will want to come back more often," says director Douglas Hyland. Hyland is the moving force and guiding spirit behind the new building and the concept of the museum as a community attraction that offers also concerts (every Sunday at 2 P.M.), parties (Art Happy Hour every second Thursday night of the month, a jazz-filled First Friday cocktail soiree), classes, lectures, films, a library and reading space, children's programs, and more.

The first gallery lures the viewer in a most tantalizing and original manner: it shows a representative painting from each distinct era or school, provides a historical context, and tells you where in the museum you will find further examples. It's like an appetizer tray or an illustrated table of contents, and it works beautifully. The subsequent galleries serve the main course: Colonial and Early Republic (John Smibert, John Singleton Copley, the Peale family, Gilbert Stuart, Ralph Earl), Hudson River School (Thomas Cole, Asher B. Durand, Fitz Henry Lane, Albert Bierstadt, and Frederic Church), Academic Painting (Winslow Homer, Thomas Eakins, and works by trompe l'oeil artists John Haberle, John Peto, and Willliam Harnett), Works on Paper (this changes frequently), and Impressionism (Mary Cassatt, John Singer Sargent, Childe Hassam, James Abbott McNeill Whistler, Willard Metcalf). These rooms connect with the long, wide corridor, which is devoted to the illustration collection and a sizable collection of bronzes by Solon Borglum, an artist who did mostly

western themes and was the teacher of Art Deco sculptor Paul Manship, who is also represented.

Needless to say, the abovementioned artists do not exhaust the exhibits, and, over time, the exhibits' contents will presumably vary. NBMAA is particularly rich in Hudson River School paintings and in American Impressionism. The illustration collection should attract older visitors who may remember such images and names as Howard Pyle, N. C. Wyeth, Norman Rockwell, and Maxfield Parrish from the illustrated magazines, advertisements, and books of their youth.

At the end of the corridor, a wide staircase leads past a site-specific, commissioned installation. At the opening it was (and currently it still is) the eye-popping *The Eye* by Stephen Hendee, a partly computer-generated sculpture of corrugated, opaque plastic lit up by bluish neon lights. It's expected to burn out by 2012, at which point it will be dismantled and replaced by something new. In competition with the installation is a large glass expanse framing a view of lovely Walnut Hill Park (see PLUS, below). Ann Beha Architects of Boston, a firm experienced in the design, expansion, and restoration of museums, took maximum advantage of natural light and the beautiful surroundings. (Other regional museums that show ABA's thoughtful and understated touch include the Currier Museum of Art in Manchester, New Hampshire, Cape Ann Historical Association in Gloucester, Massachusetts, and the University of Maine venues in Orono and Bangor.)

The second floor houses art of the twentieth and twenty-first centuries, and changing exhibitions. The museum owns more than sixty works by artists of the Ashcan School (George Bellows, Robert Henri, John Sloan, William Glackens, George Luks), who can be considered the first truly vernacular American artists, not beholden to a European school or model. Depictors of urban scenes (Reginald Marsh, Charles Burchfield), Regionalists (Grant Wood, Thomas Hart Benton), and such Modernists as Marsden Hartley, Georgia O'Keeffe, Stuart Davis, and Jacob Lawrence are all represented. (See color insert.)

Thomas Hart Benton was a close friend of the museum's ever since the Whitney Museum decided to dispose of the large murals

The Arts of Life in America, which it had commissioned from him in 1932. They show scenes from the city, the South, the West, and of Native American life, in an intense, Greco-like, swirling style. By 1953, the Whitney planned to move to new quarters, and, after much notoriety for the murals and with changing tastes at the helm, it was no longer interested in them. For a mere $500 and due to some quick action by director Sandy Low and benefactor Alix W. Stanley, the NBMAA acquired an outstanding example of socially committed, larger-than-life mural art (comparable to the large Orozco murals at Dartmouth College). In the new museum building, the six panels have their own room, with ample documentation and preparatory sketches. They seem overwhelming at first, but warrant study and immersion.

Late-twentieth-century and contemporary art commands a large space; you will see works by the major names: Andy Warhol, Louise Nevelson, Isamu Noguchi, Robert Motherwell, Lee Krasner, Adolph Gottlieb, Jim Dine, Richard Diebenkorn, Eva Hesse, and surely many more to come in the future. Rounding out the offerings is a dedicated gallery space called NEW/NOW, a designation that needs no further explanation. And, should you be tired while you absorb all these riches, you can sit down on unique benches made by artists specifically for the museum.

+ PLUS

Walnut Hill Park 🛒

NBMAA is situated at the edge of Walnut Hill Park, designed by Frederic Law Olmsted, the famous landscape designer and creator of Central Park in New York City. As director Douglas Hyland puts it: "Most of our really good early paintings are Hudson River paintings, and curiously enough, Olmsted studied Frederic Church and the Hudson River painters in developing his concepts for Central Park. So it's where art is actually leading life in a wonderful combination." It's a little unclear how much of Olmsted's original concept is still visible. Would he really have allowed tall white pines to obstruct most of the vistas from the top of the hill? And the grand war memorial that crowns the hill was erected long after his time. But the size of the park, the

topography, and its many amenities (playground, band shell, exercise parcours, bike paths, playing fields, etc.) make this a wonderful capstone to a visit to the museum. And for the footsore, the outdoor terrace of the museum will give you a good view not only of the sculpture garden, but of the park as well.

New Haven

YALE CENTER FOR BRITISH ART

1080 Chapel Street, New Haven, CT 06520; Tel. 203-432-2800; www.yale.edu/ycba.

Directions: From I-91 and I-95 take the exit for downtown New Haven onto 34 West. Take Exit 3. Turn right at the light onto York Street. Proceed two and a half blocks to the center's parking lot on the right.

Hours: Tuesday to Saturday, 10 A.M. to 5 P.M.; Sunday, 12 to 5 P.M.

Admission: Free.

Catalog: Paul Mellon's Legacy: A Passion for British Art, 2007, and numerous specialized publications. The autobiography of Paul Mellon (with John Baskett), *Reflections in a Silver Spoon* (1992), is highly readable and has specific chapters on collecting, the YCBA, and the National Gallery.

This splendid museum represents one man's passion, the requisite funds to indulge it, and, finally, the generosity to bequeath it all to the public. Paul Mellon (1907–1999) was the son of banker and industrialist Andrew Mellon, who gave the National Gallery in Washington (and his outstanding collection of paintings) to the nation. The son had no interest in business and described himself thus: "I have been an amateur in every phase of my life; an amateur poet, an amateur scholar, an amateur horseman, an amateur farmer, an amateur soldier, an amateur connoisseur of art, an amateur publisher, and an amateur museum executive." He might have added that he was an amateur Englishman, for his love of all things English suffuses all his endeavors.

Today, YCBA houses the largest collection of British art out-side Great Britain, with approximately 1,900 paintings, 50,000 prints and drawings, 35,000 rare books and manuscripts, and 250 pieces of sculpture. How did this come about?

Paul Mellon's mother was English, and he spent happy child-hood summers in England (and detested the paternal Pittsburgh and modern city-life in general). A 1929 graduate of Yale, young Mellon decided to go to Cambridge to further pursue his interest in British history and literature, and while there concentrated on the three r's: riding, rowing, and reading. He became a passionate horseman, enjoying both trail riding and foxhunting. (He would later add the breeding and racing of horses.) This led to the col-lecting of color-plate books on these topics. In 1936 he bought his first painting, *Pumpkin with a Stable-Lad* by George Stubbs (1724–1806), a Romantic painter specializing in horses. Eventually there would be fifteen oil paintings by Stubbs at the Yale Center, the largest number in any public museum. British sporting art, in oil, watercolor, drawing, or printed books, is a mainstay of the collection.

Landscapes are the other mainstay, and equally a manifestation of Mellon's love of England. Idealized landscapes in the vein of Claude Lorrain give us British landscapes with an Italian accent, like those by Thomas Gainsborough (1727–1788) and Richard Wilson (1714–1782), the latter a founding member of the Royal Academy. More darkly romantic is Joseph Wright (called Wright of Derby, 1734–1797), who also excelled in candlelit scenes. The two towering nineteenth-century landscapists, John Constable (1776–1837) and J. M. W. Turner (1775–1851), are amply repre-sented, each having his own gallery.

William Blake (1757–1827), the poet, painter, and printmaker, was another early interest of Mellon's. Blake's visionary and highly expressive images couldn't be farther from Stubbs's serene and me-ticulous depictions of specific horses in specific landscapes. What might have led Mellon to Blake was, among other things, a deep interest in the thought of Carl Gustav Jung, who melded psy-chology, myth, and archetypes. Mellon and his wife visited Jung and both underwent therapy with him, then set about to make Jung's work more widely known. The Bollingen Foundation was

created by Paul Mellon to publish English translations of Jung's work, and related topics in art, myth, and religion.

While Mellon was not initially interested in the great tradition of English portraiture (so avidly sought out by Henry E. Huntington and other collectors of the Gilded Age), eventually he acquired outstanding examples of the grand style by Peter Lely, Joshua Reynolds (*Charles Stanhope, Third Earl of Harrington*), Thomas Gainsborough (*Mary Little, Later Lady Carr*), and Thomas Lawrence, as well as more intimate portraits and "conversation pieces," i.e., group portraits that depict natural interaction between the sitters in scenes from everyday life. Hogarth, the young Gainsborough, George Romney, and the transplanted American Benjamin West provide examples of this genre.

Other foreigners who were active in England give a fuller picture of English cultural life and are evidence of the strong ties that bound England culturally to the Low Countries and Italy. There are Peter Paul Rubens and his master pupil Anthony van Dyck (*Montjoy Blount, Earl of Newport*); Canaletto, who depicted Westminster Bridge over the Thames as if it were the Rialto; and Pompeo Batoni (1708–1787), who practically made his living painting English noblemen in Rome during their grand tour.

Gradually, Paul Mellon embraced the goal of thoroughly covering British art from the fifteenth through the early twentieth centuries, in oil, prints and drawings, illustrated books, and sculpture. When it came time to present the collection to the public, he chose his alma mater to be the site of a museum that is also a research institute of international repute (with its sister institution in London, the Paul Mellon Centre for Studies in British Art). The exhibition program is of the highest caliber: each year, six to eight exhibitions are mounted that draw intensively on the permanent collection and are accompanied by scholarly and artistic programs, well-produced catalogs, and handsome (free) brochures. The special exhibitions benefit from the spacious galleries on the second and third floors, whereas the permanent collection is on the fourth, beautifully arranged around two atriums with filtered daylight.

+ PLUS

Louis Kahn building; My Architect *(film)*
Opened in 1977, the YCBA is Louis Kahn's last work, completed after his death in 1974, just as the Yale University Art Gallery is among his first major commissions. It is understated in a way that perfectly suits British art, and particularly the more intimate scale of much of this collection. The elegance of the interior is due to the pale oak veneers, the linen wall coverings, and, most of all, the way different rooms, suffused by natural light, become visible through interior (unglazed) window openings. The outside is harder to like. It is a cube with a taut surface of matte steel punctuated by windows of various shapes and seemingly random order. "On a gray day the building looks like a moth; on a sunny day, like a butterfly—just as Kahn once predicted" (from the citation of the AIA Twenty-Five-Year Award for Architecture of Enduring Significance). To get a deeper insight into the persona and aesthetics of this extremely influential architect, you may want to view the academy-nominated film *My Architect* (2003), a documentary about Louis Kahn, created by his son.

YALE UNIVERSITY ART GALLERY

1111 Chapel Street, New Haven, CT 06520; Tel. 203-432-0600; www.artgallery.yale.edu.

Directions: From I-91 and I-95, take the exit onto 34W for downtown New Haven. Take Exit 3; turn right at the light onto York Street. Park at York Garage (on left); walk to next corner, turn right onto Chapel Street; the museum is on the left.

Hours: Tuesday through Saturday, 10 A.M. to 5 P.M.; Sunday, 1 to 6 P.M.

Admission: Free.

Catalog: Susan B. Matheson, *Art for Yale: A History of the Yale University Art Gallery* (2001).

Yale's history of collecting and teaching art is reflected in a series of connected buildings along Chapel Street, which, through

their very architecture, attest to a long and proud tradition. If you stand with your back to the Yale Center for British Art and read from right to left, you see Street Hall (named after donor Augustus Russell Street) at the corner of Chapel and High streets, built in Ruskinian Gothic style, which opened in 1866 as the Yale School of the Fine Arts, dedicated to instruct both Yale students and the town's youth in drawing, painting, and sculpting. Two large galleries were set aside for the display of art. By 1928 the massive Gallery of Fine Arts, in a more severe Italianate Gothic style (designed by Egerton Swartwout) and connected to Street Hall by a bridge over High Street, was inaugurated. It helped to consolidate many diverse and scattered collections from all over campus. In 1953, the third building was connected to the previous ones: Louis Kahn's steel, concrete, and glass building, a landmark of modern architecture. If you continue to the left, across York Street you see the next addition, Paul Rudolph's Art and Architecture Building of 1963 (see PLUS, below). For the first time in Yale's history, art instruction was separated from the museum function, although they were kept in close proximity. Today, the Yale University Art Gallery comprises all three connected buildings, but, as it is in the process of a major renovation, the Street building and portions of the Swartwout are currently not open to the public. The university has painstakingly restored the Kahn building ("pennies to build, millions to restore" is the apt phrase), treating it like a delicate work of art and concerned to restore it to its original state (with modern systems, of course). The entire renovation is to be complete in 2011.

Actually, Yale's museum history goes even further back, and it has one of the most interesting "creation stories." In 1830, Colonel John Trumbull (1756–1843)—aide to Washington, "patriot artist," president of the American Academy of Arts, and still the owner of his "small American-history series" (the basis for the larger version in the Capitol rotunda)—was honored, but poor. Not wanting to disperse his pictorial record of the Revolutionary War and the birth of the nation, he offered his collection to Yale in exchange for an annuity and the promise to build a museum to his design. Trumbull Gallery was erected in 1832, and thus Yale rightly claims the oldest collegiate museum in the nation. (The

Bowdoin collection was bequeathed in 1811, but did not have a dedicated home until much later.)

Trumbull is the great history painter of the American Revolution; it is still thrilling to see his original rendering of *The Declaration of Independence*, the staple of every American history textbook, and it is important to acknowledge his dedication to the heroic task of applying history painting in the grand manner to the early history of a nation that was not terribly receptive to it. It took a lot of wrangling to get the Capitol commission, and Trumbull painted only half of what he proposed. Trumbull's collection was soon supplemented with American portraits, many of Yale and Connecticut personages. American painting, sculpture, and decorative arts form a major portion of Yale's more than eighty thousand objects, making Yale foremost among museums collecting American art and crafts. Among American painters the following are especially well represented: Benjamin West, John Singleton Copley, Thomas Eakins (eight), Winslow Homer (three), Edward Hopper (four), George Bellows (two). In the case of the last four, we have to thank Stephen C. Clark (brother of Sterling Clark of the Clark Institute), who bequeathed his outstanding collection mainly to Yale, the Metropolitan Museum in New York City, and the Addison Gallery at Phillips Andover (q.v.). His gifts are in each case outstanding, defining works of the painter in question.

Early Western art benefited from Yale's dedication to the classics, the large role of the divinity school, and an active program of excavations in Gerasa (Jordan), in Egypt, and especially at Dura-Europos (modern Syria). The latter alone yielded ten thousand objects from a Hellenistic town that turned into a Roman outpost and an Early Christian site. Ancient glass became a particular specialty, with early gifts attracting further gifts, so that at Yale this particular field boasts one of the best collections in the country.

It should be noted that Egyptian art is divided between the Yale Art Gallery and the Yale Peabody Museum's Division of Anthropology. The latter currently has the more dramatic display, in a new installation under the theme Daily Life in Ancient Egypt, which includes items owned by the Art Gallery as well. The same holds true for art of the Americas, of which the Peabody has an

outstanding collection due to its involvement in various digs and explorations. African artifacts are likewise divided, but here the Art Gallery takes the prize with the stunningly displayed permanent gallery of African art in the renovated Kahn building. The display makes dramatic use of Kahn's uninterrupted spaces, and the rough concrete of the signature tetrahedral coffered ceiling seems a perfect complement to the bold sculptures. Much of this art came to Yale as part of a bequest of six hundred African objects in 2004, and one looks forward to subsequent exhibitions.

The Greek and Roman holdings were given a huge boost by a survey collection of nine hundred vases assembled by a noted scholar and purchased for Yale by Rebecca Darlington Stoddard in 1912. It covers the gamut from the Bronze Age to Roman times, with an emphasis, naturally, on Greek vases. The stars are a hydra by the highly regarded Berlin Painter showing Athena and Hermes on the respective sides, and two vessels whose unknown artist is named "the Yale Painter." Roman sculptures after Greek originals are here, as one would expect in a well-endowed university museum, and Yale also has its share of the Assyrian reliefs from the palace in Nimrud that can be found in several New England colleges (see Dartmouth).

Early Italian art came to Yale serendipitously, in a sense. An astute expatriate in Florence, James Jackson Jarves, collected Italian "primitives" in the mid-nineteenth century, when they were unappreciated. When he needed money badly to settle debts, Yale offered a loan with the paintings as collateral. But Jarves couldn't repay the loan; in 1871 Yale acquired a portion, 119 paintings, from him. Even though many of Jarves's attributions did not survive modern scholarship, the collection is rich and varied, including *Madonna and Child* by Gentile da Fabriano, two panels from the life of St. Anthony by the Master of the Osservanza (others are at the Fogg Museum, Harvard), Antonio del Pollaiuolo's *Hercules and Deianira*, and *Portrait of a Lady with a Rabbit* by Ridolfo Ghirlandaio. Some *cassoni*, Italian painted chests, as well as a plaster cast of the Ghiberti doors in Florence, were part of the acquisition. Among later European paintings we should mention *Intemperance* by Hieronymus Bosch, whose works are a rarity in this country, Lucas Cranach the Elder's *Crucifixion with the Con-*

Pablo Picasso, *Mother and Child (First Steps)*, 1943. 51¼ × 38¼ in.
Yale University Art Gallery. Gift of Stephen Clark, B.A. 1903.

verted Centurion, and a pair of portraits by Frans Hals. The afore-
mentioned Stephen C. Clark bequeathed the latter, but his most
spectacular legacy to Yale were Manet's *Young Woman Reclining
in Spanish Costume*, Vincent van Gogh's *Night Café*, and Picasso's
First Steps, each one arresting, justly famous, and simply a great
masterwork.

The early twentieth century witnessed an intense effort on
the part of American artists to make the newest European move-
ments their own (think of the important Armory Show of 1913).
At the same time, European artists came to America, temporar-
ily or permanently, due to fascism and Nazism. At the fulcrum of
these movements was the Société Anonyme: Museum of Modern
Art, the brainchild of Katherine Dreier, Marcel Duchamp, and
Man Ray. There was nothing Dada about the goals of the society
as an "International Organization for the Promotion of the Study

in America of the Progressive in Art." Founded in 1920 and dissolved in 1950, the Société mounted over eighty exhibitions (first in its own gallery in New York City, then in venues all over the country), and—germane to our interest—collected over a thousand works of art. Among the Europeans presented by it were Wassily Kandinsky, Paul Klee, Joan Miró, Fernand Léger, Alexander Archipenko, Piet Mondrian, Constantin Brancusi, and Kurt Schwitters. Though the founding of the Museum of Modern Art in 1929 somewhat eclipsed the Société, the latter complements MoMA's Francophilia with a healthy portion of German and Russian art. The collection of the Société, as well as Katherine Dreier's personal collection, ended up at Yale, through gift and bequest, with a stipulation that the educational efforts of the Société continue. Yale did not always keep this part of the bargain, but is compensating now with the first-ever traveling exhibition of about two hundred works from the collection. It will return to Yale in 2010, after stops at four different museums. The accompanying catalog, *The Société Anonyme: Modernism for America*, 2006, contains several insightful essays and a comprehensive, illustrated listing.

+ PLUS

Modernist campus architecture

Yale's campus of mostly Neo-Gothic buildings is also home to some of the most innovative buildings of 1950s Modernism, of which the most controversial is surely Paul Rudolph's Art and Architecture Building (1959–63), directly across from the Art Gallery. This is an assertive, asymmetrical, highly sculptural building, the magnum opus of the then dean of the Yale School of Architecture. It is and was widely acclaimed and fervently hated. It is said to have thirty-seven levels in its seven floors; functionality and flexibility are not its hallmarks. But it is now a landmark of a particular point in architectural history, representing the Le Corbusier–inspired "Brutalist" style, with its unapologetic use of poured concrete. But Rudolph still wanted texture, which he achieved by pouring the concrete into ribbed forms and having workers smash the ribs with hammers to expose the aggregate

beneath. The recent renovation was overseen by Charles Gwath-
mey (a student of Rudolph's), who also designed the additions that
house the Department of Art History and the art library.

Other buildings of that era, when Yale was at the center of
architectural innovation, include Morse and Stiles colleges and
the Ingalls Hockey Rink (nicknamed the "Yale Whale") by
Eero Saarinen, the Beinecke Rare Book and Manuscript Library
by Gordon Bunshaft, and the Kline Science Center by Philip
Johnson.

For maps and tours contact the Visitor Center at 149 Elm
Street, across from the New Haven Green. Tel. 203-432-2300;
www.yale.edu/visitor.

New London

LYMAN ALLYN ART MUSEUM

625 Williams Street, New London, CT 06320; Tel. 860-443-
2545; www.lymanallyn.org.

Directions: Take I-95 to Exit 83 and follow the brown "cultural
attraction" signs to the museum.
Hours: Tuesday through Saturday, 10 A.M. to 5 P.M., Sunday,
1 to 5 P.M.
Admission: Adults $8, seniors and students $7, children under
12 free.

Perched on a hill, in a parklike setting, the handsome Neoclas-
sical building is by Charles A. Platt (see also Addison Gallery in
Andover, Massachusetts) and opened in 1932. The museum was
established by Harriet Upson Lyman in memory of her father,
captain and merchant Lyman Allyn, as a place for local citizens to
learn about art and culture. The patrician setting in an industrial
and ethnically diverse town with a long Colonial history makes
for a lively mix. The holdings of ten thousand items are predomi-
nantly American fine and decorative arts, but include a good se-
lection of European pieces, mostly drawings and prints.

The museum showcases its American holdings in a suite of

galleries, each gallery grouped around such themes as Emerging Nation, American Stories, Nineteenth-century Taste, in topical but roughly chronological fashion. The themes stay but individual pieces rotate in and out (especially the works on paper).

Painted in dark, rich colors and enriched with furniture and decorative arts (e.g., some Paul Revere silver), these rooms have a very intimate feel. Much of the furniture comes from Connecticut, particularly New London County. There are some remarkable Colonial portraits, especially a pair, *Portrait of Major Reuben Hatch* with the companion piece showing his wife, by William Jennys (1773–1858). Another portrait pair by this artist is in the Currier Gallery in Manchester, New Hampshire. In both cases Jennys painted the sitters unsparingly, with "hard precision and uncompromising realism" (Faison), stringy hair and all. They are hypnotizing presences. Other portraits are by Winthrop Chandler, Ralph Earl, Gilbert Stuart, and John Trumbull, the last a native son of Connecticut (see Yale University).

Two dramatic landscapes, one by Thomas Cole (*Mount Aetna from Taormina*, a smaller version of the one in Hartford) and the other by Albert Bierstadt (*Sunrise on the Matterhorn*), furnish exotic views, while such Connecticut painters as John Frederick Kensett and Frederic Church stay closer to home. Other nineteenth-century landscapists here are M. J. Heade, Jasper Cropsey, and George Inness. One commanding image is of a Connecticut patriot, Abigail Hinman, in silk and lace, brandishing a rifle with which she is grimly determined to shoot traitor Benedict Arnold, who is passing by below her window. Never has history painting been so much fun! Another charming oddity, by a local painter, is the full-length portrait of six-year-old James Francis Smith proudly showing off the penguin-skin coat he had acquired while accompanying his father on a whaling trip.

The later rooms contain many examples of Connecticut Impressionism. The museum is particularly rich in painters from the nearby art colony of Old Lyme (see Florence Griswold Museum), such as William Chadwick, Edmund Greacen, Charles Ebert, Willard Metcalf, and Childe Hassam. There is a portrait bust of painter J. Alden Weir by Olin Levi Warner. Weir is well represented, partly through long-term loans from his descendants.

The first director, Winslow Ames, believed that the Lyman Allyn should collect "small things" in keeping with its spaces and its budget, and he set the direction with the acquisition of some first-rate drawings (he was an expert on European drawings) such as the study for the *Portrait of Mme. Moitessier* by Ingres, which itself is in the National Gallery in Washington, D.C. Other important drawings are by Tintoretto, Tiepolo, Poussin, Claude Lorrain, Boucher, and the French court painter to Louis XIV, Hyacinthe Rigaud. Ames also acquired small sculpture—e.g., Renoir's *Maternity* of 1916—and works by the twentieth-century Germans Wilhelm Lehmbruck and Ernst Barlach. Over the last several years, the Lyman Allyn has shown exhibitions on French, Italian, Northern European, and British art, respectively, all drawn from its own holdings. (During my several visits, however, there was little to no European art on view.)

Lastly, there are some very unusual activities and collections that set the Lyman Allyn apart. A collaboration between Mystic Seaport and the museum initially was concerned with the restoration of a series of large paintings depicting New London whaling history—New London was the third most important whaling town after New Bedford and Nantucket. One of these gigantic canvasses is usually on display, laid out on the floor in the process of restoration; others are on the wall. This collaboration grew to include other maritime institutions and led to the formation of the Thames River Maritime Heritage Group, which plans celebrations, informative lectures, and tours year-round (www.thamesriverheritage.org). Another maritime collection, the Montesi Ship Collection, is on permanent view. Pasquale Montesi, an Italian immigrant and seafarer, created these models from memory, more folk art than scale reproductions.

An active program of about eight exhibitions per year includes photography, crafts, third-world artists, and selections from private collections in Connecticut and New York. Lectures, films, and family programs round out the offerings.

+ PLUS

New London architecture; Eugene O'Neill sites

Founded in 1646, New London has a number of Colonial remnants, including the continuously used New London Superior Courthouse of 1784 (State and Huntington streets), which has a commanding location above the historic waterfront district. Walking downhill on State Street toward the water, you will have on your right the New London Public Library in Richardsonian style, and on your left the Garde Arts Center, which is a loving restoration of a twenties movie palace in the Moroccan-fantasy style. It epitomizes New London's valiant efforts to upgrade and renew itself, even as that same effort led to the notorious *Kelo v. City of New London* decision of the Supreme Court (2005), which found that private property could be taken by eminent domain to further economic development. Try to see as much of the public spaces of the Garde Arts Center as you can, or plan to attend a performance, in order to see the stunning interiors (www .gardearts.org). Another beautiful restoration of an endangered public treasure is the Union Railroad Station at the bottom of State Street, the last and largest of Henry Hobson Richardson's public commissions. It is a powerful, symmetrical mass of red brick, quite simple at first sight, until one picks out the wonderfully delicate details in the brickwork and the dramatic play of light and shadow of the deeply recessed windows. Walk in and through and you will be at the waterfront, on City Pier. There you will find a bronze statue of New London's famous son, playwright Eugene O'Neill (1888–1953). If you are seriously interested in O'Neill, go to the Web site www.eoneill.com/library/touring, which provides detailed information on his links to New London, lists relevant buildings both extant and vanished, including his father's summer place, Monte Christo Cottage. O'Neill spent most summers of his early life there and immortalized it in *A Long Day's Journey into Night*. The Monte Christo Cottage is open to the public in the summer months.

Directions: From the Lyman Allyn Museum, take a left on Williams Street, make a left on Broad Street (Route 32) and a

right on Huntington. The courthouse is on your right. Visi-
tor information is at 14 Eugene O'Neill Drive, a right turn
off State Street shortly before the railroad station.

Norwich

SLATER MEMORIAL MUSEUM 🛒

108 Crescent Street, Norwich, CT 06360; Tel. 860-887-2506;
www.norwichfreeacademy.com/museum/.

Directions: From Boston/Worcester: Take 1-90 West to Au-
burn, then 1-395 to Exit 81. From New York/New Haven:
Take 1-95 North to Exit 81 East. At the exit, take Route 2
East, then take a right onto Washington Street. Pass Backus
Hospital. At the second stoplight, bear left. The museum is
the building with the tower on the left.

Hours: Tuesday through Friday, 9 A.M. to 4 P.M.; Saturday and
Sunday, 1 to 4 P.M.

Admission: Adults $3, seniors and students $2, children under
12 free.

Catalog: Booklets on the plaster cast collection are available.

When the Slater Memorial was completed in 1886, it was in-
tended as a multiuse building for the Norwich Free Academy,
with spaces for auditorium, gymnasium, library, gallery, and class-
rooms. Executed in Richardsonian Romanesque style—in brick,
sandstone, and granite, with many sculptural details—it was a
memorial to John Fox Slater, given by his son. The Slater fam-
ily goes back to the late eighteenth century, when Samuel Slater,
"the father of the American Industrial Revolution," came from
England and set up the first American water-operated cotton mill
in Pawtucket, Rhode Island, in 1790 (Slater Mill, now a historic
site).

As early as 1886, William Albert Slater was asked for further
funds to commission plaster casts of Greek, Roman, and Renais-
sance sculpture so that the academy students as well as the towns-
people could have access to the finest works of sculpture. The

high quality of the casts and their number make this one of the most impressive collections on display. (See also the George Walter Vincent Smith Museum in Springfield, Massachusetts.) While many museums eventually moved their collections into storage, or dispersed or even destroyed them, at the Slater the plaster casts are exactly where they were placed in the late nineteenth century, in a building that has been essentially untouched since its inauguration. In other words, we have a time capsule showing us what many museums looked like in the nineteenth century, when plaster casts were the mainstay of any self-respecting collection and when every art student learned to draw from plaster casts. They are all here: Egyptian and Assyrian reliefs and busts, and Archaic, Classical, and Hellenistic sculpture, including the complete Elgin marbles, the Discus Thrower, the Apollo Belvedere, the Dying Gaul, the Laokoön, the Venus of Milo, Michelangelo's *Pietà*, and many, many more—227 in all. (See color insert.)

When you are done reacquainting yourself with familiar works and gasping at this extraordinary assemblage of artistic excellence, you are ready to explore the other treasures of the Slater, which displays three hundred years of Norwich history and "the art of five continents under one roof," as the publicity states. There is a little bit of everything here, and while the labeling and display tend to be old-fashioned and the interior is still awaiting a thorough restoration and renovation (the exterior having already undergone extensive work), there is real charm to the mixture of art, history, ethnology, and sheer curiosities. Items are arranged into small ensembles or niches along the upper balcony (presumably the track of the original gym), each grouping likely to yield surprises and delights.

Local crafts and history: Colonial and Victorian furniture, implements, pewter, firearms, pottery, textiles, and paintings are assembled into roomlike settings. Norwich had important industries of clock making, ironwork, firearms, pottery, and piano making, and you'll find exemplars from all of them. One real oddity is a glass-case full of beaded handbags. Nautical artifacts attest to Norwich's history as an important harbor.

American painting and sculpture: this section features, among others, the Norwich painter John Denison Crocker (1822–1907),

who chronicled southeastern Connecticut landscapes and local personalities in the then-prevalent Aesthetic mode. Thus we have landscapes in the Hudson River School style and portraits that excel in accuracy, if not in psychological penetration. There are also several sculptures by William Zorach (1889–1966).

Asian art: the initial gift of the Vanderpool Collection of Oriental Art, which was focused on Japanese art of the seventeenth through nineteenth centuries, included Chinese and Korean art works, as well. Textiles, carvings, woodblock prints, pottery, sculpture, armory, and Chinese export ware are all represented. Items are put together the way a private collector might arrange his collection, mixing times, regions, and media into a beguiling jumble. I particularly enjoyed some fine Persian tiles.

Pre-Columbian and Native American art: six Native American cultures are featured—the Chiriqui of Panama, the Chimu of Peru, the Mound Builders of the Mississippi and Ohio valleys, the Pueblos, and the Northwest tribes. Additionally, there are Navajo rugs and baskets as well as artifacts of the Native Americans of Connecticut.

African and Oceanic art: this collection impressed me immediately for its artistic impact and stylish display against whitewashed walls. The collection was given in 1998 by Paul W. Zimmerman, an artist and professor emeritus at the Hartford Art School. There are masks, sculpture, and various ritualistic as well as everyday objects, clearly cherished and chosen for their beauty and expressive qualities.

European painting and decorative arts: these are housed in the Sears Gallery, which shows its previous life as a library. An elegant space with a large hearth, elaborate woodwork, and a balcony, it holds a small collection, the main attraction of which is some beautiful copies of major paintings, including portraits of (not by) Michelangelo and Leonardo. They come from a time when the only way to have color reproductions of cherished masterpieces was to copy them in oil in the great galleries of Europe, a counterpart to the veneration of antiquities expressed in the cast collection. One should also remember that the primary purpose of this collection was to educate high-school students. How lucky they were and still are, inasmuch as the Norwich Free Academy

is the public high school of Norwich, run, however, by a private, nonprofit corporation as an independent school.

In 1907 an addition was built to add gallery space for changing exhibitions. The Converse Gallery is reached through the cast gallery. The space is bright and airy, looking much more modern than its exterior would suggest. The museum schedules five to six exhibitions per year. Two are devoted to work done at the Norwich Art School and children's art classes; the others are mostly devoted to regional artists and to aspects of the permanent collection, or are traveling shows.

+ PLUS

Walking tour of historic district
The town of Norwich was founded in 1659 and surviving buildings from its colonial past can be seen at the Norwich Town Green. One of them, the Leffingwell Inn of 1675, is open to the public (348 Washington Street, Tel. 860-889-9440). With the industrial age, great wealth came to Norwich; the beautiful homes erected by a record number of millionaires add up to a compendium of nineteenth-century building styles. The densest grouping is along the triangle formed by Washington Street, Broadway, and Broad Street, at the north corner of which is the Norwich Free Academy. The abundance of Victorian "painted ladies" earned Norwich a listing as one of America's nine "Prettiest Painted Places." Consult the Norwich Tourism Office (77 Main Street, Tel. 860-887-4154) for maps of various walking tours.

Old Lyme

FLORENCE GRISWOLD MUSEUM

96 Lyme Street, Old Lyme, CT 06371; Tel. 860-434-5542; www.flogris.org.

Directions: From I-95 North: take Exit 70, turn left off ramp, take first right onto US-1/Halls Road to end, then left onto

Lyme Street. The museum is on the left. From 1-95 South:
Take Exit 70, Route 1 North (Lyme Street).

Hours: Tuesday through Saturday, 10 A.M. to 5 P.M.; Sunday,
1 to 5 P.M.

Admission: Adults $8, students and seniors $7, children 6–12
$4, children under 6 free.

Catalog: Jeffrey W. Andersen and Hildegard Cummings,
The American Artist in Connecticut (2002), covers the Hart-
ford Steam Boiler Collection. The "Online Learning" link
on the Web site is the entry to a host of interesting illus-
trated articles, resources, and illustrations, done in a user-
friendly way.

The Florence Griswold Museum is three delights in one: a Geor-
gian-style mansion with an intriguing art-historical past, beau-
tiful gardens and grounds sloping down to a tidal river, and a
brand-new museum of architectural distinction housing a first-
rate collection of American art. But it is no mere addition of ele-
ments: all three are interwoven and embody a brilliant chapter in
the history of American painting.

Florence Griswold (1850–1937), from a distinguished Con-
necticut family, grew up in one of the finest houses of Old Lyme,
a trading and shipbuilding center, as the daughter of a prosperous
sea captain. His fortunes so declined due to the Civil War and the
advent of steamships that in 1878, Florence's mother and the three
daughters opened the Griswold Home School for girls to support
the family. It lasted for fourteen years; by 1899, only Florence and
her ailing sister, Adele, were left, and they made ends meet by
taking in boarders.

In 1899, one of these boarders was the American, Barbizon-
trained, Tonalist painter Henry Ward Ranger (1858–1916), who
exclaimed about Old Lyme: "This is a place just waiting to be
painted!" He encouraged his painter friends from New York to
come and paint in the luminous seacoast light of Old Lyme and
stay with Miss Griswold. Thus began the Old Lyme art colony.
Every summer, the house became a bohemian conclave, with
bachelor painters bunking dorm-style on the third floor, couples
renting upstairs bedrooms, barns and sheds used for studios, the

Will Howe Foote, *A Summer's Night*, ca. 1906. Oil on canvas, 34 × 30 in. Florence Griswold Museum, Old Lyme, CT. Gift of the Artist.

front hall a gallery from which to sell the painters' works, easels set up in the gardens for painting en plein air, and communal meals served in the paneled dining room. But what panels! In gratitude for Florence Griswold's nurturing hospitality, the artists transformed each door and wall panel of the Colonial dining room into a painted souvenir.

This American version of the French Barbizon School gave way to American Impressionism with the arrival, in 1903, of Childe Hassam, followed by many of his friends and fellow Impressionists, such as Willard Metcalf, William Chadwick, Frank Vincent DuMond, Will Howe Foote, Charles Ebert, Guy Wiggins, and many others. (If you haven't seen works by many of these artists before, be prepared for some marvelous surprises.) Amateurs came to study, as well, among them President Wilson's first wife. The galleries in the former upstairs bedrooms present changing exhibits linked to the Old Lyme art colony and its artists, drawing on the over nine hundred paintings and drawings the museum owns. It is rare that one sees art in the surroundings,

the landscape, and the atmosphere in which it was created. Here, a view of the garden or of the path leading to the mansion might reappear as the subject of a painting (as in Foote's painting, left) and, in a further involution, there may be a painting of a painter painting the Griswold house. As if this were not enough, the garden areas have been restored in large part based on the record of the canvasses of Miss Griswold's summer guests.

The blindingly white (a little aging will help) Robert and Nancy Krieble Gallery opened in 2002 and is the work of Chad Floyd of Centerbrook Architects (see Hood Museum, Dartmouth). Three barnlike galleries and octagonal turrets evoke local vernacular architecture. By a stroke of good fortune, the Florence Griswold Museum was given, at the time of the building of the new gallery, one of the foremost collections of American art, assembled by the Hartford Steam Boiler Inspection and Insurance Company. When the company decided to bequeath this collection of "American art by artists associated with Connecticut" to the Griswold, it found the natural home for this treasure trove. Of the 190 pieces, fully 54 are by artists who were associated with the Old Lyme art colony. The rest span American painting from Colonial itinerant portraitists (such as Ralph Earl and Ammi Phillips), through Hudson River artists Frederic Church and his teacher Thomas Cole, Luminists Martin Johnson Heade and John Frederick Kensett, Impressionist masters John Henry Twachtman and Julian Alden Weir (see Weir Farm NHS), all the way to Modernist Milton Avery. While some of these holdings will be on display at any given time, a video presentation allows you to review the entire collection.

+ PLUS

Lyme Art Association Gallery;
First Congregational Church
At 90 Lyme Street, practically next door, is the Lyme Art Association Gallery, designed by Charles A. Platt and opened in 1921 as a permanent exhibition home for Lyme artists. It still serves this purpose, with juried art exhibitions as well as art classes.

A one-mile walk east on Lyme Street lets you savor the histor-

ical center of Old Lyme, with many stately mansions, fine shops (great ice cream and chocolate), antique shops, and galleries. (The Cooley Gallery, 25 Lyme Street, specializes in American Impressionist art and is worth a visit whether you are in buying mode or not.) The endpoint of your walk is the grand First Congregational Church of 1816, famously and frequently painted by Childe Hassam (one copy is in the Metropolitan Museum in New York City) and a fitting finale to your exploration of the Old Lyme School.

Open Tuesday through Saturday, 10 A.M. to 5 P.M.; Sundays, 1 to 5 P.M. Tel. 860-434-7802; www.lymeartassociation.org.

Stamford

STAMFORD MUSEUM AND NATURE CENTER 🚼

39 Scofieldtown Road, Stamford, CT 06903; Tel. 203-322-1646; www.stamfordmuseum.org.

Directions: From the Merritt Parkway (North or South) get off at Exit 35. Turn left at the end of the exit ramp onto High Ridge Road (Route 137). Follow it for 0.5 miles. The museum is at the junction of High Ridge Road and Scofieldtown Road.

Hours: Monday through Saturday, 9 A.M. to 5 P.M.; Sunday, 11 A.M. to 5 P.M.

Admission: Adults $8, seniors $6, children 4–17 $4.

The museum and nature center include 118 acres of woodland, pond, marshes, and meadows, crisscrossed by several hiking trails, a Neo-Gothic mansion built by department store tycoon Henri Bendel, a farm with animals and a maple-sugar house, a nature center, an art studio and classrooms, a unique "nature" playground, an observatory with a twenty-two-inch telescope, a planetarium, and, yes, there is also an art collection.

The collection is modest, but with a clear focus. Depending on the size of temporary exhibits, more or less of the permanent collection can be seen in the rooms of the former Bendel mansion and a later annex. It can be viewed, however, by appointment.

Two artists connected with the city of Stamford are the heart of the collection. Noted sculptor Gutzon Borglum (1867–1941), the force behind the carving of Mt. Rushmore, lived in Stamford from 1910 to 1920, where he built himself an impressive granite studio on his estate, Borgland. Works from his estate have been bequeathed to the museum, making it the second-largest holder of works by Gutzon Borglum and a resource for Borglum studies. You can see his *Eagle and Serpent* at the museum's entrance, and his *Centaur* in the sun room.

American sculptor Reuben Nakian's (1897–1986) work has been characterized as the sculptural equivalent of Abstract Expressionism. He trained under Paul Manship, alongside Gaston Lachaise. His works often show erotic female figures, highly abstracted, rough-textured, and based on Greek myths. (See his *La chambre à coucher de l'empereur* in the DeCordova Sculpture Park.) The Museum of Modern Art gave him a retrospective in 1966. He settled in Stamford in 1945 and lived there until his death.

Beyond the two Stamford artists, the museum concentrates on art of the first half of the twentieth century. The Herman Shulman Collection, given in 1961, included works by Milton Avery, Reginald Marsh, Guy Pène du Bois, Raphael Soyer, and Max Weber, and the museum seeks to expand around this core of urban, representational American art. Other artists include Alfred Maurer, George Grosz, and William Gropper. About seventy pieces of sculpture include the abovementioned Borglum and Nakian, but also nineteenth-century Italian marbles that were part of the garden design of the mansion.

At the entrance to the mansion's forecourt are two oversize lions guarding the Fountain Plaza, the setting of a splendid marble fountain dominated by the so-called Bendel Horses, carved in Italy in the mid-nineteenth century. Even in wintry weather it evokes an Italian piazza. The path descending from the mansion to the pond is graced by Italian marble statues depicting the four seasons, and *Ruth*, a seated figure, in a little gazebo, by Giovanni-Battista Lombardi (1822–1880). There is a sizable number of Modern outdoor sculpture scattered throughout the grounds.

Exhibitions partake of all the areas the SM&NC covers—nature, local history and industry, crafts, photography, collectibles of

all kinds—often designed to appeal to adults and children alike. Shows dedicated to the fine arts have to be sought out, so check the Web site for what's on offer at any given time.

+ PLUS

Sculptures by Reuben Nakian
Three Nakian sculptures can be seen in downtown Stamford, next to the Palace Theatre on 61 Atlantic Avenue. They are *Sea Rhapsody*, *Minerva*, and *Hecuba*. Another installation, at the Stamford Government Center, is currently being negotiated; it is controversial since it involves the removal of a group of trees.

Directions: From the Stamford Museum, turn slight right onto High Ridge Road (Route 137). Follow Route 137 for about 5.5 miles into Stamford Center (street names will change). Turn left onto West Broad Street, then right onto Atlantic Street. For Government Center, stay on Route 137, which is now Washington Boulevard, cross West Broad Street, and go for about 0.3 miles to 888 Washington Boulevard.

Storrs

WILLIAM BENTON MUSEUM OF ART, UNIVERSITY OF CONNECTICUT

University of Connecticut, Unit 2140, 245 Glenbrook Road, Storrs, CT 06269; Tel. 860-486-4520; www.thebenton.org

Directions: From Hartford, take I-84 East to Exit 68 and follow Route 195 South for 6.5 miles. Turn right onto North Eagleville Road (just after the Storrs Congregational Church on your right). Follow signs for the Lodewick Visitor Center and get a campus map. Park at the North Parking Garage opposite the visitor center.
Hours: Tuesday through Friday, 10 A.M. to 4:30 P.M.; Saturday and Sunday, 1 to 4:30 P.M. The museum is closed during semester breaks; check Web site.
Admission: Free.

This modest-size museum gets a little lost in a huge campus with massive buildings, but it has a central location opposite the student union, the hub of student activity. The original Neo-Gothic dining hall, the "Beanery," morphed into the art museum in 1967. Basically a two-storey vaulted hall with visible wooden trusses and balconies added to house exhibits of prints and photographs, the building works very well as a flexible exhibition space. In 2004, a new wing was added, providing a new façade and entry, more exhibition space, a café, and a shop.

The name was affixed to the museum in 1972 to honor a courageous senator from Connecticut who openly defied Joe McCarthy. He was hounded out of the U.S. Senate for having sent "lewd and licentious" materials (most likely modern art) abroad, through the U.S. Information Program, which he headed. Eventually a trustee of the University of Connecticut, he died shortly after the naming of the museum and bequeathed a large collection of works by Reginald Marsh (1898–1954). The complete holdings of works by Marsh now exceed a thousand items and make the Benton a pivotal site for this Realist chronicler of the New York of the twenties and thirties.

A sizable collection of nineteenth- and twentieth-century American art, accompanied by an acquisition fund, came from the president of the then Connecticut Agricultural College, Charles Lewis Beach, in 1933, with the explicit purpose to "instill and cultivate an appreciation of works of art in the student body." Artists represented include Mary Cassatt, Childe Hassam, a number of Connecticut Impressionists, Maurice Prendergast, Thomas Hart Benton (no relation), and many others.

Walter Landauer, an immigrant German geneticist on the faculty, gave the museum 107 prints and drawings by Käthe Kollwitz (1867–1945), one of the outstanding collections of her work in this country. Another large bequest consists of 300 molas, the multilayered, colorful embroidered blouse panels of the Kuna Indians of Panama. It comes from the collection of Elisabeth Hans, a major collector and connoisseur of this intriguing art form.

Today the permanent collection includes over six thousand pieces, about a third of which are European. A few of the Eu-

ropean oils that warrant your attention (if they are on view): *Noblewoman and Child* by Alonzo Sánchez-Coello (1531?–1588), a good example of rigid Spanish court painting (another example by the artist is in the Isabella Stewart Gardner Museum in Boston); the vivid *Portrait of the Poet Jan Vos* by Jan de Bray (ca. 1627–1697), a contemporary and compatriot of Frans Hals's (other paintings by him are at the Worcester Art Museum and Boston's Museum of Fine Arts); and two large mythological paintings by Benjamin West, who could also be claimed as an American, of course.

Among American works I found noteworthy are an early Edward Hopper self-portrait that is dark and brooding (before he was able to be light and brooding), and a wide, horizontal, and almost abstract landscape by Martin J. Heade (1819–1904), *Rye Beach, New Hampshire,* which Faison describes as one of his "luminous, but vaguely ominous, nature poems."

A smaller or larger selection from the permanent collection will always be on view, but due to the fragile nature of the majority (80 percent are works on paper) nothing stays on view very long. Whenever you visit, other works will be shown, and some will capture your imagination. The strength of the collection is in American art, particularly from the twentieth century. About fifteen different exhibitions per year, some created at the Benton, some originating elsewhere, occupy the bulk of the exhibition space and provide reasons for repeated visits, as does the active program of lectures, gallery talks, and recitals.

The Human Rights Gallery is an unusual feature for an art museum. It partners with the Human Rights Institute and the Institute of Comparative Human Rights on campus and is both physically and ideologically at the center of the museum. Various kinds of visual media are employed to explore topics in justice, equality, human suffering, and discrimination, each international in scope. William Benton was involved in the formation of UNESCO, so this merging of human rights issues with the visual arts seems an appropriate way to honor his legacy.

+ PLUS

Ballard Institute and Museum of Puppetry 🛒

From late April to early November, the Ballard Institute and Museum of Puppetry displays its collection of over two thousand puppets, many by Frank Ballard, who started the first ever college degree program in puppetry, here at UConn. Shadow puppets and marionettes, historical and foreign examples can be seen. Performances, exhibits, and the opportunity for hands-on experiences are provided. There is also an extensive library on puppetry.

School of Fine Arts, Depot Campus, 6 Bourn Place; Tel. 860-486-4605; www.bimp.uconn.edu.

Directions: From the campus, travel north on Route 195 (Storrs Road), take a left at Route 44 (Middle Turnpike), travel for about 2 miles and turn left onto Weaver Road. Weaver Road winds through the Depot Campus grounds. BIMP is housed in Willimantic Cottage, which will be on your right.

Hours: Open Friday through Sunday, 12 to 5 P.M.

Admission: Free.

Waterbury

MATTATUCK MUSEUM 🛒

144 West Main Street, Waterbury, CT 06702; Tel. 203-753-0381; www.mattatuckmuseum.org.

Directions: From I-84 (East or West) take Exit 21 (Meadow Street). Turn right at third light (if coming from I-84 West) or fourth light (if coming from I-84 East) onto West Main Street. Get into the left lane facing the red light. You will see a statue in the road. Bear left and pass behind it and immediately turn left, onto Park Place, a small side street. The parking lot is at end of this street; the museum is at the corner of Park Street and West Main Street.

Hours: Tuesday through Saturday, 10 A.M. to 5 P.M.; Sunday, 12 to 5 P.M.

Admission: Adults 16 and older $4, children free.

Named for the Algonquin-derived former name of Waterbury, the Mattatuck Museum is both a historical society and an art museum. The historical exhibits trace Waterbury's colonial and industrial history, with artifacts, machinery, period rooms, and examples of what gave it the name "Brass City" in the nineteenth century: namely, buttons, brass fittings, and clocks. The third floor houses the button collection assembled originally by one of the factories. Arranged in decorative patterns, the variety of materials, styles, sizes, and intricacy levels is fascinating.

The ground floor and mezzanine are dedicated to history, the second floor to art. The museum is housed in a former Masonic temple, which in the mid-1980s was readapted, expanded, and given a strikingly modern entry pavilion by the architectural firm of Cesar Pelli and Associates. The museum is a bold but not overbearing addition to the Waterbury Green, the heart of historic Waterbury.

The art collection on the second floor is centered on Connecticut artists from colonial times to the present. The earliest painters are represented by portraits and include John Trumbull (see Yale), Ammi Phillips, Erastus Salisbury Field, and William Jennys, the latter with his hauntingly intense *Portrait of Josiah Bronson*.

For the nineteenth century, the prize of the collection is Frederic Church's *Icebergs*. Church sought out exotic locales, and in 1859 he set out for Labrador with the express purpose of studying icebergs. The Mattatuck canvass is a smaller counterpart to a larger version, *The Voyage of the Icebergs*, dramatically rediscovered in the 1970s and now in the Dallas Art Museum. As always with Church, he emphasized the grandeur and drama that landscapes can embody. "Touched by strong green and orange lights, the gigantic white pile is truly a Gothic nightmare" (Faison).

Later nineteenth-century painters include some associated with the Connecticut landscape, such as Henry Ward Ranger, Emil Carlson, and Guy Wiggins. John Frederick Kensett maintained a studio on Contentment Island near Darien, Connecticut. A few years ago, he was given a show, "Images of Contentment: John Frederick Kensett and the Connecticut Shore" (which lives on as an online exhibition on the museum's Web site), amid other Connecticut-focused exhibitions. In 2000, the acquisition of

the Thaler Cohen Collection enriched the museum with some forty-eight paintings by John Singer Sargent, George Inness, Albert Bierstadt, J. Alden Weir, Jasper Cropsey, Morris Hunt, and others, and extended its range beyond Connecticut.

In 1964/65 the museum received a bequest of midcentury art from Kay Sage (1898–1963), a surrealist painter married to French Surrealist Yves Tanguy (1900–1955). They lived in nearby Roxbury, where Alexander Calder also had a studio (and where Arthur Miller and Marilyn Monroe later settled). The bequest includes many works by the couple and their friends, such as Arshile Gorky and Naum Gabo, as well as jewelry and a mobile made by Calder. The museum has set up a video display with stills and home movies showing the friendly relations between these artists.

The Mattatuck Museum, by virtue of its dual focus on local history and art, is an important educational force for the Waterbury region. It offers numerous activities and classes, child-friendly museum tours that are integrated into the public school curriculum, excursions, and walking tours, and conducts oral history projects.

+ PLUS

Cass Gilbert District
"Brass City" was extremely wealthy in the second half of the nineteenth century, and it sought to display its importance through major civic and private commissions. The leading architects of New York were engaged to build, for example, a brick Italianate railroad station, with a clock tower modeled on Siena's Torre Del Mangia (McKim, Mead and White), a massive Colonial Revival–style city hall, built at the cost of $1,000,000 in 1915 (Cass Gilbert, the architect of the United States Supreme Court Building in Washington, D.C., and of the Woolworth Building in New York City), and opposite it, the more Roman-inspired Chase Building. With three more buildings by the same architect and other fine buildings of the period, Waterbury's city center forms the Cass Gilbert District, which is on the National Register.

The museum occasionally conducts guided walking tours; a good resource is www.waterburyregion.com/tour.

Directions: (on foot) Cross West Main Street and the green, and proceed down Church Street. Turn right at Grand Street for the railroad station, now called the Waterbury Republican Building, or turn left to see the municipal ensemble of buildings.

Wilton

WEIR FARM NATIONAL HISTORIC SITE 🚼

735 Nod Hill Road, Wilton, CT 06897; Tel. 203-761-9945; www.nps.gov/wefa.

Directions: From the north: take I-84 to Exit 3 for Route 7 South. From the south: Take Merritt Parkway or I-95 to Route 7 in Norwalk. Then follow Route 7 to Branchville section of Ridgefield; take Route 102 West at the light; take second left onto Old Branchville Road; turn left at first stop sign onto Nod Hill Road. Follow Nod Hill Road for 0.75 miles to top of hill. The parking lot is on the left and the visitor center on the right.

Hours: For visitor center: November, December, March, and April: Thursday through Sunday, 10 A.M. to 4 P.M.; May through October: Wednesday through Sunday, 9 A.M. to 5 P.M.; closed January and February. Check for tour times. The grounds are open year-round from dawn to dusk.

Admission: Free.

Driving through upscale suburban Connecticut, it's hard to believe that in 1882 you could exchange a 153-acre farm—with a sizable Colonial farmhouse and the usual outbuildings—for $10 and a painting that had cost $560. That's exactly what J. Alden Weir (1852–1919) did in order to have an escape from New York's heat and dust. Having been trained in the Academic style in Paris, Weir initially loathed Impressionism, and started his professional life as a very successful portraitist and painter of still lifes. But after he had acquired the farm he gradually embraced painting en plein air and the Impressionistic technique and is now considered one of the founders of American Impressionism.

Weir summered here for the rest of his life; such visitors to the farm as Childe Hassam, Albert Pinkham Ryder, John Singer Sargent, Theodore Robinson, and John Twachtman came to fish, paint, and enjoy each other's company. Twachtman himself owned a farm in nearby Greenwich, and there were always close relationships with nearby Cos Cob and its Impressionist art colony.

The farm, its buildings, gardens, meadows, stonewalls, woodland paths, and pond, as well as the Weir family, became the subject matter of many paintings. Scholars have identified 250 such paintings as well as 60 painting sites. The visitor center supplies a little folder, the "Weir Farm Historic Painting Sites Trail," which you should pick up. Then follow the trail map, locate the twelve numbered wooden posts, and at each compare the visible landscape before you with the painting it inspired, which is reproduced in the folder. It's a vicarious look over the shoulder of the artist, allowing you to see the choices he made, the liberties he took, and the artistic will he imposed on the raw material. Needless to say, nature has obfuscated some vistas in the intervening decades. Trees do take over, and the National Park Service is to be lauded for its plans to clear some vistas to their original look. (In Weir's time you could see the ocean from the farm!)

After Weir's death, the farm stayed in the family. Weir's daughter Dorothy married noted sculptor Mahonri Young (1877–1957) in 1931, and they lived on the farm full time until his death in 1957. A grandson of Brigham Young's, Mahonri received a commission to commemorate the settling of Utah by the Mormons and called it, quoting Brigham Young, *This is the Place*. All the work was done at Weir Farm; Young built himself a studio for this large-scale work. After Young's death the farm and all its contents were sold to a local artist couple who were instrumental in saving it from the encroaching suburban sprawl and eventually arranging for it to be open to the public.

The visitor center exhibits a very small selection of Weir's work (mostly on paper) and shows a short film on Weir and American Impressionism. It offers guided tours of the landscape and studios (both Weir's and Young's) and of the distinctive stone walls, their history and function. The farmhouse itself is undergoing restoration and will eventually be open to the public. The gardens have

been partially restored, with the restoration based on old photos and records.

The Weir Farm Arts Center is a privately endowed nonprofit cooperating association, resident at Weir Farm. It emphasizes the artistic life of the site, with artist-in-residence programs, art classes, lectures, and three exhibits per year at the visitor center. Working in close cooperation with the National Park Service, WFAC also administers the adjacent 110-acre Weir Preserve and its many walking trails. (See www.weirfarmartcenter.org.)

+ PLUS

Aldrich Contemporary Art Museum
In nearby Ridgefield is the Aldrich Contemporary Art Museum, an organization that eschews a permanent collection by design. Instead it strives to be "a national leader in the exhibition of significant and challenging contemporary art," as well as an innovator in museum education. It grew out of the personal interest of Larry Aldrich, an immigrant fashion designer and art collector, who founded the museum initially in the farmhouse that now functions as administrative offices. The large, modern facility opened in 2004 (architect: Tappé Associates of Boston), and it forms a beautifully designed connection between the Colonial Main Street and the two-acre sculpture garden beyond. Inside it is all natural light and has several relatively intimate spaces to accommodate various exhibitions simultaneously. All systems are up-to-date and allow video and sound installations as well as more traditional media.

Directions: Retrace your route to CT-102, but turn left onto CT-102. After 1.5 miles, turn right onto Main Street (CT-102 and CT-35). The museum will be on your right; Tel. 203-438-4519; www.aldrichart.org.
Hours: Open year-round Tuesday through Sunday, 12 to 5 P.M.
Admission: Adults $7, seniors and students $4, children under 18 free.

Rhode Island

1 Providence
2 Newport

Newport

NATIONAL MUSEUM OF AMERICAN ILLUSTRATION

Vernon Court, 492 Bellevue Avenue, Newport, RI 02840; Tel. 401-851-8949 ext. 18; www.americanillustration.org.

Directions: From I-95 North or South take Exit 9 (Route 4 South). Shortly after Route 4 merges with Route 1, take a left onto Route 138 into Newport, crossing two bridges. Take the first exit off Newport Bridge, turn right off the exit ramp (Scenic Newport) and drive through the first set of traffic lights. Turn right onto America's Cup Avenue, which becomes Memorial Boulevard. Go uphill to the traffic light and turn right onto Bellevue Avenue. After 1 mile turn left onto Victoria Avenue at the street clock. The museum entrance is on the left, parking on the right.

Hours: From May 24 to September 1: Saturday and Sunday, 10 A.M. to 4 P.M. On Friday at 2 P.M. there is a guided ninety-minute tour for which reservations are required. During the rest of the year, reservations for the tour must be made in advance by telephone, and are subject to availability.

Admission: Adults $25, seniors $22, students $15, children 5–12 $10, group tours $20 per participant.

Catalog: The Grand Tour, a richly illustrated small guide to the collection with short biographies of the most important illustrators, is available in the bookshop. The Web site contains much information and is amply illustrated.

The admission price might seem steep, but it's really a two-for-one ticket, for a Newport mansion as well as a museum. The mansion in question is Vernon Court, built by Carrère & Hastings, the team that subsequently designed the Frick Mansion (now Frick Collection) as well as what is now the Neue Galerie, a former Vanderbilt mansion, both in New York City. Vernon Court has an understated elegance, perfect symmetry, and fine proportions that set it apart from some of the gaudier Newport "cottages."

Yet its interior is quite opulent, having been designed and furnished by the French interior designer Jules Allard. The loggias on either side of the building are particularly lovely: the Treillage Loggia on the left is decorated with a delicate ceiling mural of vine-covered trellis work and birds; the one on the right, the Rose Garden Loggia, displays what is considered Maxfield Parrish's masterwork, the multipanel mural *A Florentine Fête*. These panels (plus several more lining the staircase off the hall) depict various scenes of courtship and revelry in an imaginary Renaissance setting. They seem to have been made for this space, since their proportions fit the existing wall space perfectly, the architecture on the panels seems to echo the actual arches of the loggia, and the general mood of cultivated entertainment pervades both the art and the setting. (See color insert.)

Maxfield Parrish (1870–1966) and Norman Rockwell (1894–1978) are two of the most prominent illustrators of the "Golden Age of Illustration" to which this museum is dedicated above all. The Parrish collection is the largest anywhere, and the Norman Rockwell collection is second only to the holdings of the Norman Rockwell Museum (q.v.). Joseph Christian Leyendecker (1874–1957), Newell Convers Wyeth (1882–1945), as well as "the father of American Illustration," Howard Pyle (1853–1911), are all represented by several of their finest works. They are but the tip of the iceberg of a collection that comprises 2,500 original paintings from the mid-nineteenth century to today, and about 100,000 items related to the history of illustration, such as illustrated books, prints, posters, sketches, and memorabilia.

How did this museum come about? Judy Goffman Cutler founded the American Illustrators Gallery in New York in the midsixties as a commercial gallery "specializing in the finest works by renowned illustrators." Her own collection grew apace; eventually she and her architect husband, Laurence Cutler, were looking for a space to house their collection and make it accessible to the public. They found the perfect space here, but it took years to rehabilitate and upgrade the neglected building. Today it is in superb shape, as is the elegant garden. A plot of land on the other side of Victoria Street, known as Stoneacre and designed by Frederick Law Olmsted, has been restored, and a memorial arch

honoring the architect Louis Kahn, a mentor to Laurence Cutler, is planned.

The mission of both the gallery and the museum is to promote illustration art and to further the appreciation of those painters who, as commercial artists, used their training and visual imagination to provide the nation with iconic images and lasting memories, with patriotic feeling and gentle entertainment. Images of big-city glamour and of cozy family scenes, of historic moments captured "as if you were there" and of faraway lands and distant times, book illustrations and magazine covers, posters and murals—all this is the province of the illustrator. If you can visualize Rosie the Riveter, the Arrow Shirt Man, the Gibson Girl, Uncle Sam admonishing "I Want You," or the color plates in the books you read as a child, then an illustrator did his—or her (many were women)—work well. But while this art was made for reproduction, what you see in this museum are the artists' originals, large oil panels in vibrant colors that even the best reproduction technology cannot match.

Despite its limited hours, the museum mounts special exhibits in five galleries on the lower floor, where there is also a well-stocked gift shop. Recent acquisitions are shown there, as well as the fruits of collaborations with academic design institutions; for example, a commissioned series of new illustrations for E. B. White's *The Wind in the Willows* on the one hundredth anniversary of that classic children's book. The suite of entry hall, grand and small salons, ballroom, library, and the two loggias on the main floor is given to the permanent collection. Changes may be caused by loans, preservation needs, or by the NMAI program of sending entire exhibitions on tour in the United States and abroad. Illustration, this most American of art forms, has been particularly popular in Japan, and NMAI is also considering a formal "sister museum" relationship with the Shanghai Art Museum.

+ PLUS

Campus of Salve Regina University
Vernon Court is virtually enveloped by the campus of Salve Regina University, an institution that started as a college in one

building in 1947 and today enrolls 2,500 students. The campus consists of an unrivaled ensemble of Gilded Age mansions and their outbuildings, and extends between Bellevue Avenue and the ocean (with the famous Cliff Walk), bordered by Ruggles Avenue and Webster Street. That first building, Ochre Court, designed in 1888–92 by Richard Morris Hunt in French château style, is now the administrative center, as well as a national landmark. All the rooms on the first floor are open to the public, and, with its soaring, three-storey central hall framing a view of the ocean, the building is well worth a peek. Ochre Court abuts Vinland (now named McAuley Hall), a red-sandstone, Romanesque structure from 1883 with a number of outbuildings, all in the same red stone, clustered around its forecourt. Built for a tobacco heiress, Vinland was inspired by a purported Viking building in Newport immortalized in Longfellow's poem "The Skeleton in Armor." The next cluster of buildings inland from Vinland comprises Wakehurst, a replica of an Elizabethan manor in Sussex, England, of the same name. The interior includes the first Neoclassical room by British architect and designer Robert Adam imported to America. Retracing your steps toward Vernon Court on Shepard Avenue, there is Château-sur-Mer on the right (it is open to the public as part of the Preservation Society of Newport County's "Newport Mansions"), and on the left a Shingle-style building with Queen Anne–style undertones, designed by H. H. Richardson— the Watts-Sherman House (1874). It is considered an important monument in American architectural history, an early example of the Shingle style, America's first (post-Columbus) native architectural style. There are more historically significant buildings on campus than we can mention here. The university Web site has a virtual tour, accompanied by a downloadable campus map. Each building is photographed and identified, and the important ones are provided with detailed histories and shown in both contemporary and archival photographs.

100 Ochre Point Avenue, Newport, RI; Tel. 410-847-6650; www.salve.edu.

NEWPORT ART MUSEUM AND ART ASSOCIATION

76 Bellevue Avenue, Newport, RI 02840; Tel. 401-848-8200; www.newportartmuseum.com.

Directions: From Boston, take Route 24 South to Route 138 South. Turn left onto Route 138A, which becomes Memorial Boulevard. Turn right onto Bellevue Avenue; after two blocks turn right onto Old Beach Road, as parking and entrance to the museum are on that road.
From the Newport Bridge, take the Scenic Newport exit. Bear right onto America's Cup Avenue, go up the hill on Memorial Boulevard (Route 138), turn left onto Bellevue Avenue, then right onto Old Beach Road.

Hours: Columbus Day through Memorial Day: Monday through Saturday, 10 A.M. to 4 P.M.; Sunday, 12 to 4 P.M. Summer hours: same days, until 5 P.M.

Admission: Adults $6, seniors $5, students $4, children under 6 free.

Griswold House, "Newport's historic home for the arts," was one of the earliest works of architect Richard Morris Hunt (1827–1895). While his fame rests mainly on the Vanderbilt mansions (the Breakers and Marble House here in Newport, the Biltmore Estate in Asheville, North Carolina), at Griswold House he created, in 1864, one of the finest examples of Stick style, a picturesque Victorian evocation of various European traditions of half-timbered houses and Swiss chalets. Note the colorful roof shingles and the lively interplay of vertical, horizontal, and diagonal "sticks," wooden beams that are pure decoration. The interior has been painstakingly restored; elaborate inlaid floors, fireplaces, balusters, and wooden ceiling trusses make this a very warm and inviting house to enter. Some of the permanent collection is displayed in period rooms, while the former barn has been moved, integrated, and repurposed as a large open space for changing exhibitions.

A second building, the austere Neoclassical Cushing Gallery dating from 1919, points to the change from private residence to

public institution. Founded in 1912, the Newport Art Association purchased the Griswold House in 1916. It is the oldest American Art association still functioning, and only in 1984 was the name changed to include the "museum" designation.

As a collecting institution, therefore, the Newport Art Museum is young. But there is donated art related to the early occupants of the residence, as well as to the founders of the art association and other wealthy Newport collectors (about two thousand pieces in all). The typically genteel and academic paintings by Boston and New York painters of the mid- to late nineteenth century give you a good sense of what kind of art was attractive to the Gilded Age upper class. William Trost Richards (1833–1905) and John La Farge (1835–1910) both lived for a time in Newport, and are represented with several works. A suite of expert watercolors by Julia Overing Boit (1877–1969) is the adult work of the youngest daughter of painter Edward Darley Boit, whose four daughters were immortalized in John Singer Sargent's masterpiece *The Daughters of Edward Darley Boit*, of 1882, now in the Museum of Fine Arts, Boston. Other works on permanent display include the glowing *Sunset* by George Inness; George Bellows's *Autumn Flame*, an almost-abstract evocation of the fall foliage on Monhegan Island; and a regatta picture by Fitz Henry Lane. Collecting is ongoing, and one gallery is filled with large-scale late-twentieth-century art.

The Cushing Gallery was erected in honor of John Gardiner Cushing (1869–1916), a popular society painter and one of the founding members of the Newport Art Association. This gallery, with a 1990s addition, is home to larger temporary exhibits. It has a permanent exhibition in Cushing's memory, with a representative selection of his portraits, genre scenes, and Japanese-inspired canvasses; these are nicely supplemented by Chinese furniture and a Late Victorian color scheme and ambience. His *Woman in White* of 1905 depicts his stunning redheaded wife, Ethel, in a white-on-white composition reminiscent of Whistler. She was his favorite model and is shown here in several elegant paintings, also with their son.

There are sixteen to twenty exhibitions per year: some single-artist presentations, some topical, some showcasing private collec-

tions, and some presenting the members' artwork in juried shows. An art school, and guilds for artists, photographers, and architects, respectively, round out the picture.

+ PLUS

Tennis Hall of Fame
Just a block down Bellevue Avenue is the former Newport Casino, the original site of the U.S. Open, and now the International Tennis Hall of Fame Museum. Built in 1880 by the firm of McKim, Mead and White, it is a national historic landmark and considered one of the finest examples of Victorian Shingle-style architecture in the world. The triple-gabled façade on Bellevue Avenue shows—especially in the center brick arch on the ground floor—the influence of H. H. Richardson, with whom both McKim and White apprenticed. Pass through the massive arch and you enter the oval piazza, or interior court, surrounded on three sides by latticed porches of a faintly Chinese flavor. There are wonderful details all around. To see the interiors and the rest of the grounds you need to pay admission to the Tennis Hall of Fame Museum. A few rooms show the original opulent casino decor; the rest is obscured by the museum exhibits, which in themselves are quite interesting.

194 Bellevue Avenue; Tel. 401-849-3990; www.tennisfame .com. Open daily, 9:30 A.M. to 5 P.M. Admission: Adults $9, seniors and students $7, children under 16 $5, and $23 for a family.

Providence

ANNMARY BROWN MEMORIAL, BROWN UNIVERSITY

21 Brown Street, Providence, RI 02912; Tel. 401-863-2942; http://dl.lib.brown.edu/libweb/about/amb/.

Directions: See directions for RISD, then go three blocks further on Benefit Street, turn left onto Charlesfield Street and left onto Brown.

Hours: Monday through Friday, 1 to 5 P.M. during academic
 year only.
Admission: Free

Possibly the most peculiar museum included in this book, the
Annmary Brown Memorial is a library, a museum, and a mauso-
leum, all under one roof. General Rush C. Hawkins erected it in
1907, in the shape of a severe granite temple with bronze doors,
dedicated to the memory of his beloved wife, a descendant of
the Brown dynasty of Providence. Ironically, though, the me-
morial mostly reflects his personality, interests, and passions (and
was designed as a repository for his collections), whereas his wife
is merely present in a few portraits (and the crypt). He was a mili-
tary man active in the Civil War as the commander of the Ninth
New York Infantry Regiment, called "Hawkins' Zouaves" for
their picturesque, North African–inspired uniforms. (Some per-
tinent military memorabilia are on exhibit.) He was also an avid
collector of incunabula, making it his goal to acquire one printed
book from each press operating in Europe prior to 1500. At the
time of his death in 1920, he had accumulated 526 volumes; a se-
lection is usually on view, and the rest are in the John Hay Li-
brary, Brown's special collections library.

 His third interest was the fine arts, and it is enlightening to see
the collection of someone "not of the millionaire class," who did
not have an army of dealers and art historians at his disposal, and
who collected exactly what he liked and what was then fashion-
able, "safe" art. Clearly what he liked best were grand themes and
realistic execution. Many of the sixteenth- through eighteenth-
century paintings are "school of" or "attributed to" or "follower
of," although Hawkins in many cases assumed he had an original;
however, he asserts in the foreword to his collection catalog that
he was after beauty, not names.

 There is *The Holy Family*, painted in the sixteenth century after
Del Sarto; the severe *Pilgrim*, after Jusepe Ribera; and the charm-
ing *Portrait of a Girl*, now attributed to Gerrit van Honthorst (ca.
1590–1656). Two reliably original paintings struck me as among
the best: a down-to-earth American genre scene, Eastman John-
son's (1824–1906) *A Glass with the Squire*, depicting a farmer and a

judge confirming a sale with a glass of wine, and Angelica Kauff-mann's (1741–1807) sensuous *Zeuxis Selecting Models for His Picture of Helen of Troy*, which gives occasion to present several female beauties in various states of scant dress. Contemporary art for Hawkins meant academic art, and heroic, erotic, or exotic subject matter. *Poland Partitioned* is an allegory featuring a female nude, *The Favourite* by José del Alisal Casado (1832–1886) is a harem scene, and there are two large canvasses by American Oriental-ist painter Edwin Lord Weeks (1849–1903), *The Golden Temple* and *Crossing the Desert*, beautifully executed in high academic style.

The charm of the collection (about 150 items) is its very hap-hazardness and the insight it provides into the mindset of a pa-triotic art lover of the late nineteenth century. His compatriots esteemed him enough to entrust him with the selection of Ameri-can paintings for the Universal Exposition of 1889 in Paris. In that capacity he aroused the ire of a very irascible James Abbott Mc-Neill Whistler, who withdrew his work in protest and published an account of this feud later under the title "The Gentle Art of Making Enemies."

+ PLUS

Nightingale Brown House; John Brown House
In the immediate vicinity of the memorial are two other Brown family–related mansions. The first, the Nightingale Brown House on 357 Benefit Street, is now part of Brown University and run as the John Nicholas Brown Center for the Study of American Civ-ilization. The building itself goes back to 1792 and is considered the largest North American wood-frame house from the 1700s still standing. Thoroughly renovated, it is open for prearranged group tours only (401-863-1177).

Fortunately, the even more imposing John Brown House, just around the corner on Power Street, is open to the public as a house museum run by the Rhode Island Historical Society. John Quincy Adams called it "the most magnificent and elegant pri-vate mansion that I have seen on this continent." Built in 1788, designed by his brother Joseph Brown, this mansion was John

Brown's declaration to the world that he had been a success—as a merchant, entrepreneur, slave trader, and patriot.

To walk the length of Benefit Street from here to the first Baptist Church in America, also designed by Joseph Brown, is to experience American Colonial, Federal, and early-nineteenth-century architecture, both grand and modest, public and private. Many houses are labeled; an instructive guide with many links can be found at www.gonomad.com/features/0705/providence .html.

John Brown House Museum, 52 Power Street; Tel. 401-273-7507; www.rihs.org/Museums.html.

Hours: April through December: Tuesday through Friday, tours are at 1:30 and 3 P.M.; Saturday, 10:30 A.M., 12, 1:30, and 3 P.M.. January through March: Friday and Saturday only, 10:30 A.M., 12, 1:30, and 3 P.M.

Admission: Adults $8, seniors and students $6, children age 7–17 $4.

RHODE ISLAND SCHOOL OF DESIGN (RISD) MUSEUM OF ART

224 Benefit Street, Providence, RI 02903; Tel. 401-454-6500; www.risdmuseum.org.

Directions: From I-95 (North or South) take Exit 22A to downtown Providence. Continue straight on Memorial Boulevard, turn left onto Waterman Street at the third set of traffic lights. Halfway up the hill, turn right onto Benefit Street. The museum is one block on your right. Street parking during the week is difficult. After taking the left onto Waterman, turn left onto North Main (i.e., in front of the large white First Baptist Church); go one block to Steeple Street. The Metropark lot at the corner of North Main and Steeple streets offers discounted parking upon validation at the museum. On weekends, street parking is available on the streets above Benefit Street.

Hours: Tuesday through Sunday, 10 A.M. to 5 P.M.

Admission: Adults $8, seniors $5, children 5–18 and college students $3.

Catalog: Scholarly catalogs *Classical Sculpture* (by Brunilde Sismondo Ridgway) and *Classical Bronzes* (by David Gordon Mitten) published in the 1970s. A new general catalog is being prepared.

In the small state of Rhode Island, the RISD (pronounced RIZ-dee) Museum of Art functions both as the state's main art museum and as the academic museum for both RISD and adjacent Brown University. With eighty thousand works of art, it ranks among the foremost academic museums in New England. Like many of its sister institutions, it is in the middle of a protracted complete renovation, necessitating closings and moving of objects, which makes it difficult to describe what's where. The Chace Center by Rafael Moneo (see Davis Museum, Wellesley), opening in 2008, provides additional exhibition space and a new main entrance facing the city of Providence on Main Street (as opposed to the two current entrances on Benefit Street). Due to its location on a steep hill, the museum has six levels, with the old Benefit Street entrance on the fifth floor and the ramp into the modern Farago Wing leading onto the fourth floor. A printed floor plan is essential for your orientation and is updated regularly.

Some areas are not likely to change soon, however. Your first glimpse of the collection, as you enter the original 1926 building, is the light-suffused Roman Sculpture Gallery. It is a most generous introduction, inasmuch as it precedes your paying admission, has been recently reinstalled according to the most up-to-date scholarship, and starts right in with the museum's "great glory . . . the collection of Greek and Roman art, in which it probably ranks second only to the Boston Museum of Fine Arts among New England museums" (Faison). There are some hauntingly beautiful marble sculptures, mostly torsos and heads, and further Antique art in the next gallery.

In 1904, Charles L. Pendleton of Providence donated his entire collection of eighteenth- and nineteenth-century English and American furniture, paintings, china, pottery, and rugs with the stipulation that it "be kept separate and intact in a suitable building." The museum's Colonial House constitutes, in fact, the first "American wing" of any museum in this country. Different

rooms, while suggesting a lived-in feel, display distinct collec-
tions, well explained and labeled. The two downstairs parlors
and central hall emulate Pendleton's arrangements, paying tribute
to his passion for mostly high-style English and American eigh-
teenth-century furniture. Two upstairs bedrooms are interpreted,
respectively, as the home of a prosperous Providence farmer and
the bedroom of a China merchant. Another room is dedicated
to rural furniture and folk art, including redware pottery and
"primitive" portraits. American paintings of the colonial period
are exhibited throughout, among them four Copleys, as well as
one of the ubiquitous portraits of George Washington by Gilbert
Stuart (whose birthplace in nearby Saunderstown, incidentally, is
open to the public in the summer; see www.gilbertstuartmuseum
.com).

Lastly, a small gallery contains silver from colonial times to to-
day—an apt reminder that RISD is a design school, and perforce
collects modern design as well as historical examples. It is also a
reminder, by virtue of many dazzling examples, that since 1831
Providence has been home to the Gorham Silver Manufacturing
Company, the foremost American producer of silver flatware and
decorative art (and maker of the America's Cup, named for the fa-
mous sailboat race associated with nearby Newport).

The recently restored Main Gallery recreates the venerable
salon-style way of exhibiting art; i.e., hanging paintings close to
each other, two and three above one another, with no labels (a
reference guide is available to the viewer). Roughly 125 portraits,
landscapes, genre, religious, and historical paintings from the
sixteenth to the nineteenth century, covering all European re-
gions and schools, mingle in colorful profusion against deep blue
walls. There is something to be said for not bothering with labels
and just letting your eye wander from image to image, wonder-
ing about contrasts and relationships, picking favorites, making
guesses as to artist or century.

Ringing the Main Gallery are smaller, specialized galleries.
The Medieval Gallery is a survivor from an earlier exhibition phi-
losophy, that of "atmosphere galleries" advocated by then direc-
tor Alexander Dorner (1938–1941). They seek to place specimens
of fine and applied arts in settings that evoke the spirit and feel of

an age. Thus the Medieval Gallery is relatively dark, has stained-glass windows lit from behind, and its doorways are formed by sculpted architectural fragments from European churches and monasteries.

Three small Impressionist galleries will astound any visitor who is not aware of the quality of RISD's holdings. There are landscapes by Pissarro, Gauguin, Cézanne, and Monet; indeed, three each by Monet and Cézanne. Monet's *Le Bassin D'Argenteuil* "can be considered the very model of the Impressionist point of view. Color sparkles, textures dance, sailboats bob peacefully on the bright blue water . . . the absence of grays and blacks in all these rainbow hues" (Faison). Manet, in contrast, can be dubbed the master of white, black, and gray. His nearly six-foot-high *Le Repos* shows his favorite pupil, Berthe Morisot, in a fluffy white dress, reclining on a plum-colored sofa in a pensive mood. Purchased by George W. Vanderbilt in 1898, it is one of the first Manets to enter an American collection. Two compelling portraits are Degas' *La Savoisienne*, a peasant girl, and Carolus-Duran's informal portrait of Monet. The remaining peripheral galleries are dedicated to European and American art through the nineteenth century. Wherever works on paper are or will be exhibited, they should never be missed, as the quality and variety of the collection are simply superb. (The works on paper number twenty-six thousand!) Impressionist drawings are a particular strength.

The modern Daphne Farago Wing, with its own entrance, leads logically from a soaring lobby to the exhibition spaces for twentieth-century and contemporary art, and to special exhibitions on the third and fourth floors. One specialty here, not often found in other museums, is the collection of Latin American art made possible by the bequest of Nancy Sayles Day. It comprises works from over twenty countries in Central and South America as well as the Caribbean. Prominent names include Diego Rivera, Alfaro Siqueiros, Robert Mattá, Joaquín Torres-Garcia, and Fernando Botero, but there are always new discoveries to be made; the collection keeps growing and usually a small group is on view.

The one incongruous item on this floor is a fine collection of eighteenth-century European porcelain figurines, displayed in

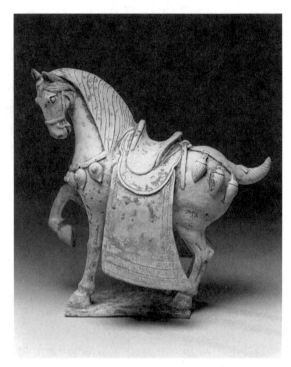

Figurine: Caparisoned Horse, 700–750 A.D. Chinese, T'ang dynasty. Earthenware, pigment; H: 12¾ in. Museum of Art, Rhode Island School of Design. Gift of Houghton P. Metcalf. Photography by Erik Gould.

elegant glass cases set into a Neoclassical, wood-paneled room that hails from an estate in Kent, England.

The top (sixth) floor is entirely dedicated to non-Western art, from a solid Egyptian collection to outstanding collections of Indian, Chinese, and Japanese textiles, sculpture, and ceramics. The pièce de résistance is the *Buddha Dainichi Nyorai*, nine feet high, carved in Japan circa 1150, a looming, mystical presence occupying his own gallery. Two galleries are dedicated to changing exhibits of, respectively, Japanese prints and Asian textiles. The latter include a rich array of temple robes and costumes for the No theatre. African and Pre-Columbian art is represented as well.

The collection of textiles and costumes is large, and a rich resource for the students of a design school. Glass, china, and pottery of all ages and continents are complemented by an important

wallpaper collection. Stimulating exhibits frequently explore the interaction of non-Western cultures with the West in the design field. The numerous bridges, stairwells, and connecting galleries of the insanely complex building are always enlivened by lovely little cross-cultural, diachronic, or thematic exhibits of beautiful objects. It is often through these unadvertised exhibits that one gets a glimpse of the riches buried in the storage vaults of the RISD Museum of Art.

+ PLUS

First Baptist Church
The slender-steepled, clapboard church you see when you look down Benefit Street is not only one of the largest and most elaborate New England parish churches, it has a most important historic significance. The congregation, for which this is the third building, was founded by Roger Williams after he had been exiled from Salem, Massachusetts, and had founded Providence as a haven for religious liberty. What he established in 1638 was the first Baptist church on American soil. The current building was dedicated in 1775 and built to a design by Joseph Brown, brother of the founder of Brown University (then called Rhode Island College); it was intended not only for services but also for the commencement exercises of the Baptist-affiliated college. They are held there to this day.

The First Baptist Church is open to the public for self-guided tours Monday through Friday, 10 A.M. to 12 P.M. and 1 to 3 P.M. (tour booklets available); admission $1. During the summer there are guided tours as well: Saturday, 10 A.M. to 1 P.M., and after the Sunday church service. Tel. 401-454-3418; www .fbcia.org.

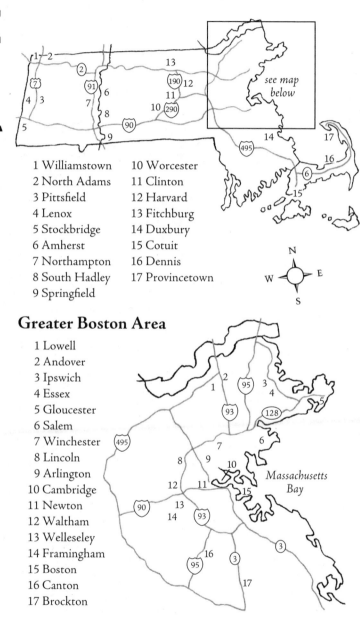

Massachusetts

1 Williamstown
2 North Adams
3 Pittsfield
4 Lenox
5 Stockbridge
6 Amherst
7 Northampton
8 South Hadley
9 Springfield

10 Worcester
11 Clinton
12 Harvard
13 Fitchburg
14 Duxbury
15 Cotuit
16 Dennis
17 Provincetown

see map below

N
W E
S

Greater Boston Area

1 Lowell
2 Andover
3 Ipswich
4 Essex
5 Gloucester
6 Salem
7 Winchester
8 Lincoln
9 Arlington
10 Cambridge
11 Newton
12 Waltham
13 Welleseley
14 Framingham
15 Boston
16 Canton
17 Brockton

Massachusetts Bay

Amherst

ERIC CARLE MUSEUM OF PICTURE BOOK ART 🛒

125 West Bay Road, Amherst, MA 01002; Tel. 413-658-1100; www.picturebookart.org.

Directions: From I-90 (East or West) take Exit 4 to I-91 North. Take Exit 19 and turn right onto Route 9 East. After crossing the Connecticut River, turn right at the first light onto Bay Road. Stay on Bay Road (which makes a left after 1.8 miles) for another 2.5 miles. The museum is on your left.

Hours: Tuesday through Friday, 10 A.M. to 4 P.M.; Saturday, 10 A.M. to 5 P.M.; Sunday, 12 to 5 P.M.

Admission: Adults $7, seniors $5, children 1–18, teachers, and students with ID $5, family of four $20.

Is picture-book art really "art"? Or is it "merely" illustration? And does it really matter? Eric Carle, possibly the best-known, and certainly one of the most prolific, children's book author-illustrators, is clearly in the "art" column and has used his presumably substantial earnings to create "the first full-scale museum in this country devoted to national and international picture book art, conceived and built with the aim of celebrating the art that we are first exposed to as children."

This program is implemented via well-thought-out, attractively staged exhibitions that treat an illustrator's work with the depth, circumspection, and scholarly thoroughness that are routinely accorded a "bona-fide" artist in traditional art museums. One exhibit I saw, which presented Quentin Blake, who is most famous for his illustrations of Roald Dahl's books, mentioned in the wall text that Blake's artistic influences had been Goya and Picasso, Daumier and the English satirists Thomas Rowlandson and George Cruikshank. On the wall alongside Blake's works were well-chosen and well-annotated examples of all of these influences. Likewise, the print material accompanying every major exhibit, with introduction by the director, a thorough essay by

the curator, numerous full-color illustrations, and an exhibition checklist, provide the factual and interpretive apparatus one would expect from an art exhibit catalog.

But that's for the grown-ups. Simultaneously, there is a second form of address, the one geared to children, and it's interesting to see how the two are intertwined. On a physical level, similar or related artwork is often hung in superimposed pairs, one at child height and one at adult height. In the galleries are baskets containing multiple copies of the printed children's books whose illustrations hang on the wall. Low-slung benches invite sitting down with a child and reading him or her the full story. Activity cards and pamphlets, geared to different age levels, lead kids on a "gallery search," in which they are subtly educated to look at pictures with concentration and an inquisitive mind. One activity involves comparing Blake's early sketches of a character with the evolved, final version, and to try to account for the changes. That's real art education on a sophisticated level, and yet it's just fun for kids.

Two temporary exhibits usually accompany the rotating presentation of the permanent collection, which is at this point very Carle-heavy, for obvious reasons. The formats include group shows, paired artists, lifetime retrospectives, and one-book explorations. Frequently, the artists are invited to speak at the museum, book signings included. The museum shop carries large numbers of books by featured artists, present or past, as well as a huge selection of qualitatively outstanding picture books and related toys. It's hard not to plunk down a lot of money there. Catalogs of previous shows, which are beautifully designed in a uniform format (a real invitation to collect them!), printed on first-rate paper and laid out in a friendly stepped-page format, are also available.

But the exhibitions are only one part of the museum's mission. A spacious art studio invites children and grown-ups to drop in during museum hours and create their own artwork. This effort is unobtrusively structured by the provision of generous amounts of a few selected materials for exploring a specific theme or process; the topic changes every month or so. Multisession classes in specific techniques are offered for adults and preschool kids during the school year, and for school-age kids during school vacations.

Teachers, librarians, and other interested professionals can pursue professional development (for a fee and with course credit) in workshops that take place about once a month. There is a rich offering of films, lectures, and theater performances in the auditorium, all linked in some way to children's books and their creators. There is, additionally, scheduled story time as well as individual, private reading in the lavishly stocked library. Where else but here would books be organized by illustrator rather than by author? Once a month the story-time slot is assigned to "the people who make the pictures," live authors and illustrators. There are family nights (when the restaurant stays open late), programs for home schoolers, seasonal events, and much more.

The museum exudes an overall friendliness, the public spaces are open and light-filled, with wonderful vistas of the surrounding old apple orchard and the hills beyond. In warm weather the café opens to the outdoors. My main regret was that I don't live close enough to take advantage of this great place to the degree that the locals can.

+ PLUS

Atkins Farm Country Market 🛒
To keep this kid-friendly, I will simply recommend a stop in the nearby Atkins Farm Country Market, where delicious freshly baked goods, local farm produce, and gourmet foodstuffs can be purchased, and the little café is the perfect place to refresh yourself (especially when the Carle Café is closed).

Directions: Upon leaving the museum parking lot, turn left onto Bay Road. Just before the next intersection (with Route 116) turn right into the market's parking lot.

MEAD ART MUSEUM, AMHERST COLLEGE

Amherst College, P.O. Box 5000, Amherst, MA 01002; Tel. 413-542-2335; www.amherst.edu/mead.

Directions: From the Mass. Pike (I-90) take Exit 4 (Interstate 91 North) to Exit 19. Take Route 9 East to Amherst. The

college is located at the intersection of Route 9 and Route 116 in Amherst. Metered parking available on Amherst streets. Walk uphill into the campus and look for the rough-stone steeple visible from the main quadrangle. The museum is adjacent.

Hours: Tuesday through Sunday, 10 A.M. to 4:30 P.M., Thursday until 9 P.M.

Admission: Free.

Catalog: Charles Morgan, *The Art Collection of Amherst College 1821–1971*, 1972, and Lewis A. Shepard, et al., *American Art at Amherst: A Summary Catalogue of the Collection at the Mead Art Gallery*, 1978 (both published by the college). The collection is accessible through the Five College Museums/Historic Deerfield Database, http://museums.fivecolleges.edu/.

On your way up to the museum, you may encounter the large bronze of famous Amherst alumnus Henry Ward Beecher (class of 1834), the preacher-abolitionist and brother of Harriet Beecher Stowe, the author of *Uncle Tom's Cabin.* Based on a death mask and photos, John Quincy Adams Ward (1830–1910), a leading sculptor of his time, gave him a massive, powerful presence, but—surprisingly—no orator's gestures.

It is fitting that a clergyman should first greet you, for Amherst was founded in 1821 "for the education of indigent young men of piety and talents for the Christian ministry." Noah Webster, of dictionary fame, was a moving force in both raising funds for and shaping the institution.

The arts arrived mostly through the generosity of major donors. In 1855, Amherst received its share of Assyrian reliefs from the palace at Nineveh (ninth century B.C.), supplied by American missionaries in the Near East, who saw these artifacts as tangible evidence of biblical events (see also Bowdoin, Dartmouth, Middlebury, Williams College, the University of Vermont, and Yale, which have similar holdings). A building dedicated to art came much later, when funds bequeathed by William R. Mead (class of 1867), a partner in the architectural firm of McKim, Mead and White, were used to erect, as late as 1949, a Neoclassical, marble-fronted small museum, appropriately designed by the above firm.

The Mead Art Museum today combines the breadth of a teaching museum with strength in specific areas, namely nineteenth-century American landscapes, Colonial and Federal period portraits, West African sculpture, Japanese woodblock prints, and Russian Modernist art.

Let's take a tour, keeping in mind that at any given time artworks may be in storage or traveling as part of an exhibition. There are only two truly permanent—in fact, immovable—displays: the aforementioned Assyrian reliefs, in a small gallery to the left of the entrance, and, to the far right, the superb Elizabethan/Jacobean banqueting hall from Rotherwas House in Hertfordshire, England (1611). Herbert L. Pratt, one of five brothers (and Standard Oil heirs) attending Amherst, and its foremost donor, gave the entire room, with walnut paneling, glass windows, and finely carved and painted floor-to-ceiling oak fireplace, to be incorporated into the museum when it was built. He had earlier bought it in England and had it shipped to the family mansion in Glen Cove, Long Island (now a resort hotel). He also bequeathed antique American furniture and silver and a wealth of American art, especially portraits.

A rotating selection of mostly American Colonial and Federal oil portraits is on view in Rotherwas Hall and looks quite at home in this British setting. If you are lucky, you will see the dashing portrait of *Sir Jeffery Amherst*, painted by Sir Joshua Reynolds (1723–1792) in 1765. To quote Faison, it is "not only one of the museum's major treasures, but must rank as one of Reynold's masterpieces. No other example in New England, at least, comes close to it in subtlety of color and expressive content. . . . [I]t shows the brilliant general in full armor at the age of forty-eight, after his many victories over the French in North America." It was Lord Amherst, of course, for whom the town and hence the college, were named.

John Singleton Copley and Gilbert Stuart are each represented with several oils. A number of the Peale dynasty of American painters is likewise represented: the college owns works from three generations of Peales; for example, Charles Willson's (1741–1827) loving portrait of his brother painting a miniature; Rembrandt Peale's (1778–1860) elegant portrait of his wife, Eleanor;

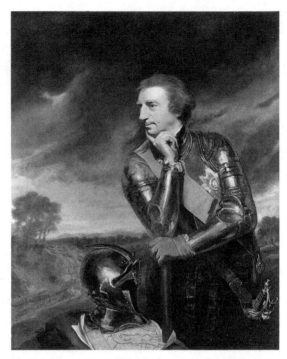

Joshua Reynolds, *Sir Jeffery Amherst (1717–1797)*, 1765. Oil on canvas, 50 × 40 in (127 × 101.6 cm). Mead Art Museum, Amherst College, Amherst, Massachusetts. Museum Purchase, AC1967.85.

and the latter's coolly probing, Neoclassical self-portrait of 1855. Benjamin West, Samuel Morse, John Trumbull, Thomas Sully, and others round out this fine collection, which shows indebtedness to British and Continental painting, but also the gradual evolution of a distinctly American style of portraiture.

Beyond the central gallery, which is reserved for changing exhibitions, are four dedicated galleries that present highlights of the permanent collection. First comes the Arms Gallery, given to Modern and contemporary art. The first half of the twentieth century seems better represented than the latter part, and American artists better than European.

The Ashcan School and George Bellows are responsible for two of the signature works of the Mead: Robert Henri's over-life-size, provocative, almost lurid *Salome*, which is featured on much of the museum's publicity, and the touching painting by George

Bellows of his daughter, *Anne in Black Velvet*, with its resonances of Velázquez and Manet. It's hard to reconcile the George Bellows of boxing scenes, urban grime, and dark etchings of war horrors with this endearing portrayal of a demure six-year-old. Amherst has extensive holdings of Bellows's drawings and prints, and the library is the recipient of his personal papers.

Another specialized area here is Russian art of the late nineteenth and twentieth centuries, from the collection of Thomas P. Whitney '37, the translator of Aleksandr I. Solzhenitsyn's works, among others. He established, in 1991, the Amherst Center for Russian Culture to preserve his archive of Russian printed and manuscript material. In 2001, he followed up with the donation of four hundred objects created by artists in Russia and in exile. To quote director Jill Meredith: "Through this remarkable collection, one can gain a greater understanding of the profound impact Russian culture has had on the West. The Thomas P. Whitney '37 Collection, in its breadth, depth and quality, not only speaks to the significance of Russian art in the 20th century, but also attests to its profound importance in the formation of modernism as an international phenomenon." Besides works representing Cubism, Futurism, Constructivism, and Suprematism, there are extensive holdings in stage and costume design for ballet, opera, and experimental theater (for example, for Diaghilev's Ballets Russes), by such artists as Leon Bakst and Natalia Goncharova. Artists well known in the West include El Lissitzky, Alexander Archipenko, Naum Gabo (a large Constructivist sculpture of his occupies the center of the gallery), and Marc Chagall. The Arms Gallery shows select examples of the Russian collection at any given time.

Going back in time, the next gallery presents nineteenth-century American art. With 600 paintings and 1,600 works on paper, this period is very well represented at the Mead, thanks again to the Pratt brothers and other donors. The pièces de résistance are two monumental works by Thomas Cole (1801–1848), *Past* and *Present*, painted in 1838. They show the same landscape, once as the setting for a Medieval castle with a courtly tournament on the lawn below, and then the same as an abandoned, overgrown ruin. This is quintessential American Romanticism, which needed to borrow from European history, since, Cole felt,

American landscape lacked "historical and legendary associations." Another large-scale landscape, *In the Woods*, is by Cole's friend Asher Durand (1796–1886). This great Hudson River School painter no longer needed the European associations: the American landscape is heroic, noble, and spiritual by itself. Other artists here include Albert Bierstadt, Frederic Church, George Inness, Thomas Moran, Thomas Eakins, and Winslow Homer, as well as the sculptors Augustus Saint-Gaudens, Daniel Chester French, and Frederic Remington.

The next permanent gallery, devoted to European art, is a somewhat motley assemblage, ranging from Early Renaissance to late nineteenth century. There is a fine, small oil sketch by Rubens and a huge, opulent still life by Rembrandt's one-time assistant, Frans Snyders, which, interestingly, was acquired from the estate of the first earl of Amherst, the nephew of Sir Jeffery. The small, hazy, almost abstract *Morning on the Seine, Giverny* by Claude Monet is counterbalanced by the photographically slick, Academic *Penelope* by his contemporary Adolphe Bouguereau (1825–1905). It is instructive to see the kind of art the Impressionists rebelled against. Renoir is supposed to have exclaimed after putting on glasses for the first time: "Mon Dieu, je vois comme Bouguereau!" (My God, I see like Bouguereau!). There is a portrait by the nineteen-year-old Henri de Toulouse-Lautrec (1864–1901) of his father on horseback, which betrays both his shy admiration for his dashing father and his immense talent.

A large print and drawing collection yields its riches mostly in special exhibits, or in the little teaching alcove in which images tied to current coursework are hung.

Lastly, and somewhat unexpectedly, there is a gallery devoted to West African art, mostly from the twentieth century. The Mead has an African collection of more than three hundred objects created for ritual and domestic purposes in many media and shows examples on a rotating basis.

In addition, there are two very important collections at the Mead that are not on continuous view: a treasure of 2,500 Japanese woodblock prints from the eighteenth and nineteenth centuries features all the major artists of that period, such as Hokusai, Utamaro, and Hiroshige. Due to their fragile nature, they are

mostly in storage, but the Mead regularly displays select examples in thematic exhibits. Another collection, less frequently on view, is the Morrow Collection of Mexican Folk Art, assembled by Dwight W. Morrow, class of 1895, during his tenure as U.S. ambassador to Mexico in the 1920s.

+ PLUS

Emily Dickinson Museum
To the literature lover, Amherst is synonymous with "the Belle of Amherst," Emily Dickinson (1830–1886). The poet's home is a stone's throw from the museum, and is run as a museum by the college. Both the poet's birthplace/home and the adjacent house, where her brother and his family lived, are open to the public.

280 Main Street (two blocks east of Amherst center); Tel. 413-542-8161; www.emilydickinsonmuseum.org.
Hours: Closed in January and February; opening times vary during the rest of the year. There are different guided tours to choose from and reservations are recommended. Admission is charged and varies according to the tour chosen.

Andover

ADDISON GALLERY OF AMERICAN ART, PHILLIPS ACADEMY

180 Main Street, Phillips Academy, Andover, MA 01810; Tel. 978-749-4015; www.andover.edu/addison.

Directions: From Boston, take Route 93N. Take Exit 41, turn right onto Route 125, go 2 miles. At cloverleaf, turn onto Route 28 North, go about 3 miles to the Phillips Academy campus. Turn right onto Chapel Avenue. The gallery is the first building on the right.
From Route 495, take Exit 41-A (Andover) and proceed south on Route 28 through the town of Andover. Phillips Academy is approximately 1 mile south of the center of town. Turn left onto Chapel Avenue.

Hours: Tuesday through Saturday, 10 A.M. to 5 P.M.; Sunday,
 1 to 5 P.M. Closed August through Labor Day.
Admission: Free.
*Catalog: Addison Gallery of American Art 65 Years: A Selective
 Catalogue,* Andover, 1996.

While Phillips Academy, aka Andover, was founded in 1778,
the Addison Gallery did not come into being until 1931, when a
wealthy alumnus joined forces with the architect Charles A. Platt
(who also designed the Lyman Allyn Art Museum in New Lon-
don, Connecticut, as well as the Freer Gallery of Art in Washing-
ton, D.C.) to create one of the first museums dedicated exclusively
to American art. The sedate, Neoclassical building belies its his-
tory as an avant-garde outpost in New England that showcased
many Modern artists before they were big names.

Upon entering, one is struck by the beautiful circular mar-
ble hall, dominated by Paul Manship's marble statue *Venus Ana-
dyomene.* Manship (1885–1966), the creator of the Prometheus
figure in Rockefeller Center in New York City, was commis-
sioned by the architect to create a sculpture for the foyer of the
gallery. *Venus Anadyomene* was designed as a fountain, in which
case the body of Venus would have been glistening wet ("ana-
dyomene" means "emerging from the water"). Technical prob-
lems kept the fountain dry; but even so, the statue is well suited
to the rotunda, filling it perfectly. Several more Manship bronzes
can be found throughout the museum.

As with many other museums, selections from the permanent
collection are on view on a rotating basis, chosen around a topic,
and change about three times a year. Not all works mentioned
below may therefore be on view at any given time. Always on
view, however, is a collection of one-fourth-inch-scale ship mod-
els depicting the history of American sailing vessels, in the lower
level.

The Addison Gallery is particularly rich in nineteenth- and
twentieth-century art, though a few extraordinary earlier pieces
should not be missed: Benjamin West's *The Drummond Brothers*
of 1767, a grand—and large—full-length double portrait of the
two sons of West's patron, Archbishop Drummond of York, in

academic gowns and surrounded by symbols of learning and vir-
tue. Eventually, West abandoned portraiture for history painting;
one can see harbingers of the grand historic style in this flamboy-
ant and eloquent painting (see, for examaple, *Agrippina Landing
at Brundisium with the Ashes of Germanicus*, also commissioned by
Drummond and now in the Yale University Art Gallery). John
Singleton Copley's *Mary Elizabeth Martin* of 1771 shows a nine-
year-old girl in a luminescent pink silk-and-lace dress with her
pet spaniel—a lively, informal composition.

Some of the nineteenth-century highlights are portraits, as
well; for example, *Self Portrait* (1812–13) by Samuel F. B. Morse, he
of telegraph and Morse-code fame, but also an important painter
and Phillips Academy alumnus. Others include *Professor Henry A.
Rowland* (1897) by Thomas Eakins, which shows the famous phys-
icist in his lab holding a color spectrum of his devising, which
creates a central point of color in the otherwise muted browns of
the superb portrait. Eakins carved a gilded frame with scientific
jottings provided by the sitter. There is another Eakins, the darkly
mysterious *Elizabeth at the Piano* (1875).

Other nineteenth-century painters represented in the col-
lection are Washington Allston, Albert Bierstadt, Mary Cassatt,
William Merritt Chase, Frederic Church, Asher Durand, Childe
Hassam, Winslow Homer (several outstanding examples, includ-
ing *The West Wind* and *Eight Bells*), George Inness (several, includ-
ing *The White Monk*), Maurice Prendergast, Frederic Remington
(an atypically dark, almost monochromatic *Moonlight, Wolf*), John
Singer Sargent, and James Abbott McNeill Whistler. The early
twentieth century is represented by excellent examples of works
by George Bellows, Arthur Dove, Marsden Hartley, Robert
Henri, Edward Hopper, and John Sloan.

From its founding in 1931, the museum mounted exhibitions
of contemporary art, out of which came acquisitions and gifts.
Leapfrogging the rather conservative Boston art world, the Addi-
son maintained close links with New York galleries, dealers, the
Museum of Modern Art, and the Whitney Museum of American
Art. A few examples may stand for the Addison's active involve-
ment with twentieth-century art and artists and its mission as an
integral part of a teaching institution:

In 1934 two solo exhibits by photographers Walker Evans (an Andover alumnus) and Margaret Bourke-White made the Addison one of the first museums to exhibit photography. Today, photography forms the largest part of the entire collection, about six thousand out of approximately sixteen thousand items.

In 1935 and 1939, exhibits of woodcuts and paintings, respectively, by Josef Albers, the Bauhaus émigré, foreshadowed a 1941 group exhibit of several artists who had come to the United States in the decade before and included George Grosz, László Moholy-Nagy, Amédée Ozenfant, and others—the first exhibit of "artists in exile" in America. The Bauhaus method also influenced the teaching of art at Andover.

In 1938 the Addison held the first retrospective of John Sloan's work. The painting *Sunday, Women Drying Their Hair* has become a signature representative of the Ashcan School and is now in the Addison collection.

In 1939 one of many instructional exhibitions, "The Architecture of a Painting: Edward Hopper's *Manhattan Bridge Loop*," elicited rare comments about his working method from the painter and resulted in the gift of preliminary sketches for the finished oil. (There are two other Hoppers in the collection.) In 1946 Charles Sheeler, the Precisionist painter and photographer, was invited to Andover as artist-in-residence for a month, with the understanding that the museum would buy a work that resulted from this experience. An exhibit of Sheeler's work was mounted to coincide with the visit. Sheeler discovered a run-down, formerly industrial area of Andover, Ballardvale, which inspired him to no fewer than five paintings and marked a creative milestone in his career. (See also Currier Museum of Art, New Hampshire.) The first major museum exhibit dedicated to an Abstract Expressionist (and exile and teacher of many American painters) took place in 1948: "Hans Hofmann, Painter and Teacher."

An alumnus of Andover, Frank Stella, helped in staging another instructional exhibit, "Frank Stella: From Start to Finish," in 1982. The goal was to trace the genesis of finished artworks (in this case, large-scale metal relief paintings) by displaying the sketches and models that preceded their final form. Stella gave to the museum several of his own paintings as well as seventeen

paintings from his personal collection, which included works by Jasper Johns, Donald Judd, Ellsworth Kelly, Kenneth Noland, and Mark Rothko.

The Addison upholds this very ambitious schedule of loan exhibits, and should be considered one of the major venues in the New England area for keeping informed about current trends in American art.

+ PLUS

Stevens-Coolidge Place

Nearby, in North Andover, is the Stevens-Coolidge Place, which shows Colonial Revival in action. Its beginnings go back to 1729, when the Stevens family acquired the land it would farm for six generations. In 1914 Helen Stevens Coolidge inherited the farm. She and her husband, John Gardner Coolidge, a nephew of Isabella Stewart Gardner, set out to transform it into a gracious "country place" to complement their Back Bay winter abode and to hold their collections of Chinese porcelain and other Asian artifacts collected on foreign postings. They engaged the leading advocate of the Colonial Revival style, Joseph Everett Chandler (1864–1945), who famously restored (and partially destroyed) the Paul Revere House in Boston, and also restored the House of the Seven Gables in Salem. His ambition was not preservation or restoration in the modern sense, but the imaginative rebirth and elaboration of existing Colonial structures. At the Stevens-Coolidge Place, this involved adding dormers, bow windows, a double interior staircase, a delft-tiled fireplace, and other Georgian and Federal design elements, as well as a brick terrace overlooking the splendid perennial garden and the meadows beyond. Other gardens and greenhouses were added over the years, with Chandler helping in the design, notably the French garden bordered by serpentine walls modeled on those designed by Jefferson (an ancestor of John Coolidge's) at the University of Virginia—another example of creative evocation of Colonial design elements.

139 Andover Street, North Andover, MA 01845; Tel. 978-682-3580; www.thetrustees.org.

Directions: From the Addison Gallery, turn right onto Route 28 (Main Street) for 0.75 miles, turn right onto Elm Street, cross Route 114. At first traffic light turn right (remains Andover Street) and go for 0.5 miles. House is at left, parking at right.

Hours: Gardens open daily year-round; house open from June through September, Saturday and Sunday, 1 to 4 P.M. Guided tours on the hour: adults $8, children $5.

Arlington

CYRUS E. DALLIN ART MUSEUM

One Whittemore Park, Arlington, MA 02474; Tel. 781-641-0747; www.dallin.org.

Directions: From I-95: Take Exit 29 (Route 2 East), then take Exit 59 (Route 60 East). Go through the first light (Massachusetts Avenue); the museum, a Colonial white clapboard, will be on your right. From downtown Boston: Take Route 2A; take a right at the intersection with Route 60; the museum is on the right-hand corner. A municipal parking lot is immediately behind the museum.

Hours: Tuesday through Sunday, 12 to 4 P.M.

Admission: Free.

You may not have heard of Cyrus E. Dallin (1861–1944), but if you live in Massachusetts, you probably have seen one of his bronze sculptures—*Appeal to the Great Spirit*, the Indian on horseback in front of the Museum of Fine Arts, or *Paul Revere*, in the Revere Mall just opposite the Old North Church, from which Revere took his famous ride, or *Anne Hutchinson*, religious dissident and early feminist, at the statehouse. Dallin was and is best known for his portrayal of heroic and noble American Indians. Wayne Craven, in his *Sculpture in America* (1968), says, "His great series of four equestrian statues carried the imagery of the red man to its finest expression in sculptural form. Dallin in these works achieved a true monumentality."

Born in Utah, he was raised in friendly interaction with local Indians. He was recognized early for his modeling talent; a generous patron sent him east to Boston, where he studied and soon established himself successfully, becoming friends with Augustus Saint-Gaudens and John Singer Sargent. By 1888 he was able to afford further study in France, mostly perfecting academic subjects. The arrival there of Buffalo Bill's Wild West Show reignited his interest in American Indians, and he sculpted the first of his equestrian masterworks, *Signal of Peace*, which was subsequently shown at the Chicago Columbian Exhibition of 1893, purchased by the city, and still stands in Chicago's Lincoln Park.

Dallin lived in Arlington from 1900 until his death in 1944. The town had commissioned two major works from him (see PLUS, below), but it was not until the 1980s that local interest reawakened and led to the eventual opening of the Cyrus E. Dallin Art Museum in 1998, in the historic Jefferson Cutter House. Four galleries show models, plaster casts, bronzes, relief panels, and medals grouped under the themes Native Americans, History and Allegories, Friends and Neighbors, and, finally, the Paul Revere Room, which traces (in photos and models) the many stages which Dallin worked out and submitted in a tortuous attempt to get the statue commissioned and funded. One striking gilded-bronze statue is a copy of the plaster model of the Angel Moroni, which Dallin executed for Salt Lake City's Mormon temple (and which graces all other Mormon temples worldwide).

+ PLUS

Robbins Garden bronze sculptures
To see two mature bronzes by Dallin nearby, cross Massachusetts Avenue and Pleasant Street. Walk past the Modernist, white First Parish Church and past the noble Neo-Renaissance Robbins Library. Between the library and the city hall beyond is a little park, Robbins Garden, where a series of water-filled basins leads to the life-size *Menotomy Indian Hunter* (*menotomy*, the former name of Arlington, means "place of swift running water"). A kneeling Indian rests from the hunt and cups his hand to scoop up some water. The setting and the sculpture make you forget the busy

street and traffic just yards away. (See color insert.) On the other side of city hall is the Robbins Memorial Flagstaff, at the base of which sit four under-life-size figures of exceptional liveliness, identified by the artist as: "Menotomy Minute Man," "Puritan Divine," "Squaw Sachem," and "Mother and Child." The figure on top—an allegorical representation of Massachusetts, with flowing drapery—is a replica, while the original is in the museum. Beyond the little park, notice the imposing (Federal) Whittemore Robbins House (the Robbins family had commissioned *Indian Hunter*), with its octagonal lantern and four chimneys, just behind the park. As you retrace your steps, you may want to enter the library to admire its opulent interior, a gorgeous entry hall with a high rotunda and an oak-paneled, vividly stenciled reading room to the left. It also houses a relief panel by Dallin.

Boston

INSTITUTE OF CONTEMPORARY ART (ICA)/BOSTON

100 Northern Avenue, Boston, MA 02210; Tel. 617-478-3100; www.icaboston.org.

Directions: The ICA is located on Boston's waterfront, adjacent to Anthony's Pier 4 restaurant. It is a short walk from downtown and South Station.

From points west: Take I-90 East (Mass. Pike) to Exit 25 (South Boston). Once in this tunnel, stay left and follow the sign for "Seaport Bulevard." At the top of the ramp, continue straight, crossing Congress Street and then Seaport Boulevard, onto Northern Avenue.

From points south: Take I-93 North to Exit 20. Follow signs to I-90 East. Take the first tunnel exit to "South Boston." At the top of the ramp continue straight, crossing Congress Street and then Seaport Boulevard, onto Northern Avenue.

From points north: Take I-93 South to Exit 23 (Purchase Street). Stay in the left lane, taking the first left at the end of the ramp onto Seaport Boulevard. At the next light, take a left onto Sleeper Street and then a right onto Northern Avenue.

Paid parking available in lots immediately adjacent to the
ICA.

Hours: Tuesday, Wednesday, Saturday, and Sunday, 10 A.M. to
5 P.M.; Thursday and Friday, 10 A.M. to 7 P.M.

Admission: Adults $12, students and seniors $10, children under
17 free, free for families with children under 12 on last Sat-
urday of each month.

The ICA/Boston barely qualifies as a museum (defined as possess-
ing a permanent collection), since for the first seventy years of its
existence it did not collect at all, but restricted itself to showing
temporary exhibits of contemporary art. Had the ICA systemati-
cally purchased examples from its previous shows, it would now
have an impressive collection of twentieth-century art.

With the opening of the stunning new building on Boston's
waterfront in late 2006, the ICA became a whole new organiza-
tion with a new acquisition policy. It is now committed to buying
artworks, mostly from its temporary exhibits, and has dedicated
a small gallery to examples from its incipient permanent collec-
tion. There is a subtle irony in collecting contemporary art, of
course, since by definition the collection will soon not be con-
temporary. Gifts and bequests will no doubt also increase, and in
a few years ICA may evolve into a bona-fide museum of twenty-
first-century art.

But is that what the ICA truly wants to be? The testimony of
the architecture suggests much larger ambitions. The bold, mostly
glass-walled, cantilevered building is home to educational facil-
ities—an art lab, a digital studio, and a "mediathèque"—a 325-
seat theater, and a gallery space, all stacked one upon the other.
Uppermost in every sense is the jutting, double-storey expanse
that provides eighteen thousand square feet of exhibition space.
This space is encased within a solid shell to shield the artworks
from direct sunlight and to provide the necessary wall space. Nat-
ural light comes filtered through scrims from a series of skylights.
A balcony gallery that runs the width of the cantilever on the wa-
terside connects the two main east and west exhibition areas. On
the balcony, light-tolerant artwork has to compete with the pan-
oramic view.

Institute of Contemporary Art, Boston, MA. Diller Scofidio + Renfro, architects. Photograph by Iwan Baan.

At any given time there are several exhibits, and while the ICA/Boston is thoroughly international in scope, it does not neglect local talent. The James and Audrey Foster Prize "recognizes Boston-area artists who demonstrate exceptional artistic promise." Awarded biennially, the prize carries a stipend of $25,000 and an exhibition at the ICA of up to four finalists.

You might wonder whether it is not impractical to have a theater and a museum with glass walls. The architects, Diller, Scofidio + Renfro of New York, note, "[T]he building is like a control valve—it turns the view on and off." This is true of the aesthetic experience, as tightly engineered lookouts, a glass elevator, and sprawling, open vistas are perfectly calibrated, but it is also true on a mechanical level, since the theater's glass walls can be covered by either translucent fabric or solid blackout panels by the push of a button. The theater's suitability for dance, music, and theater may entice directors to integrate the water and sky vistas into the performances. To judge from the first year's programming, downtown Boston will finally have a sophisticated venue for cutting-edge, multimedia performances.

In addition, there are, of course, a bookstore and a restaurant,

the latter with harbor views and outdoor seating in summer. Sets of bleachers that also function as a dramatic entrance overlook the water and are protected by the cantilevered overhang. As dramatic as this waterside entrance is, the street front and entrance are rather disappointing, at least until planned surrounding buildings will frame them and replace the current disheveled parking lots. All the drama is reserved for the waterside, and all the views from the interior luxuriate in close-up and distant water views, with the Boston and Charlestown skylines as a backdrop.

+ PLUS

Harbor Walk; Moakley Courthouse
The aforementioned bleachers, visually a continuation from the indoor theater, form a link to the outdoors, specifically the Harbor Walk. This is an ambitious project to eventually link most of Boston's waterfront via a continuous footpath. Large portions of it are in place, more will follow (information at www.bostonharbor walk.com). Taking the path from the ICA building toward the city, you will soon reach the impressive hulk of the brick-clad Joseph Moakley U.S. Courthouse, built by the firm of Pei, Cobb & Partners and dedicated in 1998. It shares with the ICA the orientation toward the water and an inviting openness to the public not exactly typical of courthouses. A sequence of public spaces— entrance hall, rotunda, great hall, and galleries—can be visited (during the week only, alas). Commissioned artwork by Ellsworth Kelly consisting of twenty-one rectangular panels is installed in the rotunda and galleries, and guided tours of the building are available by prior appointment (www.discoveringjustice.org, or call 617-748-4185).

ISABELLA STEWART GARDNER MUSEUM

280 The Fenway, Boston, MA 02115; Tel. 617-566-1401; www .isgm.org.

Directions: Using public transportation, take the Huntington Avenue No. 39 bus or the Green Line E train to the

Museum of Fine Arts stop. Cross Huntington Avenue (toward the Shell gas station) to Louis Prang Street, turn right and walk down two blocks. The museum is on the left. To drive from central Boston, take Huntington Avenue going west, turn right past the Museum of Fine Arts (i.e., onto Museum Drive) and use the parking garage across from the MFA. Walk down to the end of Museum Drive and turn left. The Gardner museum is one block away on the left.

Hours: Tuesday through Sunday, 11 A.M. to 5 P.M.

Admission: Adults $12, seniors $10, students with ID $5, children under 18 free, if accompanied by an adult. Free for anyone named Isabella and on one's birthday.

Note: Avoid dark, cloudy days when visiting, since the lighting is not very bright and depends largely on natural light.

Catalog: The Isabella Stewart Gardner Museum: A Companion Guide and History, Boston, 1995. In addition, several scholarly volumes on specific areas of the collection are available.

Fenway Court was the name Isabella Stewart Gardner (1840–1924) gave to the inverted Venetian palazzo that was her home and is the home for an extraordinary art collection, exhibited in a completely idiosyncratic way. She did, indeed, hold court there, from its opening in 1903 until her death in 1924, hosting such luminaries and celebrities as Henry and William James, Oliver Wendell Holmes, diva Nellie Melba, pianist Ignaz Paderewski, Ferruccio Busoni, John Singer Sargent, and many local academics, literary figures, and artists. She hired half the Boston Symphony to perform at the formal opening of her palazzo!

She and her husband traveled widely in Europe, Asia, and the Middle East, but she did not become a serious collector until the 1890s, when the young art historian Bernard Berenson began advising her on her purchases. When her husband suddenly died in 1898, she poured all her energy and resources into enlarging the collection and creating a fitting building to house it and herself. Buying land in what were then the outer reaches of the city, in the newly drained and filled fens (the Museum of Fine Arts only moved there in 1909), she set out to design a museum that would

be the antithesis of the cold, mausoleumlike marble palaces typical at the time.

"Years ago I decided that the greatest need in our country was art. We were a very young country and had very few opportunities of seeing beautiful things, works of art, etc. So I determined to make it my life work if I could. Therefore, ever since my parents died I have spent every cent I inherited in bringing about the object of my life," Gardner wrote to a friend. The love of great art—an emotional more than an analytic approach—informed her vision of Fenway Court.

The almost drab, pale brick exterior in no way prepares one for the flower-filled interior courtyard, an evocation of Venetian façades, with pink "distressed" stucco surfaces punctuated by Gothic windows, loggias, and arches. Authentic building fragments, brought across the ocean by the crateful, mingle seamlessly with tasteful recreations. This is the first work of art you see, and it is hers. Let yourself be intoxicated by this Victorian dream of Venice, a warm, summery garden forever in bloom (thanks to a glass roof to keep out cold Boston winters, and an endowment for nurseries and staff), dotted with Antique statuary, columns, vases, and a central mosaic, and surrounded by arcades filled with artwork. Gardner created an environment, the psychological effect of which is to transport us from the real-life world to a magic palace, whose chatelaine invites us to share her treasures.

The whole museum is a series of such artificial, or rather artistic, environments with evocative names: the Spanish Cloister, the Blue Room, the Yellow Room, the Chinese Loggia, the Spanish Chapel—just on the ground floor. On the second and third floors, we have the Early Italian Room, and rooms named for Raphael, Titian, Veronese, as well as the Dutch Room, the Gothic Room, and the Little Salon.

If you thought that all the early Italian paintings would be in the Early Italian Room, you would be mistaken. That would be much too boring and predictable for Gardner's vision. Rather, the names give a hint of the focus, the most beloved items, in a room, but each room is an orchestrated ensemble, composed not only of paintings from different periods, but also sculptures, wall coverings, ceiling treatments, textiles, antique furniture (over 450

pieces in all), lighting fixtures, fireplace mantels, stained glass, as well as mementos and bibelots from many times and cultures. Each room has a distinct mood, its own persona, and it is intriguing to inventory mentally all that had to be brought together to create the finished effect and to marvel at the utter freedom with which Gardner mixed times, media, sizes, and quality.

Gardner planned Fenway Court as a museum "for the education and enjoyment of the public forever," with her foremost goal being enjoyment of art rather than art historical learning. Thus she left most pieces unlabeled and even now the museum is quite coy with solid information; whatever labels there are, have minimal information. That can be frustrating, but electronic tour guides are provided. Scholarly publications on various subsets of the collection are of high quality.

By far the majority of masterpieces come from Italy. Some of the artists represented are Giotto di Bondone, Simone Martini (two), Fra Angelico, Sandro Botticelli (two paintings, including *Madonna of the Eucharist*), Piero della Francesca (a stunning fresco, *Hercules*), Michelangelo (*Pietà*, a drawing), Raphael (a drawing and two paintings, the unsparing portrait *Count Tommaso Inghirami* and an early *Pietà*), Giorgione, Paris Bordone, Titian (the famous *Rape of Europa*, which was copied by Rubens, and this copy in turn copied in watercolor by Van Dyck, which Gardner bought and placed on a table below the Titian), Benvenuto Cellini (a masterful bronze, *Portrait of Bindo Altoviti*), Paolo Veronese (a large ceiling painting, *The Coronation of Hebe*). Other masters include Bellini (Gentile and Giovanni), Moroni, Tintoretto, Tiepolo, Guardi.

The Northern artists are for the most part in the Gothic and the Dutch rooms, which include some superb anonymous woodcarvings, stained-glass windows, and tapestries. Germany is represented by Dürer, Cranach, and Holbein; Holland and Flanders by Rembrandt, Vermeer (whose painting, *The Concert*, was stolen), Van Dyck, and Rubens; and Spain by Velázquez and Zurbarán, among others.

Gardner collected great and costly Italian and Dutch art early on, but she also collected recent and contemporary painters (Delacroix, Courbet, Corot, Turner, Manet, Degas, and Matisse), as

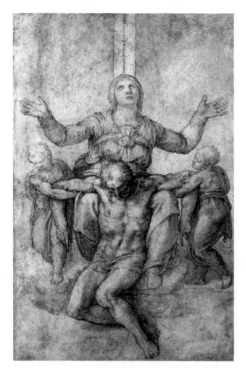

Michelangelo Buonarroti, *Pietá*, early 1540s. Black chalk
on paper, study for the Colonna Pietá, Isabella Stewart
Gardner Museum, Boston.

well as such American contemporaries as John La Farge, Whistler,
Sargent, Thomas Dewing. She was a true patron to the American
Impressionist Dennis Miller Bunker, the American Louis Kron-
berg (who also acted as her agent in Paris), and Dodge Macknight,
for whose collection of watercolors one of the small first-floor
rooms is named.

Gardner had a long and fruitful relationship with John Singer
Sargent (1856–1925). When Henry James took her to Sargent's
studio in London in 1886, she saw there the famous *Madame X*
(now in the Metropolitan Museum of Art), which the sitter had
rejected. It prompted Gardner to commission her own portrait, a
full-length frontal representation of Gardner in a black dress, her
famous pearls with ruby pendant slung around her waist, a halo
formed by the background fabric, and a décolletage that was con-
sidered daring. Boston found the picture shocking and Gardner

henceforth kept it in the Gothic Room, which was not open to the public until after her death. She remained a great advocate and friend of Sargent's. In fact, he painted a lovely double portrait, *Mrs. Fiske Warren and Her Daughter*, now in the Museum of Fine Arts, in that very room. Sargent portrayed Gardner again, as an invalid of eighty-two, dressed almost like a nun, all in white. This haunting watercolor, *Mrs. Gardner in White*, pleased her greatly; it hangs in the Macknight Room. In all, there are eleven watercolors by Sargent, several smaller oils, and the pièce de resistance, *El Jaleo* (The Ruckus), the mesmerizing evocation of a dark Andalusian tavern, with singers, guitarists, and guests barely visible in the dark recesses, and all the light on the shimmering white skirt of the dancer. Gardner built a theatrically lit setting for this painting, with a Moorish arch, even before she owned it; Sargent loved the installation.

Gardner left very explicit instructions for the museum: nothing can ever be moved, deleted, or added. Nevertheless, the museum organizes small exhibits, usually around one or two works from the collection. They tend to be in-depth, scholarly, and eye-opening. Lectures and, if appropriate, concerts accompany these exhibits. There are plans for the addition of a wing (designed by Renzo Piano), which will relieve the cramped exhibition, café, and bookstore facilities. An active artist-in-residence program and regular concerts in the large Tapestry Room round out the museum's offerings.

+ PLUS

Biography of Isabella Stewart Gardner
Once you are familiar with the museum, it is great fun to read *Mrs. Jack: A Biography of Isabella Stewart Gardner* by Louise Hall Tharp (Boston, 1963, and always available in the bookstore). Skip or skim the first third; the plot gets thicker as you learn how the various masterworks were extracted and cajoled out of European estates and hands, and how Gardner became an ever more astute collector. Various exotic trips and regular, extended stays in Europe evoke the Gilded Age, when people of Gardner's class traveled with entourages, their movements were recorded by the

papers, and they took it as their birthright to be greeted by royalty or have embassy staff cater to their whims. The last third narrates the planning and building of Fenway Court, the evolution from private treasure house to public museum, and the last decades of Gardner's life as the indomitable and eccentric lady of Fenway Court.

A documentary movie, *Stolen* (available from Netflix), enters the shadowy world of art recovery. It takes the theft of thirteen pictures from the Gardner in 1990 as its starting point. A reward of $5,000,000 is still on offer.

MUSEUM OF FINE ARTS, BOSTON

465 Huntington Avenue, Boston, MA 02115; Tel. 617-267-9300; MFA.org.

Directions: Consult the Web site for directions, as they are elaborate. Public transportation: by T (subway) on the E train of the Green Line to the Museum of Fine Arts stop, or on the Orange Line to the Ruggles stop.

Hours: Daily, 10 A.M. to 4:45 P.M., Wednesday through Friday until 9:45 P.M.; closed on major holidays and on Patriots Day (the third Monday in April).

Admission: Adults $17, seniors and students $15, children 7–17 $6.50, but free for children after 3 P.M. on weekends and during public school holidays. Students of most area colleges free with valid ID. No admission charged Wednesday, 4 to 9:45 P.M. Tickets are valid for a month. Note: Major special exhibitions are ticketed separately. Make sure to get a floor plan, as orientation is somewhat difficult.

Catalog: Many specialized catalogs; *MFA: A Guide to the Collection of the Museum of Fine Arts*, Boston, 1999, 2nd printing 2001, is an excellent, compact introduction. The online catalog is being constantly expanded and refined.

This is, of course, the crown jewel of New England art museums, befitting what is, in effect, the capital of New England. The museum rests on the wealth of a port city with a rich merchant history, an educated citizenry, and a highly developed sense of

civic obligation and philanthropy. It was the first museum in the United States to be incorporated (1870); it opened to the public in 1876, in a Victorian Gothic structure on Copley Square, which itself is named for Boston's most famous painter, John Singleton Copley. The core of the current, Neoclassical structure was erected in 1909; wings were added over time according to the master plan, the last addition being the expansion of the West Wing by I. M. Pei in 1981. In 2005, ground was broken for the four-storey American wing, which will house the arts of the Americas from the Pre-Columbian period to today. This major expansion, as well as a thorough renovation and reorientation of the existing structure, was designed by the British firm of (Norman) Foster + Partners.

With about 450,000 objects in the collection (about 340,000 are searchable online and more are added every day), with 1,000,000 visitors a year, how does one begin to introduce and guide the visitor? There are 22,000 European artworks—about 5 percent of the total. What about the rest? It is instructive to learn that the museum created curatorial departments in the following order: Prints, Classical Art (1887), Japanese Art (1890), Egyptian Art (1902), and Western Art (1908). The MFA is, of course, an encyclopedic museum, like the Metropolitan Museum; there is no area of serious art collecting that is not represented. But the extent, the quality, and the sensitive and imaginative display of the non-Western collections set the MFA apart.

With about forty thousand objects, the Egyptian collection is one of the finest and largest in the world. What makes it so special is that 95 percent of the objects were excavated by the Harvard University–Museum of Fine Arts Expedition between 1905 and 1942, mostly in the Giza Necropolis, near modern-day Cairo. In other words, the objects were found where the Ancient Egyptians had left them, dug up under the most stringent scholarly conditions, and scrupulously documented. The guiding spirit of these excavations was George A. Reisner (1867–1942). The thorough documentation of these decades of excavating is now being made electronically accessible through the Giza Archives Project (via the museum Web site, under "Resources"). It makes available to scholars and amateurs worldwide tens of thousands of photos,

expedition diaries, object records, maps, and plans. Reisner was also responsible for excavations at various sites on the Upper Nile, and the Nubian collection is the largest outside Sudan. The best-preserved and most beautiful specimens from these excavations are on view at the museum, embedded into a chronological display of Egyptian and Nubian art and artifacts from about 3100 B.C. to the Hellenistic and Roman periods. The free-standing sculptures, in particular, are breathtaking in their timeless beauty and mystery; for example, *King Mycerinus and his Queen*, from the Old Kingdom ("perhaps the first couple in the history of art," according to Faison), and the seated wife of a governor, *Sennuwy*, from the Middle Kingdom. From the late period comes *Head of a Priest*, an astoundingly lifelike bust of a bald older man. There are statues and vessels in alabaster and gold, wall reliefs, painted wooden coffins, and miniature figurines meant to serve the dead in the afterlife, and, of course, a collection of mummies (separately housed on the first floor). Consider that the Egyptian collection takes up about twice as much space as the Greek and Roman collections combined, and you have a sense of this awe-inspiring display.

The collection of Classical art covers the Cycladic period to late Roman times, with an ample selection of Etruscan art as well. Edward P. Warren (see also Bowdoin College), from his perch in Sussex, England, provided both the MFA and the Metropolitan Museum with Classical art then still available on the European market. Between 1895 and 1905 he secured major works, which he acquired for donation by such local benefactors as Catharine Page Perkins, Henry Lillie Pierce, and Francis Bartlett. If the acquisition year falls into that time frame and these names are attached to an object, it's safe to assume Warren was the buyer. An expatriate who thumbed his nose at Boston's prudish taste, he often chose vases depicting slightly risqué topics—not so unusual when one remembers that many Ancient vessels were used to hold or mix wine, and would have made their rounds at banquets. In fact, Dionysus, the god of wine, is portrayed in Greek art more than any other figure. One bell krater (vessel for mixing wine and water) shows an aroused Pan pursuing a shepherd on one side, and the death of Actaeon at the hands of Artemis on the other. The artist is identified after this vase as the Pan Painter (Bowdoin has

an example by him, as well) and the krater is considered "among the greatest of all Athenian painted vessels." Another intriguing item is a so-called bilingual amphora, which displays the same image, Hercules driving a bull, on both sides, one executed in black-figure style, the other in the newer red-figure style. According to Faison, "Boston's collection of Greek vases is considered the greatest in America." Among the marble sculptures do not miss the *Head of Aphrodite* (330–300 B.C.). "The sculpture's idealized grace, subtle modeling, and contrasting textures of skin and hair recall . . . Praxiteles," and it represents a rare surviving Greek original from that period.

The print collection expanded greatly when the print collection of Henry F. Sewall, comprising twenty-three thousand impressions by European masters, was purchased for the museum in 1897 with the aid of a bequest of $100,000 from hotelier Harvey D. Parker of the Parker House hotel (and roll) fame. The collection has continued to grow, of course, and its many thousands of works from the Renaissance to the present can be readily consulted in the Morse Study Room for Works on Paper on the first floor, by appointment (Tel. 617-369-3112). In addition, there are always intriguing temporary exhibits drawn from the extensive holdings. The superb collection of six thousand Japanese prints given in 1921 by the brothers John T. and William S. Spaulding—and bought, at their behest, by none other than the young Frank Lloyd Wright—came with the stipulation that they never be lent or publicly exhibited. The only way to see them in their exquisite state of preservation is in the study room or online.

This brings us to the Asian holdings of the MFA, and here the institution outstrips just about any collection in this country and, indeed, throughout most of the world. It all began with a triumvirate of educated Boston professionals, who, while practicing in their respective fields, became enamored of Japanese art in a serious way. Edward Sylvester Morse (1838–1925), a zoologist, studied marine life in Japan, stayed on to teach for three years, was attracted to ceramics, collected them systematically, and amassed six thousand specimens for the MFA, which in turn made him "Keeper of Pottery" in 1890. Ernest Fenollosa (1853–1908) taught philosophy and political economy at Tokyo University on Morse's

recommendation, founded the Tokyo Fine Arts Academy and the Imperial Museum, initiated the first inventory of Japan's national treasures, converted to Buddhism, and returned with a collection of two thousand paintings, which he sold on the condition that they be donated to the MFA. In 1890 he became the first curator of Oriental art, and wrote and lectured extensively on Japanese art. William Sturgis Bigelow (1850–1926), a medical doctor by training, traveled to Japan with Morse and Fenollosa in 1882 but ended up staying for seven years, exploring Japanese art all across the country, recording, photographing, and collecting. All three were granted special privileges by the Japanese government giving them access to temples, palaces, and regions otherwise not open to Westerners. They were also instrumental in protecting Japanese art when the Japanese were tempted to throw their cultural legacy overboard in an effort to westernize. Bigelow eventually bequeathed forty thousand objects of Japanese art to the MFA, and thus was born the largest collection outside Japan.

The Asian wing, to the left of the Huntington entrance on two levels, occupies more floor space by far than the entire European collection. Whether you are interested primarily in sculpture, ceramics, painting, or prints, whether Japanese, Chinese, Korean, Indian, or Near Eastern, you will be overwhelmed by the offerings. For each culture, there are permanent exhibits and what the museum calls "special exhibitions"; this usually means that the museum makes another portion of its riches available for a length of time (at times supplemented by loans), shorter for sensitive objects and sometimes a year or longer for sturdier pieces. Thus no matter how often you come, you will always discover something new, but you will also see beloved favorites. The presentation of smaller objects in the galleries is in beautifully designed cases, with architectural details suggesting the culture without being obtrusive. The large sculptures, of course, speak for themselves, and the extensive label copy helps the general public understand each piece's religious, mythological, and historical background. One outstanding display, being tucked away, could easily be missed. It is the Buddhist Temple Room, at the far end of the second-floor galleries, designed in 1909 to evoke a temple interior. Its dim lighting and benches invite you to sit down, slow down,

and let the golden shimmer of the Buddha statues (from various times and cultures) and their serene smiles enlighten you.

With so much Eastern art on paper or silk (or stipulated not to be displayed), the online catalog has become a major access point for the collection. Every month another thousand pieces are added, many with extensive scholarly apparatus. The museum does not foresee ever publishing extensive catalogs on paper again; the Web site is the catalog, and this holds true for the museum's other holdings as well.

Boston is also outstanding in the area of American fine and decorative arts; once again, a few collectors had an enormous impact. From its founding, the MFA has benefited from its location in one of the art centers of the nation. Its very first acquisition was a gift of an American painting, *Elijah in the Desert* by Washington Allston (1779–1843), a European-trained painter who lived mostly in Cambridge; his Romantic landscapes and history paintings were very popular in Boston (the Boston neighborhood of Allston is named for him). The greatest American portraitist of the eighteenth century was Bostonian John Singleton Copley (1738–1815), and the leading portraitist of the Federal era, Gilbert Stuart (1755–1828), made his home in Boston from 1805 to his death. Both Copley and Stuart are better represented in the MFA than in any other museum; many portraits were given to the museum by descendants of the sitters. Among the Copleys are portraits of Samuel Adams and John Hancock, as well as his dramatic *Watson and the Shark*, based on a real-life event in which a young cabin boy was attacked by a shark. Paul Revere's famous likeness, with a silver teapot in his hand, is here, as are portraits of just about everybody who was anybody in Boston and environs, including the ladies in silk and satin. All in all, the museum owns ninety works by Copley.

Later portrait painters with local ties and national—and international—reputations were William Morris Hunt (1824–1879) for the time of the Civil War and John Singer Sargent (1856–1925) for the late nineteenth and early twentieth centuries. Sargent eventually also painted the series of murals for the stairwell and rotunda of the Huntington Avenue entrance to the museum; his Válazquez-inspired canvas, *The Daughters of Edward Darley Boit*,

is on the must-see list of any visitor to the museum. A large collection of his watercolors, especially of Italian subjects, are occasionally on view. Winslow Homer is likewise richly represented in both oil and watercolor.

During the first third of the twentieth century, the Boston School of Painting (Frank W. Benson, Edmund Tarbell, William Paxton) dominated the local scene, and the museum, with a sweet and unthreatening style, while elsewhere Modernism raged. The museum was therefore very lucky that it was able to fill this gap much later, in the 1980s, with the acquisition of a superb collection of American Modernist art assembled by Saundra and William H. Lane. Their favorites were Charles Sheeler, Arthur Dove, Georgia O'Keeffe, and Stuart Davis, who are each represented by multiple works, together with many other artists of that period.

The collection of American decorative art reflects Boston and Massachusetts history, through the locally produced accoutrements of a comfortable or even wealthy lifestyle. From colonial times through the nineteenth century, Boston was rich. Owning elegant furniture and an assortment of silver vessels was the counterpart to having one's portrait painted or building elegant town and country homes. A sequence of period rooms or assemblies lets you experience the evolution of what was considered desirable and chic among the well-to-do. Many of these items are the legacy of an indefatigable collecting couple, Russian-born opera tenor Maxim Karolik and his Boston Brahmin wife, Martha Codman Karolik. With the active encouragement and advice of the museum staff, they systematically collected distinct areas of Americana, always with the intention of bequeathing them to the museum. In the late 1920s and 1930s they collected eighteenth-century furniture and other decorative arts, handing over the entire collection in 1938. They then turned to nineteenth-century American painting from 1815 to 1865, at the time woefully underrated and essentially unrepresented at the museum. They championed such neglected artists as Fitz Henry Lane and Martin Johnson Heade, whose canvases could then be had for under $1,000. It is thanks to the Karoliks' 333 paintings that the museum now has an impressive collection of landscapes, genre paintings, marine paintings, and "primitive" portraits. Their third great endeavor

involved watercolors, prints, and drawings, again from the nineteenth century. With this collection they made an easy transition into folk art, and joined several other trailblazers who gave American folk art its due, such as Nina Fletcher Little of Cogswell's Grant in Essex and Electra Havemeyer Webb of the Shelburne Museum (q.v.).

European art, especially painting, is at the core of most world-class museums, especially those derived from royal collections. In the MFA the balance tilts rather toward the three areas discussed above. Nevertheless, the European collection is more than merely respectable, and in certain areas, outstanding. The floor space allotted to it is rather small, and one hopes that the opening of the American wing will clear additional space for the European collection. To cite a few images you should not miss: the (re-creation of) the apse of a Catalonian Romanesque church, with its highly expressive wall paintings; a crucifixion by Duccio and workshop; Rogier van der Weyden's famous *Saint Luke Drawing the Virgin and Child* (this is the original version, which the painter copied three more times); Donatello's *Madonna of the Clouds*, a very shallow relief carving in marble of exquisite softness and grace, one of the few works by this master in the United States. Leaving the intimate Medieval gallery, turn to the large hall of European Old Master paintings, which are hung salon-style, two and three above each other. Among those not to be missed is El Greco's *Fray Hortensio Félix Paravicino*, a penetrating seated portrait of this learned monk and famous orator. This work came to the museum at the urging of John Singer Sargent, who recognized a kindred sensibility in the then still neglected El Greco. Zurbarán's full-length *Saint Francis* is more theatrical, with its pronounced light and shadows. A small portrait of the poet Luis de Góngora by a twenty-three-year-old Velázquez feels amazingly modern and, indeed, foreshadows the work of his great admirer Manet.

Among the many large Baroque canvasses are Rubens's *The Sacrifice of the Old Covenant*, Il Guercino's highly Caravaggesque *Semiramis Receiving Word of the Revolt of Babylon*, and landscapes with mythological themes by both Poussin and Claude Lorrain. The easternmost gallery is devoted to seventeenth-century Dutch and Flemish art; a small Rembrandt, *Artist in His Studio*, shows a

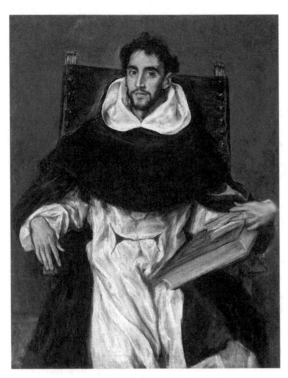

El Greco (Domenikos Theotokopoulos), *Fray Hortensio Félix
Paravicino*, 1609. Oil on canvas, 44⅛ × 33⅞ in (112.1 x 86.1 cm).
Museum of Fine Arts, Boston; Boston, MA. Isaac Sweetser Fund,
04.234. Photograph © 2009 Museum of Fine Arts, Boston.

painter (Rembrandt?) as if dwarfed and intimidated by his large
easel, which commands the center of the picture. Owing to the
prevailing taste in Boston and the advocacy of William Morris
Hunt and John La Farge, the museum has a rich collection of Bar-
bizon art and the world's largest collection of paintings and draw-
ings by French Realist painter Jean-François Millet (1814–1875).
The then president of the museum had bought the entire content
of Millet's studio at the artist's death.

The MFA's collection of Impressionist and Postimpressionist
art is simply superb. All the major painters are represented with
several paintings of the first caliber: Degas (with several rather se-
vere and probing portraits, as well as ballerinas), Monet (the larg-
est collection of Monets outside Paris), Renoir (the beloved *Dance
at Bougival*), Cézanne (with *Madame Cézanne in a Red Armchair* and

several landscapes), Van Gogh (*Postman Joseph Roulin*, a study in blues and greens), Gauguin (his masterpiece *Where Do We Come From? What are We? Where Are We Going?*, a tapestrylike visual summation of his mysterious religiosity).

There are several departments that I will only mention. Three connected galleries on the first floor cover Oceanic, African, and Pre-Columbian art; a small gallery for Native (North) American art is nearby. Once the new American wing opens (2010), all American art, North and South, ancient and modern, will be shown together, chronologically ascending over four floors. African and Oceanic art have only been added in the 1990s, thanks to the gift by William E. and Bertha L. Teel of their important collection, which they assembled over thirty-five years. It encompasses many different sub-Saharan cultures, and to this nonexpert the pieces have all the strength and expressiveness of the best in sculpture of any culture.

The collection of musical instruments combines both Western and non-Western examples, from ancient times to the present, over one thousand in all. There are regularly scheduled lecture-demonstrations, where you can hear, as well as see, the instruments. The digital catalog likewise includes audio illustrations. The textile collection of about twenty-seven thousand objects is not on view, but mounts occasional exhibitions.

The museum, finally, offers a rich program of lectures, film series, concerts (both indoors and outdoors), as well as family programs. There is a cafeteria in the basement with outdoor seating in the courtyard during summer months, the Galleria Café on the first floor, and the elegant Bravo restaurant on the second. The School of the Museum of Fine Arts, Boston (SMFA), located across Museum Road on the corner of the Fenway, is a degree-granting art school, with extensive programs, and a roster of famous teachers and alumni.

+ PLUS

Back Bay Fens and Olmsted's Emerald Necklace
With the newly reopened Fenway entrance, the museum now faces in two directions: the formal entrance is on Huntington,

with the equestrian statue *Appeal to the Great Spirit* by Cyrus E. Dallin (see Cyrus E. Dallin Art Museum in Arlington) in the forecourt. The northern entrance accentuates the connection with Boston's "Emerald Necklace," the string of parks, parkways, and other public green-spaces designed by Frederick Law Olmsted in the wake of the filling-in of marshland that created Boston's Back Bay. The area directly adjoining the museum across the Fenway is called the Back Bay Fens, where Olmsted transformed a foul-smelling, brackish marsh into a park with a meandering brook with wooded banks. Later a rose garden and playing fields were added; a victory garden has existed in another corner since 1941. If you need a restful place to reflect on your museum visit, rest your legs, or take a brisk walk, you will find this a peaceful oasis, although the city is never far away.

For general information see www.emeraldnecklace.org.

TRINITY CHURCH

206 Clarendon St., Boston, MA 02116; Tel. 617-536-0944; www.trinitychurchboston.org.

Directions: Trinity Church is located at Copley Square, in the Back Bay area of Boston, T-stop Copley Square (Green Line) or Back Bay (Orange Line). If you drive from the west: Take Mass. Pike (1-90) to Exit 22; follow signs for Copley Square. (Note: there is no exit at Copley coming from the east.) From 1-93 North or South: Take Storrow Drive exit, then take Copley Square exit. It dead-ends at Beacon Street. Take a right onto Beacon, then a left onto Clarendon. Parking in commercial garages around Copley Square and on Boylston Street.

Hours: The church is open for guided or self-guided tours (via detailed brochure), Monday through Saturday, 9 A.M. to 5:30 P.M.; Sunday, 1 to 5 P.M. Tours meet in the bookshop. Times and dates for guided tours are posted on the Web site.

Admission: Adults $5, seniors and students $4, children under 16 free with adult.

Why include a church and a library (see PLUS below) in a book on art museums? Think of the ensemble of Trinity Church, the Museum of Fine Arts (which stood where the Fairmont Copley Plaza Hotel is now) and the Boston Public Library as the Acropolis of Boston. The Copley Square ensemble represented Boston's loftiest aspirations in bringing the gifts of the spirit, of art, and of learning to all of the people. In the second half of the nineteenth century, in a city as wealthy and educated as Boston, such things were done in style; art was lavished on public buildings to a degree that is hard for us to fathom now.

Trinity Church came first, opening in 1877. When the congregation decided to move from the commercial center of Boston to the newly filled-in Back Bay, it chose a young unknown, thirty-three-year-old Henry Hobson Richardson (1838–1886), to build an innovative, "open auditorium"–style space, based on a Greek-cross footprint. It is the first and perfect realization of what would be called "Richardsonian Romanesque," that free adaptation of French and Spanish Medieval antecedents, transmuted into an original, American style. The interior is suffused by a warm reddish color and delicate, stenciled patterns. Richardson had engaged another young unknown, John La Farge (1835–1910), to undertake the interior decoration of the church. The style has a Byzantine-inspired hieratic quality and none of the sentimentalism so often encountered in nineteenth-century religious art. In true Victorian manner, though, decoration is everywhere, yet the stencil designs on walls, organ pipes, arches, and pillars are delicate, abstract, and almost modern in their colorful, geometric simplicity.

La Farge also is responsible for four major stained-glass windows, which show his layering of opalescent glass and other technical innovations. (He preceded Louis Comfort Tiffany as an innovator, but was less commercially successful.) The tripartite *Christ in Majesty* dominates the west front with its "heavenly" blue background. An adaptation of Titian's *Presentation of the Virgin* is on the right side of the nave. Two monumental windows in the north transept, *The Resurrection* and *The New Jerusalem*, have a painterly quality, with fluid transitions of color tones made possible by the opalescent glass and the absence of heavy leading.

At the center of the north transept are three windows depicting the nativity story; they were designed by the English painter Edward Burne-Jones (1833–1898) and executed in the William Morris studio in London. The technique is of the more traditional painted glass, in paler shades; the wan-looking maidens and androgynous angels have the ethereal and vulnerable qualities seen in Pre-Raphaelite art. Another window design by Burne-Jones, *David's Charge to Solomon*, is in the baptistery. The rest of the windows were produced by various British and French firms and form a veritable museum of nineteenth-century stained-glass design.

The commanding figure of founding rector and bishop Phillips Brooks (1835–1893) is immortalized in a marble portrait bust by Daniel Chester French, in the baptistery, just to the right of the chancel. Outside the church, a majestic bronze, Brooks preaching in the grand style and divinely inspired, is one of the last works of Augustus Saint-Gaudens (1848–1907). The architectural enclosure was designed by his friend and frequent collaborator, Stanford White.

+ PLUS

Boston Public Library

Directly opposite Trinity Church is the elegant, Renaissance-inspired Boston Public Library, in pale pink granite, its arched windows a counterbalance to Richardson's arches, but otherwise a much more restrained edifice. It is the 1895 masterwork of Charles Follen McKim, who conceived it as "a palace for the people." Built between 1888 and 1895, it is more openly sumptuous than the church; the materials exude money spent and the artworks were crafted by the most acclaimed artists of the day, unlike the young unknowns of Trinity Church.

Starting on the outside, two large bronze sculptures, the allegories *Art* and *Science*, are by Bela L. Pratt (1867–1917), a student and protégé of Augustus Saint-Gaudens. The latter was to have had a major role at the library, including the two entrance statues, but because of his death in 1907, only the seals over the three entry arches and the head of Minerva above the central arch are by him.

Frederick MacMonnies, *Bacchante and Infant Faun*, 1894. Bronze, H: 83 in.
The Trustees of the Boston Public Library, Boston, Massachusetts.

The vestibule, clad in three kinds of marble, exhibits, at the
left, a lively, full-length bronze of Sir Harry Vane, governor of
the Massachusetts Bay Colony in 1636–37, by Frederick Mac-
Monnies (1863–1937). The pose is informal and the flamboyant
dress, hat, and boots obviously gave the sculptor much pleasure.
Who knew the Puritans were so fashionable? MacMonnies is in-
finitely more famous—and infamous—for his fountain statue in
the library courtyard, *Bacchante and Infant Faun*, which, donated
by McKim as a gift to the library, aroused such a storm of indig-
nation for its nudity and intoxicated abandon that it had to be re-
moved and was given to the Metropolitan Museum (a later cast
is in place today). The three entrance doors boast six bronze re-
lief panels, with mostly female figures in loose draperies, by Dan-

iel Chester French. While he is better known for free-standing sculpture, such as *Minuteman* in suburban Concord, these allegories of Truth, Romance, Knowledge, Wisdom, Music, and Poetry are elegant and refined.

As you climb the main staircase, you begin to see the Puvis de Chavannes Gallery, named for the murals covering the second-floor corridor and the upper portion of the stairwell. Pierre Puvis de Chavannes (1824–1898) was that rare creature, beloved both by the Academy and by such young radicals as Seurat, Toulouse-Lautrec, and Gauguin. The Academy loved his idealized, timeless depictions of a past golden age, while the young painters were impressed by his archaizing style, the flat surfaces, and the simplified forms. These murals are actually oil paintings, their pale colors made to resemble Early Italian frescoes. The central image is *The Muses of Inspiration Hail the Spirit, the Harbinger of Light*; the walls of the staircase represent various realms within Poetry, Philosophy, History, and Science in a mixture of allegorical, mythical, and historical scenes. Lest you think all these toga-clad figures are hopelessly antiquated, look at the representation of Physics (on the wall across from the lions), which shows telephone poles traversing the landscape—rendered in archaizing pseudo-fresco, this image is a startling experience!

This grand work by a major French painter is matched, one storey above, by an even more ambitious mural program, which John Singer Sargent labored over from 1895 to 1916. Sargent, whose fame and fortune rested on society portraits in a dashing, fluid style in the tradition of van Dyck, Gainsborough, and Romney, chose a rather severe, monumental, historically informed mural style to come to terms with the weighty theme of the Triumph of Religion. Starting (on the north end of the hall) from pagan religions that tempt the children of Israel to forget their covenant with the Lord, the mural proceeds to Moses and the Rule of Law. A frieze below shows twenty of the prophets, the only portion of the mural that recalls the former Sargent in the strongly individualized full-length portraits. The opposite end of the hall is given to Christianity and Redemption, with various Medieval and Renaissance iconographic traditions embraced and recombined. Here Sargent integrated carving, gilding, and

relief features into the mural. On the connecting walls are more abstract concepts, such as the Judgment, the Law, Hell, and the Entrance of the Blessed into the Kingdom. On the east side, immediately above the staircase, are the figures of Ecclesia and Synagoge—again, inspired by Medieval iconography. While Sargent understood them as both superseded by the triumph of subjective, individualized religion (a very American, progressive thought), his contemporaries read the old meanings, with their anti-Semitic undertones, into the images: blind (Jewish) Synagoge is vanquished by the triumphant (Christian) Church. The controversy that followed the 1919 installation was in part responsible for Sargent's abandoning the work unfinished: the central panel on the east wall has been left empty.

Ultimately, it was probably impossible to deal with complicated theological and philosophical issues in a mural and not encounter misunderstandings and misreadings. The handout provided by the library is actually Sargent's own explanatory text and is indispensable for "reading" the murals. His text ends with the elements executed up until 1916, and therefore does not include the controversial last images, Ecclesia and Synagoge. There is, however, a highly informative article by Sally M. Promey on the theological underpinnings of the work at www.bpl.org/guides/sargentinfo.htm.

There is yet a third mural of grand proportions, *The Quest of the Holy Grail* by Edwin Austin Abbey (1852–1911), in the sumptuous Abbey Room on the second floor. An expatriate American like his friend John Singer Sargent, Abbey is better known as an illustrator; among other things, he illustrated the entire works of Shakespeare. His Grail story is heavily influenced by the Pre-Raphaelites, around whom he was active in England. It is hard to believe that this most Victorian extravaganza of a room was simply the delivery room in which patrons waited for the books they had requested.

Feel free to explore other areas of the building, and if you need a respite, relax in the most beautiful Renaissance courtyard in New England, where you can also get a snack from the café.

700 Boylston Street, Copley Square, Boston, MA 02116; Tel. 617-536-5400; www.bpl.org.

Directions: See Trinity Church, above.

Hours: Monday through Thursday, 9 A.M. to 9 P.M.; Friday and Saturday, 9 A.M. to 5 P.M.; Sunday, 1 P.M. to 5 P.M.

Admission: Free. Art and architecture tours lasting one hour are conducted Sunday at 2 P.M. (October through May), Monday at 2:30 P.M., Tuesday and Thursday at 6 P.M., Friday and Saturday at 11 A.M. Pick from the array of explanatory sheets available at the reception desk if you will be self-guided.

Brockton

FULLER CRAFT MUSEUM 🚼

455 Oak Street, Brockton, MA 02301; Tel. 508-588-6000; www.fullercraft.org.

Directions: From Route 128, I-93, or 495: Take Route 24, Exit 18B to Route 27 North (Stoughton). Take your second right onto Oak Street. The museum is located 1 mile down on the left.

Hours: Daily, 10 A.M. to 5 P.M., Wednesday until 9 P.M.

Admission: Adults $8, seniors and students $5, children under 12 free. Wednesday 5 to 9 P.M. free for all.

Opened in 1969 as the Fuller Museum of Art, the museum was made possible by the generosity of Myron Leslie Fuller, a geologist and a Brockton native. In that year, the building's architect, J. Timothy Anderson, received the national blue-ribbon award for excellence from the Society of American Registered Architects. The structure was cited as "one of America's finest small museums . . . in a brilliantly achieved environment, growing naturally and gracefully out of its surrounding woods and rocky grounds." This sensitivity to the environment led Anderson to become a national figure in the adaptive reuse of historic buildings. An annual prize named after him is awarded for outstanding examples of adaptive reuse.

In 2004 the museum reinvented itself as the Fuller Craft Museum, dedicated to "collecting, exhibiting and experiencing contemporary craft." This new identity and purpose made the institution the only one in New England so focused and brought new vitality and visibility to its bucolic campus. The director is in the enviable—and daunting—position of starting a collection from scratch. At this point, the collection is small: the benches located throughout the museum are not just furniture, but in fact one-of-a-kind artifacts and part of the collection; there are also a few large outdoor metal sculptures. On the other hand, the active exhibition program makes up for the modest permanent holdings.

About eighteen shows are mounted every year, usually three or four concurrently. There are themed shows, one-man and group shows, as well as retrospectives and multimedia installations. Artists come from throughout the country, but local talent and students taking classes are not neglected. Video or live demonstrations and interviews with the artists complement many shows. This is a good time for crafts: it has become acceptable, even fashionable, to seriously collect crafts. The difference between multimedia art or nontraditional sculpture and cutting-edge craft is often hard to discern. Many women who started in traditional crafts have taken their medium to innovative and expressive levels; in the wake of globalization and immigration, non-Western forms and techniques exert a strong influence on the domestic craft scene—crafts, in a word, are "hot."

The museum sponsors numerous courses, workshops, and lecture-demonstrations; in addition, museum-sponsored artists teach in the local schools. The museum is also at the forefront of a government-supported feasibility study to make crafts an engine for economic development in the Brockton area.

+ PLUS

Buildings by H. H. Richardson in North Easton
The craft of architecture is well represented in the nearby town of North Easton, which boasts four major buildings by Henry Hobson Richardson (1838–1886), more than any other town in the

United States. This is due to the generosity of Frederick Lothrop
Ames, heir to the Ames Tool and Shovel Company as well as to a
railroad fortune, and a great patron of Richardson's. In the center
of town are the Ames Free Library and, next to it, situated on a
dramatic rock outcropping, the Oakes Ames Memorial Hall. The
latter, intended to be the city hall, now serves for private func-
tions only. The Ames Free Library right next door, though, still
functions as the town library and you should feel free to check
out the interior. Smaller than the Woburn Library (q.v.), the bold
asymmetry, the massive Syrian arch, the bands of windows framed
in red sandstone, and the lively surface of the rough-hewn gran-
ite combine to form a strong, harmonious whole. The nearby rail
line, which boasts "one of the most beautiful small railroad stations
in the country," was also given by Ames—and also designed by
Richardson. It betrays Japanese influences in the sweeping roof-
line and wooden details. The most idiosyncratic and controver-
sial building is the Ames Gate Lodge. The use of massive boulders
and a most graceful, sinuous roof leave even the modern viewer
slightly speechless. Frank Lloyd Wright commented, "[T]he pres-
ence of a building is in its roof, and what a roof the Ames Gate
Lodge has!" Contemporary architect Henry Van Brunt called the
lodge "an extraordinary piece of architectural athleticism."

Directions: From the Fuller Museum, turn right onto Oak
 Street; go until you reach Route 27 (North Pearl Street).
 Turn left and stay on Pearl Street for about 1 mile. Turn
 right onto Torrey Street, which becomes Main Street and
 leads into the center of North Easton, location of the Ames
 Free Library and the Oakes Ames Memorial Hall. Park here.
 To see the train station, follow the right turn of Main Street,
 and you will shortly notice on the right the attractive Ames
 Shovel Works buildings, now converted to adaptive use.
 The train tracks and the station are a bit beyond, in that
 same block. (This is all within easy walking distance.) You
 reach the Ames Gate Lodge by driving further on Main
 Street and turning right onto Elm Street. The lodge (135
 Elm Street) is on your right; it is private property, so only
 the exterior can be seen. Street parking available.

Cambridge

HARVARD ART MUSEUM

32 Quincy Street, Cambridge, MA 02138; Tel. 617-495-9400; harvardartmuseum.org.

Directions: As parking is scarce and expensive, try to take public transportation (T Red Line or buses to Harvard Square). Enter Harvard Yard through any gate and proceed straight through to Quincy Street. The Fogg and Busch-Reisinger occupy the same building; the Sackler is to the left, at the corner of Quincy and Broadway. By car: From I-90 (Mass. Turnpike) take Cambridge/Allston exit, cross Charles River and turn left onto Memorial Drive, then right onto JFK Street. Seek garage parking around Harvard Square.

Hours: Monday through Saturday, 10 A.M. to 5 P.M.; Sunday, 1 to 5 P.M.

Admission: Adults $9, seniors $7, college students $6, under 18 free; free to Cambridge residents with ID (such as a public library card). One admission includes all three museums and study rooms.

Catalog: Harvard's Art Museums (New York, Abrams, 1996) provides brief histories, a timeline, and selections from all three museums. There are numerous specialized books and catalogs, as well as an excellent online database.

Fogg Museum

The oldest, largest, and most famous of the three museums opened in 1895, to serve as a teaching tool for the Fine Arts Department, established in 1875 when the first chair of art history in the United States was created for Charles Eliot Norton. The original building by Richard Morris Hunt was designed as a home mostly for plaster casts and photographs, and was deemed inadequate early on as the collection took a completely different turn under its legendary director Edward W. Forbes (from 1908/9 to 1944) and codirector Paul Sachs (from 1915 to 1944), referred to as the "heavenly

twins." It's hard to overestimate the influence of these two men on the teaching of art history, connoisseurship and art collecting, the development of art museums, and the Fogg Museum itself. It probably would not be an overstatement to say that they jointly invented the academic art museum, with its emphasis on teaching, encyclopedic coverage, and scholarship. Object-based teaching with original works of art is definitely their innovation and legacy, and their students populated America's art museums and art history departments to a stupendous degree.

When a new building, the current Fogg, was inaugurated in 1927, it set new standards of beauty and functionality. The soaring interior courtyard is an adaptation of an Italian Renaissance façade from Montepulciano, executed in warm beige Italian travertine. The building "was to comprise the entire apparatus for the study of the history of art—galleries, offices, classrooms, study and storage areas, a library, conservation and analytic laboratories, and painting studios."

Starting in 2008, the Fogg began a major renovation under the architectural leadership of Renzo Piano, which promises not only up-to-date mechanical systems, but also expanded exhibition space. Both are desperately needed. There must be few museums in which the discrepancy between the size of the collection and the size of the exhibition space is as extreme as here. Currently, and until the re-opening in 2013, only the Sackler facility is open to the public. It offers a longterm exhibit, called Re-View, of about six hundred works drawn from all three museums.

Not knowing how the renovated museum will display its riches, and given the collection's enormous size, I will simply let some numbers and examples speak for themselves.

Drawings: The Fogg owns about thirteen thousand European and American drawings from the fourteenth century to the present. The collection is particularly strong in seventeenth- and nineteenth-century French drawings, making it the foremost U.S. institution in these fields (e.g., sixty by Ingres, twenty by Géricault, nearly one hundred by David). Another strength is the nineteenth century in England and America, with works by Blake, Beardsley, the Pre-Raphaelites, Homer, Sargent (over five hundred drawings as well as sketchbooks), Whistler. Old Master

drawings include examples by Michelangelo, Veronese, Dürer, Holbein, Brueghel, Rembrandt, Poussin, and Fragonard.

Prints: About sixty thousand with particular strength in Old Master etchings, engravings, and woodcuts (Schongauer, Dürer, Rembrandt, Goya). Just as an example, the Fogg was able to mount an exhibit of Dürer's *Passions* (the so-called large and small woodcut passions, as well as the engraved version) drawing essentially on its own holdings. For the Rembrandt Year (2006), an exhibition at the Busch-Reisinger, "Rembrandt and the Aesthetics of Technique," analyzed prints, drawings, and paintings by Rembrandt as to the aesthetic implication of various techniques. The fifty-odd works were again mostly drawn from the Fogg's own collections, with a rare letter by Rembrandt from Harvard's Houghton Library thrown in.

Paintings: There are about two thousand Western paintings, with particular strength in early Italian Renaissance, seventeenth-century Dutch, ninteenth- and twentieth-century French, and nineteenth-century British and American art (including the second-largest collection of Copleys in this country). The foundations of the collection were laid by Edward Forbes, who in 1899 gave his first Italian painting and kept giving for over fifty years, either directly or by guiding others to buy and donate. As an avid preacher for the crucial importance of original works of art for teaching, he was most persuasive. Early Italian crucifixions, nativities, Madonnas with Child abound: Duccio, Cimabue, Simone Martini, Fra Angelico, Pietro Lorenzetti, Spinello Aretino, Giovanni di Paolo, and hundreds more by "Master of . . ." or just identified by region. Then we segue to Giovanni Bellini, Fra Filippo Lippi, a haunting Madonna from the studio of Botticelli, and, again, scores of lesser-known or anonymous works, moving to the High Renaissance and Baroque with portraits, landscapes, genre scenes, and dramatic evocations of biblical or mythological events. And that's just the Italian portion. The other European painting traditions are less exhaustively covered, but still allow surveys of their history, punctuated by highlights: French (Poussin, Watteau Boucher, David, Ingres, Corot, Moreau); British (Lely, Gainsborough, Reynolds, Romney, Raeburn, Lawrence, Blake, numerous Pre-Raphaelites); Spanish (Murillo, Ribera);

Dutch and Flemish (Dirck Bouts, Joos van Cleve, Frans Hals, Rembrandt, van Goyen, Ruisdael, ter Borch, Rubens).

Nineteenth- and early-twentieth-century paintings in the Fogg are in large part due to two major bequests, one by Grenville L. Winthrop and one by Maurice Wertheim. Both had been cultivated by Paul Sachs, who himself was one of the major donors to the museum (the Goldman Sachs fortune helped). Upon his death in 1943, Winthrop left the Fogg 3,700 objects, paramount among them Ancient Chinese jades and bronzes, and eighteenth- and nineteenth-century British and French paintings, drawings, and decorative arts. He had assembled small collections each of David, Degas, Delacroix, Ingres, and Renoir among the French, and Beardsley, Blake, and the Pre-Raphaelites among the British. We owe to him, as well, works by Manet, Toulouse-Lautrec, Daumier, Degas, Sargent, Whistler, and Homer, to name but a few.

The Wertheim bequest is much smaller; it consists of twenty-five oil paintings, a dozen drawings, and a half-dozen bronze sculptures, almost all by French Impressionists and Postimpressionists. The collection is on permanent display as an entity, as stipulated by the donor. It is a collection consisting of nothing but highpoints, world-famous signature works by Manet (*Skating*), Degas, Cézanne, Monet (three in all), Renoir (*Self-Portrait*, *Seated Bather*), Toulouse-Lautrec, van Gogh (*Self-Portrait Dedicated to Paul Gauguin*), Gauguin, Matisse, Seurat, Pissarro, and Picasso (the haunting *Mother and Child* from the Blue Period). You will know many of them from reproductions, but standing in front of them and seeing them all in close proximity is truly breathtaking.

Sculpture: There are about a thousand examples of Western sculpture in the Fogg. *Censing Angel* is the only piece in the United States attributed to Arnolfo di Cambio (active 1260–1302). As the early German art is incorporated into the Fogg, you will see some wonderful carved-wood sculpture, including *St. Anthony Abbot* by Tilman Riemenschneider (ca. 1450–1531) and an exuberant Baroque group, circa 1690, *The Return of the Holy Family from Egypt*, by Meinrad Guggenbichler (see also Wellesley College). A real plum is a collection of fifteen (of the forty extant) small terracotta sketches by Bernini, the largest collection anywhere. If you

are interested in the creative process of a great artist, this group of angels and saints is wondrous indeed. Later sculptors well represented are Rodin, Maillol, Brancusi, Lachaise, Calder, Moore, Nevelson; a group of metal sculptures by the American David Smith (1906–1965) is the largest assemblage of his work in any public institution.

Photographs: There are 70,500 in the collection, many of strictly historical or archival interest. Photographs spanning the history of photography are being collected, but rarely is exhibition space devoted to photographs exclusively.

It must be emphasized that all three Harvard art museums are most generous in letting the general public use the study rooms and accommodate requests to see works of art most graciously. At the Fogg, the Agnes Mongan Center for the Study of Prints, Drawings, and Photographs is open to the public Tuesday through Friday, 2 to 4:45 P.M., or by appointment, 617-384-8310.

+ PLUS

Corbusier's Carpenter Center for the Visual Arts
Immediately adjoining the Fogg is the Carpenter Center for the Visual Arts, the only building by Le Corbusier in all of North America, completed in 1963. The contrast with the neocolonial Fogg couldn't be starker, but as a space for making art, it seems very appropriate. Walk through, under, and within the building to experience it properly. The Sert Gallery at the top of the ramp shows contemporary art; the main gallery at street level has exhibits relating to the curriculum or by students and faculty. There is also a small cafeteria and outdoor seating in summer.

617-495-3251; www.ves.fas.harvard.edu.

Busch-Reisinger Museum
The Busch-Reisinger Museum is an almost unique entity, a university museum dedicated to just one area of art history. It started out as the Germanic Museum, dedicated in 1903, brought into life by the efforts of the chairman of the German Department, Kuno Francke, and endowed from the outset with gifts of plaster casts

of German sculpture and architectural elements by none other than Kaiser Wilhelm. Housed in a former gym on campus, it was the crowning achievement of a long Germanophile academic tradition at Harvard during the nineteenth century. The museum was to teach the cultural history of the Germanic people, and was part of the German Department rather than the Art Department. Copies, plaster casts, and photos were deemed more than adequate for the purpose.

Money for a dedicated building came from beer king Adolphus Busch and endowment funds from his son-in-law Hugo Reisinger. Construction began in 1914, weeks before the outbreak of WWI. Amid rising anti-German feeling, Francke resigned his professorship, and the finished building stood empty for "lack of coal." In 1921 the Germanic Museum reopened in its vaguely Bavarian-Baroque building, called Adolphus Busch Hall (see PLUS, below). The proud assertiveness of the initial vision of Germany's "great national civilization" had become a sham, and developments in museology emphasized original works of art. It was thus logical, practical, and politic to put the Germanic Museum under the wings of the Fogg Museum and the Art History Department.

A new American-born, Harvard-trained art historian, Charles L. Kuhn, was appointed curator in 1930 and served until 1968. This second phase has a bittersweet quality, as the denuding of Germany's art museums of all modern art, designated as "degenerate" by the Nazis, made it possible to acquire first-rate German Expressionist art at absurdly low prices. Max Beckmann's (1884–1950) *Self-Portrait in Tuxedo*, the museum's "signature piece," was acquired for $600! The major paintings and sculptures on display today, as well as a huge collection of works on paper, came to the Germanic Museum in the 1930s and again in the late '40s and '50s under Kuhn's stewardship. Sculpture, a major field ever since the plaster-cast tradition, is superbly represented by major works of Ernst Barlach, Max Kolbe, Gerhard Marcks, and Wilhelm Lehmbruck. Among painters, all the major names in early-twentieth-century art are here, often with works that had hung in major museums: among the Expressionists, Ernst Ludwig Kirchner, Erich Heckel, Otto Mueller, Karl Schmidt-Rottluff,

Max Pechstein, Oskar Kokoschka, Emil Nolde, and others; of the Blaue Reiter School, Franz Marc, Wassily Kandinsky, Lyonel Feininger, and Alexej Jawlensky. The Vienna Sezession, represented by *Pear Tree* of 1903 by Gustav Klimt and various works by Egon Schiele, is joined by a rich collection of applied art, such as silver, china, glass, and furniture by Josef Hoffmann, Koloman Moser, Adolf Loos, and others.

As the Bauhaus, the "twentieth century's most important school of design, architecture and art," was dissolved by the Nazis, many of its faculty and students immigrated to the United States. Its founder, Walter Gropius, was appointed professor of architecture and chairman of the Graduate School of Design at Harvard in 1937. He and Kuhn were instrumental in making the Busch-Reisinger Museum (so renamed in 1950 to honor the sustained beneficence of the Busch family) a major repository of Bauhaus-related art, crafts, and design, second in importance only to the Bauhaus Archiv in Berlin, and thus gave the museum a new raison d'être. The harvest was rich: paintings and drawings by Paul Klee, Wassily Kandinsky, Josef Albers, Lyonel Feininger, Oskar Schlemmer; sculpture by László Moholy-Nagy (including his *Light-Space Modulator*, a kinetic sculpture that is regularly demonstrated in the gallery), Gerhard Marcks, and Hans Bill; numerous prints, photographs, textiles, works in metal and wood, furniture, and wallpaper samples. In addition, Walter Gropius donated some 3,000 drawings, prints, and photographs documenting his architectural work. Likewise, Lyonel Feininger's family donated some 5,400 sketches spanning his entire career, as well as paintings, drawings, and personal papers, making Harvard the foremost repository of materials related to Feininger. Such troves are not likely to come to the Busch-Reisinger again. In the latter part of the twentieth century, the museum added contemporary art of the German-speaking countries as well as Northern European artists at a steady pace. In 1995 a large collection of works by Joseph Beuys (1921–1986) with related research material, was acquired, which makes the Busch-Reisinger a center for Beuys's work. German foundations, firms, individuals, and the Friends of the Busch-Reisinger Museum in Germany help support the future work of the museum.

Adolphus Busch Hall having outlived its viability as a modern museum, in 1991 a new building by Gwathmey Siegel & Associates was erected in back of the Fogg Museum and accessible through it. Werner Otto Hall (named for the donor, owner of a German mail-order firm), while ostensibly its own building, certainly feels like a wing of the Fogg Museum. The light-filled, modern exhibition space displays highlights of the permanent collection of late-nineteenth- and twentieth-century art and design only, in six connected galleries; all earlier Northern European art has been folded into the Fogg. There is also a larger space for temporary exhibits, and, on the third floor, a study room for the examination and study of works on paper and other objects not on display. Given a permanent collection of thirty thousand pieces, this added access is a true gift to the art lover and specialist. The study room is open to the general public Tuesday through Friday, 2 to 4:45 P.M. and by appointment at other times (617-495-2317).

+ PLUS

Adolphus Busch Hall organ concerts
Adolphus Busch Hall still houses some monumental architectural copies and plaster casts and some original Baroque sculpture, as well as the famous Flentrop Organ that noted organist E. Power Biggs donated to the museum. His weekly organ recitals from 1942 to 1958 were broadcast live by CBS from the Busch-Reisinger Museum, and gave him a national following.

The building is open to the public on the second Sunday of each month, 1 to 5 P.M., and Thursday, 12:15 to 12:45 P.M., when lunchtime organ recitals are given, as well as for scheduled organ concerts. For details see www.hcs.harvard.edu/organ/recitals.php.

Arthur M. Sackler Museum
Although non-Western art had been exhibited at the Fogg Museum from its inception, only in 1985 were the collections of Ancient, Byzantine, Asian, and Islamic art, as well as numismatics, spun off and housed in their own building, the Arthur M. Sackler

Museum, designed by British architect James Stirling. With the Sackler located across Broadway from the Fogg, the design foresees an overpass connecting the Sackler to the Fogg, indicated by the large square window in the front. Separate, but meant to be connected, the Sackler has the superior modern exhibition space, with galleries on the second and fourth floors and a space for changing exhibits on the first. (The Sackler functions as the temporary main venue during the Fogg's renovation.)

Asian art comprises sixteen thousand works, of which six thousand are woodblock prints. Early Chinese bronzes and jades bequeathed by Grenville Winthrop (see Fogg Museum) put the museum on the map in terms of Asian art. "Numbering some seven hundred items, the collection of archaic jades is, quite simply, the world's premier collection." But even before Winthrop's magnificent bequest, large, focused collections had come to the Fogg. The Arthur B. Duel collection comprises four thousand Japanese woodblock prints, among them nine hundred surinomo, privately printed, luxurious prints, usually combining an image with poetry and exchanged as gifts among poets and artists. It is "the largest and finest assemblage of such materials in the world." Likewise, the collection of Jun ceramics from the Song (960–1126) and Yuan (1271–1368) dynasties is the largest such collection in the world. Having been part of the Chinese imperial household through the ages, these vessels were purportedly used in the late nineteenth century as collateral for a loan that the imperial family defaulted on, and came to the Fogg in 1942, via British and American collectors.

The Gregory Henderson Collection of Korean Ceramics, considered the most comprehensive outside Korea and given in 1991, allows the visitor to follow the development of this medium from the fifteenth to the nineteenth century. A collection of Korean paintings followed in 1994 and a collection of fifty-six Japanese lacquer boxes in 1996.

The Department of Ancient and Byzantine Art and Numismatics comprises examples of Egyptian, Greek, Etruscan, Roman and Near Eastern art, including Early Christian art of the East— twenty-four thousand items in all. (It should be noted that Harvard's main venue for Byzantine art is Dumbarton Oaks, the estate

in Washington, D.C.; www.doaks.org.) While one would not make a pilgrimage to this collection (the MFA's holdings are far more extensive and impressive), there are fine Greek vases (such as the red-figure Hydra depicting a distraught Priamus pleading with Achilles for the remains of the slain Hector, or a black-figure prize amphora showing Athena and two competing boxers, beautifully delineated male nudes). The prize marble statue represents most likely the hunter Meleager; it is a Roman copy of a presumed bronze by one of the greatest Greek sculptors, Skopas of Paros. "Best known for the twisted action and inner expressiveness of his figures, Skopas is sometimes referred to as the initiator of the Baroque point of view in Western art" (Faison). A striking Roman sarcophagus carved in Attica shows the battle between Greeks and Amazons, with a jumble of dying bodies and rearing horses.

Lastly, the Department of Islamic and Later Indian Art excels in Persian paintings and drawings from the fourteenth through seventeenth centuries, and in that field is considered on a par with the British Museum and the Bibliothèque Nationale. It is also rich in works of art from the Mughal and Rajput courts of India. John Kenneth Galbraith, economist and one-time ambassador to India, gave an excellent collection; alumnus, teacher, and curator emeritus Stuart Cary Welch, considered a leading authority on Turko-Indian-Iranian art, presented the Sackler with three hundred paintings and drawings that he had assembled over his lifetime. Calligraphy from the ninth to the twentieth century, from Arab, Indian, Persian, and Turkish sources, covers what is among the most important art forms of Islam. The collection is displayed in changing, themed exhibits that are typically shown for half a year.

+ PLUS

Peabody Museum of Archaeology and Ethnology
If you are interested in Pre-Columbian or American Indian art, then there is yet another Harvard Museum for you to visit, the Peabody Museum of Archaeology and Ethnology. While the focus is not on artistic beauty, there are nevertheless striking and

dramatic examples. Two quasi-permanent exhibitions are note-worthy: Encounters with the Americas, which documents the Central American cultures before and after the arrival of Columbus; and Change and Continuity in the Hall of the North American Indian. This exhibit centers on objects produced in the nineteenth century by various North American tribes, reflecting both their indigenous traditions and their interactions with Europeans. There are always specialized temporary exhibitions, and a growing program of online exhibits, with full scholarly apparatus.

Directions: The Peabody is at 11 Divinity Avenue, which you reach by continuing on Quincy Street (turn right after emerging from the Sackler), crossing Kirkland Street, and then proceeding on Divinity Avenue.

Admission (separate from the art museums): Adults $9, seniors and students $7, children 3–18 $6.

Hours: 9 A.M. to 5 P.M., seven days a week; www.peabody .harvard.edu.

Canton

MILTON ART MUSEUM

900 Randolph Street, Canton, MA 02021; Tel. 978-598-5000; www.miltonartmuseum.org.

Directions: From I-93 North or South take Exit 2A (Route 138 South). At second light take a left onto Randolph Street. The museum is a quarter mile on the left, at Massasoit Community College. After entering the campus, turn left to park. Enter the Dwyer Building (administrative wing).

Hours: Monday through Thursday, 7 A.M. to 7 P.M.; Friday until 6 P.M.; closed on weekends.

Admission: Free.

This is a little museum representative of an early institutional stage. Incorporated in 1986 with a mandate to be in a public place, the collection was first housed in an elementary school in Mil-

ton, renovated out of its space there, and, in 2003, found a home at nearby Massasoit Community College. The college (which offers degrees in graphic design and fine art) had plenty of empty wall space in a rather drab, functional building. Displayed in elegant Chinese-style wooden vitrines inherited from a fashionable Newbury Street haberdasher, the 260-piece collection consists mainly of works on paper, 5 bronzes by Frederic Remington, and Far Eastern objects, including furniture, armature, dolls and fans, as well as prints. The objects reflect Milton, a wealthy suburb of Boston with a special link to the China trade (see PLUS, below).

The artworks have all come from private donors in the community and are mostly etchings, engravings, and other prints by Goya, Turner, Whistler, Millet, Manet, Renoir, Bonnard, Signac, Vuillard, Kollwitz, Calder, Dali, Miró, Warhol, and others. There are several Chagalls in a separate room (some of them reproductions).

In addition to the museum proper, the college runs the Akillian Gallery, which mounts temporary shows of local artists, faculty, and student work. The alumni office, moreover, stages exhibits of alumni who have made their way in the arts field.

+ PLUS

Forbes House Museum (Milton)

In Boston, the China trade in the age of sail was spearheaded by the Forbes and Perkins families, who intermarried as well. Captain Robert Bennet Forbes (1804–1889) learned the trade from the bottom up with his Perkins uncles, and by age thirty had made his first million. In 1833 he commissioned noted architect Isaiah Rogers (who also designed the Commercial Wharf in Boston in 1830) to build a countryhouse for his mother and siblings, on a hill in then fairly rural Milton. You can see as far as Boston Harbor from the front porch. The house stayed in the family for four generations and was opened to the public in 1965, first as a museum highlighting the China trade, then, in 1984, after a large portion of the collection was transferred to the Peabody Essex Museum in Salem, as the Forbes House Museum. Needless to say, the house is furnished with many imports from China—elaborately carved

rosewood furniture, embroidered silks, hand-painted wallpaper, and, of course, lots of china—presumably the best pieces the captain brought home. It's a house more than a museum; the original kitchen is also preserved. The last resident, Mary Bowditch Forbes, collected Lincoln memorabilia and even had a replica of the famous log cabin built on the lovely grounds. Across the street is a swath of public green (Governor Hutchinson's Field), which descends down to the Neponset River. It would make a nice place to take in the vista, walk, and picnic.

Directions: From I-93 take Exit 5B (Randolph Avenue) northbound toward Milton. When Randolph Avenue ends, turn right onto Adams Street. The Forbes House is at 215 Adams Street, parking in rear. Open Sunday and Tuesday through Thursday, 1 to 4 P.M. Tel. 617-696-1815; www.forbeshousemuseum.org.

Clinton

MUSEUM OF RUSSIAN ICONS

203 Union Street, Clinton, MA 01510; Tel. 978-598-5000; www.museumofrussianicons.org.

Directions: From I-495, take Exit 26 West onto Route 62 for about 7 miles to Central Park in Clinton. The museum faces the park; there is street parking around Central Park.
Hours: Tuesday through Saturday, 11 A.M. to 3 P.M.
Admission: Adults $5, seniors and students voluntary donation, children 16 and under free.

Opened in 2006, this museum is the creation of one person, Gordon Lankton, chairman of Nypro, Inc., a plastics company headquartered in the small mill town of Clinton, Massachusetts. On business trips to the Soviet Union (and, later, Russia), he started buying icons as souvenirs, cheaply at first, in flea markets. He caught the collecting bug and graduated to larger, better, older ones, eventually acquiring them in the West and at auction as well. When his home could no longer hold his collection, he

approached several museums about donating them, but learned that they would be held mostly in storage and only occasionally shown. We should be happy his offer was turned down, since he founded his own museum instead, right in his own town. He acquired a mid-nineteenth-century commercial building situated on the town Green (called "Central Park") of Clinton, gutted it, and, $3,000,000 later, had created an inspired setting for these timeless witnesses to the deep religiosity of Russia.

In Orthodox Christianity, icons are considered "windows to heaven," the visible manifestation of invisible things. They are not in themselves sacred the way that relics of saints are in the Catholic Church, but they are more than mere representations of religious figures (as in Western painting) and are believed to have protective and redemptive powers.

Icons are also to a large extent codified; an initial, often miraculously endowed image is copied over and over again, with seemingly little variation. But human talent, Western influences, and technical developments in painting and reproduction are nevertheless reflected in the icons at hand. They span a time frame roughly of 1500 to 2000 and run the gamut from truly inspired art, to competent workmanship, to folk art, to commercial kitsch. Since they are grouped by topic (e.g., St. George and the Dragon, the Dormition [death of the Virgin], the Holy Trinity, etc.) you can ascertain for yourself how tightly or loosely the individual artist, usually nameless, clung to the respective prototype.

In the eighteenth and nineteenth centuries, many icons were overlaid with a gilt or silver frame, both to enhance their beauty and preciousness and to protect the painted image from the touch and kiss of the ardent believer. A decline in painted icons took place during the nineteenth and twentieth centuries, since, for the believer, a mechanically reproduced image was just as effective. Communism, of course, rejected all religious images, and, in fact, many were burned in bonfires—but many were hidden and survived. The religious revival after the fall of the Soviet Union has also led to a revival of icon painting, with new schools established; the collection contains a few paintings dating from around the year 2000. (See color insert.)

The museum is really one large, continuous space on three

floors, connected by a seemingly free-standing, wide circular staircase that allows unimpeded vistas from floor to floor. To create an equivalent of the mystical atmosphere of an Eastern church, the architect chose minimal natural light, a golden-hued indirect lighting strip at the base of the perimeter walls, dark brown fabric covers for the walls, and individual spotlights that make the icons glow in the semidarkness.

+ PLUS

National Plastics Center and Museum (Leominster) 🚼
Lankton's company is part of the larger plastics industry centered in the nearby town of Leominster, the so-called Pioneer Plastics City. Celluloid was invented here, as was the pink flamingo lawn decoration. At the National Plastics Center and Museum in Leominster, you can learn this and many other facts about plastics (including shellac, celluloid, bakelite, nylon, acrylic, kevlar) and their roles in medicine, war, and everyday life. Housed in a large former schoolhouse, the museum displays collections of early Tupperware, medical devices, combs, toys, and sunglasses, as well as machinery for injection molding. A cut-through of a life-size ambulance will be fascinating to children, and a large area is available for children to play with various plastics toys on plastic mats; the issue of recycling is addressed in detail in another gallery. The Plastics Hall of Fame on the second floor honors pioneers of the industry, including Gordon Lankton.

210 Lancaster Street, Leominster MA 01453; Tel. 978-537-3220; www.plasticscenter.org.

Directions: Follow Route 62 North for about 4 miles. Turn right onto Route 12 North, then merge onto I-90 (Mass. Pike) North toward Fitchburg. Take Exit 7 (Route 117) toward Leominster for about 2.5 miles. At the first light turn right onto Derwin Street to reach the parking lot behind the museum.

Cotuit

CAHOON MUSEUM OF AMERICAN ART

4676 Falmouth Road (Route 28) Cotuit, MA 02635; Tel. 508-428-7581; www.cahoonmuseum.org.

Directions: From Route 6 on Cape Cod, take Exit 2 onto Route 130 South to Route 28 and turn left onto Route 28. The museum is the second building on your left. Entrance to parking is just prior to the building, a red clapboard house.

Hours: Tuesday through Saturday, 10 A.M. to 4 P.M., closed in January.

Admission: Adults $5, seniors and students $4, children under 12 free.

A most welcoming little museum, tied to local history, local artists, and local subject matter. The family-size clapboard Georgian house dates back to about 1775 and was at one time a tavern and overnight stop for the Hyannis-Sandwich stagecoach. Today that distance is about one half hour by car, but upon entering the house it's easy to slow down one's pace and delight in the solidly crafted interiors and the whimsical "modern primitive" paintings on view.

Martha Farham Cahoon (1905–1999) was born to Swedish immigrant parents. Her father had learned the art of rosemaling, the folkloristic style of furniture decoration, in his native Sweden. His daughter apprenticed with him and developed expertise in painting, stenciling, and varnishing.

Ralph Cahoon (1910–1982) was born and bred on Cape Cod, with fishing, clamming, and boating all childhood activities. Gifted at drawing, he became a commercial artist. He and Martha Farham married in 1932 and three years later they opened their own shop for decorated furniture and antiques. They expanded their designs to absorb American Colonial and Pennsylvania Dutch motifs and stencils. As they worked side by side, their art became ever more imaginative and fanciful and went beyond

mere decorative flowers, garlands, and such to include more figurative and narrative scenes.

In 1945 they acquired the current house to have more studio and gallery space. They restored the old tavern with its wide floorboards, wainscoting, and remnants of circa 1820 wall stenciling in the entrance stairwell (all other stenciling was added by them). The Colonial house proved the perfect setting for their thriving painted furniture and accessories business.

In 1953 the wealthy art patron and heiress Joan Whitney Payson (see also Portland Museum of Art) saw their work and encouraged them to "try confining it in a frame." They made the transition from furniture decoration to easel painting quickly and easily, especially once they found their perfect base, masonite. From 1953 onward they exhibited annually at the Long Island Country Art Gallery, which Payson owned, and sold out every year. Other exhibition venues followed, in Nantucket, Boston, Florida, and California, with customers including Jackie Kennedy, Merriweather Post, and the Dupont and Mellon families.

The work that is on view stems mostly from this postwar period, when the couple had pretty much abandoned furniture decoration. Ralph developed charming little stock characters, above all mermaids and sailors, which he put into all kinds of everyday or festive settings (shucking oysters, harvesting wheat, maypole dancing, having tea). My favorite shows mermaids doing laundry on a whale, with a clothesline tied to its tail. Hot-air balloons and old-fashioned bicycles, wooden ships under full sail, charming seaside villages and nineteenth-century costumes all add to the nostalgic, whimsical tone of the works. The mermaids show their physique to best effect, with their fishtails starting just below a hint of posterior cleavage. All this art is firmly tongue-in-cheek, and local friends, neighbors, shops, and landmarks are often included.

Martha's scenes are more varied and tend to evoke childhood experiences, set in a never-never land of nostalgia. The palette of both painters is muted—compared, for example, with that of Grandma Moses (see Bennington Museum)—the slate grays, dark greens, and pale skies add to the antique look, giving these twentieth-century paintings an inherent patina.

In addition to the Cahoons' work, there is a collection of

American nineteenth- and twentieth-century art. The marine painter James Buttersworth, John J. Enneking (who also was a friend of Martha's father), Frank Benson, Benjamin Champney, Dwight Tryon, and others are represented. An active exhibition program of seven to nine different shows every year often takes a work from the collection as a springboard. Themed exhibits—such as Angels, the Circus, Music (etc.) in American Art—have been popular and, as director Cindy Nickerson explains, "We do try to inject a bit of fun into our shows whenever possible."

The number of Cahoon works on display varies depending on the scope of the temporary exhibitions, but dedicated Cahoon exhibits happen every two or three years.

+ PLUS

Historical Society of Santuit and Cotuit
The Historical Society of Santuit and Cotuit is the perfect place to see the real-life tools and artifacts of the activities depicted in the Cahoon paintings: whaling, sailing, boatbuilding, fishing, and just everyday living. It also has information on the builder of the Ebenezer Crocker House (the site of the Cahoon Museum), which was one of seven houses one father built for his seven sons. The 1808 Samuel B. Dottridge Homestead forms part of the historical society and is used to display collections of pottery and china as well as early-nineteenth-century furniture.

1148 Main Street; 508-428-0461; www.cotuithistoricalsociety
.org.
Directions: As you exit from the museum, turn left, and then immediately right onto Main Street. Follow Main Street for about 2 miles.

Dennis

CAPE COD MUSEUM OF ART

Route 6A, Dennis, MA 02638; Tel. 508-385-4477; www.ccmoa
.org.

Directions: From the west: take Route 6 to Exit 8, Union Street. Turn left off the ramp onto Union Street and continue about 1 mile until Route 6A. Turn right on 6A and go for about 4 miles until you see the sign for the Cape Cod Center for the Arts, on the left. Enter and follow the signs for the museum.

From the East: Take Route 6 to Exit 9B (Route 134). Turn right off the ramp and continue several miles until Route 6A. Turn left and proceed on 6A for about 2 miles to Dennis Village, until you see the sign. See above.

Hours: Tuesday through Saturday, 10 A.M. to 5 P.M., Thursday until 8 P.M.; Sunday, 12 to 5 P.M.. Between Memorial Day and Columbus Day the museum is also open on Mondays.

Admission: Adults $8, children under 18 free. Admission by donation on Thursdays.

Founded in 1981, the Cape Cod Museum of Art is dedicated to exhibiting and preserving the works of generations of artists associated with Cape Cod, the islands of Nantucket and Martha's Vineyard, and southeastern Massachusetts. When it celebrated its twenty-fifth birthday in 2006, the museum boasted a permanent collection of two thousand works going back to the turn of the twentieth century, when the first art school sprung up on Cape Cod. There is a rotating exhibit of works from the permanent collection in the Stout Gallery on the lower floor (feeling unfortunately a little cramped). While not many of the artists are household names, the quality is high, and it is intriguing to survey the relationship of teachers and students, of colleagues working in close proximity and interaction, and of the influence of the clear light and plain landscape of the region. The subject matter tends toward the figurative rather than the abstract, with landscape, still life, sea and coast, portrait and figure all represented. Hans Hofmann (1880–1966), the father of Abstract Expressionism, taught in nearby Provincetown for many years, and his influence is still strongly evident. (See color insert.)

There is also a sizable collection of sculpture in the permanent collection. It is displayed in a charming outdoor sculpture garden that embraces the building on three sides. In addition, there is a glassed-in veranda space that allows sculpture to be ex-

hibited away from the weather, while visitors may still fully partake of the landscaped surroundings. The founding spirit of the sculpture collection is the Swiss-born Arnold Geissbuhler (1897–1993), who, having studied in Paris alongside Alberto Giacometti, moved to the States and lived in Provincetown from 1934 to 1937, taught drawing and sculpture at Wellesley College from 1937 to 1958, and eventually settled in Dennis in 1970. He donated forty-one of his works to the young museum. His son-in-law, Harry Holl, is one of the cofounders of CCMA, which is currently supporting a scholarly effort "to bring attention to Geissbuhler's contributions to art history and Cape Cod" through its Geissbuhler Project. What makes repeated visits worthwhile are the many and varied special exhibits, which cover Cape Cod–related topics but also go way beyond them. To give you a flavor, here are the titles of six exhibitions on offer during a visit in 2006:

"Highlights from the Permanent Collection of the Art Students League of New York," with works by William Merritt Chase, Georgia O'Keeffe, George Grosz, Will Barnet.

"Rosemary Simpkins, Twin Books: World Trade Center Memorial," an interactive memorial using folding books stacked into towers.

"Ernst Haeckel: Art Forms in Nature," a selection of enlarged reproductions of the famous biologist's artistic representations of various simple life forms.

"Printmakers of Cape Cod," a juried show of current work.

"Collector's Choice: Glimpses from 500 Years of Printmaking," selections from the private collection of Sandra and Robert Bowden that included examples by Dürer, Altdorfer, Rembrandt, Callot, Blake, Kollwitz, Chagall, and Picasso, among others.

To come to a small regional museum and be offered such a smorgasbord of well-curated, substantial, and thought-provoking shows was invigorating. In addition, the museum has an active

teaching and lecture program and an annual fine arts auction, "One Night Stands" (which showcase a local emerging artist every first Thursday of the month); additionally, it organizes house and garden tours. It is truly the artistic hub of the Cape.

+ PLUS

Rockwell Kent mural

The Cape Cod Museum of Art (see color insert) was a latecomer to a twenty-six-acre campus of historic buildings associated with the arts, when it joined the Cape Playhouse and the Cape Cinema. Both have their histories. First came the playhouse, which started life in 1870 as a Unitarian meetinghouse and was purchased by Raymond Moore, an enterprising producer and playwright, for $200. He then had it moved to its current location and it opened in 1927 with *The Guardsman*, starring Basil Rathbone. It was easy to convince actors to spend summers on Cape Cod, and many stars had their beginnings here: Bette Davis, Gregory Peck, Lana Turner, Ginger Rogers, Humphrey Bogart, Helen Hayes, Julie Harris, Henry and Jane Fonda, among others. (A complete set of show posters is one of the treasures of this theater.) The season comprises six productions and lasts from June to September.

Merely three years later, Moore opened the Cape Cinema, "a miniature talking picture theater deluxe." It was a commissioned building; the architect, Alfred Easton Poor, combined vernacular elements (a church façade, barnlike sides) into a pleasing, large-scale ensemble, Postmodern before there was even Modernism. The "deluxe" feature, however, is a gigantic ceiling mural by Rockwell Kent (1882–1971), a symbolic representation of the heavens, galaxies, and constellations, filled with floating figures. It covers the vaulted ceiling and is over 6,400 square feet in size.

To view it, either see a movie or ask the manager to let you in for a peek between shows. Show times are typically at 4:30 and 7:00 P.M. from early April through early January.
Cape Playhouse: Tel. 877-385-3911; www.capeplayhouse.com.
Cape Cinema: Tel. 508-385-2503; www.capecinema.com.

Duxbury

ART COMPLEX MUSEUM

189 Alden Street, Duxbury, MA 02331; Tel. 781-934-6634; www.artcomplex.org.

Directions: From Boston, take Route 3 South to Exit 11. Turn right onto Route 14 East, travel 2 miles to first traffic light (at Route 3A). Turn right onto 3A; Alden Street is the first street on the left.

Hours: Wednesday through Sunday, 1 to 4 P.M.

Admission: Free.

Catalog: Planned for 2011; the brochure *1971–2001: A Commemorative History and Highlights of the Collection* provides a nice summary.

As you approach the oddly named Art Complex Museum, it's hard not to be enchanted by the graceful building with its undulating roofline, framed by trees and forest. Set on thirteen acres of woodland in the historic town of Duxbury (founded by Myles Standish), this is a little earthly paradise.

Enter and you are struck by the warm colors of varied woods on both the walls and the sloping, wavelike ceilings. A "monument to wood" is what the cofounder of the museum, Carl A. Weyerhaeuser, wanted to erect in honor of his heritage. His grandfather's lumber fortune allowed him to become an ardent art collector and eventually build, fill, and endow the ACM in Duxbury. He started out collecting European and American prints, then branched out into Shaker furniture, American paintings, and Japanese art. In the latter field Weyerhaeuser enjoyed the friendship and advice of Kojiro Tomita, curator of the Asiatic Department of the Museum of Fine Arts, Boston, who assisted him in building an outstanding collection of twentieth-century Japanese ceramics. It was also Tomita who helped commission the Japanese teahouse, which was reassembled on the grounds of the Art Complex Museum and is the stage for traditional tea ceremony presentations in the summer months.

Art Complex Museum. Richard Owen Abbott, architect. Courtesy of Art
Complex Museum, Duxbury, Massachusetts.

The museum building itself was designed by Richard Owen
Abbott, with input from the family and the artist, Ture Bengtz,
who also was the founder in 1939 of the Graphics Department at
the Museum of Fine Arts, Boston, and was the first director of the
ACM when it opened in 1971.

Within the main exhibition space, the Bengtz Gallery, is the
small Rotations Gallery, which always presents a sampling from
the permanent collection, changing two to four times a year. In
addition, a few cases on the left of the entry display smaller Shaker
and Asian artifacts. Otherwise, you'll have to be on the lookout
for exhibitions that draw on the permanent collection, about four
to six per year. These major exhibitions frequently cross chrono-
logical and geographical lines. One example is the 2001 exhibi-
tion "Contemporary Studio Furniture (Shaker Inspired)," a few
pieces of which entered the collection and can be seen (and sat on)
in the vestibule. Another is "Complex Women," which featured
handicrafts by Shaker women, pottery and painting by the Japa-
nese artist/nun Otagaki Rengetsu (1791–1875), prints by Angelica
Kauffman, Käthe Kollwitz, and Mary Cassatt, as well as twen-
tieth-century paintings and sculpture—everything drawn from

the permanent collection. There is, of course, a sensibility and a reverence for craftsmanship that informs Asian art, Shaker furniture, and European prints, so the juxtaposition works just fine.

The works on paper range from Dürer, Rembrandt, Callot, Turner, Manet, Corot, Whistler, Japanese woodcuts, the American Regionalists (Thomas Hart Benton, Grant Wood) and Realist George Bellows to the annual prize-winning print selected by the juror of the Boston Printmakers' Society (these prize-winning prints are systematically acquired by ACM). American painting, on the other hand, concentrates almost exclusively on landscapes from the nineteenth and twentieth centuries, with fine examples from the Hudson River School, Luminism, American Impressionism, and the muscular early-twentieth-century depictions by George Bellows (of whom ACM owns six oils). Major names include Sanford R. Gifford, George Inness (his *Eventide–Tarpon Springs* is considered the star of the collection), Albert Bierstadt, Jasper Cropsey, and John Singer Sargent, but there are lovely rural and maritime scenes by lesser-known painters.

Shaker furniture is another strong branch, with about five hundred pieces of furniture or tools coming mostly from New York and Massachusetts Shaker settlements. Carl Weyerhaeuser's mother, Maud, was active in the restoration of Hancock Shaker Village in the Berkshires, and her son and grandson (the current director of ACM) assembled a major collection before it was chic to collect Shaker furniture. Pieces are often lent out and have been documented in major publications on Shaker furniture. (See color insert.)

The fourth leg of the collection, Asian art, is actually the heftiest, with about 1,500 pieces, ranging over 5,000 years. It covers, above all, India, China, and Japan, with paintings, prints, bronzes, and ceramics, but also textiles, lacquerwork, dolls, netsuke, and other items of daily use.

Strong community involvement was the vision of museum cofounder Edith Weyerhaeuser. Art classes for children and adults; a regular program of six well-attended Sunday afternoon concerts; lectures; outdoor sculpture; and an extensive art library of over five thousand volumes (including artist books) are among the activities and amenities of the ACM. Last but not least, we should

mention an artist-in-residence program housed in the (Colonial) Judah Alden House diagonally across from the museum.

+ PLUS

John Alden House 🍁

Just a little distance down on Alden Street is the John Alden House, a historic site open during the summer months. This was the dwelling place of Mayflower pilgrim John Alden and his wife, Priscilla, true historical personages immortalized in Longfellow's poem "The Courtship of Miles Standish." The house has never belonged to anyone but an Alden, and today is owned and managed by the Alden Kindred of America, Inc., a family-run non-profit. We are, of course, in very close proximity to Plymouth and all the genuine as well as re-created Pilgrim sites, but this modest and perfectly preserved house is quite special.

105 Alden Street; Tel. 781-934-9092; www.alden.org. Open noon to 4 P.M. Monday through Saturday between mid-May and Columbus Day. Admission is $5 for adults and $3 for children 3–17.

Essex

COGSWELL'S GRANT 🍁 🐦

60 Spring Street, Essex, MA 01929; Tel. 978-768-3632; www.HistoricNewEngland.org.

Directions: From Route 1-95 (North or South) take Exit 15 to School Street North (Essex), which becomes Southern Avenue. When it ends at Route 133, turn left onto Main Street. Take the second right, Spring Street, and proceed to the end.

Hours: June 1 through October 15, Wednesday through Sunday, 11 A.M. to 4 P.M. Guided tours on the hour.

Admission: $10.

Catalog: A small brochure for $5 is available in the bookstore. For detailed information see Nina Fletcher Little, *Little by*

Little: Six Decades of Collecting American Decorative Arts, New York (Putnam), 1984, reprint 1998.

This charming eighteenth-century New England farmhouse is the repository of one of the foremost collections of American folk art by one of the foremost authorities on the subject, Nina Fletcher Little. She and her husband, Bertram, started collecting in the 1920s and continued for over sixty years. In 1937 they bought this farm as a summer place and filled it with the "country art" portion of their collection. Shortly before their deaths in 1993, they bequeathed it, contents and all, to the Society for the Preservation of New England Antiquities (later renamed Historic New England), of which Bertram had been the director for many years. The collection encompasses furniture, paintings, and utilitarian objects of every conceivable kind, made in the seventeenth to nineteenth centuries: weather vanes, decoys, pottery, lighting implements, bedspreads and rugs, boxes and chests, plus oddities such as carved ostrich eggs brought back by New England mariners. But this was a house lived in by a family with children, where they slept, cooked, entertained, and worked on their research and writing. So rather than looking like a museum or a display of historically perfect period rooms, the feel of the house is more that of an amiably overstuffed, well-worn, and homey grandmother's house, with somber ancestral portraits overlooking the bustle of life.

There are no labels here, of course, but the Littles researched and documented each item with a museum curator's care. They sought out items with local roots and provenance, and through the crafty use of archives, historical societies, interviews of family descendants, consultations with other collectors and antiquarian societies, and painstaking examination of the actual pieces themselves, they were often able to attribute them to the specific makers, date them, trace their origins and histories and in the process helped establish whole areas of research.

Nina wrote the monographs *American Decorative Wall Painting 1700–1850*, *Floor Coverings in New England before 1850*, *Boxes and their Contents in Early American Households*, and a survey, *Country Arts in Early American Homes*; she catalogued the important

folk-art collection of Abby Aldrich Rockefeller (at Colonial Williamsburg), and contributed dozens of articles to antiquarian and historical magazines.

Moreover, Nina became an expert on a number of "primitive" painters or "limners," and published on John Brewster, Jr., Winthrop Chandler (whom she first identified), Rufus Hathaway, and Asahel Powers. Her particular expertise is relevant for the purpose of this book, for a substantial collection of early portraits and land- and seascapes is scattered around the house. They look wonderfully at home here; notably, as Nina Little explained, she eschewed any special lighting since these paintings were only to be seen in day- or candlelight when they were first created.

The most outstanding are a pair of seated portraits of Colonel Joseph Dorr and his wife by the prolific and gifted Ammi Phillips (1788–1865), examples of whose work are also at the Currier Museum in Manchester, New Hampshire, and the Fogg Museum in Cambridge, Massachusetts. They have the stern expression and awkward posture, the slightly askew proportions typical of the untrained, itinerant portrait painters of the eighteenth and early nineteenth centuries. There are many other examples, bust length or three-quarter length, in profile or three-quarter profile, some attributed, some anonymous. But they all have the charm of the less than perfect, the unstudied, earnest effort. One portrait, however, stands out for its technical accomplishment, and that is *Portrait of Eli Forbes*, the ancestor of the legendary Forbes dynasty, by Danish-born Christian Gullagher (1789–1826). Forbes, pastor in Gloucester throughout the Revolutionary years, is shown preaching from a pulpit, with a lively facial expression and a commanding presence. Besides oil paintings, there are painted overmantels (wooden panels above a fireplace) and fireboards (panels used to cover fireplace openings in the summer time). Much of the furniture shows traces of painting, some to suggest fancier woods, others just exuberant depictions of flowers and other ornaments.

Everything fits together so well and is so pleasingly arranged that it feels almost intrusive to give the pieces the scholarly attention they deserve. But whether you enjoy this house museum for the atmosphere and overall impression, or if you study it with a connoisseur's eye, you will have much to savor.

+ PLUS

Essex Shipbuilding Museum 🍁 👶

Essex, situated on the tidal Essex River, was a major shipbuilding center for three centuries; most of the schooners for the Gloucester fishing fleet were built here. The Essex Shipbuilding Museum traces this history through models, photos, dioramas, and hands-on displays. On the museum's Story Shipyard, surviving historic boats are being restored.

The museum is located at 28 Main Street in a former schoolhouse; the shipyard as well as the gift shop at 66 Main Street. Tel. 978-768-7541; www.essexshipbuilding.org.

Hours: June through October: Wednesday through Sunday, 10 A.M. to 5 P.M.. November through May: Saturday and Sunday, 10 A.M. to 5 P.M.

Admission: Adults $7, seniors $6, children over 6 $5.

Fitchburg

FITCHBURG ART MUSEUM 👶

185 Elm Street, Fitchburg, MA 01420; Tel. 978-345-4207; www.fitchburgartmuseum.org.

Directions: Take Route 2 East or West to Exit 31B. Take Route 12 North for ca. 4 miles, turn right after the Central Shopping Plaza. Turn left onto Main Street; after post office turn right onto Merriam Parkway. The museum is on the right, through the stone courtyard wall; parking is to the left.

Hours: Tuesday through Sunday, 12 to 4 P.M.

Admission: Adults $7, seniors and students $5, children under 12 free.

This little gem was founded by a spirited nineteenth-century artist, Eleanor Norcross (1854–1923). A native of Fitchburg, she studied at the Art Students League in New York, where her teacher, William Merritt Chase, advised her to pursue further studies in Paris. She essentially stayed there for the next forty years,

exhibiting regularly at the Salon. Meanwhile she also collected, mostly decorative objects, with an eye to creating a small museum in her native town, which she visited most summers.

The museum opened in 1927. While Norcross did not see her project come to fruition, her legacy, which included a $10,000 endowment and a commitment to education, lives on. Both the collection and the building have grown, and galleries in two wings connected by a light-filled passageway embrace a small greenspace. You enter the original building, which exhibits the permanent collection of American and European paintings, in galleries painted in varied rich colors and organized by topic: Modernism, Portraits, Landscape, Still Life, and Genre. It's unusual, but very instructive, to see comparable American and European art mixed. Among the highlights are portraits by Joseph Wright of Derby, John Singleton Copley, John Singer Sargent, and William Merritt Chase; a typical interior scene by Edouard Vuillard (who seems to have influenced Eleanor Norcross's own interiors); Childe Hassam's small but luminous *Isle of Shoals, Moonlight* (see color insert); an astoundingly realistic still life by William M. Harnett and a very painterly one by William Merritt Chase, who clearly emulated the grand Dutch style. John Singer Sargent's oil sketch for the prophet Hosea in the Boston Public Library murals is powerful and betrays his admiration for El Greco. Among the landscapes, Rockwell Kent's *Monadnock Afternoon* stands out.

Upstairs are the decorative arts, particularly rich in ceramics from various ages and countries and well supplemented by permanent loans from the Rhode Island School of Design. A large gallery is reserved for changing exhibitions; during my visit, excellent examples from the large collection of works on paper were on view. Paintings by Eleanor Norcross are displayed throughout the building, and she stands up well against the more famous competition.

The connecting corridor showed a loan exhibition of African sculpture from the famed William E. Teel collection (the bulk of which now forms the African-art collection at the Museum of Fine Arts in Boston).

You enter the new wing on its second floor, which consists of several rectangular galleries set into a trapezoidal footprint, gen-

erating interesting nooks and corners, as well as vistas to the floor below. The upper floor is entirely dedicated to changing exhibitions; the biennial showcasing of local talent, "New England/ New Talent," has taken place nine times already. After you have descended the staircase to the ground-level lobby, turn to the Egyptian gallery, which you approach through a narrow, tomb-like tunnel. The artifacts are surrounded by a large collection of paintings of Egyptian wall reliefs and tomb interiors. The painter, Joseph Lindon Smith (1863–1950), was the founder of the Dublin, New Hampshire, art colony, a friend and art buyer to Isabella Stewart Gardner, and a member of the Harvard MFA Expedition at Giza (see Museum of Fine Arts, Boston). He depicted what he saw so thoroughly, cracks and chips included, that you find yourself checking again and again that the surface is not stone, but painter's canvass. This painting collection is on long-term loan from the MFA and raises the smallish collection of artifacts to a compelling visual experience.

The Fitchburg Art Museum seems to have made an art of cajoling larger and more prestigious institutions into transferring sizable collections of objects as long-term loans. Thus, subsequent galleries dedicated to Greek, Roman, and Pre-Columbian art are heavily indebted to the Sackler and Peabody museums of Harvard University, while almost the entire Asian collection is on loan from the Arthur M. Sackler Foundation. These attractively displayed and thoroughly labeled exhibits, set off from each other by different wall colors, are most inviting. This very ambitious museum is also host to a charter school centered on the arts, with most of the teaching taking place right in the museum. A large, fully equipped studio space complements the educational mission.

+ PLUS

Bulfinch Church in Lancaster

The town of Lancaster, just one of many picturesque towns in this area (Harvard, Princeton, Groton, Ashby, Templeton), boasts one of the two surviving churches designed by Charles Bulfinch (1763–1844). Considered the first professional architect in the

United States, he designed the Connecticut and Massachusetts statehouses and finished the Capitol in Washington, D.C. The rather simple brick core of the First Church (1816) is enlivened by a veritable encyclopedia of white, Classic elements such as fluted columns, Ionic and Corinthian capitals, pilasters, a portico with pediment, and volutes. The tower is particularly elegant. The bell, incidentally, was cast by Paul Revere's foundry.

Tel. 978-365-2427; www.firstchurchlancasterma.org.

Directions: From Route 2 take Exit 35 to Route 70 South. The church is on the town green, and informal tours are given during church office hours.

Framingham

DANFORTH MUSEUM OF ART 🛒

123 Union Avenue, Framingham, MA 01702; Tel. 508-620-0050; www.danforthmuseum.org.

Directions: Mass. Pike (I-90) to Exit 13 (Framingham and Natick). After tollbooth, bear right onto Route 30 West. After 1 mile turn left onto Route 126 (Concord Street). Continue 1 mile and take a right onto Lincoln Street, then first left onto Pearl Street. The Danforth will be on your right. Enter the parking lot before the stop sign at Union Avenue.

Hours: Wednesday, Thursday, and Sunday, noon to 5 P.M.; Friday and Saturday, 10 A.M. to 5 P.M.

Admission: Adults $8, students and seniors $7, children under 12 free.

This is a young museum and an art school, in equal measure. Founded through the leadership of local families in 1973, it enjoys a working relationship with Framingham State College and provides art education to over sixty schools in neighboring communities. It is centrally located in this mostly blue-collar community of sixty-five thousand west of Boston and functions as Framingham's cultural center, with concerts, film series, gallery

talks, lectures, etc. The name recalls the original owner of the Colonial land grant of this area, Thomas Danforth, who was also a judge at the Salem witch trials. Housed, appropriately enough, in a solid former high school building, the museum galleries take up the first floor.

The permanent collection is dedicated to American painting, prints, sculpture, and photography of the nineteenth to twenty-first centuries. While the same is true of any number of New England museums, the Danforth has carved a distinct niche for itself through its advocacy of Boston Expressionism, both in collecting and exhibiting. According to Judith Bookbinder, who wrote *Boston Modern* (2005), the definitive study of the movement, it "found its sources primarily in German expressionist images by Max Beckmann, George Grosz, and Oskar Kokoschka . . . [and] confronted the issues at the heart of expressionist sensibility: personal and group identity in the modern world; the role of the artist as witness to violence, prejudice, and corruption in modern society, and the nature of the creative process and its formal and spatial implications." This movement formed a way of "being modern" parallel to Abstract, Pop, and Minimal art, which thrived primarily in New York, and would in the 1960s and '70s eclipse the more humanist, figurative Boston tradition. The main artists are Jack Levine (b. 1915), Hyman Bloom (b. 1913) and David Aronson (b. 1923), all three of whom were included in a major exhibit at the Museum of Modern Art, "Americans in 1942: 18 artists from 9 States," and were celebrated and showcased as major American artists of the midcentury. Recently, there has been renewed interest in Boston Expressionism, as witnessed by several publications and exhibitions. Among the latter must count a major retrospective, "Hyman Bloom: A Spiritual Embrace," at the Danforth Museum in 2007. A documentary about Bloom is also under way. (See color insert.)

In addition to the holdings of Boston Expressionists, there are notable holdings in German Expressionism, and a few choice paintings from the nineteenth century, among which are a smallish, lovely early work by Albert Bierstadt (1830–1902), *North Conway, New Hampshire*, and landscapes by Jasper Cropsey (1832–1900) and Frank Shapleigh (1842–1906). An oddity, albeit a welcome

one, is a pair of Gilbert Stuart portraits, *Dr. and Mrs. Nathaniel Coffin*.

But it is not really the permanent collection of about three thousand objects that would draw one to the Danforth again and again. It is the high caliber, accessibility, and richness of the exhibition program. Three to five major exhibitions per year are supplemented by smaller shows that often have a subtle relationship to the main event. The Hyman Bloom exhibit, for example, was accompanied by an exhibit featuring noted photographer Jules Aarons with scenes from the vanished Boston West End, the very neighborhood in which Hyman Bloom and his friend and fellow painter Jack Levine grew up. At the same time, the permanent collection yielded an exhibit, "Other Voices: Expressionism in Boston," which put Bloom's work in context and indicated the continuity of Expressionist tendencies in Boston. The creative symbiosis between the three exhibits was remarkable.

The smaller Swartz Family Gallery is the locus of "New England Currents," a series of about six exhibits per year that feature contemporary local artists. This series brings the art gallery experience of downtown Boston to the metro-west area. Lastly, a collection of Hopi kachina dolls and a rotating selection from the Arter collection (a private treasure of American Indian art) form an unexpected counterpoint. These North American Indian exhibits have been integrated into the school system's social studies curriculum, so that all third graders in Framingham visit the museum as part of their study of American Indians.

Another unexpected feature is a gallery (on the second floor, accessible by elevator) dedicated to children's-book illustration. There, six to eight shows per year are hung at child level, and the room has been made into a comfortable reading and viewing space for the younger set.

Once past the children's gallery you are in the art school space, and by all means proceed further. You will see student examples hanging on the corridor walls and be able to peek into classrooms, where adults and teens are busy studying painting, drawing, ceramics, weaving, watercolor, jewelry making, photography, and more, all taught by professionals at levels from beginner to advanced, throughout the day and evening. There are also special

classes for toddlers and children, as well as family events; art-themed birthday parties can be arranged, as well. The teaching faculty numbers nearly forty and validates the director's claim that the school has "as good an education program as any in the country." The centrally located museum school gallery hosts exhibits of advanced students, instructors, and local artists, and definitely warrants a look.

One last note regarding the museum store: it is highly selective, selling art by faculty and students only, on the one hand, and books, children's books, and catalogs related to the exhibits, past and present, on the other. A welcome relief from the sameness and randomness of many a museum store.

+ PLUS

N. C. Wyeth in the Needham Free Public Library
In nearby Needham, the public library boasts a small collection of paintings and drawings by N. C. Wyeth, the renowned illustrator and father of painter Andrew Wyeth (see also Farnsworth Museum and Wyeth Center in Rockland, Maine). Wyeth père was born and grew up in Needham, attending the local high school before he bolted for art school in Boston, and eventually attended the Delaware-based art school of Howard Pyle, often called "the father of American illustration." Wyeth is best known for his illustrations of literary classics, especially for children (*Treasure Island* was his breakthrough work). His full-color covers and inside color plates became the norm for other publishers. The Wyeth Room is on the second floor; the librarian has a folder with detailed information on the pieces.

Needham Free Public Library, 1139 Highland Avenue, Needham, MA 02494; Tel. 781-455-7559; www.needhamma.gov/library.

Directions: From Interstate 95, take Exit 19B, travel west on Highland Avenue. At the fourth traffic light, turn right onto Rosemary Street. The library and parking lot are on the right.

Gloucester

BEAUPORT (SLEEPER-MCCANN HOUSE) ❦

75 Eastern Point Boulevard, Gloucester, MA 01930; Tel. 978-283-0800; www.historicnewengland.org.

Directions: Take Route 128 to the end. Go through two rotaries. At second set of lights after the second rotary, go straight onto East Main Street for 1.5 miles. Note stone gates at entrance to Eastern Point Boulevard; take Eastern Point Boulevard and Beauport is 0.5 miles down on the right (ocean) side.

Hours: June 1 to October 15: Tuesday through Saturday, 10 A.M. to 5 P.M. Guided tours on the hour; last tour at 4 P.M.

Admission: $10.

Catalog: A lavishly illustrated and thoroughly researched publication, *Beauport*, published by Historic New England (formerly SPNEA), is available in the gift shop.

Beauport is the creation and the former summer residence of an eccentric with superb taste, Henry Davis Sleeper (1878–1934). Born into money, Sleeper started to build his summer home on a granite ledge overlooking Gloucester Harbor in 1907. It started small, but he kept adding rooms, wings, turrets, and loggias for his ever-expanding collection of Americana (and some European, mostly French, collectibles); today, the final number of rooms is fifty-six and the house a maze of crooked passageways, odd levels, secret staircases, and surprising angles. The rooms are furnished for the most part as dining rooms (five in all) or bedrooms, each having a distinct theme and character. Sleeper would decorate the room to his imaginative taste, with historical furniture, doors, and paneling salvaged from historic houses; display artifacts grouped by color, material, or period, or imaginatively mixed; and supplement the whole with items made to his specifications. Once a room was perfect, he would move on to the next.

Meanwhile, Sleeper loved to entertain friends and neighbors,

Carving of Eagle Feeding Its Young, made between 1830 and 1850. North Gallery, Beauport: Sleeper-McCann House, Gloucester, MA. Photograph by David Bohl. Courtesy of Historic New England.

among them Isabella Stewart Gardner, the painter Cecilia Beaux, Harvard professor A. Andrew Piatt (whose summerhouse, Red Roof, is two houses down). Sleeper was happy to show his house to interested visitors, and it was featured in such style magazines as *House Beautiful* and *Country Life*. Thus began a career as an interior decorator for out-of-state clients, including Henry Francis du Pont of Winterthur, Delaware, and even some Hollywood clients.

Sleeper had enormous influence on the emerging Neocolonial movement. The depiction of his rooms in magazines set a standard for the display of American artifacts within either restored Colonial houses or newly built Neocolonial mansions. The overstuffed and cute New England B&B of today is in some way the trivialized descendant of his highly artistic and tasteful model. Upon Sleeper's death in 1934, the house was purchased by Helena Woolworth McCann, who left it almost untouched and used it as a summer home. Eventually her heirs transferred it to the Society for the Preservation of New England Antiquities (now named

Historic New England), which runs it as a house museum under the name Beauport, the Sleeper-McCann House.

+ PLUS

Hammond Castle Museum 🛒

From the lawn of Beauport you can make out, on the far shore, a vaguely Medieval-looking castle. This was the home of John Hays Hammond, Jr. (1888–1965), a brilliant engineer and inventor who preferred to live in the past, surrounded by some genuine and many re-created historical artifacts and architecture. In the early decades of the twentieth century, Hammond developed and perfected radio-operated remote control. In 1914, the "father of remote control" sent his forty-four-foot yacht on an unmanned trip from Gloucester to Boston and back! Needless to say, the U.S. military was vitally interested in his work, which later included radio-guided torpedoes. He eventually registered over four hundred patents, second only to Edison.

A childhood stay in England and later touring through Europe infatuated him with castles and the architectural remnants of earlier civilizations. In 1926 he started construction of his Medieval castle, recruiting the Boston firm of Allen & Collins, the architects of Riverside Church and the Cloisters in New York City. The Great Hall boasts an 8,200-pipe organ and is the heart of the castle. From it, several stairways and "secret" passageways lead to other rooms: a Renaissance dining room, a Medieval as well as a Colonial bedroom, and the dungeon tower, with a weapons collection. Tucked inside is also a lovely, small courtyard with a pool. Here and there are architectural relics, small sculpted items, columns, balustrades, and window frames, each from various countries and times, woven into a fanciful if somewhat gloomy ensemble. The castle also housed Hammond Radio Research, his firm, which was instrumental in the development of FM radio, the synchronization of motion-picture sound, and the dynamic amplifier (today's stereo)—all developed right here in the castle.

80 Hesperus Avenue, Gloucester, MA 01930; Tel. 978-283-7673; www.hammondcastle.org.

Directions: From central Gloucester, take Western Avenue (Route 127) south for about 2 miles. On the left you will see a blue-and-white sign for Hammond Castle and Magnolia, Massachusetts. Take a left onto Hesperus Avenue; the Castle is ahead 0.75 miles on the left.

Hours: Call or check Web site before visiting, as opening hours and days are limited and vary according to season.

Admission: Adults $8.50, seniors $6.50, children 4–12 $5.50.

CAPE ANN MUSEUM 🚼

27 Pleasant Street, Gloucester, MA 01930; Tel. 978-283-0455; www.capeannmuseum.org.

Directions: From I-95 North, take Exit 44 to Route 128. Take Exit 45 toward Gloucester. At roundabout, take first exit onto Washington Street, turn left onto Prospect Street, then right onto Pleasant Street. Parking is available opposite the museum in the city hall parking lot.

Hours: Tuesday through Saturday, 10 A.M. to 5 P.M.; Sunday, 1 to 4 P.M. Closed the month of February.

Admission: Adults $8, seniors and students $6, children under 12 free.

The Cape Ann Museum (formerly Cape Ann Historical Society) is a wonderful amalgam of history and art. There are exhibits that trace Gloucester's early glory as America's oldest fishing port, made rich by King Cod (salted and exported), and its continuing importance as a fishing port, immortalized in the book and movie *The Perfect Storm.* There is a gallery showing exotic goods and artifacts imported via the flourishing Surinam trade of the nineteenth century. One gallery is devoted to the quarrying of granite, cut from the rocky ground by hardworking immigrants mostly from Finland. Folly Cove Designers, a fabric design cooperative founded in 1941 by artist Virginia Lee Burton, left numerous samples and its archive to the Cape Ann Historical Society. The fabrics are displayed like curtains at the back of the auditorium. Burton, who was married to sculptor George Demetrios (also represented here), is more famous as a children's book

author and illustrator (*Mike Mulligan and his Steam Shovel*, *The Little House*, and others). In keeping with the scope of this book, however, we will concentrate on the art.

The physical nucleus of the museum is the historic Captain Elias Davis House of 1804. It has been added to numerous times, so that the museum now occupies an entire city block, and is internally rather complicated to maneuver, or—put another way—offers serendipitous discoveries at every turn. The latest, twenty-first-century addition is a soaring pyramidal shape sitting atop an existing building. Its wood-plank ceiling and crossing trusses allude to wooden ship hulls, and an oversize northern porthole sets a Postmodern accent on this playful construction. It is the perfect space for larger-scale twentieth-century painting and sculpture.

All art in this museum is related to Cape Ann (which, in addition to Gloucester, includes the towns of Rockport, Manchester-by-the Sea, and Essex); since Cape Ann has been a thriving art colony for over 150 years, and has attracted a veritable who's who of American artists, this geographic restriction is anything but limiting. One artist above all commands the center spot, and that is Fitz Hugh (or, as recent scholarship has it, Henry) Lane (1804–1865). Born and buried in Gloucester, the partially paralyzed Lane derived most of his oeuvre from Gloucester Harbor and the surrounding Cape Ann, with a few Maine landscapes resulting from summer trips. Within this extreme restriction of subject matter, he created harbor scenes and ship portraits of exquisite, luminous serenity. "Through a pervasive, limpid light and discreet spottings of color . . . he turns descriptions and topography into poetry," remarks Faison, who ranks him and Martin J. Heade as the outstanding American Luminists. The Cape Ann Museum has the largest collection of Lane works anywhere, with forty oils, a hundred drawings, and rich archival material; they are on permanent view in a large gallery that also exhibits local historic furniture.

The late nineteenth century saw Winslow Homer and William Morris Hunt as regular visitors. In fact, it was on Cape Ann that Homer decisively turned to watercolor and fully mastered the then neglected medium. Such American Impressionists as Mau-

rice Prendergast, Childe Hassam, John Henry Twachtman, William Trost Richards, and Willard Metcalf came next. Among harder-to-peg artists active in Gloucester at the turn of the century were Leon Kroll, Frank Duveneck, Paul Manship. In the early twentieth century came the American Modernists, including John Sloan, Edward Hopper, Stuart Davis, Marsden Hartley, and Milton Avery. In many cases the exposure to the light and the landscape of Cape Ann proved pivotal to their artistic development. Said Stuart Davis: "I went to Gloucester, Massachusetts, on the enthusiastic recommendation of John Sloan. That was the place I was looking for. It had the brilliant light of Provincetown, but with the important additions of topographic severity and the architectural beauties of the Gloucester schooner." Marsden Hartley was attracted to the stark interior of Cape Ann, an area known as Dogtown, which he described as "a weird stretch of landscape . . . all boulders and scrub."

Milton Avery visited a dozen times between 1920 and the 1940s. He abandoned Impressionism and, while still sketching outdoors, he worked out the final, simplified paintings in the studio, developing a distinct style of flat, broad color areas. In 1932, his friends, the Minimalists-to-be Mark Rothko, Barnett Newman, and Adolph Gottlieb, joined him in Gloucester.

Edward Hopper's vision of Gloucester centered on the Italianate Victorian clapboard houses that are still a major presence in the town. Unfortunately, the museum does not own anything by Hopper, but six Gloucester-related watercolors can be seen at the Web site of the Museum of Fine Arts in Boston (www.mfa.org); a Hopper oil, *The Bootleggers*, at the Currier Museum of Art in Manchester, New Hampshire, has one of those brooding Victorian houses hulking over the bootleggers in their boat below.

Clearly Cape Ann had something different to offer to different artists. The Luminists and American Impressionists were fascinated by the shimmering reflections on water, the summer vegetation, and the picturesque landscapes framed by the harbor bay; the Modernists found in the streetscapes, the local architecture, the boat hulls, and the granite-strewn landscape the subject for stark, almost Cubist compositions, as well as grittily realistic depictions of the tough workers on sea and in the quarries; others

concentrated on ships, on the rocky shore, or on the beaches. But certain subjects and vantage points are shared by almost everyone; for example, the view of Gloucester from Banner Hill, just above Rocky Neck, which must have been painted hundreds of times (see, e.g., Willard Metcalf's breakthrough work, *Gloucester Harbor*, at the Mead Art Museum in Amherst).

Sculpture was not neglected on Cape Ann, either. The museum boasts fine examples by Paul Manship, Charles Grafly, Walker Hancock, George Demetrios, and George Aarons, all in a representational vein.

+ PLUS

Art-related sites on Cape Ann

Fitz Henry Lane's home, a somber granite structure he designed himself, is just a few steps downhill from the museum, near the waterfront. It sits in a little park and has a lifelike bronze portrayal of him sketching. His studio was on the top floor, from which he had unobstructed views of the harbor. (The house is not open to the public.) Many locations in and around Gloucester are tied to the artistic community, above all Rocky Neck, which to this day boasts many artists' studios. To reach it, follow Main Street (Route 127) east; turn right at Bass Avenue and right again at East Main Street. Near the entrance to Rocky Neck, at 197 East Main Street, is the North Shore Art Association, established in 1922 to provide a venue for exhibits and active ever since. Try to walk rather than drive through Rocky Neck; it's really tight! Banner Hill is above Rocky Neck, reachable by going up Mt. Pleasant Avenue, the second right off East Main Street, as you return from Rocky Neck.

Also of interest are Halibut Point State Park, at the extreme north of Cape Ann, for its quarries; Dogtown for its sparse landscape; and Rockport, another, more touristy, art center, with the famous *Motif #1*, a red-colored fishing shack overlooking the small harbor.

Childe Hassam, *Isle of Shoals, Moonlight*
Oil on canvas, 12¾ × 9½ in., Fitchburg Art Museum, Fitchburg,
Massachusetts. Gift of Carl & Rosamond Pickhardt, 1994.4.

Hyman Bloom, *Skeleton in Red Dress*
Oil on canvas, 53 × 19 in., Danforth Museum
of Art, Framingham, Massachusetts. Promised
gift of Drs. Fran and Tim Orrok.

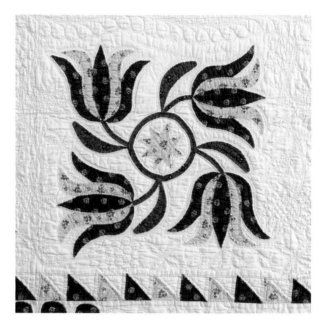

Windblown Tulips with Feathered Border (detail), circa 1875
Pennsylvania, 88 × 89 in., from the collection of the New
England Quilt Museum, Lowell, Massachusetts. Gift of Gail
Binney Sterm 2007.09.

Ilan Averbuch, *Skirts and Pants (after Duchamp)*, 2000
Etched glass and wood, 10 × 20 × 20 feet. DeCordova Museum
and Sculpture Park, Lincoln, Massachusetts. Lent by the artist.

Herman Maril, *The Model Stand*
Oil on canvas, 29 × 22.5 in. Courtesy Provincetown Art
Association and Museum, Provincetown, Massachusetts.

George Walter Vincent Smith Art Museum, exterior, with a view of Springfield Public Library, Springfield, Massachusetts. Photo by the author.

Fletcher Steele, *The Blue Steps*, in the garden of Naumkeag, Stockbridge, Massachusetts. Photo by the author.

Paul Cézanne, *Portrait Romantique*, 1868–70
Oil on canvas, Davis Museum and Cultural Center, Wellesley
College, Wellesley, Massachusetts. Gift of Dr. Ruth Morris
Bakwin (Class of 1919) in the name of the Class of 1919. Photo
© Davis Museum and Cultural Center, Wellesley College,
Wellesley, MA.

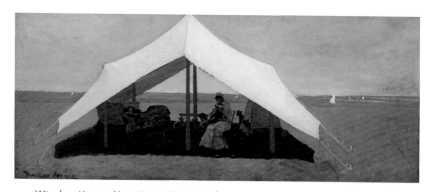

Winslow Homer (American, 1866–1910),
The Tent (Summer by the Sea), circa 1874.
Oil on board, 9.5 × 22 in., Robert Hull Fleming Museum,
Burlington, Vermont. Bequest of Henry Schnakenberg 1971.2.2.

Elizabeth de C. Wilson Museum of the Southern Vermont Arts
Center, Manchester, Vermont, with Joseph Fichter, *Clarion Call*,
2005, in the foreground. Photo by the author.

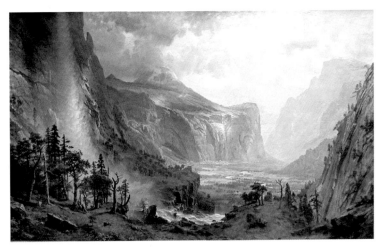

Albert Bierstadt, *The Domes of the Yosemite*, 1867
Oil on canvas, 116 × 180 inches. From the collection of the
St. Johnsbury Athenaeum, St. Johnsbury, Vermont.

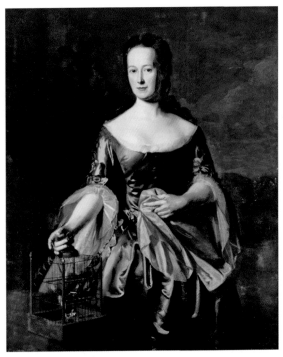

John Singleton Copley (1738–1815), *Mrs Metcalf Bowler
(Ann Fairchild, 1732–1803)*, circa 1758
Oil on canvas, 50 × 40 in., Colby College Museum of Art,
Waterville, Maine. Permanent Collection. Gift of Mr. and
Mrs. Ellerton M. Jetté, 1982.006.

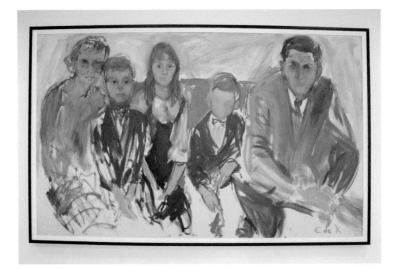

Elaine de Kooning, *Family Group*, 1967
Oil on canvas, 50 × 80 in., Housatonic Museum of Art,
Bridgeport, Connecticut. Gift of the artist.

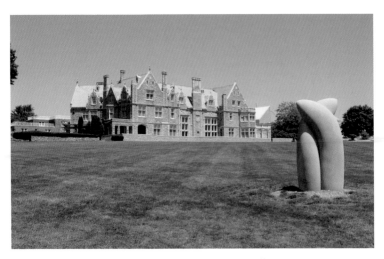

Branford House, home of the Alexey von Schlippe Gallery
of Art, University of Connecticut, Avery Point, Groton,
Connecticut, with Nick Santoro, *One World*, in the foreground.
Photo by the author.

Jacob Lawrence, *Dreams #1*, 1965
Gouache on paper, 33 × 22½ in., New Britain Museum
of American Art. Charles F. Smith Fund, 1989.03.

Slater Memorial Museum, Norwich, Connecticut, interior view
with plaster casts. Photo by the author.

Maxfield Parrish, *Griselda*, 1910
Oil on canvas, mounted to wood panel, 40 × 32 in., signed
lower right. National Museum of American Illustration,
Newport, Rhode Island. Photo Courtesy Archives of American
Illustrators Gallery, NYC, www.americanillustrators.com.
© Copyright 2008 National Museum of American Illustration,
www.americanillustration.org. Art ® Maxfield Parrish—
Licensed by ASaP Worldwide and VAGA. New York, NY.

Cyrus E. Dallin, *Menotomy Indian Hunter*
Bronze, located in Robbins Garden, Arlington, Massachusetts.
Photo by the author.

Saint Paraskeva, circa 1560
45 × 29 in., Museum of Russian Icons, Clinton,
Massachusetts, USA.

Hans Hofmann, *Untitled*, 1950
Oil on canvas, 21½ in. × 17½ in. × 2 in. (framed), Courtesy
of the Cape Cod Museum of Art, Dennis, Massachusetts.

Cape Cod Museum of Art, Dennis, Massachusetts, exterior view.
Photo by the author.

Three Shaker chairs. *Left*, Canterbury, New Hampshire, Shaker
Community, rocker, 1830–1850 (ACM 81.49). *Center*, New
Lebanon, New York, Shaker Community child's highchair,
1870s (ACM 29.19). *Right*, New Lebanon, New York, Shaker
Community, rocker, 1870s (ACM 36.36). Courtesy of the Art
Complex Museum, Duxbury, Massachusetts.

Harvard

FRUITLANDS MUSEUM ❧ 🛒

102 Prospect Hill Road, Harvard, MA 01451; Tel. 978-456-3924; www.fruitlands.org.

Directions: Take Route 2 to Exit 38A (6 miles west of intersection with I-495). Bear right at ramp, and take first right onto Old Shirley Road. Follow for 2 miles. Fruitlands is on the right.

Hours: May through October only; weekdays, 11 A.M. to 4 P.M.; weekends and holidays, 11 A.M. to 5 P.M.

Admission: Adults $10, seniors and students $8, children 5–17 $5.

Catalog: None, but a biography of the founder is available: Cynthia H. Barton, *History's Daughter: The Life of Clara Endicott Sears, Founder of Fruitlands Museums*, 1988.

This assemblage of four small museums is set on a hillside overlooking one of the loveliest vistas in Massachusetts. It includes miles of hiking trails, picnic tables, and hands-on activities for children. The tearoom provides elegant, although pricey, lunches. Just thirty miles from metropolitan Boston, Fruitlands makes a perfect family outing, with great variety but intimate in scale. The four museums, each in its own building, are the personal legacy of a remarkable daughter of the Boston Brahmin establishment. Clara Endicott Sears (1863–1960), a bright, bookish descendant of Winthrops, Endicotts, Peabodys, and Crowinshields, was thus born into a tradition of social obligation and discreetly carried, substantial wealth. Isabella Stewart Gardner's heritage was very similar, and both women eventually liberated themselves from confining female roles to establish something permanent entirely of their own making.

In Clara Endicott Sears's case, it took a while to bring focus to her ambitions, and she literally stumbled onto her first endeavor. In 1910 she had bought land on Prospect Hill in Harvard,

Massachusetts, to build an Italianate summer place there, The Pergolas, now destroyed. Shortly thereafter she discovered that her property abutted the farm on which A. Bronson Alcott (father of Louisa May Alcott of *Little Women* fame) had attempted to build a community based on transcendentalist principles, which would lead an ascetic life and live off the fruits of the land—hence, "Fruitlands." The impossibly high-minded and impractical group survived only seven months. They would not even subjugate oxen to work for them or deprive lambs of their fleece! Clara Sears immediately bought up the land and the ramshackle farmhouse, immersed herself in the history of the transcendentalist experiment, contacted descendants and neighbors, and set out to restore the farm to what it might have been in that fateful year, 1843. Historic preservation was in its infancy then, but she learned what she could and hunted down farm and household tools, as well as any written materials pertaining to the experiment and Bronson Alcott. In 1915 she published her first historical work, *Bronson Alcott's Fruitlands*, and the restored farmhouse was opened to the public. Although it probably would not pass a modern authenticity test, it is a good example of an early farmhouse enriched by many documents, images, and artifacts relating to the utopian movements of the time.

Her next "discovery" was the Shaker settlement in Harvard, which had been established in 1791. During her research for the Fruitlands restoration, Sears had become familiar with the Shakers, who had been helpful to Bronson Alcott during his tribulations, and she won their trust. Here was a spiritual community that had thrived for over a hundred years, despite their rule of celibacy and their neighbors' deep mistrust regarding their religious enthusiasm. Sears saw parallels in the aspirations of both communities, but profound differences in the executions. Her sensitive and inquisitive manner gave her access to written Shaker materials and diaries and an easy familiarity with the last eldresses of the community. When in 1916 the community knew it would have to disband, they asked Clara Sears to write a history of their undertaking and to buy the oldest building of their settlement and preserve it as a museum. *Gleanings from Old Shaker Journals* appeared in 1916, and the building was moved to Prospect Hill; it opened

in 1922 as the first museum dedicated to Shaker life. Built in 1796, today the individual rooms show lively displays of various aspects of Shaker life and industry.

The third museum also owes its existence to a local find, some Indian arrowheads that turned up on Clara's property in 1928. "The discovery fired my curiosity and I began looking into the history of the Nashaway Valley and the Indian lore." At first her searches were local, then she expanded the scope to cover American Indian tribes in all regions of the country. Contacting dealers and experts, she again made herself knowledgeable in the field and accumulated a serious collection. And again it was the spiritual dimension of native lore and tradition that attracted her the most. By the early thirties a museum had been built and filled; an imposing bronze statue of an Indian warrior shooting an arrow at the stars unveiled in the presence of a Sioux chief; and a book, *The Great Powwow*, published.

Last came the picture gallery, built to house her extensive collection of "primitive" portraits, painted locally during the nineteenth century. She must have been one of the very first collectors, asking local farmers what they might have in their attics and gathering information about sitters and painters alike. The collection numbers over two hundred portraits, and by the early forties she had not only had the museum built, but also had published *Some American Primitives* (1941). While only a changing portion of the collection is to be seen at the gallery, all images are available online.

Throughout the years Miss Sears had been collecting Hudson River School paintings. For Clara Sears this movement had the added attractions of its transcendental mysticism and a devotion to the New England region that was home to her and her revered ancestors. So in 1945, at age eighty-two, she set out to build the last addendum to her museums, a wing to display the over one hundred landscapes she had accumulated. They begin with the early American landscapists Alvan Fisher (1792–1863), Thomas Doughty (1793–1856), and Charles Codman (1800–1856), segueing to such major figures of the Hudson River School as Kensett, Cropsey, Gifford, Inness, Church, and Bierstadt, and many lesser-known figures. The collection is quite focused; seascapes and genre scenes are rare,

the formats tend toward domestic sizes, and most of the scenes embody the transcendentalist view that God can be found in nature, and that Nature herself evokes religious feelings. True to form, in 1947 Clara Sears published her *Highlights among the Hudson River Artists*. The collection is shown in rotation, often in thematic exhibitions that include loans; the picture gallery also hosts traveling exhibits that connect in a general way to Clara Sear's interests.

The Web site of Fruitlands Museum has all its paintings online, shows previous exhibitions, and is the portal to the extensive archive of printed and manuscript sources regarding the transcendentalists, adherents other visionary movements, and the Shakers, especially the records of the Harvard and nearby Shirley communities.

+ PLUS

Harvard Shaker Village Historic District

Harvard Shaker Village Historic District holds a number of Shaker buildings and a Shaker cemetery with multiple rows of "lollipop"-style grave markers. Of the four major, five-storey buildings, only two remain today; all are in private hands and not open to the public. But you can take a walk along Shaker Road and visit the cemetery. The Fruitlands Museum sells a little brochure with further information.

Directions: From Fruitlands turn left onto Prospect Hill Road, which becomes Old Shirley Road. After 2 miles, turn left onto Ayer Road (MA-110 and MA-111) and cross Route 2. Take the second right, onto South Shaker Road. The large Shaker building and cemetery will be on your left. Turn left onto Shaker Road to see more buildings.

Ipswich

IPSWICH HISTORICAL SOCIETY AND MUSEUMS ✽ 🛒

54 South Main Street, Ipswich, MA 01938; Tel. 978-356-2811; www.ipswichmuseum.org.

Directions: Take 1-95 to Exit 55 (Route 133 East). Turn right onto Route 1A when 133 and 1A become the same road. Proceed through the center of town and over Choate Bridge (a stone arched bridge dating from 1764). At this point, Route 1A becomes South Main Street. On your left, you will see the Ipswich Visitor Center; turn left into its parking lot. The Heard House, headquarters of the historical society, is the next house down.

Hours: Memorial Day to Columbus Day only: Wednesday through Saturday, 10 A.M. to 4 P.M.; Sunday, 1 to 4 P.M.

Admission: Adults $7, children 6–12 $3, children under 6 free. This includes the Whipple House Museum of 1677, right across from the Heard House. Admission to Heard House only is $5.

Catalog: None, but extensive information on the Web site.

Tucked away in the Ipswich Historical Society building, which is itself a historically significant house, is a small collection of paintings and prints by the Ipswich painter Arthur Wesley Dow (1857–1922). Dow was born in Ipswich and maintained at least a summer residence there throughout his life; he was a founding member of the historical society. He trained in Paris, but an encounter with Japanese woodblock prints at the Museum of Fine Arts in Boston and exposure to the Arts and Crafts movement led him to a simplified style emphasizing line, color, and tonal contrasts. His subject matter is, above all, the Ipswich landscape: beach, marshes, the Ipswich River. He also went west, and a fiery rendering of the Grand Canyon is the centerpiece of the little exhibit. His woodblock prints tend to be in narrow, oblong formats; sometimes he used the same blocks with different inks to show the same landscape in different seasons.

Dow was especially important as a teacher, revolutionizing how art was taught in America; his book *Composition: A Series of Exercises in Art Structure for the Use of Students and Teachers* has been in print since its publication in 1899. He taught at the Art Students League, the Pratt Institute, and Columbia University's Teachers College, and in 1891 he founded the Ipswich Summer School of Art. Arts and crafts (including candlemaking!) and photography

were equally honored and taught. Among Dow's students were Georgia O'Keeffe and Max Weber, as well as important potters and photographers (e.g., Gertrude Käsebier).

The collection also includes some cyanotypes, blue images, similar to blueprints, resulting from an early photographic process; Dow recorded Ipswich scenes in this medium. To see the collection, join the house tour of the Heard House and let your tour guide know that you are especially interested in the paintings. The house itself is an elegant Federal-style mansion from 1800, built by a family dynasty that became rich in the China trade. It was occupied by the last member of the Heard family until 1936 and retains furnishings and household goods the family assembled over the years. These include Chinese furniture and a superb, carved mirror frame, as well as portraits of Mr. and Mrs. George Washington Heard by William Morris Hunt.

Across the street, and also owned by the historical society, is the Whipple House Museum of 1677 with its re-created colonial kitchen garden. Seeing both houses together provides an inkling of how simply even well-to-do early settlers lived, and how much opulence the nineteenth-century trade bequeathed to the merchants of the Northeast.

+ PLUS

Arthur Wesley Dow walking tour
Settled in 1633, Ipswich still has fifty-eight first-period houses— i.e., houses dating from before 1725—more than any other town in the United States. Yet Ipswich yields its charms somewhat reluctantly, due to expansive nineteenth-century factory buildings and major roads cutting through the center of town. There is, however, a nice way to explore it: ask the tour guide for the pamphlet *Arthur Wesley Dow in Ipswich: A Walking Tour,* and follow it. The tour starts at the Heard House, and includes some lovely vistas of the Ipswich River, sites associated with Arthur Dow's life and work, and, inevitably, a goodly number of first-period as well as later historical houses. Various loops allow you to tailor the length of the walk to your taste.

Lenox

FRELINGHUYSEN MORRIS HOUSE & STUDIO

92 Hawthorne Street, Lenox, MA 01240; Tel. 413-637-0166;
www.frelinghuysen.org.

Directions: From Lenox take Route 183 South (same direction
 as for Tanglewood). From Tanglewood's main gate, go 0.3
 miles and turn left onto Hawthorne Road. After 0.7 miles
 turn left again, onto Hawthorne Street. The entrance is 0.4
 miles on the left.

Hours: July Fourth weekend through Labor Day: Thursday
 through Sunday, 10 A.M. to 4 P.M. September through Co-
 lumbus Day: Thursday through Saturday, 10 A.M. to 4 P.M.
 Hourly guided tours only, last tour begins 3 P.M.

Admission: Adults $10, children $3.

*Catalog: Suzy Frelinghuysen and George L. K. Morris: Ameri-
 can Abstract Artists*, the catalog of an exhibition sponsored
 by Williams College in Williamstown, Massachusetts, in
 1992.

Tucked away in the verdant Berkshire hills near Tanglewood is a
stark white, Bauhaus-inspired private retreat, the house and stu-
dio of an extraordinary artistic couple. They designed it, they
decorated the walls with their frescoes, they painted there, and
they left it all, including their private art collection, to the enjoy-
ment of the general public.

George L. K. Morris (1905–1975), scion of a prominent and
wealthy East Coast family (one ancestor signed the Declaration
of Independence), was educated at Groton and Yale, and devoted
his life to fostering Abstract, Cubist art in America. He stud-
ied in Paris with Fernand Léger and Amédée Ozenfant and met
Picasso, Braque, and Brancusi. Through his writing (he was an
editor at *Partisan Review* from 1937 to 1943), his prominent role
in the group American Abstract Artists, his painting, and, to a
lesser degree, his sculpture, he sought to create a Cubism-suffused

American style of Abstract painting. This was to be a refutation of the predominant figurative American stylistic trends of the '20s and '30s, such as Regionalism and the Ashcan School.

Suzy Frelinghuysen (1911–1988) was also born into a prominent family, one that is politically active in New Jersey to this day. She had voice and painting lessons as a child, and embraced Abstract art upon her marriage to Morris in 1934. He was clearly the intellectually and artistically dominant partner in the marriage, but she developed a personal style—within a general Cubist idiom—that is quite distinct from his. The frescoes and the general color scheme of the dining room are hers and show her predilection for yellows, grays, and blues. She seemed to hew to a more austere Cubism, while Morris often included symbolic representations, especially of Native American topics or architectural features.

The large studio attached to the house now serves as an exhibition space, in which a changing selection of the works of these two "Park Avenue Cubists," as well as their art collection, can be viewed. The latter contains mostly small works by Picasso, Miró, Braque, Gris, and others.

+ PLUS

Morris Elementary School
As you leave Lenox on Route 183 South, which is also West Street, you will see at No. 129, on the left (before you reach Tanglewood), a modern brick school building, the Morris Elementary School. It was built on land donated by the Morris family, named for them in gratitude, and is decorated by a large outdoor mosaic designed by George L. K. Morris.

Lincoln

DECORDOVA MUSEUM AND SCULPTURE PARK 🛒

51 Sandy Pond Road, Lincoln, MA 01773; Tel. 781-259-8355; www.decordova.org.

Directions: From I-95 take Exit 28 (Trapelo Road/Lincoln).
Follow Trapelo Road for 2.5 miles to a five-road intersection
(stop sign). Continue straight ahead onto Sandy Pond Road.
DeCordova is less than 0.25 miles on your right.

Hours: Museum: Tuesday through Sunday, 10 A.M. to 5 P.M.;
sculpture park: every day during daylight hours.

Admission: Adults $12, seniors $8, students, and children under
12 $6, children under 6 free. Admission is charged during
museum hours only; outside of these times access to the
sculpture park is free.

Catalog: No catalog, but a booklet, *Julian and Lizzie de Cordova:
From Mansion to Museum,* and an illustrated map of the sculp-
ture garden are available.

Pick a beautiful day for your visit of the DeCordova, since its set-
ting in the woodsy, hilly Colonial-era town of Lincoln, thirty
minutes west of Boston, is one of its key attractions. Plan to spend
at least as much time outdoors as indoors, especially if you have
children with you, for across the thirty-five acres of parkland are
scattered over seventy outdoor sculptures in various media and
moods. (See color insert.)

As you enter the long driveway, you will immediately see
some large pieces to the left and right of you on an expanse of
lawn and set against the dark green backdrop of mature trees. The
next thing you see is a futuristic piece of sculptural architecture
or architectural sculpture—the visitor station by artist-architect
Wellington Reiter. A circling road takes you to the parking area
behind the knoll from which "the castle," i.e., the museum, over-
looks the grounds, Flint's Pond, and the forest preserve beyond
it. The low pavilions you have passed house the museum school's
studios, a gallery, and a store that quite exceeds most museum
stores with its varied offerings of original art, craft items, artis-
tic goods, and unusual and educational toys. The museum school,
incidentally, has the largest non-degree-granting art program in
New England.

At the visitor station you will have been given a map, which
is very helpful in fully exploring this "ongoing, rotating exhibi-
tion of American modern and contemporary outdoor sculpture."

The works are either from the permanent collection (very few), on loan from artists, galleries, or private collectors, or have been created as site-specific, commissioned installations. These installations sometimes use transitory media such as tree trunks, twigs, and ropes, and may be suspended from trees or scattered on the forest floor. Keep your eyes peeled—or make the search into a treasure hunt for your kids. Over the years I have detected a distinct bent toward whimsy and wit, as if the artists felt freer knowing they were not creating "for eternity" and as if the very forest setting inspired them toward gnomes and wood sprites and a playful interaction with Mother Nature.

About eight to ten pieces are rotated in and out each year, and the site-specific installations have varying durations of one to five years. As a consequence, the outdoor exhibit is never quite the same—and yet not completely different—each time you visit. The changing seasons and the beautifully designed year-round garden just below the museum make the sculpture park a slow-motion kaleidoscope of colors and shapes. Alice's Garden, as it is called, serves also as a display for earth-hugging, small sculpture and adjoins the more formal sculpture terrace, which is an integral part of the museum itself and can be accessed only from the interior.

The museum is housed in the original "castle" (complete with coat of arms) that Julian DeCordova built for himself to validate his claim to aristocratic Spanish ancestry and to hold the myriad artworks, souvenirs, and knickknacks he and his wife amassed during years of world travel. Upon his death the land, the house, and its contents were left to the town of Lincoln as a house museum. Contemporary photos show overstuffed, Victorian-type interiors, with architectural details designed to give certain rooms a Moorish or Gothic feel, with paintings five rows deep seamlessly covering many walls. It's all quite over the top (for a surviving example of the frozen-in-time house museum, you might look to Hammond Castle in Gloucester); the Gardner Museum it was not!

The town of Lincoln found itself in a quandary: the house was badly in need of repair, the maintenance bequest was inadequate, the complicated legal and financial provisions hampered swift de-

cisions, and the artwork was deemed not of museum quality. So the town filed—successfully—to be relieved of the responsibility for the gifted property, whereupon the museum was incorporated as a nonprofit, independent organization. Subsequent suggestions by advisory panels and experts led to a complete change: the building was stripped of some badly deteriorated crenellations and porches (giving it a more sober, less Victorian look) and completely overhauled inside and out, and all the artwork was auctioned off. The completely revamped "museum" opened in 1950 with a sturdily renovated building, bare walls, and museum lighting, no traces of former architectural detail—and no collection. The museum then invented itself; with the mission "to establish a new institution which fostered the cause of modern art," it began collecting "contemporary art of the New England region, so that in the course of time, a representative collection may be built." The collection comprises art from 1945 to the present. Today the museum presents a dozen or so individual or group exhibits annually, among which is a yearlong larger-scale, thematic exhibition drawn from the permanent collection, which currently numbers over three thousand artworks.

Over the years, the DeCordova has acquired additional land, established a museum school, built studios and a school gallery, and expanded the museum greatly through the addition of an entrance wing. It was designed by Kallmann, McKinnell & Wood Architects, the firm that built Boston's controversial city hall (1962) and the Hynes Convention Center. The entrance wing is a highly dramatic structure that hugs the side of the hillock all the way down to level ground. The main staircase, in one long sweep up the hill, goes directly from ground level to the third floor along the left wall of the building, which is completely glassed in and thus provides views into the landscape from every step of the staircase. Individual exhibition rooms and areas open off this staircase and vary in size from small alcoves to large, open halls. There are other stairwells connecting these spaces, which are equally dramatic in their own way: they are narrowly enclosed but with very high ceilings. The building is a complex sculpture in itself, and the curators make creative use of all this unorthodox wall and window space.

Evidently well endowed, the museum also has wonderful educational and creative tie-ins to its exhibits, both for children and adults. There is much to discover in this museum, and the ambitious landscaping plan (by Halverson Design Partnership) has been beautifully executed. We should also mention that, from the parking lot, there are woodland trails leading into the adjacent forest preserve and around the pond.

+ PLUS

Walter Gropius House
For anyone interested in modern architecture, there is a pivotal work almost within walking distance: the house that Walter Gropius, the famous Bauhaus director and Modernist architect, built for himself when he came to Harvard to teach architecture in 1937. Built in 1938, a spare, white edifice, with bands of windows set flat into the walls, a flat roof, and glass-block walls, it is an elegant and refined Modernist house with a New England accent, evidenced in the use of clapboard instead of the more typical masonry. The house was bequeathed by Gropius's wife to Historic New England and is open to the public. It looks exactly the way Gropius left it, with all the furniture, books, even clothes in place. Here you experience a snapshot of 1938 avant-garde living, an architecture, in Gropius's words, "radiant and naked, unencumbered by lying facades and trickeries . . . an architecture adapted to our world of machines, radio and fast motor cars."

Directions: Leave the DeCordova grounds, turn right and immediately left onto Baker Bridge Road. The house, No. 68, appears shortly on your left.

Hours: Open June 1 to October 15: Wednesday through Sunday; October 16 to May 31: Saturday and Sunday. Tours are on the hour, 11 A.M. to 4 P.M. Admission $10. Call 781-259-8098 for more details. www.historicnewengland.org.

Lowell

NEW ENGLAND QUILT MUSEUM

18 Shattuck Street, Lowell, MA 01852; Tel. 978-452-4207; www.nequiltmuseum.org.

Directions: From 1-95, take Route 3 North, then Exit 30 to the Lowell Connector. After about 2 miles, take Exit 5B, Thorndike Street. At the fourth light Thorndike merges into Dutton. After two more lights turn right onto Market Street. Parking on street or at the Market Street Garage. Upon leaving the garage, cross Market Street and walk up Palmer Street, take first left (Middle Street); the museum is at the corner of Middle and Shattuck Streets.

Hours: Tuesday through Saturday, 10 A.M. to 4 P.M. (until 5 P.M. May through December); Sunday, 12 to 4 P.M.

Admission: Adults $5, students and seniors $4.

Catalog: Jennifer Gilbert, *The New England Quilt Museum Quilts*, Lafayette, Calif., 1999.

It is altogether proper that the New England Quilt Museum's home should be Lowell, since this city is synonymous with textile manufacture on an industrial scale in the nineteenth century. Although quilts predate the nineteenth century, most were made by hand from machine-made fabrics. The American Textile History Museum, just three blocks south on 481 Dutton Street (www.athm.org), provides the historical and technical context of the making of textiles in this country. The Lowell National Historical Park (www.nps.gov/lowe/) offers unique opportunities to see what a working nineteenth-century textile mill and the life of its (mostly female) workforce were like. The New England Quilt Museum covers the artifacts that were created by women from the eighteenth century to today. Founded in 1987, the museum is dedicated to collecting and preserving antique and contemporary quilts and quilt-related items.

Forty years ago it would have been unthinkable to include

a quilt collection in a book on art museums. When did quilts start figuring as art? Interestingly, the date can be pinpointed—namely, 1971, the year of the exhibition "Abstract Design in American Quilts" at the Whitney Museum of American Art in New York. This was "the first major retrospective to distinguish American quilts as art. The simple forms, bold use of contrasting colors, and large planes of fabric of antique quilts were visually related to the modern American art movements of Abstract Expressionism, Minimal Art, and Color Field painting" (Jennifer Gilbert). To this I would add Op Art, as many a quilt pattern (such as Tumbling Blocks) plays with optical illusion.

The museum collection of over 150 quilts traces their histories and styles, from preindustrial dark and simple woolen quilts of the late eighteenth century and white-on-white Federal quilts, to the burst of color and pattern in chintz or calico quilts, with their British India–inspired fabrics. As fabrics became much cheaper due to the Industrial Revolution, quilting exploded in the mid-nineteenth century. A new form, the friendship or album quilt, came into being, on which verses and signatures were either embroidered or written in indelible ink to serve as mementoes of special occasions, as going-away presents (for the many who moved west), or as tokens of friendship. The spread of quilting into the western territories gave rise to regional styles, while the Amish of Pennsylvania, Ohio, and Indiana maintained their own, more conservative and yet visually bolder styles. They initially frowned on patterned fabrics and pastel colors as being too worldly, and used black fabric to great effect in offsetting large blocks of deep, saturated colors.

The latter part of the nineteenth century saw the emergence of new dyes, the mixing of techniques such as embroidery and appliqué in addition to piecing and quilting. It also saw the birth of "crazy quilts"—Victorian free-for-alls, often in silks and velvets, but with an astounding freedom of mixing shapes, colors, and fabrics and adding memorabilia, ribbons, and personal mementoes, then overlaying it all with elaborate embroidery. Fancy work, indeed! Almost as an antidote, the Colonial Revival emphasized sobriety and a return to simplicity in the decades following the centennial. Log Cabin and Schoolhouse became popular

patterns; colors were often reduced to just two, such as blue and white. (See color insert.)

The Depression era saw another revival of quilting and the emergence of quilting as a home industry, often run by women. Kits containing all necessary fabric already precut led to a certain conformity, but also spread the popularity of quilting.

Quilts made the way from the bed to the wall only in the later twentieth century. Loosening boundaries between crafts and art, weaving as a creative medium, "soft" sculpture, and the rise of feminism all contributed to a creative explosion in the medium of quilt, leading to the art quilt movement. Sizes and formats are no longer bound by function, and many materials, such as wood, metal, and plastic, are included that would not be appropriate on a bed cover. The interplay of color (the fabric swatches), line (the quilting stitches), and outline (the borders between colors), as well as texture, and the unlimited subject matter—from representational to abstract, serious to whimsical—allow for so much variety, innovation, and creativity that the art quilt must be considered an art form on a par with the more traditional ones.

The museum holds four to five exhibitions per year. A few rooms are set aside to show samples from the permanent collection and are, indeed, set up as period rooms, with appropriate furnishings. The New England Quilt Museum Auxiliary conducts the annual Lowell Quilt Festival, held the second weekend in August (www.lowellquiltfestival.org) as a fundraiser. The resource library, workshops, and lectures are open to the public. The gift shop is a quilter's paradise, with fabrics, patterns, kits, materials, finished quilts, and many quilting-related books and CDs.

A word about the building. An 1845 corner brick building with a fine wrought-iron balcony, it used to be the Lowell Institution for Savings, into which many of the young mill girls would deposit their hard-earned money.

+ PLUS

Brush Art Gallery and Studios
The Brush Art Gallery and Studios mounts a juried show of art quilts from around the country each summer. Most are for sale.

During the rest of the year there are changing exhibits of local and regional artists, with an emphasis on the many nationalities that make up present-day Lowell. Beyond the exhibition gallery are fourteen open studios that provide cheap work and sales space for selected artists. It is a wonderful opportunity to meet and observe the artists and do a little shopping, as well.

256 Market Street, in the same complex as the visitor center of the National Historic Park. Tel. 978-459-7819; www .thebrush.org.

WHISTLER HOUSE MUSEUM OF ART

243 Worthen Street, Lowell, MA 01852; Tel. 978-452-7641; www.whistlerhouse.org.

Directions: From I-95 (which is also Route 128 at this point), take Exit 32 (Route 3 North); follow signs for Lowell Connector, then follow signs for Lowell National Historical Park Visitor Center. Park in free lot, obtain permit (and maps) at visitor center. As you exit visitor parking (the way you came in), cross the Merrimack Canal and Dutton Street, proceed one block on Broadway, turn right onto Worthen Street.

Hours: Wednesday through Saturday, 11 A.M. to 4 P.M.

Admission: Adults $5, seniors and students $4.

"Come see where Whistler first met his mother" is the tagline of the museum. Indeed, James Abbott McNeill Whistler (1834–1903) was born here, at the official residence of the chief engineer of the Proprietors Locks and Canals Corporation, Major George Washington Whistler, the artist's father. It is an attractive clapboard house dating from 1823, largely intact. Whistler's family moved away when he was three years old, so his connection with Lowell is marginal, and he himself later invented different, more impressive birthplaces for himself, such as Russia, whence his father was recruited by the tsar to build the St. Petersburg–Moscow railroad. Nevertheless, there are a few intriguing, tangible links to be seen. Right away in the central hallway is a picture of Whistler's . . . father, an official portrait of an important personage executed by

William S. Elwell (1768–1849) of Massachusetts, who also painted a touching portrait of the eighty-year-old Dolley Madison (National Portrait Gallery).

In the first room to the right is the famous/infamous *Whistler's Mother*, except that it is a (full-size) copy, the original being in Paris's Musée d'Orsay. A painter cousin of Whistler's, Edith Fairfax Davenport (1880–1957), made the copy in 1906, by which time the varnish of *Arrangement in Grey and Black* (Whistler's own title for the picture) had darkened to something more like brown and black. The original, meanwhile, has been restored to its original brightness, so this version covers a moment in the famous painting's history.

Upstairs, in the room in which Whistler was born, is a small selection of etchings and a few memorabilia, including an early etching he made when employed by the navy as a cartographer, having been expelled from West Point.

The house was bought in 1908 by the Lowell Art Association and is, to this day, its headquarters and exhibition space. The organization was cofounded in 1878 by William Preston Phelps (1848–1923), whose work is well represented. The association's focus is on representational art from the late ninteenth and early twentieth centuries, mostly from New England. The first-floor rooms are furnished with period pieces and provide a nice setting for the appealing landscapes, portraits, and genre scenes by such artists as William Morris Hunt, Frederick Porter Vinton, Frank W. Benson, Louis Kronberg, and Chauncey Ryder. Upstairs are changing exhibits from the permanent collection, and on the third floor is an artist's studio, made available to an artist-in-residence, which and whom, respectively, you are welcome to visit. The paintings on exhibit are competent and pleasant—yet so unlike Whistler's work, which pushed the boundaries of painting toward the abstract and upset the art critics of his time.

There is a new wing (the Parker Gallery, accessible from the house itself) for changing exhibitions, mostly of New England artists. And last but not least, there is a very lively statue of Whistler himself by Rumanian-born sculptor Mico Kaufman, in the little park adjacent to the museum. Kaufman captured the theatrical quality of Whistler's persona, his marvelous moustache and

the self-assured tilt of his head, while freely applying the butterfly, Whistler's personal signature emblem, to the painter's smock.

+ PLUS

Lowell National Historical Park 🚼
Lowell is famous for being the first planned industrial city in the United States, and the National Historical Park does a wonderful job showing and explaining the complex system that transformed southern cotton bales into yarn and wove that yarn into cloth. All this was driven by the power provided by the thirty-two-foot vertical drop of the Merrimack River at the Pawtucket Falls. The water was channeled into a network of canals and locks that drove the spinning machines and mechanical looms of ten mill complexes and a workforce that grew to over ten thousand. Various tours are available to visit the working Bootts Cotton Mills Museum and its related exhibits, including the boardinghouses for the mostly female workforce. Some tours include boat rides that let you appreciate the complex gate-and-lock system for which Whistler's father was responsible.

Newton

MCMULLEN MUSEUM OF ART, BOSTON COLLEGE

Boston College, 140 Commonwealth Avenue, Chestnut Hill, MA 02467; Tel. 617-552-8587; www.bc.edu.

Directions: Coming from the north, south or west, take I-95 (Route 128) to Exit 24 (Route 30). Proceed east on Route 30, which is Commonwealth Avenue, for about 5 miles to Boston College. From Boston, take Commonwealth Avenue to the Boston College T station.

Parking: One-hour street parking available on Commonwealth Avenue. For longer parking, enter the campus on Campanella Way and take the next right toward the security guard station. Follow this road to the parking garage, which will be on your right. Walk out of the garage at Level 7, turn

left and cross the plaza in front of O'Neill Library to reach Devlin Hall.

Hours: Monday through Friday, 11 A.M. to 4 P.M.; Saturday and Sunday, 12 to 5 P.M.

Admission: Free.

Housed in Neo-Gothic Devlin Hall, facing the central quadrangle of Boston College, this small academic museum compensates for its size by regularly bringing extraordinary and high-quality shows to the Boston area. While other universities that lack a sizable permanent collection tend to concentrate on exhibiting contemporary art (e.g., Tufts, MIT, BU, UNH), the McMullen's exhibitions have ranged from antiquity to today and included art and artifacts from all over the world, always in the context of a compelling idea or concept. These are academic exhibits in the best sense of the word: thoughtful, intellectually challenging, frequently presenting underserved and under-exhibited areas or masters, and often interdisciplinary. They are supported by lectures, concerts, gallery talks, readings, symposia, and other events.

How do they do it? It seems several forces are at work: the museum is small enough that it is run by and completely integrated into the Art Department; it also interacts closely with other academic departments, including theology. As Nancy Netzer, the McMullen's director since its inception in 1993, put it: "We are an academic-driven institution, where the private enterprise of faculty research is shared with the public, in the form of an exhibit, a catalog, a film, a symposium."

The other driving force is the faculty's excellent relationship with smaller European museums, individual collectors, and with U.S. academic and public museums. The traveling exhibits chosen always adhere to high artistic and intellectual standards. I have yet to see a merely trendy, edgy, or silly show at the McMullen. Concentrating on quality over quantity, there are just two to three exhibits per year, each of a manageable size that encourages in-depth viewing in a tranquil setting. They often receive national media attention.

To give a certain permanence to these academic results, the

Web site lists past exhibitions both by period and by country; you can "visit" these past shows and view slideshows of selected works, read essays, listen to lectures, and enjoy guided tours. Catalogs of previous shows are available for sale. Conversely, before a show even opens, the audio tour can be downloaded to MP3 players, so you can come prepared and use your own equipment.

The permanent collection dates back to the nineteenth century and reflects the religious (Jesuit) nature of Boston College, its Irish heritage, and the unpredictable nature of gifts and bequests. There is a sampling of mostly Italian religious painting from the sixteenth through eighteenth centuries, often copies after famous masters. A group of large fifteenth-century Flemish tapestries, given by William Randolph Hearst to adorn the Neo-Gothic buildings, depicts both mythological and biblical themes. And there is a collection of American art, mostly nineteenth century and mostly from New England; Surrealism and contemporary Irish art are also well represented. Among the oddities of the McMullen are collections of fans and of Irish delftware. In all, there are about five thousand items, not necessarily works of art; an electronic database of these items is in progress.

The tapestries are on semipermanent display, and a small group of paintings is on view in the downstairs gallery, unless the spaces are needed for the main exhibit. But you would not visit the museum for its permanent collection. Rather, trust the gifted and daring faculty and the museum's director to delight you with an intellectual and visual feast every time you visit.

+ PLUS

Bapst Library, Boston College
In 1909, the Boston firm of Maginnis and Walsh won the bid to design the new Chestnut Hill campus of Boston College. Known for churches and campus buildings (Holy Cross in Worcester, Massachusetts, and Notre Dame in South Bend, Indiana), they are responsible for the Oxford-inspired Neo-Gothic core campus, including Devlin Hall. The jewel of the original campus is Bapst Library, opened in 1928 and until 1984 the main library. It has been called "the finest example of Collegiate Gothic in

America." From the ground floor, a graceful, high-ceilinged double staircase leads up to Gargan Hall, the main reading room. On the first landing, note the stained-glass window with scenes from six Shakespeare plays, flanked on the adjoining walls by small vignettes of Shakespearean heroes. Gargan Hall is indeed "a cathedral to learning," with soaring vaults and superb stained-glass windows. "A syllabus in stained glass," they illustrate the subjects of study in a university. Each window represents one topic, which is illustrated in various historical and mythological scenes and flanked by major contributors to the field. Detailed labels near each window make the identification easy. A printed explanatory sheet is available from the front desk.

Open 24 hours a day on weekdays until Friday at 5 P.M.; Saturday, 9 A.M. to 5 P.M.; Sunday, 1 to 5 P.M.

North Adams

MASS MOCA (MASSACHUSETTS MUSEUM OF CONTEMPORARY ART)

87 Marshall Street, North Adams, MA 01247; Tel. 413-622-2111; www.massmoca.org.

Directions: From 1-90 (Mass. Pike) take Exit 2 toward Lee. Take Route 20, which will feed into Route 7 to Williamstown. In Williamstown take Route 2 East for 5.2 miles to the center of North Adams. Take exit ramp marked "For Downtown Business District, Route 8." At the traffic light take a left onto Marshall Street, drive under the overpass, and MASS MoCA will be on your left.

Hours: September through June: 11 A.M. to 5 P.M. daily, closed Tuesday. July and August: 10 A.M. to 6 P.M. daily. Tours are offered weekdays at 2 P.M. and weekends at 12 and 3 P.M.

Admission: Adults $12.50, students $9, children 6–16 $5; tour included in admission.

Catalog: None, but the Center for Creative Community Development, also housed in the complex, makes the case for "Economic Revitalization through Cultural Institutions,"

with MASS MoCA presented as a prominent case study: see www.c-3-d.org.

The Massachusetts Museum of Contemporary Art has been the savior for a twenty-five-building industrial complex that had been abandoned and neglected. Yet to call this a museum is misleading. It is, rather, an art space of gigantic proportions, a tabula rasa on which to create, install, or perform large, complex, and category-defying works.

This complex had been an industrial site since colonial times (due to the Hoosic River). Its last tenant, Sprague Electric Company, had produced, from 1942 through 1985, electric components for the war effort, the space program, and the consumer electronics market, employing over 4,000 workers until cheaper competition drove it out of business. The demise was devastating to the town: 70 percent of storefronts were empty, unemployment at 20 percent. Into the void stepped Thomas Krens, then director of the Williams College Art Museum, on the lookout for a space in which to show large-scale contemporary artworks. Of space, there was enough: some 2,000,000 square feet of empty floor space in North Adams, 780,000 specifically in the Sprague complex. Creating an exhibition space for contemporary art seemed like a good idea. Ample state funding was pledged, later withheld; private fundraising started and snowballed; plans for a museum with a permanent collection were abandoned in favor of a multifunctional art space; and in 1999 the Massachusetts Museum of Contemporary Art (MASS MoCA) opened its doors. Many doubted that cutting-edge art could attract crowds, but they have been proven wrong: 120,000 annual visitors have spawned a boomlet in hotels and restaurants, but, above all, North Adams has become a magnet for artists and brainy businesses. The complex, really more a campus than a museum, includes restaurants and theaters, but also rental office space, which in turn helps fund the artistic endeavors.

At the heart are the galleries, 110,000 square feet of exhibition space, with one gallery as large as a football field. The raw industrial architecture is not hidden and works well as "perhaps the most fertile site in the country for new art." Forget framed

paintings or sculptures on pedestals. Think, instead, large instal-
lations, multimedia works, and one-time artistic events. Often
the work will come into being during the residency of an in-
vited artist. While some of the works are silly and many hard to
understand, there is always something on view that will take your
breath away—one way or another. There is a freshness, audacity,
and sense of exploding limits and expectations that can be very
bracing.

Five to seven shows are presented simultaneously, and they
tend to stay rather long, typically several months. (This is no
doubt due to the fact that the vast majority of visitors arrive in the
few summer months.) There are some works that have found a
more or less permanent home at MASS MoCA, although nobody
talks about permanent collections, only about ongoing exhibits.
Take *Tree Logic* by Natalie Jeremijenko, an array of inverted tree
saplings in planters, hanging from a grid system of poles and wires
along the entryway to the museum. They were installed in 1999,
and as a gardener myself I did not think they would survive long.
But in 2007 they still were there, displaying their contorted ef-
forts to grow toward the light in spite of having been hung upside
down. Another ongoing installation is Joseph Beuys's *Lightning
with Stag in Its Glare*, an environment consisting of many dispersed
pieces cast in bronze, on long-term loan from the Philadelphia
Museum of Art.

If you live or vacation in the area, you should check out the
program of film, video, dance, music, artists' talks, and theater
that is offered year-round. Here, too, be prepared for edgy, pro-
vocative events that blur the lines between genres and bring avant-
garde events to a dynamic corner of the Berkshires.

+ PLUS

Hallmark Museum of Contemporary Photography
(Turners Falls)
The Hallmark Museum of Contemporary Photography repeats
the story of North Adams and MASS MoCA on a miniature scale.
Housed in a nineteenth-century opera house, in the "renaissance"
district of Turners Falls, it is part of a gradual revitalization of a

planned industrial village that produced paper, cutlery, and cotton from the late nineteenth century until about 1940. The mostly abandoned industrial buildings still line the Connecticut River and the canal that circumvented the eponymous falls. HMCP opened to the public in 2006 and functions currently as a gallery that mounts between four to eight shows a year featuring the work of regional, national, and international photographers. The exhibitions so far have included such well-known photographers as Jay Maisel, Douglas Kirkland, Paul Caponigro, and Ron Rosenstock. Expanded space opened in early 2008 in the 1860 Crocker Bank Building across the street, to allow for study, research, lectures and seminars, and expanded exhibition space, as well as the assembly and storage of a representative collection of contemporary photography (defined as 1975 or later).

85 Avenue A, Turners Falls, MA 01376; Tel. 413-863-0009; www.hmcp.org.

Directions: The museum is about 40 miles east of North Adams. Take Route 2 East to Gill-Turners Falls Bridge, cross bridge to traffic signal; the museum is on the left at the intersection. Open Thursday through Sunday, 1 to 5 P.M. Admission is free.

Northampton

SMITH COLLEGE MUSEUM OF ART

In the Brown Fine Arts Center, Elm Street at Bedford Terrace, Northampton, MA 01063; Tel. 413-585-2760; www.smith.edu/artmuseum.

Directions: From the north: Follow I-91 to Exit 20. Go south on Route 5 (King Street) for 1.4 miles. Take a right onto Route 9 (Main Street), travel 0.3 miles through the downtown area and at light bear right onto Elm Street. The Brown Fine Arts Center is the large brick, glass, and zinc building on your left.

From the south: Follow I-91 to Exit 18, turn left onto Route 5 North. Continue for 1.1 miles to Main Street (Route 9).

Make a left onto Main Street, travel 0.3 miles through the downtown area and at light bear right onto Elm Street. The Brown Fine Arts Center is the large brick, glass, and zinc building on your left.

Hours: Tuesday through Saturday, 10 A.M. to 4 P.M.; Sunday, 12 to 4 P.M.; check summer hours.

Admission: Adults $5, seniors $4, students with ID $3, children 6–12 $2. Free to all on the second Friday of the month, 4 to 8 P.M.

Catalogs: The Smith College Museum of Art: European and American Painting and Sculpture 1760–1960, New York, 2000; and other specialized catalogs.

Smith College, founded in 1875 for the education of young women, set out to be intellectually equivalent to any men's college, while putting a strong emphasis on the arts. This early determination—its first building, College Hall, already contained an art gallery—led to the establishment of one of the finest college art museums in the nation. As was typical for the times, plaster casts of Classical sculpture, and photos or engravings of European paintings provided models for the students to learn from and copy. The founding president felt, though, that it was important that students be exposed to artworks of their own time as well, and began to assemble a collection of contemporary American art, which by 1879 already numbered twenty-seven paintings, often bought directly from the artist. A prescient purchase was Thomas Eakins's *In Grandmother's Time* of 1876, the first Eakins to enter any public institution. When the noted Tonalist painter Dwight W. Tryon (1849–1925) joined the faculty in 1886, he drew upon his connections in the New York art world to solicit gifts or make purchases. He himself donated many works to the museum and crowned his devotion by funding, upon his retirement in 1924, the first museum building on campus, the Tryon Gallery. A breakthrough work of his own career, *The First Leaves* of 1889, hangs in the museum today, keeping company with some of the artists he collected for the museum: James McNeill Whistler, Augustus Saint-Gaudens (the rather daring *Diana of the Tower*), William Morris Hunt, Childe Hassam, William

Merritt Chase, Rockwell Kent, Albert Pinkham Ryder, and others.

Generous funding and the leadership of the first professor of History and Interpretation of Art, Alfred Vance Churchill, resulted in a purposeful, clearly planned expansion of the collection, which was named, in 1919, the Smith College Museum of Art, with Churchill as its director. To quote from his planning document: "It seemed to me that attention must be devoted, first of all, to the cultures from which our own is derived and on which it rests—Egypt, Greece, Rome, and the rest, down to the Renaissance. . . . The next step was the choice of a special field for concentration—a difficult choice. My proposal was this: Let us select, not a nation or a school but a *topic*—The Development of Modern Art." He postulated that modern art began with the French Revolution, when "ancient beliefs, traditions and practices were ruptured and new ones started in every realm of thought including art." While he demanded that artworks acquired be of high quality ("A weak or inferior work could only be misleading to the student") and show the essence, the "handwriting," of the artist, he was willing to include fragments or unfinished works for their instructional value. Among the latter is Paul Cézanne's *A Turn in the Road at La Roche-Guyon*, which he painted while a guest of Renoir's in the Ile de France, and left with Renoir as a gift. To quote from the catalog: "The unfinished state of the painting, with areas of raw canvas, pencil markings, passages partially resolved with halting strokes, aids in our discovery by exposing stages of Cézanne's working process."

A large, early work by Gustave Courbet (1819–1877), also unfinished, has a fascinating story to tell. Acquired under the title *The Preparation of the Bride*, it seems to show a bride being dressed amid a group of women setting a table and sheeting a bed. Research and X-rays, however, uncovered that the painting originally represented the preparation of a dead girl (the washing of a nude corpse), which had been overpainted after Courbet's death to show a more uplifting and thus more saleable subject matter.

The subsequent director, from 1932 to 1946, was Jere Abbott, who had been associate director of the Museum of Modern Art in its early years. He brought a whiff of Modernism to Northamp-

Ernst Ludwig Kirchner, *Dodo and Her Brother*, 1908–20.
Oil on canvas, 67⅛ × 37¹/₁₆ in (170.5 × 94.1 cm). Smith
College Museum of Art, Northampton, Massachusetts.
Purchased SC 1955:59. © by Ingeborg & Dr. Wolfgang
Henze-Ketterer, Wichtrach/Bern.

ton, acquiring in 1932 a major Cubist painting by Picasso, *Table, Guitar and Bottle* of 1919. We owe to him the excellent representation of French nineteenth-century art (Bonnard, Degas, Manet, Monet, Seurat, Vuillard) and certain Modernists, as well as his outright gift of Paul Klee's (1879–1940) *Goat*.

When you view the museum's holdings in nineteenth- and early-twentieth-century European and American art on the third floor, note the stunning cross-vistas this new, light-infused space allows. There are intriguing visual alignments, for example, of Jean Arp's marble *Torso* with Saint-Gaudens's *Diana* and Wilhelm

Lehmbruck's *Torso of the Pensive Woman*, while Rodin's *Walking Man* is visible through large picture-windows in the distance.

Ancient and prerevolutionary European artworks, on the second floor, provide the historical survey that Churchill called for. Smith also has an extensive collection of prints and drawings, of which a selection is always on view in the specially designed print gallery (second floor). They should not be missed. Late-twentieth-century and contemporary art is on the lower level and attests to the ongoing, active acquisition—through purchase or bequests—of high-caliber modern art (Franz Kline, Louise Nevelson, Robert Motherwell, Helen Frankenthaler).

Today's museum is housed in the newly renovated, expanded, and renamed Brown Fine Arts Center, designed by Polshek Partnership Architects of New York. The complex, clad in brick, glass, and zinc, also houses a print study area, the Art History Department, and classrooms. Quite a bit of buzz was created by the artistically designed restrooms on the lower floor. Be sure to take a look! Another commission project is visible—and usable—throughout the galleries. Under the title "Sit Up & Take Notice!" eleven New England artists designed benches of great elegance and whimsy in a variety of woods and techniques (there is even a glass bench), and it is lovely to sit on them, feel their textures, and enjoy the variety of artistic expression and craftsmanship.

The atrium between the museum and the Hillyer Art Library is dominated by Rufino Tamayo's (1899–1991) mural *Nature and the Artist: The Work of Art and the Observer*, which he created for the original art library building, since razed. Tamayo is part of the group of Mexican muralists active in the 1930s and '40s, in both Mexico and the United States (see also José Clemente Orozco at Dartmouth College). You can contemplate this ninety-nine-by-forty-three-foot colorful fresco while having a delicious snack at Sam's Café, also in the atrium.

+ PLUS

Campus Center

For coffee or lunch, or just a break, you can also stroll down Elm Street for about three hundred yards and enter the blinding white,

new Campus Center, built by Weiss/Manfredi Architects of New York City in 2003. Its Elm Street façade is narrow and modest, and seems to speak a New England vernacular of white board-and-batten walls. Once inside, the building expands dramatically, like a three-dimensional river delta, until it spills, via terraces and stairs and lit by roof-high glass-curtain walls, onto the green lawn of the center campus. It's such a cheerful building that we found ourselves dawdling there after lunch, comfortably seated in ultra-modern easy chairs, observing the bustle of coeds and teachers. A little further down on Elm Street, taking a left onto College Lane, you will find the admissions building, where you can pick up a campus map to further explore the lovely campus.

Pittsfield

BERKSHIRE MUSEUM 🛒

39 South Street, Pittsfield, MA 01201; Tel. 413-443-7171; www.berkshiremuseum.org.

Directions: Take Exit 2 off Mass. Pike. After tollbooth take a right. Follow Route 20 through Lee and Lenox. In Pittsfield, Route 20 becomes Route 7, which is South Street. The museum is on the right, shortly before the rotary at the center of Pittsfield, roughly across from the highest building, the Crowne Plaza. Parking free at local streets or paid at the Crowne Plaza garage.

Hours: Monday through Saturday, 10 A.M. to 5 P.M.; Sunday, 12 to 5 P.M.

Admission: Adults $7.50, children 3–18 $4.50, students with ID and seniors $6.

With one world-class art museum, the Clark Art Institute in Williamstown, two home museums (Daniel Chester French, Norman Rockwell), and a plethora of excellent college-based museums in the vicinity, why would or should you visit the Berkshire Museum? One answer might be that you have children and want to ease them into museum going. The Berkshire has something of

the flavor of small-town museums of times past, betraying its origin as an athenaeum. It has science, it has local history, it has art; it has a mummy, an aquarium with a touch tank, dinosaurs, minerals, and plaster casts of Greek and Roman sculpture (which other museums have long ago dispensed with but which used to be the mainstay of early art museums). It has bits and pieces of Egyptian, Greek, and Roman artifacts; it has Tang dynasty clay figurines. It has miniature animal dioramas, and, in the cafeteria, there is a Rube Goldberg–like contraption of a vending machine, which is both funny and functional—and its bathrooms have child-level toilets and sinks.

And then, on the second floor, it has some perfectly astounding, first-rate works of art. In the European gallery there is Adriaen Isenbrant's (ca. 1500–1551) *Flight into Egypt*, with its deep perspective into an open landscape dotted with little figures and episodes and buildings, and ending in turquoise-blue distant mountains. (This would be a perfect picture to draw children into, asking them to find lots of details—a variation on *Where's Waldo*.) Another Late Medieval painting, dated 1477, is *Adoration of the Magi* by the Spanish painter Juan Pons. Here the figures are crammed in the foreground with just a little window of a seascape in the upper right. "The painter combines a native delight in rich brocades, gold and Burgundy red, with a Flemish-inspired insistence on realistic detail. He leaves no doubt, for example, that Joseph was a carpenter" (Faison). A small Dutch interior, Pieter de Hooch's (1629–1684) *The Music Party*, is a work of Vermeer-like beauty and intimacy.

In the American gallery, there is the fine, bust-length *Portrait of John Newton* by John Singleton Copley (1738–1815), Thomas Moran's (1837–1926) *The Last Arrow*, a romantic and wistful depiction of the incursion of the white man into Native American territory, a charming *Portrait of Eliza Shepard Pumpelly* by John Singer Sargent given by a descendant of the sitter, and Frederic Church's *Valley of the Santa Ysabel* of 1875. Here the great Hudson River painter seems to be intoxicated by the vision of sun rays penetrating the mist that fills the deep gorge of the river, with some dramatic palms in the foreground indicating the tropical setting in New Granada, i.e., present-day Colombia.

Also on the second floor is an exhibit devoted to Alexander Calder's (1898–1976) very early work. Best known for his mobiles, he was an avid tinkerer from childhood and a trained engineer. He supported his budding artistic career by designing wooden pull toys and located a company in Wisconsin that produced and sold these "futuristic toys for advanced kiddies." His prototypes from 1927, on display here, show his early fascination with mobile three-dimensional objects. The frog, duck, fish, bear, seal, and others move in funny and ingenious ways, driven by cranks, levers, and eccentric wheels. How do we know this? Because the museum has thoughtfully provided replicas in the gallery, which you can try out on the spot. So even if you don't have children with you, play with these intriguing toys, and then contemplate Calder's earliest serious proto-mobiles, also on display, which look rather inelegant and are starkly white, not disguising their crank mechanism and visible bolts. Everybody has beginnings, and this delightful little exhibit provides a glimpse into the creative infancy of a great American artist. In 1930 the Berkshire Museum gave Calder his earliest commission, two mobiles hanging in niches on either side of the stage of the museum's theater; they were designed to flutter in the airflow of the original ventilation system. While they don't move anymore, their colorful, simple forms show the accomplished artist in the making.

Calder's father, Alexander Stirling Calder, who himself was a renowned public sculptor, left his mark in the final room to be considered, the Ellen Crane Memorial Sculpture Gallery. He provided a carved stone fountain and its wood enclosure for this very room, a newly renovated, skylit Art Deco hall. The sculptures are mostly Classicist Italian and American marbles from the nineteenth century. Yet here, too, there are some real surprises. Six limestone funerary busts from Palmyra (Syria), dated circa 150 A.D., stare frontally into space, more Eastern than Roman and anticipating Byzantine Early Christian art. A small marble panel from sixth-century Italy of a bishop and a few monks makes one wonder what its place in art history or its architectural context might have been. There is also a model head by Daniel Chester French (see Stockbridge), and a bust by British sculptor Jacob Epstein (1880–1969).

+ PLUS

Arrowhead, Herman Melville's home

Herman Melville moved his family to Pittsfield in 1850 at the urging of Nathaniel Hawthorne and found that the move revived his creative energies. He finished *Moby Dick* in 1851 and wrote *Pierre, The Confidence Man* and many short prose works during his thirteen-year stay. The simple farmhouse, which he dubbed "Arrowhead," is on the outskirts of Pittsfield and open to the public. From his desk Melville had a full view of massive Mt. Greylock, and the barn was the locus of literary conversations with his many visitors, including Hawthorne and Longfellow. The massive center chimney of the eighteenth-century farmhouse inspired the rambling musings of *I and My Chimney*.

780 Holmes Road; Tel. 413-442-1793; www.mobydick.org.

Directions: From the center of town follow Route 7 South for 4 to 5 miles, past Yankee Candle. At the next light turn left onto Holmes Road. Arrowhead is 1.5 miles ahead on the left. During summer months: hourly guided tours between 11 and 4 P.M. (last tour at 3 P.M.) daily except Thursdays. Admission charged. There is also a hiking trail on the forty-acre property and exhibits by the Pittsfield Historical Society.

Provincetown

PROVINCETOWN ART ASSOCIATION AND MUSEUM

460 Commercial Street, Provincetown, MA 02657; Tel. 508-487-1750; www.paam.org.

Directions: If you arrive by boat (highly preferable to driving), walk the length of the wharf, then turn right onto Commercial Street; walk for about ten minutes. By car from anywhere on Cape Cod, take Route 6 to Provincetown. At the intersection with Race Point Road (which leads to Race Point Beach) turn left instead onto Conwell Street, then right onto Bradford Street. Take any commercial parking

you can find. Bradford and Commercial run parallel, so any connecting lane lets you reach Commercial. Turn left until you reach PAAM, at No. 460.

Hours: October through May: Thursday through Sunday, 12 to 5 P.M. Memorial Day to September: Monday through Thursday, 11 A.M. to 8 P.M.; Friday, 11 A.M. to 10 P.M.; Saturday and Sunday, 11 A.M. to 5 P.M.

Admission: Adults $5, children under 12 free, no charge Friday evenings.

Catalog: Provincetown Art Association and Museum: The Permanent Collection, published by the museum in 1999, lists the holdings as of that date and has selected color and black-and-white reproductions and several essays on the history of the institution.

Arriving by boat on a perfect summer day, it's easy to see why so many artists made the very tip of Cape Cod their summer home. Provincetown is surrounded by water on three sides, and all that reflected sunlight bathes the village (and it certainly has the feel of a village) in a shimmering, sparkling atmosphere that seems to clarify objects and intensify colors.

Summer art colonies were a product of the nineteenth century: they depended on rail travel, the interest in plein air painting (and the invention of easily transportable oil-paint tubes), and the emergence of a middle class that could afford summer vacations and art buying. Ogunquit, Gloucester, Cornish, Lyme . . . the East Coast is dotted with summer art colonies. Provincetown is the oldest and the most durable; to this day, many artists make it their summer or year-round home and scores of galleries provide the intermediaries between the artists and the buying public. I can't imagine there is another place on earth with this ratio of galleries to inhabitants.

When the first artists arrived toward the end of the nineteenth century, Provincetown was a fishing village settled mostly by Portuguese. Room and board was cheap, a fishing shack made a fine studio. By 1899 the first art school of many was established by Charles Hawthorne (1872–1930). The schools attracted as students both professionals and amateurs, the latter preponderantly

women. The prevalent style was Impressionism, which by the twentieth century had become the established "academic" style, and certainly lingered much longer in the United States than in Europe.

In 1914 a group of artists and townspeople joined forces to provide "a permanent art exhibit as one of the attractions of the town." From its beginnings, the Provincetown Art Association settled on a rhythm of two summer exhibits and pursued the acquisition of a permanent collection, mostly through donations by exhibiting artists. In 1915, the first duo of exhibits listed forty-four artists for the July and sixty for the August show. During WWI, many artists who would have gone to Europe during the summer months chose Provincetown instead.

Writers and actors followed (John Reed, Eugene O'Neill); the Provincetown Players, a troupe of mostly Greenwich Village transplants, brought modern plays and a cooperative organization to Provincetown, opening the Wharf Theater in a decrepit old fishing shack in 1916. *Bound East for Cardiff*, O'Neill's first play on any stage, had its premiere here.

This intrusion of bohemians and avant-gardists was matched by painters who had gone beyond Impressionism, been deeply affected by the 1913 Armory Show, and embraced Cubism, such as Marsden Hartley, Charles Demuth, William and Marguerite Zorach. While the PAA was more conservative, such members as Edwin Dickinson, Ross Moffett, and Karl Knaths bridged the old and new, still painting from nature but using simplified formal means.

In 1918 the PAA acquired a permanent home and held exhibitions there starting in 1921; today Hargood House is still used and is connected to the new museum, which is a stunning expansion and renovation by the firm of Machado and Silvetti of Boston.

PAAM struggled for many years to reconcile the conservative and modern camps. Alternating exhibits, or exhibits divided between opposite walls, still managed to show the work of painters like Ben Shahn, Stuart Davis, Jack Tworkov, and lesser-known Modernists. Meanwhile, Edward Hopper summered in nearby Truro from 1930 to the end of his life, painting several Provincetown subjects. Things took a decisive turn when German-born

Provincetown Art Association and Museum, Provincetown, MA. Machado and Silvetti Associates, Boston, architects. Photograph © Anton Grassl/Esto.

Abstract Expressionist and sought-out art teacher Hans Hofmann (1880–1966) opened his summer school in 1935. It made Provincetown a national—not just a regional—art colony, as well as the breeding ground for a number of Abstract Expressionists. Robert Motherwell, Adolph Gottlieb, Jackson Pollock, Lee Krasner, and William Baziotes all came to Provincetown in the 1940s, some staying, some eventually preferring the Hamptons, validating Adolph Gottlieb's dictum: "When you are a young artist Provincetown is the place to be. When you make it, move to East Hampton."

Some of these developments occurred outside the orbit of the PAAM, but in recent decades, PAAM has been able to regain its central role as a nurturer and collector of artists of Cape Cod. (See color insert.) The collection now counts almost two thousand pieces and also contains rich archival material relating to the history of the Provincetown art colony and its artists. Open year-round, the museum offers two sets of concurrent exhibitions in early and late summer, some retrospective and drawing on its

own holdings, some showcasing living artists. Concerts, lectures, workshops, and art classes round out the offerings.

+ PLUS

The Mayflower Compact; Unitarian Universalist Meeting House 🛒

Provincetown, not Plymouth, was where the pilgrims first landed and where the Mayflower Compact was written and signed. The town has immortalized this event by erecting—rather implausibly—an Italian-style tower, which can be seen from afar and provides excellent views over Cape Cod bay. At the bottom of the hillock and facing Bradford Street is a large bronze relief by Cyrus E. Dallin (see Cyrus E. Dallin Museum in Arlington, Massachusetts) commemorating the signing of the Mayflower Compact. Executed in his vigorous style, it shows a group of pilgrims, including women and a boy, for whom his son was the model.

Just a few steps away, at 236 Commercial Street, stands the Unitarian Universalist Meeting House of Provincetown, built in 1847. The pretty, white-clapboard and steeple-crowned church is not unusual from the outside. The interior, however, is a tour de force: it is painted entirely in trompe l'oeil (i.e., fool-the-eye fashion), so that the flat walls and ceiling seem to bulge with pilasters, alcoves, and panels, while the ceiling is modeled on the dome of the Temple of Jupiter in Athens.

The church is open for viewing Monday through Thursday, 9 A.M. to 1 P.M.; Tel. 508-487-9344; www.uumh.org.

Salem

PEABODY ESSEX MUSEUM 🛒

East India Square, Salem, MA 01970; Tel. 978-745-9500, 866-745-1876 (toll-free); www.pem.org.

Directions: Call directions hotline 978-745-9500; ext. 3145, or take Route 128 North to Exit 25A, follow Route 114 into Salem, then follow the signs for PEM and/or visitor cen-

ter parking. The museum is located on the Essex Street pe-
destrian mall, opposite the visitor center. There are several
municipal parking lots and garages nearby. Street parking
available around the Salem Common, which you pass on
the way in.

Hours: Open Tuesday through Sunday, 10 A.M. to 5 P.M., closed
Thanksgiving, Christmas, and New Year's Day.

Admission: Adults $15, seniors $13, students $11, children 16
and under free. The historical houses are included, but a
time slot needs to be reserved at the admissions desk. $4
extra for Chinese House and some special exhibitions.

This museum can easily overwhelm you, should you try to absorb
it all on one visit. The museum's holdings are literally "all over the
map," brought back from every continent, and its history is just as
diverse, rich, and multifaceted. Founded in 1799, America's oldest
continuing museum boasts fine art, crafts, manufactured goods,
and ethnological specimens from all five continents; architecture,
furniture, and clothing. But what holds everything together is the
maritime experience, the story of Salem's enterprising merchants
and intrepid sea captains who roamed the far corners of the world
and brought back the useful and the luxurious goods that made
them wealthy, as well as the souvenirs and oddities that piqued
their fancy. Forget the witches. That's another Salem, and today
mostly a hypercommercial, if not tawdry, enterprise.

In 1799 Salem captains and merchants founded the East India
Marine Society, which was open to "any persons who shall
have navigated the seas near the Cape of Good Hope or Cape
Horn, either as Masters or Commanders or (being of the age of
twenty-one years) as Factors or Supercargoes of any vessels be-
longing to Salem." Their sumptuous assembly room, East India
Marine Hall of 1824, held their first foreign trophies and memen-
toes and is embedded in the current museum. The solemn ele-
gance of the hall is enlivened by a spirited arrangement of ships'
figureheads. Look for the one from the ship *Rembrandt*!

Today's PEM emerged from the fusion and permutation of
such various other institutions as the Essex Historical Society, the
Peabody Academy of Science, the Salem Athenaeum, the Phillips

Library, and the Museum of the American China Trade, all of which have origins in the early nineteenth century and were founded to advance trade and exploration, foster learning, and preserve local history. As the museum's holdings grew, so did the building, with additions built in 1884, 1906, 1952, and 1974. In 1988, the Asian Export Art Wing, with its lovely Asian Garden, was created by the firm of Kallmann, McKinnell & Wood (see DeCordova Museum) to receive the holdings of the Museum of the American China Trade. The latest and most transforming addition was finished in 2003 and is discussed below.

The PEM of today reaches far beyond the museum itself and includes twenty-three historic American buildings scattered in the vicinity of the museum; some were moved to this location, forming what is indeed the first house collection by a museum in America. Four are designated national historic landmarks, including the original East India Marine Society building. The John Ward House of circa 1684, the Peirce-Nichols House of circa 1782, and the Gardner-Pingree House of 1804 are fully furnished examples of their respective periods (their visit is included in the price of admission). Tucked in between the houses are lovely historical gardens.

The most spectacular house, however, is not American but Chinese. Yin Yu Tang (Hall of Plentiful Shelter) is a merchant's house from circa 1800 from a village in southeastern China. In a bicultural cooperative venture, the house was acquired, completely dismantled, and shipped, then reassembled and restored in Salem. It is a worthy counterpart to the elegant merchants' mansions you see all over Salem. Built like a fine piece of furniture with mortise-and-tenon joinery, two stories high, it accommodates sixteen bedrooms and several ceremonial rooms, all opening to galleries surrounding an interior courtyard, a "sky well" that provides all the lighting for the rooms. Eight generations of the same family lived in this compound into the late 1970s, and their belongings, from chests, baskets, beautiful beds, clothes, family photos, and Mao posters down to chamber pots, are all here. The lived-in quality of the house is almost eerie and is unfortunately absent from the Web site's Fly-Through virtual tour. The house, forecourt, and outbuildings are integrated into the museum, but

given enough surrounding garden space that one can see the elegantly stenciled curtain walls through the large glass panels of the museum's central atrium.

This atrium forms the hub of the museum and the core of the 2003 addition by noted Canadian architect Moshe Safdie. As you step into the museum, take your time to take in the high, narrow, but light-flooded entrance passage (admissions desk on the left, fabulous museum store on the right): looking up, you will see a ceiling shaped like an inverted wooden boat, one side evoking the structural ribs, the other, clad in smooth metal planks, suggesting the outside surface. This passage follows the street that was once here and now leads to the central atrium. Here again, maritime topics are alluded to, without being obtrusive or kitschy. The soaring, curvy glass ceiling picks up on the rib structure of the entrance, but in a more expansive way. During the summer months, the sunlight can be partially blocked by sail-like, white fabric shades; when you explore the passageways and balconies surrounding the atrium, you get the feel of walking on a cruise ship's different decks—even the ventilation holes seem to resemble portholes. The overall effect is dramatic, bright, and eminently welcoming. Café tables and chairs invite one to linger over a cup of coffee or a simple lunch. (There is also a very elegant restaurant, the Garden Café, overlooking the lovely Asian Garden and providing al fresco dining during summer months).

But you came to see the museum holdings, after all. By all means get a visitor's map and get your bearings. Let me quickly list the main offerings and be sure to be selective.

The third floor is mostly dedicated to temporary exhibits. These are always interesting, sometimes stupendous, and like the museum itself cover the art and culture of all continents. Check out the listing for the time of your visit and see whether the current show is a must-see for you. The other time-sensitive offerings are the Chinese House and the historic houses mentioned above. If these are your main interests, make sure to reserve a time slot for the respective tours.

Located on the ground floor are the most "permanent" exhibition areas: Maritime Art, American Decorative Arts, Asian Export Art from China, and Korean Art.

PEM's collection of maritime art and artifacts is considered the finest in the country. It contains about thirty thousand paintings, drawings, and prints, as well as twenty thousand objects, such as ship models, navigational equipment, decorative art (figureheads, scrimshaw), tools, weapons, and more. Of special interest is the elegant grand salon of *Cleopatra's Barge*, the earliest private American sea-going yacht, built in 1805 for a local grandee, which set the standard of luxury for decades to come. The exhibits usually mix images and physical objects, historical times and countries of origin in order to explore specific topics. This freedom from chronology and strict categories is a hallmark of the entire museum and makes for wonderful juxtapositions and an intellectually bracing experience.

Asian art at PEM is unlike Asian art in a traditional museum—let's say, the Museum of Fine Arts, Boston, with its famous collections of Japanese and Chinese art. PEM's exhibits tend to begin where most museums' exhibits end, somewhere in the nineteenth century. The driving force behind what we see is— money; i.e., global trade for profit. We see the items that were of value to Americans; some were part of the foreign culture (silks, finely carved furniture, paintings, pottery) and some were made specifically for the foreign trade, as documented by the extensive, if not exhaustive, collection of export china. So each object poses the question anew: is this art, is it kitsch, is it an everyday object that's especially well made or just exotic, is the foreign culture degrading itself by providing inferior wares because that's what the importing nation wants? No matter where you come out on these questions, the exhibits are utterly fascinating and mind expanding, and unlike anything else in New England museums.

In an unusual commitment, the museum continues to collect contemporary art from the old exporting nations, China, Korea, India, and Japan. These exhibits are mostly on the second floor, where there are also displays of Oceanic, African, and native North American art, again mingling old and new. These exhibits are either truly permanent or change every four to twelve months, to showcase a new selection from the museum's huge holdings of 2.4 million items in all. Such cultural events as concerts, lectures, films, and demonstrations by contemporary artists

and craftspeople further enrich the offerings; they are announced in the bimonthly newsletter and on the Web site.

And this is not all. As a legacy of the Essex Institute and the Essex Historical Society, PEM boasts a fine collection of American decorative art (on the ground floor and the second floor), mostly from Massachusetts, and more particularly from Essex County, where Salem is located. The wealth created by trade translated into elegant homes, fine furniture, china sets, silver, glass, rich clothing, and, of course, paintings, especially portraits, to immortalize the proud owners of these riches. The holdings are not arranged into period rooms, but rather organized around such topics as Children, Inspired by Nature, Architecture, which, again, is a more thought-provoking system than a mere chronological or object-centered approach would be. Among the paintings, such early American artists as Robert Feke, John Smibert, Gilbert Stuart, and John Singleton Copley are represented, the last by the lovely *Portrait of Sarah Erving Waldo*, in which the sitter daintily holds a twig of cherries glistening dark red against the white silk of her gown. Also shown is the most famous portrait of Salem native Nathaniel Hawthorne, by Charles Osgood; it forms part of a rich collection of Hawthorniana at the museum-associated Phillips Library, which is located diagonally across from the museum entrance.

The library has extensive collections in all the areas the museum pursues; in addition, it houses local historical records, including those pertaining to the Salem witchcraft trials. You may want to take a look at the glorious main reading room. It's a dream in gold, white, and peach—New England sobriety raised to an almost glamorous level. It used to be the Essex Institute's exhibition space, which explains the glassed-in period rooms on the lower level. (Check with the museum desk for admission details.) Once outside the museum, by all means walk around it. You will see Moshe Safdie's brilliant solution to the problem of placing a large addition into an eighteenth-century–scale neighborhood. The new wing, built of the same red brick as many of Salem's historical dwellings, is visually broken into five house-shaped sections, making this, in effect, the "House of Five Gables." A small park, designed by noted garden architect Michael Van Valkenburgh,

wraps around the rather somber gable-side and leads to the Witch Memorial and, further down, to the waterfront.

+ PLUS

McIntire Historic District, Chestnut Street
The town of Salem is itself a museum of seventeenth-, eighteenth-, and nineteenth-century residential architecture. Good clusters can be found encircling the Salem Common and the area near the harbor bounded by Essex and Derby streets. But the most enchanting is a quiet stretch of Chestnut Street, a few blocks west of PEM. It is part of the McIntire Historic District, named after the renowned Salem architect Samuel McIntire (1757–1811). Numerous Federal townhouses and freestanding mansions abut the brick sidewalks of the tree-lined street, which is very much lived in and not crowded by tourists. No. 34, the Stephen Phillips House, is open to the public. On your way back, take one of the small lanes that lead through to Essex Street. Don't miss a stroll through the Colonial Revival garden of the Ropes Mansion (318 Essex Street, free of charge), and visit the Witch House (No. 310, admission charged), the only original structure in Salem really connected to the witch trials, and a fine example of seventeenth-century architecture.

Directions: Walk west on Essex Street (left as you leave PEM), cross Washington Street, walk two more blocks on Essex, turn left onto Summer Street and the next right is Chestnut. A walking map of the McIntire Historic District is available at the U.S. Park Service information center.

South Hadley

MOUNT HOLYOKE COLLEGE ART MUSEUM

Lower Lake Road, South Hadley, MA 01075; Tel. 413-538-2245; www.mtholyoke.edu/offices/artmuseum.

Directions: From I-95 (Mass. Pike) take Exit 4 to I-91 North, to Exit 16 (Route 202). Turn right and proceed on Route 202

to exit marked "South Hadley/Amherst" (Route 116 North). The college is about 2 miles further. Turn right onto Church Street, and second right onto Lower Lake Road. The museum is on the right. Two-hour parking is available in the lot located across from the museum; take first left past the museum. Use spaces labeled "Visitor" or "Willits Parking."

Hours: Tuesday through Friday, 11 A.M. to 5 P.M.; Saturday and Sunday, 1 to 5 P.M.

Admission: Free.

Catalog: The Mount Holyoke College Art Museum: Handbook of the Collection (1984) has to date not been replaced. It covers a small selection in depth, supplemented by a selected checklist. A digital catalog of the collection is under way.

The museum of this venerable women's college was founded in 1876 and started with a bang—the donation of the just-painted *Hetch Hetchy Canyon* by Albert Bierstadt (1830–1902). It is one of his large, hyperdramatic landscapes, soon to be joined by others in a more subdued vein, such as several paintings by George Inness (1825–1894). For an academic museum in a seminar-turned-college, however, contemporary art was of little use, since the teaching of art history centered on the art of past ages. Plaster casts, copies, and photographs came to the rescue (a few pieces from the Parthenon are displayed on a high ledge in the vestibule today), and gradually funds were set up to buy originals in two areas, Antiquity and the Italian Renaissance. These are still the highlights of the collection, supplemented by a long-term loan of Asian art by the Arthur M. Sackler Foundation, sizable holdings in American art of the nineteenth and twentieth centuries, as well as representative pieces from Western art to facilitate the teaching of art history.

The layout of the museum is simplicity itself: the vestibule leads into a central hall furnished with a few large, contemporary pieces. On the left is the space for temporary exhibitions, while on the right Asian art inaugurates a sequence of six galleries in loosely chronological order, each painted in a different color and focused on a specific era. The circular layout leads back to the central hall.

Asian art includes several large sculptures, such as a smooth, elegant male torso from the Khmer dynasty (Angkor Wat), several Buddhas, pottery, and paintings, beautifully presented in subdued light.

Greek and Roman art benefited from the efforts of a number of classics professors in the twenties and thirties, when such art was still widely available. An early low-handled bowl, or skyphos, decorated in Geometric style, dates from circa 750 B.C. Two more skyphoi, more graceful in shape and from the Classical period, are prize pieces. One is a black-figure depiction of Herakles being served wine by Athena; the slightly later one is in red-figure style and shows a running women on either side. The artist has been named the Holyoke Painter for this piece. A krater and a kylix, both in red-figure style, show lively dancing women, with tunics and mantles flowing. This feminine dominance in subject matter is also noticeable in two fine portrait busts, one the Hellenistic, softly modeled *Head of a Woman*; the other, *Faustina the Elder*, Roman empress and wife of Antoninus Pius. Easily the most important piece is a bronze, *Statuette of a Youth, Probably Apollo*, circa 470 B.C., much studied and exhibited. While small (8.5 inches in height), it shows many of the finest achievements of the Classical style of Greek sculpture, and has been compared both to the famous Charioteer of Delphi and the Zeus from Artemision, their shared ideal being that of "the triumphantly self-sufficient being, whose wooden, deliberate gestures portray action exempted from the effects of time."

The next gallery surveys Medieval and Renaissance painting and sculpture. Here, an assembly of small Early Italian paintings in tempera and fresco stand out. Among them is *Bust of an Angel* from the Maestà altar by Duccio di Buoninsegna (active 1278–1315), created for Siena. If the angel is not by Duccio, it was certainly executed under his supervision. (Other fragments from this altar are at the Frick Collection in New York and in the National Gallery, Washington, D.C.; a digital full assembly can be seen at www.wga.hu.) Two lovely Madonnas, one in painted stucco from the Ghiberti workshop and another, smiling one from northern France, reminiscent of the statuary of Reims Cathedral, show the delicate, even sweet side of Renaissance and Gothic sculpture.

Statuette of a Youth, probably Apollo, ca. 470 B.C. Greece, Sikyon-Corinth. Cast bronze. Mount Holyoke College Art Museum, South Hadley, Massachusetts. Museum purchase, Nancy Everett Dwight Fund.

The next gallery presents Baroque and eighteenth-century painting, with several contemporary copies after famous paintings (by Rubens and Van Dyck). There is an excellent pair of portraits by Dutch painter Caspar Netscher (1639–1684) and a quintessentially Baroque *St. Sebastian Attended by St. Irene*, attributed to Daniel Seiter, in which the theme of martyrdom and pain

is countervailed by the sensuous execution and the Caravaggio-inspired chiaroscuro.

The next room is the largest and covers American painting throughout its history. Next to a pair of Colonial portraits by Erastus Salisbury Field is a "Hadley chest," an example of simple but colorful Early Colonial furniture. When new, they must have looked a lot like a quilt, with their distinct front panels painted in red, black, brown, and green and embellished with incised and/or painted simple leaf-and-vine designs. A famous maker was John Allis of Hadley, hence the name.

The huge Bierstadt mentioned above is in this gallery, as is a collection of paintings inspired by Mt. Holyoke, a very popular tourist spot and cultural icon in the nineteenth century. The contrast between the rugged mountain and the fertile, cultivated Pioneer Valley below inspired many ninteenth-century landscapists, as well as writers and poets.

Just off this gallery is an intriguing, small room dedicated to British art. It contains a fine portrait by George Romney, *Lord George Augustus North*; a somewhat awkward conversation piece by Francis Wheatley (1747–1801); and, as Benjamin West is considered an honorary Englishman, that artist's Neoclassical *Chryses, the Priest of Apollo* of 1773.

+ PLUS

Wistariahurst and Mt. Holyoke 🛒
On the campus itself, do not miss two Neo-Gothic gems by Charles Collins (architect of the Cloisters in New York City and Hammond Castle, q.v.): Williston Memorial Library and Abbey Memorial Chapel, next to each other along College Street, were built in the 1930s. Nearby Mary Lyon Hall, with its tall clock tower, is named after the college's founder and dates from 1897. A drive (or hike) up Mt. Holyoke is highly recommended. The road is open April through November, and the historic Summit House is open for tours on summer weekends. Mt. Holyoke is located in J. A. Skinner State Park, a four-hundred-acre area crisscrossed by hiking trails.

The Skinners were a wealthy industrialist family in Holyoke,

owners of the William Skinner Silk Mill, which kept American brides in silk and satin for over eighty years, and the Skinners in enough money not only to buy the land for Skinner Park and to fund various philanthropies, but also to build and later expand an elegant Victorian mansion, Wistariahurst. Surrounded by large formal gardens and overgrown by wisteria, it is open to the public.

To reach Mt. Holyoke, follow Route 47 North (which splits off from Route 116 at the corner of College and Church streets) for about 7 miles. A park map can be downloaded at www.mass.gov/dcr/parks/skinner. Wistariahurst is located in Holyoke at 238 Cabot Street (Route 202). Follow directions for the museum; after leaving I-91, follow Route 202 through six lights. Wistariahurst is on your right. Tel. 413-322-5660; www.wistariahurst.org. Open weekends and Mondays, 12 to 4 P.M.

Springfield

SPRINGFIELD MUSEUMS

21 Edwards Street, Springfield, MA 01103; Tel. 800-625-7738; www.springfieldmuseums.org.

Directions: From I-90 (Mass. Pike) take Exit 6 to I-291. Take Exit 2B (Dwight Street) and turn left. Follow Dwight to State Street. Turn left at light, go through another light and you will see the large, white marble Springfield City Library on your left. Take the first left past the library onto Eliot Street and then the next left onto Edwards Street. Free parking in the lots on Edwards Street.

Hours: Tuesday through Saturday, 10 A.M. to 5 P.M.; Sunday, 11 A.M. to 4 P.M.

Admission: Adults $10, seniors and students $7, children 3–17 $5. One admission for all museums.

Catalog: Museum of Fine Arts: The American and European Collections, Springfield, 1979.

This must be one of the finest assemblages of public buildings anywhere in New England. Arranged around a central green are

an Italianate, warm-ochre brick villa (the George Walter Vincent Smith Art Museum, 1895), a Renaissance marble palazzo of grand proportions (the Springfield City Library, 1912), a staid Classical museum building (the Springfield Science Museum, 1899), an imposing granite Neocolonial structure (the Connecticut Valley Historical Museum, 1927) and a fine Art Deco limestone building (the Museum of Fine Arts, 1933). Look a little farther and you'll see two major churches on either side (Colonial-style St. Michael's Cathedral and Romanesque Christ Church Cathedral). A bit beyond the parking entrance, at the corner of Elliot and Salem streets, is another church, the North Congregational Church by Henry Hobson Richardson. You know you are in the cultural and spiritual center of Springfield and can glean from the grace and luxury of these buildings that Springfield at one time was a very rich and self-confident town.

War being the father of all things, weapons made Springfield rich. In 1777, George Washington requested the establishment of an armory to store weapons and ammunition for the colonial army. The armory (today a national historic site) attracted weapons makers, and the first boom came with the war of 1812. Later, the Springfield Armory produced more than half the guns used in the Civil War, while Smith & Wesson turned out 110,000 revolvers and the Ames Sword Company supplied 150,000 swords. Much innovation and manufacturing caused the city to thrive into the 1930s, when a major flood and a hurricane proved devastating. The closing of the armory in the 1960s and the general decline of manufacturing have hit the city hard. It is therefore all the more encouraging to see the museum complex being refurbished, painted, and generally well cared for. (See color insert.)

Springfield is also the birthplace of Theodore Geisel, aka Dr. Seuss; in the center of the green, large bronze sculptures of the Cat in the Hat and other Dr. Seuss characters attract families with children (as do Seuss-related rooms in the historical museum and the dinosaurs in the science museum). Another bronze not to be missed is the famous *Pilgrim* (Deacon Samuel Chapin) by Augustus Saint-Gaudens, probably his most beloved work, which memorializes one of the founding fathers of Springfield. It is situated

just outside the museum quadrangle, in the greensward at the corner of State and Chestnut streets.

George Walter Vincent Smith Art Museum 🏛

Named for the donor of the museum's collection, the building was erected through the efforts of the citizenry. Smith, a self-made man from New York, retired at age thirty-five and, with his Springfield-born wife, dedicated himself to collecting for the rest of his life, by which time he had amassed about six thousand pieces. The building itself, the design of the galleries, the display cases, and, of course, the collection, reflect the Victorian taste for sumptuous, exotic decorative arts and expensive materials. The first room on the ground floor is the Japanese Arms and Armor Gallery, which includes six full suits of armor, swords, and sword guards from the fifteenth to the nineteenth centuries, as well as an elaborately carved, large Shinto shrine. This gallery exudes the Victorian era, an impression enhanced by its stained-glass windows, each of which exalts a great man from the past—Dante, Bacon, Goethe, etc. (Likewise, the far outside wall of the museum displays a long list of great and lesser artists, an invocation of the redeeming value of art.) A short connecting room is dedicated to the Smiths, with biographical information enhanced by memorabilia, letters, and pictures. Next comes a large gallery, painted in bright green and filled with full-size plaster casts of Greek, Roman, and Renaissance artworks, about fifty in all. These casts were purchased with funds provided by Horace Smith of Smith & Wesson (and no relation to G. W. V. Smith). They closely resemble the selection of the Slater Museum in Norwich (q.v.) and were, in fact, selected and installed by the same Edward Robinson of the Museum of Fine Arts, Boston. Next, a recently installed Ancient Treasures Gallery is mostly geared to educational purposes— through Ancient artifacts, video displays, and various interactive endeavors—great for local schoolchildren, but of limited artistic interest. The only striking thing is a literal "cabinet of curiosities," which looks as if it had come down through the ages unchanged, and includes handwritten, charmingly scant labels for a hodgepodge of natural, scientific, and man-made objects and relics.

The best part of the museum is the second floor. Here is the

superb collection of Chinese cloisonné objects, at 150 pieces considered the largest outside of China. The delicate tracery of the inlay and the rich turquoise-blue of the backgrounds of the finely crafted vases, dishes, and figurative objects (ranging from the fourteenth to the nineteenth centuries) speak to the modern sensibility as much as to the Victorian. The cloisonné technique itself and the common symbols employed are well explained and illustrated. In adjacent galleries are Chinese jade carvings and ceramics (especially striking is a glass case full of the reddish *sang de boeuf* ware from the Ch'ing dynasty), Japanese bronzes and other decorative objects, as well as Middle Eastern art, including a large collection of Oriental rugs. The galleries are freshly painted in rich colors, with the wood trim in white, making for a festive and elegant environment.

Also on this floor are the paintings the Smiths collected. They are entirely nineteenth-century American, mostly landscapes and genre scenes. A conservative taste prevails, with fine examples by William Merritt Chase, Thomas Cole, Frederic Church, Sanford Gifford, and George Inness.

Along the front length of this floor is the brightly decorated Hasbro Games Art Discovery Center, a well-supplied and imaginatively laid-out area for children to paint, do crafts, read, dress up, and otherwise be creative. Children (and their elders) could spend long hours in this enticing environment.

Museum of Fine Arts

This museum was willed into existence by one couple, the James Philip Grays (themselves not even art collectors), who left their entire estate for the "selection, purchase, preservation, and exhibition of the most valuable, meritorious, artistic and high class oil paintings obtainable," as well as for a building to house them. Neither was still alive when the museum opened in 1933, but the collection grew quickly; today it encompasses an extensive and well-balanced collection of American art and a survey of European art from the Middle Ages to today, organized in country- and epoch-specific galleries. Given the late starting date, the museum's collection is very impressive, and now includes sculpture and works on paper as well.

The physical organization could not be clearer: the first floor is dedicated to American art, the second to European art and changing exhibitions. The galleries surround the interior Blake Court, dominated by one of the most curious and intriguing American paintings, *Historical Monument of the American Republic*, by Erastus Salisbury Field (1805–1900). Created for the centennial of the nation, this nine-by-thirteen-foot panel endeavors to tell the early history of the United States via painted stone reliefs carved into massive, fantastic towers, a mixture of ziggurat and Tower of Babel. The sheer ambition, allegorical overreach, and quaint fussiness (the towers and storeys are numbered and labeled in the painting) are both moving and amusing. The museum owns what is probably the largest collection of Fields (courtesy of Eleanor Morgan Wesson, of Smith & Wesson fortune), mostly his typical simple, flat portraits—he was an itinerant painter in Massachusetts and Connecticut—but also a few of his stabs at history and religious painting. The remaining walls of Blake Court present other traditional nineteenth-century American paintings, including two Bierstadt views of the Hetch Hetchy Valley, which at his time was as magnificent as Yosemite, but is covered by a reservoir today. There are also very fine still lifes of the trompe-l'oeil variety by William M. Harnett (1848–1892), Raphaelle Peale (1774–1825), and others.

Galleries on either side of the entrance cover American eighteenth and late nineteenth centuries, respectively. The former consist mostly of portraits, as is to be expected. A lively *Portrait of Philip Nicklin* by Gilbert Stuart, we are informed, was requested by the sitter to be "in the manner of" Stuart's famous and oft-repeated rendering of George Washington. A large group portrait by Ralph Earl and matched portraits of Mr. and Mrs. Hewitt by William Jennys (1774–1858) represent the untutored "primitive" American art with its stiffness and intense seriousness, while a portrait of the rotund and apple-cheeked *Deacon Jonathan Simpson*, and *Portrait of Mary Faneuil*, both by Joseph Blackburn (ca. 1730–1778 or later) offer a whiff of English style and elegance. The late-nineteenth-century gallery has some good Winslow Homers, especially *Promenade on the Beach*, several landscapes by George Inness, and an unusually contorted and intense landscape by John

Singer Sargent, *Glacier Stream—The Simplon*, painted during one of his painting trips in Switzerland, where he escaped the pressure to paint nothing but portraits.

A collection of over 750 tinted lithographs by the firm of Currier & Ives occupies its own gallery. Computer terminals let you search the entire collection by various topics (you can also do this from the Web site), while there is always a small, themed exhibition on view. It is hard to overestimate the influence of the more than 7,000 prints created by the firm, which brought visual representations of major events and disasters, important persons, and scenes of everyday life to an information- and sensation-hungry America during the second half of the nineteenth century.

At the far end is a gallery devoted to early-twentieth-century art; it also includes some fine Art Deco furniture as well as a large mural by Sante Graziani (b. 1920), *The Museum of Fine Arts Fostering the Arts in Springfield*, commissioned for this space. It has that earnest realism typical of the WPA era; the museum has several paintings created under the auspices of the WPA, as well. There is a powerful painting by George Bellows, *Edith Cavell*, of 1918. She was a British nurse who in WWI helped Allied soldiers escape from German-occupied Belgium, for which she was executed. Her martyrdom figured prominently in the Allies' war propaganda. Bellows depicts her, in white robe, descending a long staircase leading to the cellar in which she is to be executed; the lighting and drama are reminiscent of Goya. Bellows created lithographs after this painting to maximize the political effect. Other painters represented here include Lyonel Feininger, Georgia O'Keeffe, Charles Sheeler, and Reginald Marsh. Next comes a large gallery for Modern and contemporary art, with an animated terracotta, *Striding Woman*, by Mary Frank (b. 1933) and—to stay with women artists—a ten-foot-high acrylic, *Cave*, by Helen Frankenthaler (b. 1928), for me the most beautiful works on view. Motion-activated lighting in the small adjoining Starr Gallery allows selections from the large collection of works on paper to be shown, among which are over three thousand Japanese woodblock prints.

The second floor leads you on a tour of European painting, with an emphasis on the Italian, French, and Dutch schools. As

you come up the stairs, turn left to the Late Medieval gallery. Going clockwise around the courtyard will give you a more or less chronological sequence, ending with French Impressionism. Twentieth-century European art is displayed along the balcony overlooking Blake Court. While the many well-chosen examples by lesser masters certainly deserve your scrutiny, there are a few true masterworks as well, and to encounter them here, unawares, is doubly enjoyable.

In the French collection, *The Journey to Market* by François Boucher; *Rafraîchissements*, an oval-shaped still life by Jean Baptiste Siméon Chardin; *The Madman-Kidnapper*, a frighteningly penetrating portrait by Théodore Gericault, the "inspirer of Delacroix and . . . initiator of French Romanticism" (Faison); Gustave Courbet's *Castle of Chillon*; and Jean François Millet's sketch for *The Gleaners* (in the Louvre) are not to be missed. In the Impressionism gallery, Pissarro, Degas, Monet, Renoir, and Caillebotte are well represented, some by several works.

The Italian collection is rich in bronze and marble sculpture and eighteenth-century painting. Francesco Guardi, *Portrait of a Boy in Uniform*; Giovanni Paolo Panini, *View of the Arch of Titus*; and *Portrait of an Oriental* by Giovanni Domenico Tiepolo are outstanding. There are several landscapes and cityscapes by Canaletto and Bellotto that make you want to buy a plane ticket to Italy immediately.

In the Dutch gallery, a few land- and seascapes are first-rate: Willem van de Velde the Younger (1633–1707), considered the greatest Dutch marine painter, gave us *Fishing Boats Offshore in a Calm*; with its low horizon line, all the emphasis is on the slack sails, masts, and towering clouds—a distillation of "calm." Jan van Goyen's (1596–1656) *River View with Leyden in the Background* likewise shows almost nothing but sky, in his characteristic warm, yellowish tones. Jacob van Ruisdael's (1628/9–1682) *Landscape near Dordrecht* depicts "land, sea, clouds, trees, human interest, all constituting a voyage into infinite distances" (Faison). *Self-Portrait* by Ferdinand Bol (1616–1680), Rembrandt's gifted pupil and imitator, could easily be taken for a work by the master. Many other treasures await discovery in a museum that has an exceptionally fine collection and too few visitors.

Willem van de Velde (The Younger), *Fishing Boats Offshore in a Calm*, ca. 1660. Oil on canvas, 28 × 34½ in (69.9 × 84.5 cm). Springfield Museum of Fine Arts, Springfield, MA. James Philip Gray Collection, 50.02.

+ PLUS

Two courthouses

When you turned the corner of Eliot Street, you may have noticed a striking white stone-and-glass structure, the just-built U.S. Federal Courthouse, designed by world-famous architect Moshe Safdie (see Peabody Essex Museum). For a courthouse it looks almost too upbeat and joyous, but it is a welcome and powerful addition to this tremendous cluster of architectural statements. Another Springfield courthouse, the Hampden County Courthouse, is an early work of Henry Hobson Richardson's, constructed 1871–74 in local granite. Its monochromatic, castle-like exterior represents a more austere side of Richardson's palette, and seems to convey the imposing power of the law. The location, Court Square, marks the civic heart of Springfield; the two multicolumned Greek-style buildings are City Hall and Symphony Hall, with a towering campanile between them. Old

North Church, now sadly defunct as a congregation, was built in 1819, but the congregation goes back to 1637.

Directions to Hampden County Courthouse: Walk down State Street, turn right at Main Street, and turn left into Court Square. You have to go to the far left corner of the square to see the courthouse.

Stockbridge

CHESTERWOOD, THE STUDIO OF DANIEL CHESTER FRENCH 🚼

4 Williamsville Road, Stockbridge, MA 01262; Tel. 413-298-3579; www.chesterwood.org. On the Web site, note the Hidden Treasure link, which provides information on French's sculpture within Massachusetts.

Directions: Take I-90 (Mass. Pike) to Exit 2 (Route 20 South), then 102 West. After you have gone through Stockbridge, take a left onto Route 183. Three quarter miles past the Norman Rockwell Museum turn right onto Mohawk Lake Road, then left onto Willow Street, which becomes Williamsville Road just before Chesterwood.

Hours: May to October: Daily, 10 A.M. to 5 P.M. Guided tours of the house and studio depart on the half hour.

Admission: Adults $12, children 6–18 $5.

Chesterwood was the summer residence of Daniel Chester French (1850–1931), arguably the best-known American sculptor due to his *Seated Lincoln* of the Lincoln Memorial in Washington, D.C., and his *Minute Man* in Concord, Massachusetts, the quintessential embodiment of the colonial citizen-soldier. French summered here for thirty-six years, from 1896 to his death. In 1969 his daughter bequeathed the completely preserved estate to the National Trust for Historic Preservation.

For the tourist and art lover, the elegant home, the studio, the artist-designed garden, and the barn converted into a gallery space provide a rare opportunity to experience the artist at work and at leisure in a setting that he himself called "heaven."

French chose the location for its proximity to New York, where he had his other studio, to his native Concord, and to Boston, having dismissed the Cornish art colony as "too arty." The site came with an old farmhouse, and the first thing French had built was his studio, a thirty-by-twenty-nine-foot cube, with a twenty-three-foot ceiling and a fifteen-foot-high hip roof that could accommodate a full-size equestrian statue with room to spare. He had an ingenious mechanism installed that allowed him to roll out his work-in-progress on railroad tracks through tall sliding doors so he could study the work in outdoor lighting, a major consideration for public sculpture intended for outdoor spaces.

By 1901 the farmhouse had been replaced by a stucco villa, built, like the studio, by Henry Bacon, who was a close friend and collaborator of French's. He designed the plinths and enclosures for many of French's major works, including the "temple" of the Lincoln Memorial. French then settled into a routine of spending May through October in Stockbridge, the rest of the year in New York City. Fortunately for us, he kept many of his plaster casts and models, storing them in his studio or the barn, or giving them to museums. After his death, his daughter secured many of them from museum storage facilities and moved the contents of his New York studio; today Chesterwood boasts over five hundred casts and models of French's work, as well as his tools, library, photographs, and personal papers. It is rare that an artist's life is so completely open to inspection and that one can gain such a clear impression of the physical as well as artistic part of the sculptor's trade.

While the studio houses random pieces, including rejected versions, partial casts, and intermediate stages, the Barn Gallery presents the making of four major works in their historical and social contexts. The works treated in detail begin with the *Minute Man*, an astonishing work by a virtually self-taught twenty-four-year-old. Being a resident of Concord, he was the natural choice when the town wanted to commemorate "the shot heard 'round the world." Leaning on a plow and taking up his gun, his shirt-sleeves rolled up, this man is ready for action at a minute's notice. Even though the pose is very much modeled on the famous Apollo Belvedere (a copy of which French could study in the Bos-

ton Athenaeum), it conveys strength and determination, and has become an icon of America.

The next major works treated are *The Continents*, elaborate allegories of Asia, America, Europe, and Asia, which decorate the Beaux Arts–style United States Custom House in lower Manhattan (architect Cass Gilbert). These are stately public monuments, informed by an elaborate symbolic program, intended to convey the global reach of America at the cusp of the twentieth century.

The third example, the *Dupont Memorial*, is typical of French's languid female figures in fluid draperies, which often adorn his (cemetery) memorials. Here they represent Sea and Sky, with a male figure symbolizing Wind. They form the base of a large fountain basin at the center of Dupont Circle in Washington, D.C. *The Spirit of Life* (see PLUS) as well as the door panels at the Boston Public Library (q.v.) fall also into this most alluring genre, the elegance of which seems to foreshadow Art Deco sculpture.

Lastly, the Lincoln Memorial's history is presented, its evolution over eleven years until the installation in Washington, D.C., in 1922. Its location at the far end of the recently extended Mall, its lofty theme, and the need for grandeur as well as colossal size made this a difficult undertaking, and even after the dedication French worked on various aspects of the lighting. "What I wanted to convey was the mental and physical strength of the great President and his confidence in his ability to carry the thing through to a successful finish," French wrote of the statue that continues to be praised for its natural majesty.

The grounds of Chesterwood, with their woodland trails and open spaces, are the setting, each year, of an exhibition of contemporary outdoor sculpture. All works must have been created within the previous four years and are for sale.

+ PLUS

St. Paul's Episcopal Church
The town center of Stockbridge is also home of St. Paul's Episcopal Church, built by Charles McKim from 1883 to 1885, in a massive, Norman-inspired style. This is the church where the French family worshipped. The entrance porch is now home to Daniel

Chester French's *The Spirit of Life*, given by daughter Margaret French Cresson in memory of her parents. This cast was made from the working model for what would become the much larger *Spencer Trask Memorial* in Saratoga Springs. There, water flows from the cup, and the sculpture is set against a semicircular wall crowned by urns.

St. Paul's Episcopal Church is at the corner of Main and Prospect streets. If the church is open, take a look at the interior, with La Farge and Tiffany windows and an interesting truss structure.

NORMAN ROCKWELL MUSEUM 🚼

P.O. Box 308, Route 183, Stockbridge, MA 01262; Tel. 413-298-4100; www.nrm.org.

Directions: From I-90 (Mass. Pike) take Exit 2. At the end of the ramp turn left onto Route 20, and then immediately right onto Route 102 West into Stockbridge Center (ca. 5 miles). Continue on 102 West for another 1.8 miles. At the flashing light turn left onto Route 183 South. The museum is half a mile down on your left.

Hours: Weekdays, 10 A.M. to 4 P.M., but until 5 P.M. on weekends, holidays, and daily May through October. The studio is open only from May through October.

Admission: Adults $12.50, students $7, children under 18 with adult free.

Norman Rockwell (1894–1978), beloved illustrator and mythologizer of American life, is still looked at rather snobbishly by many in the art establishment. Yet how do you ignore the fact that Rockwell is the best-known and most-reproduced American artist, and that the Norman Rockwell Museum in Stockbridge is the most visited venue in the entire Berkshires? Clearly he speaks to many, and while he himself knew that he was representing a selective and prettified reality, nevertheless his version of the America of the 1930s, '40s, and '50s has itself reached iconic status, shaping how we see and understand that past.

He is called an illustrator because he worked for popular magazines rather than the art market. In most of his work, he did not illustrate a preexisting text but, rather, created scenes out of his own imagination that function more like genre painting. While they are infused by the reality that surrounded him (specific locales and people from Stockbridge and his previous home in Arlington, Vermont, appear in the paintings), his own artistic decisions account for content, composition, and execution. He excelled in the traditional craft aspect of painting at a time when the art world could not have been less interested in it.

He painted his first cover for the *Saturday Evening Post* at age twenty-two; another 321 would follow. His total output has been estimated at over 4,000 images. In 1939 Rockwell moved to Arlington, near Bennington, Vermont, joining a group of artists that included the painter Rockwell Kent (he famously illustrated *Moby Dick*) and the composer Charles Ruggles, and included visits by his admirer Grandma Moses (see Bennington Museum). In 1953 Rockwell moved permanently to Stockbridge, where he died. He bequeathed his personal collection of some 367 paintings and sketches as well as his studio and its contents to the museum. Subsequent purchases, gifts, and bequests have added more original paintings, but also tear sheets, magazine covers, and illustrated books. Rockwell's personal archive of letters and photographs and an extensive reference library round out the museum's holdings, which make it the center of Norman Rockwell studies.

The museum takes seriously the mission provided by Rockwell—namely, "the advancement of art appreciation and art education"—by mounting temporary exhibitions to supplement the permanent collection, which is always amply displayed. The exhibitions tend to revolve around illustration in the widest sense; for example, an eighty-year survey of *New Yorker* magazine covers, or an exhibition of illustrated private letters by famous artists, or an exploration of the world of the graphic novel. Many of these exhibitions go on national tours.

The museum's grounds encompass thirty-six acres of a hilltop landscape with vistas over the Housatonic River Valley. A visit during the summer season allows you to lunch at the Terrace Café and also to take in his studio, which was moved here,

contents and all. The studio confirms that Rockwell was a thorough researcher for his paintings, making sure that every detail was historically and factually accurate. A large collection of props, books, photos and mementoes from trips, his easel and art supplies give you the feeling that he just stepped out for a few minutes. The museum building of 1993 "draws on the simple classicism of New England's traditional public buildings" in the words of the architect, Robert A. M. Stern. It is modest in its mien, and seems to convey the same simplicity and directness as Rockwell himself. The permanent gallery, lit by natural light, is on the main level, which also boasts an octagonal space that reverentially displays the famous *Four Freedoms* (1943). These images were inspired by President Roosevelt's State of the Union speech of 1941, in which he listed freedom of speech and of religion, and freedom from want and from fear as the fundamental freedoms that humans everywhere in the world ought to enjoy. Rockwell's interpretation translates each freedom into an American domestic or civic scene, with freedom from want showing a traditional Thanksgiving dinner. These four paintings toured the country to help sell war bonds and netted $130 million dollars!

+ PLUS

Naumkeag

There is much to see and enjoy in and around Stockbridge (see www.stockbridgechamber.org). I would like to single out Naumkeag, the 1885 summer home of the Choate family, designed by McKim, Mead & White, when this part of the Berkshires was the "inland Newport." The forty-four-room Shingle-style "cottage" contains the original furniture, ceramics, and artwork collected in Europe (Joseph Hodges Choate was ambassador to Great Britain), and shows Gilded Age living in its understated, tasteful variety. More famous than the house is the garden, the fruit of a thirty-year collaboration between daughter Mabel Choate and famous landscape architect Fletcher Steele, begun in 1926 and finished a year before Mabel's death in 1957. They created individual "garden rooms," such as the Afternoon Garden (with fountain, Venetian gondola poles, and a sculpture by Frederick MacMon-

nies), the Tree Peony Terrace, the Chinese Garden, the Linden Walk, and others. Slow down when you visit and appreciate how meticulously each section has been designed and yet how naturally it fits into the overall landscape (which was heavily altered to make it look just so). The Perugino View, for example, frames a vista of far-away, blue mountain ridges by means of flanking trees in the foreground and fills the middle ground with scattered trees on a sloping lawn, all to be enjoyed from the Great Seat. The highpoint, the Blue Steps of 1938, is considered a quintessential Art Deco design. (See color insert.) The steps consist of a series of connected, descending stone basins whose backdrops are painted blue, with a stepped path on either side, flanked by the most gracefully curving, thin, white railings, and the whole overshadowed by a grove of white birches. The effect is magical and much photographed and reproduced.

Naumkeag, Prospect Hill Road, Stockbridge, MA 01262; Tel. 413-298-8146; www.thetrustees.org.

Directions: Retrace your steps back to Stockbridge Center. At the Intersection of Route 102 and Route 7, take a left onto Pine Street, then take the next left onto Prospect Hill Road. After half a mile the house will be on the left.

Hours: Open Memorial Day weekend to Columbus Day: Daily, 10 A.M. to 5 P.M.

Admission: For house and garden, adults $10, children 6–12 $3.

Waltham

ROSE ART MUSEUM, BRANDEIS UNIVERSITY

415 South Street, Waltham, MA 02453; Tel. 781-736-3434; www.brandeis.edu/rose.

Directions: From I-95 (Route 128): Take Exit 25, follow signs for Brandeis University; from the Mass. Pike: Take Exit 15, follow signs for Brandeis. The main campus entrance is on South Street. Take a left at the entrance pavilion. The Rose Art Museum is the fourth major building on your left. Parking is with Brandeis parking pass (obtainable at entrance

pavilion), either at the museum or on H Lot, just beyond the
museum on the left.

Hours: Tuesday through Sunday, 12 to 5 P.M.; closed on national
and Jewish holidays, and for installation of new exhibits.

Admission: Adults $3, children under 12 free.

Catalog: In progress, due out in 2009; the catalog for the 2001
exhibition, *A Defining Generation, Then and Now 1961 and
2001*, provides a thumbnail sketch of the history of the first
forty years.

This is a young museum (founded 1961) in a young university
(founded 1948), and its first director, Sam Hunter, set the agenda
early on: "I did have a particular vision for the museum. Since it
did not have a representative historical collection of art of all pe-
riods, I felt we must focus our strength in the present, on contem-
porary art. . . . My main interests were in late-twentieth century
modernism and more particularly on contemporary art beginning
with the Abstract Expressionists." Luckily, art collectors Leon and
Harriet Mnuchin soon called out of the blue to give the Rose Mu-
seum $50,000 to be spent on purchasing contemporary art. The
subsequent early-sixties shopping spree resulted in the acquisi-
tion of twenty-one paintings from such up-and-coming artists as
Robert Rauschenberg, Jasper Johns, Robert Indiana, Roy Lich-
tenstein, Claes Oldenburg, James Rosenquist, Jim Dine, Andy
Warhol, Alex Katz, and Ellsworth Kelly. The selection has stood
up well over time and these now-classic works, supplemented by
major canvasses by Willem de Kooning, Adolph Gottlieb, Robert
Motherwell, Morris Louis, and Philip Guston, validate the Rose's
claim of being "the largest, finest, and most comprehensive col-
lection of twentieth century art in New England" (former direc-
tor Joseph Ketner).

While the Rose excels in Abstract Expressionism, Pop Art,
and Color Field Painting, it also has Realist and Modernist art
from the late nineteenth and early twentieth centuries, both Eu-
ropean and American (e.g., Surrealists René Magritte and Yves
Tanguy; Ashcan School representatives Reginald Marsh and
George Bellows; a handful of drawings by Amadeo Modigliani;
works by Cézanne, Renoir, Rouault, and Léger). More unex-

pected is the presence of about five hundred Japanese woodblock prints, sixty Rembrandt prints, thirty works on paper by William Hogarth. Why is this all so unexpected?

The answer, sadly, is that most of these things are never seen. There is no selection of images on the Web site, there is no printed catalog yet, there is no publicly accessible database, and there is only a tentative commitment to really showcase the permanent collection, which now numbers over six thousand items. A planned expansion is to remedy that last-mentioned deficit.

Instead, the Rose mounts cutting-edge exhibits, usually two or three concurrently, three times a year, and often involving mixed and nontraditional media. In fact, the first exhibition of video art in a museum took place at Brandeis in 1970. The exhibits take advantage of three distinct physical spaces: the original two-storey building of 1961, with its central, open staircase descending to a rectangular fountain; the intimate Mildred S. Lee Gallery to the right; and the soaring, uninterrupted open space of the Lois Foster Wing, added in 1999 (Graham Gund, architect).

What you can expect is to be challenged. The Rose exhibitions are never predictable and there is always something edgy and unforeseen. There have been exhibitions of Conceptual, feminist, Photorealist, and Minimalist art; installations, multimedia exhibits, and cross-disciplinary explorations. Frequently the museum will be completely transformed as an exhibition takes over not only the walls, but also air- and floor space. Occasionally an exhibit is tied to an artist-in-residence's sojourn on campus. Among such artists in the past were Frank Stella, Philip Guston, and Barry McGhee.

The Rose Museum is now in competition with the Institute for Contemporary Art, for they both concentrate on Modern and contemporary art, and they are now both collecting institutions. Will Brandeis suffer from the hoopla engendered by the new ICA on the waterfront? Will both institutions vie for the benefactions of the same local collectors? If the past is any guide, Brandeis will "continue to be a pacesetter in New England, and beyond," but we hope that there will also be room and enthusiasm for sharing its permanent collection.

+ PLUS

Stonehurst, the Robert Treat Paine Estate

Before Waltham became world-famous for its early industry employing steam energy and division of labor (i.e., the so-called Waltham model), it was a rural place along the Charles where wealthy Bostonians built their summerhouses. A few survive, and one is H. H. Richardson's only intact and unchanged country house, Stonehurst, aka the Robert Treat Paine House, built 1883–86. The exterior, with its interplay of massive boulders, the refined, Shingle-style second storey, and the curving roofs and formidable towers, is bold in the extreme. The interior has a grandiose sweep and elegance that is simply breathtaking. Experts consider it Richardson's finest country-house design. Frederick Law Olmsted worked with Richardson and designed the terrace and transition to the natural landscape. The estate is surrounded by over a hundred acres of parkland, with hiking trails open to the public at all times.

100 Robert Treat Paine Drive, Waltham, MA 02452; Tel. 781-314-3290; www.stonehurstwaltham.org.

Directions: From Boston: Take Route 20 West through Watertown Square on Main Street to Waltham. Turn right onto Lyman Street. Proceed straight through rotary to Beaver Street, and 100 yards later turn left at sign for Stonehurst.

From I-95 (Route 128): Take Exit 27A, Totten Pond Road, into Waltham. Turn right at the light onto Lexington Street. Proceed about 100 yards and take first left at the traffic light onto Beaver Street. Proceed through rotary, taking second right. After 100 yards, turn left at sign for Stonehurst.

Hours: Open Tuesday through Friday (and the first Sunday of each month), 2:30 to 4 P.M. Admission $3. Guided tours at 3 P.M. or by appointment: Adults $7, seniors and students $5.

Wellesley

DAVIS MUSEUM AND CULTURAL CENTER, WELLESLEY COLLEGE

Wellesley College, 106 Central Street, Wellesley, MA 02481; Tel. 781-283-2051; www.wellesley.edu/DavisMuseum.

Directions: From Route 128/I-95, take Exit 21B. Follow Route 16 West for 3 miles to the town of Wellesley. At the fork in the center of Wellesley stay to the right, onto Route 135. At the third light take a left into the main entrance of the campus. Follow the signs for visitor parking. As you leave the parking garage, walk past (or through) the award-winning Lulu Chow Wang Campus Center (Mack Scogin and Merrill Elam, architects) and you will see the back of the Davis Museum ahead of you.

Hours: Tuesday through Saturday, 11 A.M. to 5 P.M., Wednesday until 8 P.M.; Sunday, 12 to 4 P.M. Reduced hours (12 to 4 P.M.) during summer break; closed during winter break.

Admission: Free.

Catalog: Davis Museum and Cultural Center: History and Holdings, Wellesley, 1993.

Note: The Davis is in the middle of a complete rehanging of art begun in 2007 and slated to end in late 2008. As of this writing, only the second floor has been reconfigured; the first and third floors will be reopened later.

More than other museums in the greater Boston area, Wellesley's shines as an architectural gem. The college twice hit the jackpot, first when Paul Rudolph created the Jewett Arts Center in 1958 (now used for art teaching and student exhibits), and the second time when Wellesley commissioned the Spanish architect (later winner of the Pritzker Prize in architecture) Rafael Moneo to create the Davis Museum and Cultural Center in 1993. The two buildings face each other, bracketing a courtyard; the Jewett's "ascent of the exterior stair up through and out into the old Neo-

Gothic quad above and behind it is one of the great experiences of Boston architecture" (Shand-Tucci, *Built in Boston*, p. 280). Rudolph's low-slung, brick-and-concrete ensemble (which reflects the redbrick and limestone Neo-Gothic of the larger campus) is visually the more enticing, and has a warmth and human scale reminiscent of Frank Lloyd Wright. Moneo's building's larger hulk could easily have overpowered the Jewett, but its sparse, austere exterior does not call attention to itself and almost seems to defer to the Jewett.

The Davis is conceived as a protective shell for the riches within. Even the entrance is understated, leading into a low-ceilinged, small foyer. All drama is reserved for the gradual revelation of the museum space via a double staircase of low risers that scissors back and forth, an intimate space encased in a honey-colored maple paneling. As you ascend these stairs, window cutouts or open balconies allow you to glimpse parts of the galleries, inviting you to enter the galleries proper, which encircle the core staircase. But one is almost magically drawn to ascend to the third—the top—level, flooded with the light of clerestory windows. It houses the earliest art, Classical sculptures, pottery, and mosaics, which benefit from the almost Mediterranean lighting, even on gray New England days. A few seemingly random floor-length windows capture beautifully chosen views of the campus.

Since the founding of Wellesley in 1875, drawing and painting have been part of the curriculum. In 1885 the teaching of art history began, making Wellesley one of the first American institutions to offer this subject. The "Wellesley method" centered on the actual object of art, making the museum objects an integral part of instruction. The collection therefore covers the entire history of Western art from Ancient Greece to contemporary art, supplemented by small but significant collections of African, Asian, and Pre-Columbian artifacts.

Beginning on the top floor, a large mosaic from the Villa Daphne in Antioch, circa 500 A.D., is a prize from a joint excavation undertaken in the 1930s (there is a counterpart at the Worcester Art Museum). Next to a representative collection of Greek pottery is the *Wellesley Athlete*, a Roman copy after Polykleitos (fifth century B.C.), considered the finest of the extant nine copies

of his Discophoros. Another Roman copy, this time after Prax-
iteles, of the Aphrodite of Knidos, much reduced in size, is lovely
to look at.

Wellesley's strength in sculpture becomes apparent as you pro-
ceed to the Italian, French, and German Renaissance and Ba-
roque masters: Jacopo Sansovino's *Madonna and Child,* Giovanni
da Bologna's bronze reduction of the large marble *Rape of the Sa-
bine Women* (1583) that is in the Loggia dei Lanzi in Florence, and
the gilded *Angel* by Meinrad Guggenbichler are highlights among
many named and anonymous examples. Having walked the pe-
rimeter around the light-flooded atrium, you find yourself in a
little cabinet that holds the Pre-Columbian art. The transition
seems completely logical and aesthetically sound. Greek black-
figure vases and Moche-painted sculptural vessels are not that far
apart!

The second floor is devoted to European painting from the
Renaissance through the nineteenth century, and American eigh-
teenth- and nineteenth-century art. An exhibit within the exhibit
is devoted to representations of the Virgin Mary, which include
Giorgio Vasari's (1511–1574) *Holy Family,* with a sensitive head of
Joseph, and an exquisite *Virgin and Child with the Infant St. John
and Saints Andrew and Jerome* by Il Pinturicchio. The Madonna has
a stillness and inwardness that recalls Botticelli. Female painters
are represented by Lavinia Fontana, considered the first profes-
sional woman artist, and by the Swiss Neoclassical painter An-
gelica Kauffmann.

While one would not visit Wellesley for its Early Ameri-
can art, there are a few notable portraits: two by Ammi Phillips,
which have that austere charm of the early-nineteenth-century
folk painters, the *Portrait of Mrs. Roland Cotton* by John Singleton
Copley, and the portrait of George Washington by Adolf Ulric
Wertmüller of 1794, which gives us a much more accessible,
thoughtful Washington than the more familiar, imperious Gil-
bert Stuart versions. The nineteenth century is well represented
by a number of landscapes (by Frederick Kensett, Asher Durand,
Jasper Cropsey, and George Inness).

In the twentieth century, Wellesley has been at the forefront
of America's increasing appreciation and institutional advocacy

of Modernism, both European and American. Alfred H. Barr, Jr., became associate professor in 1926 and developed a celebrated course in Modern art, the first in the United States. It went beyond painting and sculpture to include film, photography, architecture, and design—categories that formed the original departments when he became founding director of the Museum of Modern Art in New York. Barr's first curator of architecture and design at MoMA, John McAndrew, in 1947 became director of the Wellesley museum and built up the collection to include works by many pioneers of European and American Modernism.

Outright gifts by John McAndrew include an austere portrait bust of Baudelaire by Raymond Duchamp-Villon; the large-scale *Double Nude: Two Women* (1913) by Oskar Kokoschka, which seems to prefigure Willem de Kooning's 1966 *Woman Springs*, nearby; a mobile by Alexander Calder, *Study for Lobster Trap and Fish Tail*.

Among the more unusual items is an early Cézanne, *Portrait Romantique*; with its flat planes of black and gray, it clearly reflects Cézanne's indebtedness to Manet. (See color insert.) An equally atypical Rodin, the sensuous marble sculpture *Eve*, shows her covering her face in shame. The art of the second half of the twentieth century benefits greatly from the expansive, high exhibition space on the first floor. While only a few pieces can be shown at any time, the collection counts many pivotal names among its holdings: Jackson Pollock, Lee Krasner, Andy Warhol, Jules Olitski, Kenneth Noland, Louise Nevelson, Jim Dine, Robert Morris, Sol LeWitt.

The print and photography collections are extensive; the quality of temporary exhibits is always worthwhile and often superb. Scholarly and educational programs also are of high quality and open to the general public. Lastly, one minor but important note: the cafeteria in the Davis building features choice lunch selections and regular topical dinners.

+ PLUS

Elm Bank Horticultural Center 🛒
The Wellesley campus is lovely to wander around, and it boasts its own glass houses, Botanic Garden and Arboretum (www

.wellesley.edu/WCBG). I would like to guide you, however, toward the Massachusetts Horticultural Society's Elm Bank Horticulture Center nearby. It's a former estate built for lavish summer entertaining along the Charles River, which here is narrow and overhung by large trees. The manor house carries its former glory in a rather romantic state of disrepair, yet one hopes that funds will be available to restore it fully. Several outbuildings have been given new functions, but what attracts are the topical gardens (herbs, medicinal plants, a spiritual garden with plants mentioned in the Bible) and an Italianate garden that boasts the large-scale statues of Ceres, Flora, and Pomona that once crowned the former headquarters of the horticultural society in downtown Boston. Of interest to the gardener is the experimental garden, one of thirteen in the nation that test newly developed plant varieties for their suitability to various climates. There is also a lovely children's garden with a little aerie built from branches and twigs, in the nature of a garden folly. The whole place has an understated charm and intimate scale that makes it a perfect little excursion for nature lovers, children, gardeners, and seekers of serenity.

900 Washington Street, Wellesley, MA 02481; Tel. 617-933-4900; www.masshort.org.

Directions: From Wellesley center: Take Washington Street (Route 16) west for 1.7 miles, past the Wellesley campus. A sign on the left indicates the entrance. Drive beyond the two first parking lots, following the signs for the horticultural center. From the main entrance of Wellesley College: take Central Street (Route 135) west for 1.1 miles, take a sharp left turn onto Pond Road; at the end of Pond Road, turn right onto Washington Street; the entrance is 0.2 miles on the left. Open daily 8 A.M. to dusk; voluntary donation.

Williamstown

STERLING AND FRANCINE CLARK ART INSTITUTE

225 South Street, Williamstown, MA 01267; Tel. 413-458-2303; www.clarkart.edu.

Directions: Take Mass. Pike to Exit 2 (Lee). Take Route 20 West to Route 7 North into Williamstown. At the edge of town, Route 7 proceeds around a rotary, from which you take a right onto South Street. The Clark is a half mile down on your right.

Hours: July and August: Daily, 10 A.M. to 5 P.M. September to June: Tuesday through Sunday, 10 A.M. to 5 P.M.. Closed Thanksgiving, Christmas, and New Year's Day.

Admission: November through May free; June through October, adults $12.50, children under 18 and students free. There are joint reduced tickets with MASS MoCA.

Catalog: Many specialized catalogs and monographs (see Web site). *Art in Nature: The Clark Inside and Out* is a general introduction and includes a CD.

How did a superb art collection find a home—a white marble temple, no less—in the heart of the Berkshires, in the rather remote collegiate idyll of Williamstown? Chalk it up to a rich and savvy collector, Sterling Clark (1877–1956), an heir to the Singer sewing machine fortune, who wanted to be sure that the fruit of a lifetime of collecting, over five thousand items, would be safe from the government, from his family, and from warfare. The time was the 1950s, fear of the bomb was high, and New York was not considered safe. There were family connections with Williams College (both father and grandfather had been trustees) and the college was avidly courting the elderly donor and his wife, convincing them to expand the mission beyond a museum to a research institute, which accounts for the name. Since the opening of the original building on 140 acres in 1955, the museum has continued to grow, both in physical plant and in its holdings. A major expansion designed by Pritzker Prize recipient Tadao Ando is under way and scheduled to be complete in 2013. It will tie together and refocus the somewhat haphazard group of buildings that have been added to the signature temple and provide smoother integration into the landscape, a hallmark of Ando's style. The first new building, the Stone Hill Center, opened in 2008 and provides galleries for Modern and non-Western art.

The Clark "campus" today houses, above all, the art collec-

tion, but also the Williams/Clark Graduate Program in the History of Art, and the Williamstown Art Conservation Center. To support these scholarly and educational programs, the institute has assembled a first-rate art library of more than two hundred thousand volumes, which, incidentally, is open to the public. In addition, academic conferences and symposia bring scholars from all over the world, enriching the museum's programs.

But enough of the preliminaries! It's the museum you came for, and you will not be disappointed. Sterling Clark started collecting in his thirties and kept at it until his death. He has been described as a "manic shopper." He knew what he liked; beautiful art from the Renaissance through the nineteenth century. He particularly favored landscapes, genre scenes, and paintings of women, and he loved French Academic and Neoclassic painting (William Adolphe Bouguereau, Jean-Léon Gérôme, Jacques Louis David) as well as their opposing movement, French Impressionism. There seems to be no twentieth-century work in the original collection, and nothing non-Western. He was a conservative collector, unlike his brother Stephen, likewise an avid collector, who sought out more forward-looking painters, such as Cézanne, Matisse, Picasso, and Van Gogh, and left their works mostly to the Met, MoMA, and Yale (q.v.).

Initially, Sterling Clark collected Old Masters; the two small galleries devoted to them are real treasure chambers, yet easily neglected because of the overwhelming impact of the French Impressionist collection. One of his first purchases was Piero della Francesca's *Virgin and Child Enthroned with Four Angels*, considered one of the finest works by that artist in the United States. Domenico Ghirlandaio's *Portrait of a Lady*, the hauntingly beautiful and moving *Sepulcrum Christi* by Perugino, and Hans Memling's *Portrait of Canon Gilles Joye* are not to be missed. Some paintings have now been demoted to "circle of" or "school of"—such as canvasses originally thought to be by Botticelli, Rubens, and Rembrandt—but they are nevertheless wonderful works, and can delight us as much as they did Sterling Clark. Claude Lorrain, Ruisdael, Gainsborough, Goya, Turner—the list goes on and on.

Once Clark married a Frenchwoman, Francine Clary, their acquisitions took on a distinctly French flavor. While there are

Piero della Francesca, *Virgin and Child Enthroned with Four Angels*, ca. 1460–70. Oil on panel, transferred to fabric on panel. © Sterling and Francine Clark Art Institute, Williamstown, Massachusetts, 1955.948.

the aforementioned Academic painters, French Romantics as well as members of the Barbizon School, the Impressionists are the heart of the museum. There are thirty-nine Renoirs, and you will gasp as you see a (rotating) selection of them in the airy central gallery. They are simply stunning in their lush beauty, softness, and painterly bravura. Many are of women, running the gamut from a little girl (*Mademoiselle Fleury in Algerian Costume*) to languid nudes, maids, and high-society ladies in lace and silk. There are also a dramatic self-portrait and a still life of onions that was one of Clark's earliest purchases and his favorite. All the other major Impressionists are represented, as well—Monet, Degas, Pissarro, Berthe Morisot, and the American Mary Cassatt—and I can't think of another room, in any museum, that is quite as en-

chanting as this assembly of delights. And it does, indeed, feel like a room, because the scale of the Clark Art Institute and its layout situate it halfway between a house museum (like the Frick Collection in New York) and a public institution.

American art is also represented, albeit selectively. Clark was a loyal patron of Winslow Homer's, buying works as Homer's career progressed until the collection now has more than two hundred works in different media. Homer's *Sleigh Ride* of 1893 stands out for its almost abstract spareness. Another favorite was John Singer Sargent, whose *Fumée d'Ambre Gris* of 1880, showing a white-dressed North African woman in a white setting, is a perennial favorite of museum visitors. The portrait of Sargent's teacher Carolus Duran, painted when Sargent was all of twenty-four years old, is equally stunning. The third pillar of American painting is Frederic Remington, due in large measure to Sterling Clark's second love—horses. Additionally, with the donation, in 2007, of a group of British paintings, oil sketches, and watercolors by Gainsborough, Constable, and Turner assembled by Edwin A. G. Manton, the Clark Art Institute now has a richer representation of English art as well.

We should quickly mention that the Clarks avidly collected English and American silver, which is on display, and drawings, prints, and pastels, which generally are not. Master drawings by Dürer, Rembrandt, and Rubens (the sketch for the painting of Thomas Howard, earl of Arundel, now in the Isabella Stewart Gardner Museum) are just the tip of an iceberg. Luckily, the Clark Art Institute regularly mounts top-notch exhibits that draw on its holdings, be they in paint, on paper, or, increasingly, in the medium of photography. Because of its stature among museums, the Clark collaborates as an equal with many institutions worldwide, and brings major traveling shows to the Berkshires.

+ PLUS

Williamstown Theatre
During the summer months, the Williamstown Theatre Festival becomes a magnet for actors, audiences, and theatre apprentices. Each summer there are about two hundred performances

of over ten different plays, both classic and new, with actors from Broadway and film, famous or soon-to-become-famous. Former apprentices include Dick Cavett, Christopher Reeve, Gwyneth Paltrow, and Sigourney Weaver, while stars such as Frank Langella, F. Murray Abraham, Joanne Woodward, Kate Burton, and Olympia Dukakis have repeatedly graced the stage or directed. Many productions originating here have gone to Broadway or regional theaters around the nation.

The '62 Center for Theatre and Dance, a massive expansion that envelops the original Adams Memorial Theatre, boasts three different performance venues. Designed by William Rawn Associates of Boston (also responsible for Seiji Ozawa Hall at Tanglewood, in Lenox, Massachusetts), this welcome modern addition to the Williams College campus ensures that a lively performance season will extend through the school year as well.

1000 Main Street (Route 2) near the intersection with South Street, in the heart of the college campus; www.wtfestival.org, and www.williams.edu/go/62center.

WILLIAMS COLLEGE MUSEUM OF ART

15 Lawrence Hall Drive (postal address), Williamstown, MA 01267; Tel. 413-597-2429; www.williams.edu/WCMA.

Directions: From I-90 (Mass. Pike) take Exit 2 (Lee) to Route 20 North. It will merge with Route 7, which you follow into Williamstown. At the traffic circle turn right onto Route 2 East (Main Street). The entry to the museum is located on Main Street, on the right, shortly after Spring Street. You can park across the street from the museum in the lower lot behind Thompson Memorial Chapel.

Hours: Tuesday through Saturday, 10 A.M. to 5 P.M.; Sunday 1 to 5 P.M.

Admission: Free.

Catalog: Encounter: Williams College Museum of Art, ed. Vivian Patterson, Williamstown, 2006.

Williamstown is blessed with two art museums, which thrive in close proximity and engage in many cooperative endeavors, not

the least of which is a joint master's degree in art history. While the Clark has the dazzling European masterworks, the unified vision, the seemingly bottomless endowment, and the crowds, the Williams College Museum of Art is the typical college teaching museum, albeit one of the best. It boasts examples from many cultures and times, and has been lucky to have generous alumni givers of art and foresighted donors who have endowed acquisition funds. The holdings number about 12,000 items, of which over half are American and 1,600 are drawings. The collecting emphasis is on Ancient, Medieval, American, contemporary, and non-European art, thereby complementing the Clark's collection. The permanent collection is often showcased in smartly thought-out assemblages, which usually stay for a year or so. What is striking is the bold asynchronicity and eclecticism of many displays. Typical of these are the "Labeltalk" exhibitions, in which a small number of artifacts are displayed, and three or four faculty members from various departments are invited to write a commentary based on their viewpoint and expertise. The idea is that many disciplines can learn from the arts, and at the same time the knowledge and insights from those disciplines enable others to gain a better understanding of the arts.

The building of the WCMA is an amalgam of old and new—with a twist. The old is the brick octagon from 1846, built originally as a library, Lawrence Hall, with radiating stacks based on the latest in European library design. It was conceived by a gifted young architect, Thomas Alexander Tefft, in a mixture of Greek Revival (interior) and German Rundbogenstil (round-arch style) on the outside. While collecting began in the mid-nineteenth century, and artwork was displayed in various buildings, including the library, it was not until 1926 that the art collection was constituted as the Lawrence Art Museum and housed in the refurbished and expanded former library.

Renamed the Williams College Museum of Art in the 1970s, the institution embarked on a major expansion program in the early eighties. The architect, Charles Moore (see Dartmouth College), has designed a tongue-in-cheek Postmodern building that both respects and plays with the elements of the original rotunda. The entrance opens into a triangular, open stairwell, with

a dramatic Sol LeWitt wall treatment and clever transitions from the old to the new, including a lofty bridge across the stairwell; note the "quoted" Classical architectural elements that mark the transitions. (A walk around the outside of the building on its various levels offers more such ironic allusions.) The printed building map will help you find your way around and not overlook any of the tucked-away spaces.

On the entry level is the Faison Gallery, named for the long-time director of the museum who is also the godfather of this book (see introduction). He taught generations of Williams students to learn art and art history not from books or slides, but by closely looking at artworks, "learning from the object." So many of his students became curators, museum directors, and art historians that the term "Williamstown mafia" has been applied to them. This and the following Bloedel Gallery hold prized examples from many eras of mostly non-American art. It's the intensive, intimate, "Kunstkammer" part of the museum versus the more expansive, American-dominated second floor. Greece, Rome, and the Far East are all represented by fine sculpture: a superb Greek red-figure vase showing Poseidon attacking the giant Polybotes, with "three drunken youths making merry" on the reverse (what perfect subject matter for a men's college!); a Hellenistic head (presumably of Zeus); a Roman sarcophagus fragment showing the apotheosis of Hercules; a Roman mosaic head; several Buddha figures; and the serenely beautiful *Female Divinity*, carved of stone in tenth-century Cambodia, this last now prominently displayed in the central stairwell. A notable group of Spanish paintings includes a powerful *Executioner* by Jusepe de Ribera (1591–1652) and a portrait of an unidentified, bespectacled Knight of the Order of Santiago by Velázquez's teacher and father-in-law, Francisco Pacheco (1564–1654). The *Annunciation* attributed to José Moreno (1642–1674) is an outsize, dramatic display, which Faison characterizes as blending "the Baroque action of Rubens and Bernini with the Venetian technique of Titian and Tintoretto."

Two smallish upstairs galleries are dedicated spaces, one to the Assyrian reliefs received by various New England colleges (described in detail at Dartmouth), the other to a number of Medieval artifacts. This latter, the Blashfield Room, has the dimensions

Female Divinity, early tenth century. Khmer (Cambodian) Koh
Ker (Cambodian). Sandstone, H: 107.00 cm, W: 35.50 cm, D: 20.50
cm. Williams College Museum of Art. Museum purchase, Karl E.
Weston Memorial Fund 68.2.

of a small chapel and is dimly but suggestively lit to preserve, for
example, a millefleur Flemish tapestry, whose fauna includes a
unicorn. Here the treasure is a fifteenth-century alabaster figure,
St. John the Evangelist, of Franco-Flemish origin, presumably part
of a crucifixion scene. "Brownish-warm in tone, elegant in shape,
fluid in cascades of soft drapery, the Saint projects an intense spiri-
tuality as he gazes upward" (Faison). Five large galleries, some in-
terconnected and some isolated, allow for a combination of large
and small exhibits, both of the permanent collection and of trav-
eling shows. One of these galleries is the rotunda, and the lovely
circle of Ionian columns under a blue dome at times eclipses what
is exhibited here.

Early American art here starts with John Singleton Copley's *Portrait of Rev. Samuel Cooper (1725–1783), Pastor of Brattle Square Church, Boston*, shown as a benevolent, soothing presence. Two further portraits have a close relationship with Williamstown and the college. First, there is the *Portrait of Col. Benjamin Simonds (1726–1807)* by the itinerant painter William Jennys (see also Lyman Allyn Museum). Simonds sat for this portrait as a seventy-year-old man, a sturdy, no-nonsense kind of man, after a life of adventure. In 1750 he settled in Williamstown and built several houses that also served as taverns. He sat for the portrait in the tavern room of River Bend Farm, which still operates as an inn today (see PLUS, below). He also made significant contributions to the Free School, the precursor of Williams College. A donor of major proportions is depicted in *Portrait of Amos Lawrence, Benefactor, 1846*, by Chester Harding (1792–1866), a successful portraitist and rival of Gilbert Stuart's in Boston. The town of Lawrence, Massachusetts, is named after Amos Lawrence, as is the abovementioned Lawrence Library. The full-length portrait, in warm reds and browns, shows him relaxed, in a paisley dressing gown, as he was sickly and infirm—his expression, however, noble and kindly.

The later nineteenth century includes several examples of the Luminist School: *Lake George* by John Frederick Kensett (1816–1872), *Twilight* by George Inness (1825–1894), and *The Palisades at Dusk* by Sanford Robinson Gifford (1823–1880). William Hunt's colossal *Niagara Falls* was originally intended for the New York State capitol; the scene is devoid of any human figure and takes the viewer right into the churning waters of the Horseshoe Falls. The pols, however, rejected it, for they wanted something allegorical, more along the lines of what Elihu Vedder (1836–1923) did for the Library of Congress. Vedder decorated five lunettes of that library with allegories of Government, Good Administration, Peace-Prosperity, Corrupt Legislation, and Anarchy. The oil studies for these are at WCMA, showing full-breasted females—naked or semi-draped—earnestly holding their symbolic attributes. This is not art that speaks to us very well today, but was a lively concern for late-nineteenth-century artists, invigorated by the 1893 Columbian Exposition in Chicago and the craving by government

agencies for high-minded monumentality. WCMA owns another set of mural studies, by Edwin Howland Blashfield (1848–1936): *The Evolution of Civilization*, for the dome of the Library of Congress. Here the allegorical figures representing various civilizations are more varied, the execution more painterly and less cold than those by Vedder. A college museum seems to be the logical repository for such glorifications of the highest achievements of mankind, and their iconographic traditions.

A survey of the first half of the twentieth century includes examples by George Bellows, Max Weber, Charles Demuth, Marsden Hartley, John Marin, Georgia O'Keeffe, Marguerite Zorach (a powerful portrait of her baby daughter with her black nurse), Joseph Stella, Milton Avery, and a pivotal work by Edward Hopper, *Morning in a City* of 1944, among many others. Some are watercolors or pastels and therefore rarely on view. The brothers Maurice (1858–1924) and Charles (1863–1948) Prendergast hold a very special place at WCMA. Charles's widow bequeathed their estate of over four hundred items, the museum published the *Catalogue Raisonné* of their work in 1990, and it maintains the Prendergast Archive and Study Center. Expect always to see some of their colorful, joyful work in the galleries.

As we approach the museum's holdings of art from the recent past, we note that WCMA is active in collecting photography and continues its commitment to sculpture. The Kathryn Hurd Fund, an endowment exclusively for the acquisition of works by living American artists, ensures that the museum will remain engaged in this country's artistic life, seeking out, studying, and eventually assembling the collection of the future. It is thus most fitting that the museum celebrated its seventy-fifth anniversary in 2001 by commissioning the powerful environmental sculpture *Eyes*, by Louise Bourgeois (b. 1911) that greets you as you ascend the hillock to the museum.

+ PLUS

River Bend Farm

River Bend Farm B&B lets you experience an authentic eighteenth-century inn and still have modern comforts. The owners

are committed to preserving and maintaining the 1770 building; they are living history books eager to share their knowledge and expertise. You encounter creaking, wide-plank floors, corner cupboards filled with pottery and pewter, original paneling, copper sinks, but also a modern shower skillfully wedged into the storage pantry brimming with eighteenth-century pottery and implements. Breakfast is served in front of the open hearth, blazing in cooler weather, and a copy of the Simonds portrait mentioned above hangs in the tavern room where the original would have been.

643 Simonds Road (Route 7 North), Williamstown, MA 01267; Tel. 413-458-3121; www.riverbendfarmbb.com.

Winchester

GRIFFIN MUSEUM OF PHOTOGRAPHY

67 Shore Road, Winchester, MA 01890; Tel. 781-729-1158; www.griffinmuseum.org.

Directions: From Boston: take I-93 North to Exit 33, bear left to cross over I-93. Take first right (South Border Road) for 2.5 miles. At rotary in center of town, take first right, Shore Road. The museum is 200 yards on the right.
From Route 128 (I-95): Take Route 3 South at Burlington. Follow for 3 miles. At second set of lights turn left onto Church Street. Continue 1.5 miles to rotary. Take third right (Shore Road).
Hours: Tuesday through Thursday, 11 A.M. to 5 P.M.; Friday, 11 A.M. to 4 P.M.; Saturday and Sunday, 12 to 4 P.M.
Admission: Adults $5, seniors $2, Thursdays are free.
Catalog: New England in Focus: The Arthur Griffin Story (1995) provides a survey of the photographer's life and work, and a look at the founding of the museum.

Arthur Griffin (1903–2000) has been called "New England's Photographer Laureate," and this museum intends to "promote an appreciation of photographic art and a broader understanding of

its visual, emotional, and social impact." The museum preserves and presents his work, which spans the evolution of photography, photojournalism, and the commercial use of color photography, from the late twenties to his death. Griffin started out as an illustrator and brought his artist's eye to photography, as both a staff photographer for the *Boston Globe* and a much sought-after freelance photographer and photojournalist for such publications as *Life*, *Colliers*, *Saturday Evening Post*, and *Yankee Magazine*. He also published the first full-color book on New England landscapes, *New England* (1962), followed by *New England Revisited* (1966) and *Arthur Griffin's New England* (1980), thereby setting the standard for the pictorial representation of the region. He photographed celebrities, capturing the nineteen-year-old Ted Williams on color film as early as 1939.

Late in his life, Griffin persevered in the establishment of this charming little museum, situated on the shore of Judkins Pond in the center of Winchester, where he had spent most of his life. The building, which opened in 1992, looks like a quintessential Yankee gristmill, sporting a bright red waterwheel on the pond side, and comprised of a clapboard Colonial house and a barnlike structure of fieldstones, connected by the entry vestibule. It is a bit of theater, but in an understated New England way. (Note the weather vane in the shape of a photographer with tripod.) The interior of the barnlike structure is a large, high-ceilinged gallery, with hand-hewn wooden trusses, a huge circular, wrought-iron chandelier (but also state-of-the-art lighting and movable walls). It serves as the venue for three to four yearly exhibitions by "aspiring and acclaimed fine art and commercial photographers."

The clapboard portion of the compound houses the much smaller Emerging Artist Gallery and the Griffin Gallery, the latter featuring a selection of the pioneer photojournalist's own work. His entire archive is on site, and there is also a small gift shop. The cozy atmosphere should not deceive one as to the high quality, intellectual ambition, and originality of the exhibition program. In 2000, for example, there was an exhibition tracing the history and aesthetics of the photo booth, in 2004 a showing of Sebastião Salgado's documentation of the global efforts to end polio. The online Virtual Gallery presents a featured artist chosen by the

museum staff six times a year; for Critic's Pick, also online, noted photography critics pick an emerging artist of their choice.

+ PLUS

Richardson Library in Woburn

The next town north, Woburn, boasts a public library designed by H. H. Richardson, which more than fulfills its donor's wish to create "an architectural ornament in the town." The library joins a fine assembly of public buildings that ring the central town green. Set back a bit on an expanse of lawn, it is a majestic presence with its bold asymmetry, strong Romanesque arches, intricate carved stonework, and the lively interplay of reddish brownstone and cream-colored sandstone. (The architect's masterpiece, Trinity Church in Boston, was consecrated only two years earlier, in 1877, and there are many similarities.) This was Richardson's "first, largest, most ornate, and most complex library," and its success no doubt led to the subsequent library commissions in Quincy, North Easton (q.v.), and elsewhere (see also Burlington, Vermont).

The librarian at the time was one George Champney, father of the painter Edwin Champney (who helped La Farge in the decoration of Trinity Church) and uncle of the more prominent Benjamin Champney (1817–1907), a painter and Woburn resident known for his numerous "White Mountains" scenes in the vein of the Hudson River School. The library's donor, leather magnate Charles Bowers Winn, collected art and made his collection a part of the bequest, with the stipulation that a picture gallery be included in the building. There are twelve paintings by B. Champney, mostly landscapes that now hang in the octagonal room to the right. The library today is overflowing with books, computers, desks, etc., so that unfortunately many of the paintings are hung too high, above the bookshelves, in corners, or are in storage. In the original setup, imagine the central room as a picture gallery only, the octagon as a "lady's parlor," the cross-nave with fireplace and Richardson-designed furniture as the reference and reading room, and the open stacks area with its barrel vault much as it is today. The remainder of the art collection consists of various genre paintings,

landscapes, and historical paintings by local painters, but, surprisingly, also includes some Antique busts, Renaissance sculpture, and nineteenth-century marble and bronze portraits. The Italian works come from the Jarves collection, the core of which is in the Yale University Art Gallery. The library has two pamphlets on sale, one on the building, the other on the art collection.

45 Pleasant Street, Woburn, MA 01801; Tel. 6781-897-5800; www.ci.woburn.ma.us/.

Directions: From the Griffin Museum, proceed on Shore Road, turn left, then right onto Main Street (Route 38) which leads directly into Woburn center. The library is open daily, except Sunday; Monday through Thursday, 9 A.M. to 9 P.M.; Friday and Saturday, 9 A.M. to 5:30 P.M.

Worcester

HIGGINS ARMORY MUSEUM 🛒

100 Barber Avenue, Worcester, MA 01606; Tel. 508-853-6015; www.higgins.org.

Directions: From Mass. Pike (I-90) take Exit 10 to I-290 East. Take Exit 19 to I-190 North and immediately take Exit 1 (Route 12 North). Follow Route 12 (West Boylston Street) for a quarter mile, past the Greendale Mall. Cross railroad bridge and immediately take a sharp right onto Barber Avenue. The museum is on your right. Free parking in the museum lot.

Hours: Tuesday through Saturday, 10 A.M. to 4 P.M.; Sunday, 12 to 4 P.M. Closed on major holidays.

Admission: Adults $9, seniors $8, children 6–16 $7.

Catalog: Stephen V. Grancsay, *Catalogue of Armor: The John Woodman Higgins Armory* (1961) is long out of print, but a little booklet, *The Higgins Armory Museum: The Age of Armor* (2002) is available in the gift shop.

John Woodman Higgins (1874–1961) was an engineer and industrialist, president of Worcester Pressed Steel Company, and an

avid collector of historic arms and armor. He appreciated their beauty, their historic reverberations, and their fine craftsmanship. When his collection grew too big for his own home, he had a steel-and-glass, Art Deco building erected to house the administrative offices of his firm on the first two floors and the exhibition on the top floors, a wing each for historical and contemporary steel products. He saw his institution, finished in 1931, as a temple to steelmaking, and invited visitors, after they had toured the museum, to watch steel products being made in the adjacent factory, which he called "the biggest exhibit of them all."

After Higgins's death in 1961 and the demise of the factory in 1975, the museum deleted the modern artifacts and today is focused entirely on historical armor. The setting could not be more suggestive: the third floor is modeled on a Medieval great hall, with vaulted Gothic ceilings, colorful banners, and stained-glass windows. Several full-size horses with knights in armor astride, and numerous full sets of Late Medieval and Renaissance armor, from mail shirts to full garnitures of plated armor, placed at eye-level and well labeled, are supplemented by collections of lances, swords, and other weaponry hung upon the walls. The two wings are divided into battle armor and tournament outfits; on weekends there are often live demonstrations of various weapons and fighting styles (check Web site for calendar of events).

Upon closer inspection, you will notice the various ways of ornamenting the metal surfaces. Etchings developed directly from the armorer's art of decorating steel armor, and we know that Albrecht Dürer's first etchings were done on iron plate, before the more practical copper plate came into use. Gilding, damascening (i.e., hammering gold or silver wire into the grooves created by engraving), and embossing (hammering decorative patterns into the plate itself), as well as the addition of decorative rivets and studs and the application of brass or gold ornaments were all used to create a treasured possession that gave the owner not only protection but also status and prestige. Some of the helmets, including Ancient Greek helmets, have such striking shapes that they reminded me of African or twentieth-century sculpture. The shape of the body armor, incidentally, was more influenced by contemporary fashion in clothes than by the physique of the wearer.

The fourth-floor gallery overlooking the great hall displays armor from non-European countries and from Antiquity, and offers a systematic explanation of the nomenclature and functions of various pieces of armor. The great hall also has a painting germane to its content, *Venus at the Forge of Vulcan*, by Jan Brueghel, son of the more famous Pieter, showing Vulcan, the armorer to the gods, being visited in his workshop by his wife, Venus.

If you are here with children, then the second floor is a paradise. A large area has been set aside where kids can dress up, try on various helmets, play chess with kid-size pieces, and otherwise let their imaginations roam freely. This floor houses temporary exhibits, as well. The ground floor has an orientation gallery with an introductory video as well as a well-stocked gift shop.

+ PLUS

Tower Hill Botanic Garden (Boylston)

During the warmer season, and especially in the spring, Tower Hill Botanic Garden offers over 130 acres of bloom and greenery, special gardens and woodlands trails, about nine miles from the Higgins Armory. The Worcester County Horticultural Society was founded in 1842, and attests to the same bent for scientific and practical improvements that fed New England's early industrialization. A horticultural hall was built in 1851, but the Botanic Garden, only established in 1983, is being created incrementally, with the completion of the master plan envisioned for 2040. Gardening takes time! Already in place is an apple orchard that preserves 119 heirloom varieties (apple tastings take place in the fall); the Lawn Garden, which displays more than 350 species of trees and shrubs; the Secret Garden of perennials; the Systematic Garden, in which plants are planted according to their evolutionary relationships; moss steps; a romantic eighteenth/nineteenth-century-inspired park with architectural "follies"; and much more.

Tower Hill Botanic Garden, 11 French Drive, Boylston, MA 01505; Tel. 508-869-6111; www.towerhillbg.org.
Directions: From the parking lot of the Higgins Armory, turn right onto Barber Avenue, take left onto Randolph Road,

take right onto Burncoat Road, and follow the signs for I-290 East. Take this to Exit 23B to Route 140 North. After I mile, turn right onto School Street, which merges into Main Street. Take a right onto French Drive.

WORCESTER ART MUSEUM 🛒

55 Salisbury Street, Worcester, MA 01609; Tel. 508-799-4406; www.worcesterart.org.

Directions: Take Mass. Pike (I-90) to Exit 10 (Auburn); take I-290 East to Worcester to Exit 17. At top of ramp turn left onto Route 9 to Lincoln Square, proceed through square to fourth set of lights at top of hill; turn right (Harvard Street); museum is on left at second traffic light (Salisbury Street). Parking in museum lots and on Lancaster and Tuckerman streets.

Hours: Wednesday through Sunday, II A.M. to 5 P.M.; third Thursday every month, II A.M. to 8 P.M.; Saturday, 10 A.M. to 5 P.M.

Admission: Adults $10, seniors and students $8; children under 17 (and everybody Saturday, 10 A.M. to 12 P.M.) free.

Catalog: Worcester Art Museum: Selected Works, published by the museum, 1994; as well as several specialized catalogs.

How many Bostonians know the Worcester Art Museum? Way too few! There is so much more to Worcester than outlet malls. Less than an hour from either Boston or Hartford sits another excellent art museum, founded in the civic-minded nineteenth century "for the benefit of all the people of Worcester," and—luckily—for us as well.

Worcester was a thriving city in the nineteenth and early twentieth centuries, with a large manufacturing base that has left its visible traces in the grand and sober brick factories and in the substantial civic buildings you see throughout the city. The founding father of the Worcester Art Museum, Stephen Salisbury III, was the scion of one of the richest and most philanthropic old families in Worcester, which started with young Stephen Salisbury I setting up a hardware shop in 1767. Salisburys have been instru-

mental in every major Worcester civic and cultural undertaking: the Worcester Free Library, Mechanics Hall, Worcester Polytechnic Institute, the American Antiquarian Society, Worcester City Hospital, and many others.

When the museum opened in 1898 in a handsome Greek Revival building (enveloped in the 1933 expansion), its collection was modest and consisted mostly of plaster casts of Ancient statuary. Due to an ample endowment and the generosity of mostly local donors, the holdings have grown to more than thirty-five thousand works of art dating from Ancient Egypt to today. The museum was the first American museum to buy works by Hogarth, Monet, and Gauguin, and began early to collect photography; due to its participation in excavations in Ancient Antioch (now Turkey), it boasts some spectacular Roman mosaics.

When you visit, do yourself the favor of entering through the main (Salisbury Street) entrance rather than "sneaking in" through one of the two side entrances: the dramatic and well-proportioned Renaissance Court—two stories high, with its skylight illuminating the twenty-by-twenty-four-foot Roman hunting scene mosaic on the floor, and its balconied second floor—lifts the spirit and beckons you to explore the galleries that ring this grand space.

The layout of the museum is simple enough, like a chronological pyramid: the Ancient and Medieval worlds, as well as Asian art, are on the first floor; European painting from the Early Renaissance to today on the second; American art and crafts on the third; and, finally, contemporary American and—here the chronology breaks down—Pre-Columbian art on the fourth. Among the highlights of the first floor is the late-twelfth-century Romanesque chapter house that was transported in its entirety from France. While its overall mood is of Romanesque heaviness and gloomy darkness, a look at the ceiling with its ribbed cross vaulting provides a first inkling of the coming Gothic age. Among the Medieval objects nearby is the contemporary *Virgin and Child* from Burgundy, carved in wood, a rare example of Romanesque sculpture. Compare its otherworldly reticence with the sweet elegance of the ivory *Virgin and Child* from the late fourteenth century.

Among the artifacts of Antiquity, do not miss the *Female Torso* from the Egyptian Fifth Dynasty and the large black-figure amphora attributed to the Rycroft Painter, with its representation of Leto and her twin children, Apollo and Artemis, mounting a chariot. The Rycroft Painter is famous for his finely drawn horses; note the care with which all sixteen legs are accounted for in the tight space. A marble relief gravestone, the life-size *Warrior*, is made from the same Pentelic marble as the Parthenon frieze and only slightly later, while a fine bronze bust, *Portrait of a Lady* from the second century A.D., shows a contemplative woman of noble bearing, possibly the wife of an emperor.

The Asian collection began with the 1901 bequest of John Chandler Bancroft's over three thousand Japanese prints, supplemented upon his death in 1906 by his Japanese paintings and a generous acquisition fund. Today the Asian collection covers the major periods of Persian, Chinese, Indian, and Japanese art, in such media as textiles, prints, ceramics, sculpture, jade, and painting. Because of the fragility of works on paper and textiles and the vastness of the collection, you need to be on the lookout for special exhibits that present topical or historical groupings of selected art works (e.g., Birds in Japanese Art and Poetry, or Samurai Spirit). The more durable bronze, stone, and ceramic objects are displayed in four rooms to the right of the Renaissance Court, one each for Islamic, Japanese, Chinese, and Indian/Southeast Asian art. While the Metropolitan Museum or even the Museum of Fine Arts, Boston, threaten to overwhelm the visitor, Worcester has the broad coverage but a manageable number of pieces in each distinct gallery to allow you to ponder, contemplate, and absorb each piece and let the ensemble of a culture impress itself on you.

The same contained, concentrated presentation of distinct epochs prevails in the second-floor suite of rooms housing European painting. Eleven connected rooms surround the Renaissance Court; the paintings are in chronological order and grouped by region. While this is not extraordinary, I have rarely experienced such clearly focused, well-selected ensembles, which seem effortlessly to express the essence of Italian Baroque, sixteenth- to seventeenth-century Flemish painting, or eighteenth-

to nineteenth-century French art. It helps that each room is small enough that you can easily see all paintings from the middle of the room and make the mental cross-references between pictures that almost seem to talk to each other. This says a lot about the talent of the directors and curators, and the methodical and deliberate way in which the collection was built.

It seems therefore unfair to pull out the "stars," but let me drop a few names anyway: Quentin Massys, Andrea del Sarto (a tender *St. John the Baptist* that had been hanging—incognito—in a Worcester Church until it was recognized by the then curator James A. Welu and acquired by the museum in 1984), El Greco, Bernardo Strozzi (an amazing *Calling of St. Matthew*, reminiscent of Caravaggio's treatment of the same subject), Rembrandt, Jan Steen, Jacob van Ruisdael, William Hogarth (enchanting portraits of a blustery country squire and his sweet, would-be-worldly young wife), Thomas Gainsborough (the haunting double portrait of his two daughters), Gustave Courbet, Paul Cézanne (a study for his famous *Card Players*), Paul Gauguin (*The Brooding Woman*, once owned by Edgar Degas), Claude Monet, Henri Matisse, Wassily Kandinsky.

American art at the Worcester Art Museum (third and fourth floors) is interwoven with the history of Worcester residents who figure as sitters, artists' patrons, and donors, most prominently among them the Salisbury family. You may discover some of these connections as you read the labels of paintings in the galleries or if you consult the excellent online catalog of the American holdings of the WAM.

The matched, anonymous portraits, *John Freake* and *Elizabeth Freake with Baby Mary* (ca. 1670), are rare examples of pre-1700 American painting. Their stiff, flat style is reminiscent of Elizabethan painting rather than the contemporary Baroque, and is in the same stern, hard-edged, sober style of much eighteenth- and even early-nineteenth-century American portraiture executed by itinerant painters or "limners."

Several portraits by John Singleton Copley and Gilbert Stuart are incorporated into the third-floor American Decorative Arts Gallery; others are in the painting galleries and in the dramatic stairwell. Worcester owns five Copleys and, among its Stuarts, an

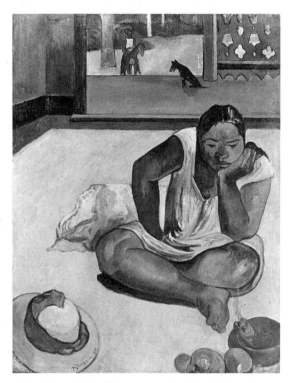

Paul Gauguin, *The Brooding Woman*, 1891. Oil on canvas, 35⅞ × 27¹/₁₆ in (91.2 × 68.7 cm). Worcester Art Museum, Worcester, Massachusetts. Museum purchase, 1921.186.

extraordinary, almost impressionistic portrait sketch of *Mrs. Perez Morton* (Sarah Wentworth Apthorp, the Boston poet known as "the American Sappho"). No wonder Stuart kept this canvas in his studio until his death!

From the nineteenth century, there are fine landscapes by John F. Kensett, Thomas Cole, Albert Bierstadt, and George Inness. John Singer Sargent cuts a dramatic presence: of five portraits he painted in Worcester, the museum owns three. *Venetian Water Carriers*, an early study in grays, beiges, and browns, shows Sargent's lively brushstrokes and a finely balanced composition. Mary Cassatt, Winslow Homer, Thomas Eakins, Childe Hassam, and a particularly enchanting *Portrait of My Daughters* by Frank Benson (1862–1951) lead us into the twentieth century. Here the holdings are not as rich, although a dramatic seascape, *The Wave*,

by Marsden Hartley (1877–1943), stands out. Sharing the fourth floor with Modern American art is the Pre-Columbian collection, small, but exquisitely installed. Worcester was among the first museums to exhibit Pre-Columbian artifacts as art (as early as 1942), when they were more traditionally exhibited in ethnographic museums. The ubiquitous Salisbury had a hand in assembling this collection as well.

There are about eight exhibitions a year, rich offerings and resources for children, and exceptionally well-researched and -produced brochures, catalogs, and pamphlets. The restaurant has delicious fare and in summertime you can consume it al fresco in the courtyard. A large library and a well-stocked museum shop round out the offerings.

+ PLUS

American Antiquarian Society
The museum neighborhood boasts a wealth of nineteenth- and early-twentieth-century civic buildings and churches that are quite impressive. You can download a map and informative virtual tour at www.preservationworcester.org.

One block past the back of the museum, at 40 Highland Street, is the original Salisbury mansion, now administered by the Worcester Historical Museum as a house museum.

If you happen to be visiting on a Wednesday afternoon, it pays to take the ten-minute walk down Salisbury Street to the American Antiquarian Society, the nation's foremost repository of anything printed in the United States before 1876 (at which point the Library of Congress assumed that role).

The Salisbury mansion is open to the public on Thursday through Saturday, 1 to 4 P.M., Thursday until 8:30 P.M. Tel. 508-753-8278; www.worcesterhistory.org. There is a guided tour of the American Antiquarian Society every Wednesday at 3 P.M., worthwhile for anybody interested in books and history. 185 Salisbury Street, Worcester, MA 01609; Tel. 508-755-5221; www.americanantiquarian.org.

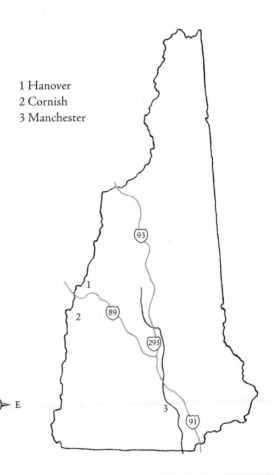

New Hampshire

1 Hanover
2 Cornish
3 Manchester

93

1

2 89

293

3 91

N
W E
S

Cornish

SAINT-GAUDENS NATIONAL HISTORIC SITE ✿

139 Saint-Gaudens Road, Cornish, NH 03745; Tel. 603-675-2175; www.nps.gov/saga; see also the Web site of the Friends of the Saint-Gaudens Memorial, www.sgnhs.org.

Directions: From I-91, take Exit 9. Take Route 5 South to Windsor. After passing through Windsor, take a left onto River Street and cross the river via the covered bridge. Right after the bridge turn left onto Route 12A. The national site is about 1 mile further on your right.

Hours: From late May to late October: Daily from 9 A.M. to 4:30 P.M.; guided tours of the house on the hour; the grounds are open year-round during daylight hours.

Admission: Adults $5, children under 17 free. Golden Age, Golden Access, Golden Eagle, and National Park passes are honored.

Catalog: Henry J. Duffy and John H. Dryfhout, *Augustus Saint-Gaudens, American Sculptor of the Gilded Age*, 2003, is an illustrated overview, published jointly by the Trust for Museum Exhibitions and the Saint-Gaudens National Historic Site.

Saint-Gaudens (1848–1907), born to French and Irish parents, has been dubbed "the American Michelangelo." While this may be hyperbole, it is true that Saint-Gaudens is the first authentic American sculptor, one not beholden to the cool, marble Neoclassicism that reigned in Paris and Rome and was much imitated by earlier American sculptors. Saint-Gaudens's style instead combines "simplicity of subject, realism of form, and strength of emotion" (Duffy and Dryfhout). His career coincided with two fortuitous trends: the conclusion of the Civil War called for commemorative sculpture on a scale never experienced before or after, and the subsequent economic explosion of the Gilded Age created a huge demand for art and decoration by newly minted millionaires who desired to be seen as cultured patrons of the arts.

Trained as a cameo cutter, Saint-Gaudens spent seven years in Paris and Rome seeking out Realist artists and teachers, and immersing himself in Renaissance art. When he returned in 1875, it did not take long for him to gain commissions for major public sculptures. Fortunately, the Saint-Gaudens Historical Site can show about half of his oeuvre in bronze casts, models, or copies. Several of the landmark works by which Saint-Gaudens is known are here.

The first major commission (New York, completed in 1881), was an over-life-size statue of Civil War hero Admiral David Farragut (he uttered the famous words: "Damn the torpedoes, full speed ahead!"). The statue shows Farragut with determined mien, flapping coat, and assertive stance, as if he were bracing himself against the wind. It rests on a curved stone exedra into which are carved two female relief figures, *Loyalty* and *Courage*. Famous architect and close friend Stanford White collaborated on the design of the enclosure.

The *Shaw Memorial* (Boston, facing the State House) commemorates Colonel Robert Gould Shaw, the commander of the first unit of African Americans in the Union army. The concept evolved from a traditional equestrian statue to a high relief of the commander on horseback and his marching men, a sympathetic and moving depiction of individual African Americans, probably a first in American sculpture. Saint-Gaudens worked on it for fourteen years and even after its installation perfected it further. Many visitors will be familiar with the *Sherman Monument*, which shows General William Tecumseh Sherman on horseback, led by an allegory of Victory. The original, in gilded bronze, stands on the southeast corner of Central Park in New York. The national site has a later cast of Victory, in flowing robe, dramatic stride, palm frond in one hand, the other hand raised. It's a thrilling piece. Perhaps his most moving sculpture is the *Adams Memorial*. A funerary monument, it combines male and female traits in a cloaked, seated figure that can be read as a mourner, but that Saint-Gaudens described as "[t]he Mystery of the Hereafter . . . beyond pain and beyond joy."

There are many other pieces to discover. Attached to the gallery is a beautiful atrium, the walls of which hold a number of

portrait reliefs (the equivalent of oil portraits)—a genre at which Saint-Gaudens excelled. In bronze or plaster, full or half size, they often show friends and artistic colleagues and can evoke Renaissance grandeur or intimate domesticity. A major such commission was that of the bedridden Robert Louis Stevenson, of which a number of variants are on view. Saint-Gaudens also designed coins for the U.S. Treasury at the behest of Teddy Roosevelt. The studio building holds several preliminary studies and unfinished works, his art library, and artworks he wanted around him. There is no other venue in which one can study Saint-Gaudens so well, and there certainly could not be a more congenial setting.

The large estate, which Saint-Gaudens called Aspet in honor of his father's (French) birthplace, boasts sweeping views of Mt. Ascutney. He transformed the main house, a rather dour former inn, into a charming summer home (and his permanent home during his last years) by adding a large piazza with Ionian columns and designing exquisite flowerbeds. The studio building was embellished with a pergola and Antique friezes (which one could then buy through the Sears and Roebuck catalog!). There are hedge enclosures hiding major sculptures, a long birch allée, several paths (one leading to a pond), and the aforementioned complex of exhibition spaces. In nice weather it's easy to spend long hours as a guest of Saint-Gaudens, in the birthplace of the Cornish art colony (see separate entry under Windsor, Vt.).

+ PLUS

Glory: Robert Shaw and the Fifty-fourth Regiment
The assault on Fort Wagner by Robert Gould Shaw and the Fifty-fourth Regiment of Massachusetts Volunteers has been made into a movie, *Glory* (1989). Starring Matthew Broderick, Morgan Freeman, and Denzel Washington (who won an Oscar for his role), it is considered one of the best Civil War movies. Saint-Gaudens's memorial certainly influenced this thrilling dramatization of one of the bloodier battles of the Civil War.

Hanover

HOOD MUSEUM OF ART, DARTMOUTH COLLEGE

Dartmouth College, Hanover, NH 03755; Tel. 603-646-2808;
www.hoodmuseum.dartmouth.edu.

Directions: From I-91: take Exit 13 into Hanover. From I-89:
Take Exit 18 and follow Route 129 North for 5 miles into
Hanover, turning left onto Wheelock Street. Metered park-
ing available on Wheelock Street and behind museum on
Lebanon Street. All-day public parking at the parking ga-
rage on Lebanon Street.

Hours: Tuesday through Saturday, 10 A.M. to 5 P.M.; Sunday, 12
to 5 P.M.; Wednesday evening to 9 P.M.

Admission: Free.

Catalog: T. Barton Thurber, *European Art at Dartmouth: High-
lights from the Hood Museum of Art* (2008) and its companion,
American Art at Dartmouth by Barbara J. MacAdam (2007).

Let's talk about the building first. It is one of the quirkiest I have
ever encountered, and description of it as "Postmodern Neover-
nacular" on the Web site Greatbuildings.com attests to the Web
site writer's bewilderment. Yes, it is Postmodern in that it alludes
to previous styles, be they Mayan temples or New England brick
factory-buildings; it is also a building full of sudden surprises and
unexpected pathways and is altogether playful. The architects
(Charles Moore and Chad Floyd of Centerbrook Architects, the
same firm responsible for the Florence Griswold Museum and
the Williams College Museum's new wing) worked under ter-
rific constraints: with a narrow site wedged between Wilson Hall
(the sturdy Romanesque former library) and the Modernist Hop-
kins Center for the Performing Arts (1962), the architects had to
mediate visually between the two, create a distinct identity and
compelling entrance for the museum, while also allowing for a
pedestrian way from the other end of the site and for internal
connections with both flanking buildings. They solved this via

a series of courtyards, a low but powerful entrance portal on the front facing the college green, and rising building sections further back with odd angles, steep rooflines, a cupola, and bold color elements. It's worth walking through the length of the site in both directions to see these various components unfold; the large yet delicately mobile wood-and-steel composition *X-Delta* by Mark di Suvero (b. 1933) fills one of the "courtyards."

It was only in 1985 that Dartmouth acquired this dedicated art museum building, named for a major donor, but collecting began in 1772, shortly after the founding of the college, with "a few curious elephant bones" from the Ohio River. The first "artwork" was a silver monteith, a kind of punch bowl, given by the Colonial governor, John Wentworth, in celebration of the first graduation held at the young college. His portrait, a rare pastel by John Singleton Copley, is in the collection.

Dartmouth's is a true teaching museum that seeks to cover every period from Prehistoric times to the twenty-first century and cultures from every corner of the earth. In the early periods of its history, the collection covered science, paleontology, anthropology, ethnology, even sociology. While it is streamlined now, it certainly puts Western and non-Western art on equal footing and is very embracing of ethnographic items and articles of daily use from various cultures and times.

A small museum boasting sixty-five thousand artifacts will, of course, exhibit only the tiniest fraction at any time, so very little will be reliably there to see. But the Assyrian reliefs from the palace of Ashurnasirpal II (ninth century B.C.) in modern Nimrud (Iraq) will never be in storage. They have their own room, unfortunately rather small, which these more-than-life-size courtiers share with other antiquities. Of the several New England colleges that acquired such carved slabs in the mid-nineteenth century (Williams College, Amherst, Yale), Dartmouth got the best (second only to those in the British Museum), particularly the full representation of the king himself. While the British did the actual excavations and were driven by antiquarian interests, American missionaries educated at New England colleges vied with each other to procure such evidence of biblical history for their alma maters. The slabs had to be sliced and cut for transportation by donkey and camel

Henri Marie Raymond de Toulouse-Lautrec, *The Jockey*, 1899.
Lithograph printed in six colors, 20⅜ × 14¼ in (51.6 × 36.2 cm).
Hood Museum of Art, Dartmouth College, Hanover, New Hampshire.
Gift of Mrs. Daisy V. Shapiro in memory of her son, Richard David
Shapiro, Class of 1943.

to reach Beirut for shipping to the New World. (A booklet about
the history and meanings of these reliefs and their tortuous route
into the collection is available free of charge.)

Another rather immovable object is a large Renaissance man-
telpiece from the château of Chenonceaux, once the abode of
François I; the piece bears his initials and salamander emblem.
It is the focal point of a room dedicated to European painting
and some outstanding American portraits. Several smaller galler-
ies show works from the permanent collection on a rotating basis.
For the rest, the Hood Museum chooses to display its riches in
small, well-thought-out contextual settings, through about eight

different exhibits per year and two teaching exhibits per term. They attest to the intimate relationship between the museum and various academic departments, strike a balance between Western and non-Western topics, and give college students the opportunity to take their own first curatorial steps. Precisely because Dartmouth is relatively far from major museums, it seems to use its own collections very creatively, integrates them into the teaching life of the campus, and makes the most of the depth of its multidisciplinary holdings.

The titles of a few recent exhibits organized by the Hood Museum will give you a flavor of the varied and thoughtful offerings:

"Coaxing the Spirits to Dance: Art and Society in the Papuan Gulf of New Guinea" (also shown at the Metropolitan Museum of New York);

"Rembrandt: Master of Light and Shadow. Etchings from the Collection of the Hood Museum of Art" (the large holdings of prints and works on paper include, among others, complete sets of Albrecht Dürer's *Large Passion,* the rare *Reisho Tokaido Road* series by Utagawa Hiroshige, and Picasso's *Vollard Suite*);

"Illuminating Instruments: Studying Light at Dartmouth" (this attests to the Hood's continuing inclusion of science into the realm of the arts and its outstanding collection of historical scientific instruments);

"Picturing Change: The Impact of Ledger Drawing on Native American Art" (an exploration of cross-cultural fertilization between Western and non-Western art);

"Coming of Age in Ancient Greece: Images of Childhood from the Classical Past" (this show included many loan objects and went on to New York, Cincinnati, and Los Angeles; its catalog, published by Yale University Press, won major awards).

Altogether, the printed materials produced by the Hood Museum are exceptional. The *Quarterly* is a lavishly illustrated, well-

written newsletter, and the little brochures that accompany even small exhibits attest to the dedication (and the generous funding) that is lavished on the museum's efforts. Equally impressive is the online catalog, with excellent search capabilities, entirely open to the public.

After you leave the smaller exhibition rooms on the first floor, a sleek, straight staircase brings you into a very different environment. The ceiling is about twice as high, the space open and large to accommodate twentieth- and twenty-first-century art, and the walls avoid right angles. Here, too, the exhibits rotate and include video installations and other nontraditional media. The twentieth-century collection grew from a bequest by Abby Aldrich Rockefeller of over one hundred paintings, drawings, prints, and sculptures. She was not only a cofounder of the Museum of Modern Art and a major art collector, but also the mother of Nelson A. Rockefeller (class of 1930, later governor of New York State, a presidential candidate, and also a donor to the museum).

Abby Rockefeller was instrumental in bringing about the creation of the most spectacular work of art on campus, both in size and impact, which is not in the museum at all. You have to cross the college green and reach Baker Library to experience *The Epic of American Civilization* by the Mexican muralist José Clemente Orozco (1883–1949). Here, on the walls of a long and wide corridor on the basement level, unfolds a powerful reading of America's struggle for human dignity against various forms of oppression and degradation from the Pre-Columbian to the machine age. The fresco cycle consists of twenty-four compositions on four walls. Each works as an individual scene, yet they are woven together into large, coherent panels that have a distinct character due to their color schemes or mood. This is a didactic, almost posterlike style familiar from other Mexican muralists such as Diego Rivera, but it is also much more. The expressive figures, the hieratic poses and eloquent gestures, the intense colors and bold outlines are reminiscent of German Expressionism, as is the intense spiritual urging. But, ultimately, it is a thoroughly original work of art that came about because a few intrepid professors and benefactors had the courage and foresight to invite Orozco to the campus as an artist-in-residence, pro-

vide him with a salary for two years, and give him the choice of venue, theme, and topic. Dartmouth wound up with its "greatest art treasure," to quote the catalog, and "an object of pilgrimage" (Faison).

+ PLUS

Hopkins Center for the Performing Arts
From the center of the college green, focus on the façade of the Hopkins Center for the Performing Arts, to the right of the Hood Museum. Does it look familiar? Have you seen these five tall, glass-filled arches before? What about the Metropolitan Opera House in New York? Indeed, the same architect, Wallace K. Harrison, is responsible for both, and Hopkins Center can be regarded as a dress rehearsal for the Met. Harrison (1895–1981) apprenticed with McKim, Mead & White (a firm that epitomizes Beaux Arts–style architecture), went on to design Rockefeller Center, considered among the best mixed-use urban developments, and then created the Trylon and Perisphere, the emblems of the 1939 World's Fair in New York. Following major commissions in New York City (Time-Life Building, United Nations headquarters, Battery Park City), his career culminated in the huge and still controversial Empire State Plaza in Albany, a major urban-renewal project fostered by New York governor Nelson Rockefeller.

Manchester

CURRIER MUSEUM OF ART

150 Ash Street, Manchester, NH 03104; Tel. 603-669-6144; www.currier.org.

Directions: From I-93 take Exit 8 (Wellington Road, Bridge Street). Take Bridge Street for about 1.5 miles. Turn right at Maple Street. After a quarter mile turn left onto Myrtle Way. Parking is in lot across from entrance or on surrounding streets.

Hours: Daily, 11 A.M. to 5 P.M., except: first Thursday of each

month, 11 A.M. to 8 P.M.; Saturday, 10 A.M. to 5 P.M.; closed
Tuesday.

Admission: Adults $10, seniors $9, students $8, children under
18 free.

Catalog: The Currier Gallery of Art: Handbook of the Collection,
1990.

The Currier Museum is named for Moody Currier (1806–1892)
whose lifetime coincides with Manchester's prodigious growth.
The city, for its part, was named in rivalry with its English coun-
terpart, and housed the world's largest textile plant, the Amoskeag
Manufacturing Company, with up to seventeen thousand work-
ers. Currier was one of those nineteenth-century Renaissance
men who shaped New England: lawyer, newspaper editor, banker;
active in politics as senator and governor; advocate and sponsor of
all kinds of educational and civic enterprises; proficient in vari-
ous sciences; and a published poet. His will stipulated the estab-
lishment of an art gallery on his estate, even though he himself
did not collect art. The Currier eventually opened, in 1929, with
a great building but scant holdings; however, there was a budget
for purchases. From the start the museum adhered to a highly se-
lective acquisition policy. In the words of its midcentury direc-
tor, Gordon M. Smith, "Our long-range objective is a necessarily
small but very choice collection of top-quality paintings, each
making a distinct contribution toward an appreciation and under-
standing of the major movements and periods in history."

The Currier Museum of Art has since undergone several ex-
pansions, the last of which was completed in the spring of 2008.
As a result, the original building, an elegant Neoclassical edifice
by Edward L. Tilton (who also designed the Springfield Pub-
lic Library, q.v.), is now enveloped and somewhat overwhelmed
by much larger additions. Two matching wings—one on either
side of the current entrance—were designed in 1982 by the firm
of Hardy Holzman Pfeiffer. The just-completed annex (by Ann
Beha Architects) made the original, formal façade with its stately
columns and mosaic panels into one side—and the visual fo-
cus—of a sunken, skylit winter garden and café. This is, in turn,
surrounded on the other three sides by large, flexible galleries,

elevated above the winter garden. These spaces are intended for special exhibitions and the showcasing of New Hampshire and New England artists.

It's worth taking a good look at the original building, especially the central hall with its mosaic floor, the spirited bronze *Crest of the Wave* by Harriet Whitney Frishmuth, and the detailing of the staircases and balconies. The upper floor of the original building is devoted to American fine and decorative arts from 1680 to 1815, the main floor to Modern (i.e., twentieth-century) art, both European and American. The two wings flanking the entrance are given to European art (up to the end of the nineteenth century) on the left and contemporary (late twentieth and early twenty-first centuries) on the right.

The small but choice collection of European art begins with a Tuscan *Madonna and Child* from circa 1275, embodying the transition from Byzantine icon to the first stirrings of the early Renaissance. A magnificent Flemish tapestry, *The Visit of the Gypsies* from circa 1490, is a much-reproduced masterwork in the Gothic style, with the intense colors of stained glass (companion pieces of the set are in the Corcoran Gallery in Washington, D.C.). The self-portrait by Jan Gossaert, called *Mabuse*, shows him alert, self-aware, with an eloquent hand gesture, as if about to address the viewer. The pale Italian beauty pictured in Lorenzo Costa's *Portrait of a Lady* has a pert, intelligent demeanor tempered by a proud aloofness. Continuing a line of wonderful portraits is Tintoretto's courtly and elegant *Pietro Capello, Governor of Friuli*, and the striking painting of an old man with a white mane, *John Clerk of Eldin* by Henry Raeburn. Among the presentations of the Virgin, there is the sweet and soft Perugino *Madonna and Child*, the earthy, detail-obsessed *Holy Family* by the Flemish Joos van Cleve, as well as the sweetly elegant terracotta *Madonna and Child* by Benedetto da Maiano. There are landscapes by Jacob van Ruisdael, Corot, Constable, and (one of my personal favorites) *The Seine at Bougival* by Claude Monet, which shows the sun breaking through rain clouds and has a freshness and shimmer that make you almost feel the moist air and slight breeze.

Among the European Moderns, Picasso's *Woman Seated in a Chair* of 1953, Matisse's bronze, *Seated Nude* (1922–25), and

Jan Gossaert, called Mabuse, *Self-Portrait*, ca. 1515–20. Oil on panel, 17 × 12¼ in (43.18 × 31.12 cm). Currier Museum of Art, Manchester, New Hampshire. Museum Purchase: Currier Funds, 1951.6.

Rouault's *The Wounded Clown* stand out, vindicating the acquisition policy of quality over quantity.

As you mount the stairs to the American collection, you will see (in the open balcony) John Singer Sargent's *Portrait of Marchioness Curzon of Kedleston*, his last work. More lovely ladies by American Impressionists Childe Hassam, Frank Benson, and Edmund Tarbell overlook the balcony and are joined by William Merritt Chase's *Master Otis Barton and his Grandfather*, which was bequeathed in 1980 by the very boy depicted here. This close interrelation of the art object with the community in which it originated can be seen many times in the ample American collection of painting, furniture (much of it of New Hampshire origin), silver, pewter, and glass. There is a pair of portraits by the leading folk painter of the nineteenth century, Ammi Phillips, given by

a descendant of the sitters. Likewise, *Colonel Richard Varick* (1831), a portrait by Henry Inman of George Washington's private secretary, was given by an eponymous descendant. New Hampshire landscapes appear in *Moat Mountain, Intervale, New Hampshire* (ca. 1862) by Albert Bierstadt, a watercolor by Childe Hassam, and in Jasper Francis Cropsey's *Indian Summer Morning in the White Mountains*.

The most intimate relationship, however, exists between Charles Sheeler (1883–1965) and his boldly geometric yet evocative *Amoskeag Canal* (1948): it was commissioned by the museum to record the mill buildings that were then in decline following the bankruptcy of the Amoskeag Mills in 1936. (For a similar Sheeler commission, see Andover, Massachusetts.) With Sheeler's painting we are already on the main floor, the twentieth-century collection. Among the American Modern masters, Marsden Hartley, Arthur Dove, Walt Kuhn, Edward Hopper, Lyonel Feininger, Georgia O'Keeffe, and Andrew Wyeth are all represented with major paintings.

In the wing devoted to contemporary art, the emphasis is clearly on Americans. Among the artists shown here are Louise Nevelson, Alexander Calder, Adolph Gottlieb, Jules Olitski—proof that the Currier maintains its selectivity. Yet another link to the New England landscape, *Blue Pool* by Neil Welliver (1929–2005), shows what landscape painting after Abstract Expressionism can be. Its bold flatness and simplification tie Welliver to the aesthetic of his teacher, Josef Albers, also represented here; but the powerful evocation of the harsh and rocky Maine landscape is anything but abstract.

Nineteenth-century and modern glass (especially a large collection of 330 glass paperweights), studio ceramics, and studio furniture, mostly by regional artists, extend the collection of American decorative arts into the twentieth century and beyond.

+ PLUS

Zimmerman House by Frank Lloyd Wright
The Currier owns the Zimmerman House, the only building by Frank Lloyd Wright in New England that is open to the public. It

is fully furnished with pieces by Frank Lloyd Wright and artwork collected by the original owners, major patrons of the Currier Museum. A special feature is a music stand for a quartet designed by Wright. Transportation from the museum is offered for tours of varying lengths. There is even a tour that includes a house concert!

Call 603-669-6144, ext. 108, for information and reservations or make reservations via the museum Web site. Admission prices vary depending on the tour chosen and include museum admission.

Vermont

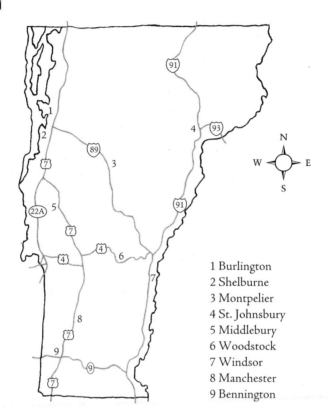

1 Burlington
2 Shelburne
3 Montpelier
4 St. Johnsbury
5 Middlebury
6 Woodstock
7 Windsor
8 Manchester
9 Bennington

Bennington

BENNINGTON MUSEUM 🚼

75 Main Street, Bennington, VT 05201; Tel. 802-447-1571;
www.benningtonmuseum.org.

Directions: From I-90 (Mass. Pike) take Exit 2 (Lee) to Route
 20 North. It will merge with Route 7, which you follow
 into Bennington. At the intersection with Route 9 (Main
 Street) turn left for 1 mile. The museum is at your left.
Hours: Daily 10 A.M. to 5 P.M.; closed Wednesdays and major
 holidays. During September and October: Open on Wednes-
 day, as well.
Admission: Adults $9, seniors $8, children under 18 free.

The Bennington Museum grew out of a historical society formed
in 1875 to focus on the pivotal local event, the Battle of Benning-
ton of 1777. Today one gallery is dedicated to the battle, in which
a small number of local militia (the Green Mountain Boys) over-
whelmed a superior force of Hessian soldiers and thus deflected
General Burgoyne's progress. There are large historical paintings,
battle dioramas and maps, uniforms and equipment, as well as a
collection of firearms made by Vermont gun makers. Another
gallery holds a hallowed relic, the Bennington Battle flag, consid-
ered the oldest American flag in existence, thoroughly faded and
protected from daylight.

 The museum's mission is still in large part historical, focused
on southern Vermont history and culture. Luckily this includes
fine early paintings, a large collection of pottery and glass, and lo-
cally produced furniture, well displayed and explained. Did you
know that the rocking chair seems to be an American invention?
That in the early nineteenth century seven known cabinetmak-
ers were active in Bennington? That clay for Bennington earth-
enware had to be brought up the Hudson from New Jersey? That
abolitionist William Lloyd Garrison established his first news-
paper in Bennington?

Bennington pottery-making was first established in 1785 by one Captain John Norton. The Norton pottery, in operation through 1894, supplied New England with salt-glazed jugs, crocks, and jars, decorated with simple blue floral motifs, now highly coveted by collectors. The Bennington Museum has the largest collection anywhere, including later and fancier local pottery of various kinds. When the itinerant painter Erastus Salisbury Field (see Springfield Museum of Fine Arts) came to Bennington, a Norton descendant, Julius, had himself painted as a cultivated gentleman, holding a flute, and also commissioned a picture of his son, Luman Preston Norton, in a bright red dress; both portraits are hanging in the second-floor gallery dedicated to Vermont furniture and early paintings. Other early paintings include works by William Jennys and Ammi Phillips, and three canvasses by Ralph Earl, painted right here in Bennington in 1798. His *View of Bennington* is a very early, pure landscape, into which he painted himself sketching, in the foreground. His *Portrait of Captain Elijah Dewey* shows the historic Walloomsac Inn, then known as Dewey's Tavern, in the background (see PLUS, below). As captain of the Bennington militia, Dewey hosted many political meetings and visitors at his tavern, among them Thomas Jefferson and James Madison.

Another dedicated gallery exhibits glass, with an emphasis on nineteenth- and early-twentieth-century American pressed glass. The installation has recently been overhauled and is quite beautiful. On the other end (both figuratively and also literally at the other end of the aforementioned furniture gallery) is the so-called Church Gallery, installed in what was the first home of the Bennington Historical Society, an abandoned mid-nineteenth-century stone church. When it opened in 1928 as a museum, the latest in museum display cases were ordered and crammed full of an incredible array of tools, gadgets, machinery, clocks, household goods, toys, etc., etc. (Seeing this array makes one realize that it is plausible that the museum's collection numbers over sixty thousand items!) It is the quintessential cabinet of curiosities, quirky and full of surprises, and the museum is to be commended for preserving this mode of display as another historical artifact in itself.

Turning another corner, you will encounter a gleaming early

automobile. It turns out that in 1920 Karl Hamlin Martin built the first Wasp touring car in Bennington. When it was exhibited in New York, Douglas Fairbanks, Sr., saw it and bought it on the spot. Only sixteen of these super-deluxe cars were built; the last, from 1925, is what you see before you.

Perhaps the museum's greatest claim to fame is the largest public collection of paintings by the Naïve painter known as Grandma Moses (1860–1961). It's a good thing she was blessed with a long life, as she only started painting in her seventies, when arthritis prevented her from knitting. She became world famous in the 1940s and '50s, when a New York art dealer discovered one of her pictures in a local drugstore and arranged for a New York show. It is impossible not to be charmed by her colorful rural scenes, picture-book-like evocations of an earlier time, which for her were living memories. Like any artist, though, she did not disdain models (in this case, popular prints) to help with overall composition and she felt free to rearrange, invent, and archaize to suit her taste. Also exhibited are personal mementoes and a video interview conducted by Edward R. Murrow. Part of the Grandma Moses Gallery is a clapboard, one-room schoolhouse moved here from Eagle Ridge, New York, where Grandma Moses had gone to school. It is set up as an interactive exhibit for children so they can explore what school was like in the olden days, dress up, or create their own Grandma Moses wall installation.

The museum has several spaces for changing exhibitions, and usually two occur at a time. They may feature private collections, local artists both current and historic, regional art colonies of summer visitors (such as "The Arlington Artistic Community, 1920–1960"), or explore local craft traditions (e.g., covered bridges, costumes), in addition to exhibits amplifying on the permanent collection. There are also podcasts of curator talks and other public lectures and events.

+ PLUS

Old Bennington and Robert Frost Gravesite
Leave your car in the parking lot and walk up the hill on Main Street to reach Monument Avenue and the Old Bennington

District, the perfect antidote to the bustling commercial district. To the left is the commons, with one of the most beautiful New England churches, built in 1802 to replace a meetinghouse of 1763. The adjacent cemetery holds the graves of many revolutionary heroes, as well as that of poet Robert Frost, who had lived in nearby Shaftsbury from 1920 until 1929 (his home can be visited; see www.frostfriends.org/stonehouse.html). Across the green from the church is the Walloomsac Inn shown in the Captain Dewey painting mentioned above; it is now a private residence. Down Monument Avenue is the gigantic obelisk commemorating the Battle of Bennington; it can be ascended by elevator (open daily, 9 A.M. to 5 P.M.) and provides excellent views.

Burlington

ROBERT HULL FLEMING MUSEUM, UNIVERSITY OF VERMONT

61 Colchester Avenue, Burlington, VT 05405; Tel. 802-656-0750, recorded message 802-656-2090; www.uvm.edu/~fleming.

Directions: From I-89 take Exit 14W. Proceed 1 mile west on Williston Road (Route 2). Turn right onto East Avenue, go to second stoplight and turn left onto Colchester Avenue. At first stop sign turn right, then make first right into Fleming Museum visitor lot. Obtain parking pass at museum and place on dashboard.

Hours: Hours vary by day and between the academic year and the summer, so it's best to check the Web site. Roughly, the museum is open during the academic year from 9 A.M. to 4 P.M. on weekdays, 1 P.M. to 5 P.M. on weekends; during the summer months from midday to 4 P.M.; and closed on Mondays, major holidays, and during winter and spring recesses.

Admission: Adults $5, students and seniors $3, children under 6 free.

Catalog: Checklist of the Paintings, Prints and Drawings in the Col-

lection of the Robert Hull Fleming Museum, ed. Nina G. Parris, 1977.

Set on the campus of the University of Vermont, abutting the University Green Historic District, the Fleming Museum houses Vermont's largest collection of art and cultural objects (about twenty thousand items), and is Vermont's northernmost outpost of visual culture. Its origins are in the early nineteenth century as a cabinet of curiosities of natural history, history, and ethnology—an addendum to the university library, in fact. In 1931, through the generosity of two donors, a substantial museum in Neocolonial style was erected by the firm of McKim, Mead and White. It has an elegant interior courtyard decorated in Italian, French, and Vermont marble, with pillared balcony galleries overlooking the court and a grand double staircase. In the fifties, all natural-science objects were returned to the respective departments, and the Fleming became more focused as an art museum, with Ancient, European and American art, but also retaining distinct collections of African, Pre-Columbian, Oceanic, Native American, and Asian art. In the 1980s the museum underwent a massive renovation, which included an addition that reoriented the museum toward the campus.

Today you enter through this addition, which, in effect, lengthened and fattened the base of this T-shaped building. The wall in front of you was the original outside back wall; it now opens into the Wilbur Room, which looks like a library because it was conceived to hold a large collection of Vermont papers, now moved to the university library. While it is not an ideal gallery space with its elaborate wood paneling and chandelier, the museum tends to use it for exhibitions that require horizontal display cases, not wall space. The Wilbur Room is flanked by two corridors that feature exhibit cases showing items from the non-Western collections. One is tempted to just walk through, but it's worthwhile to linger a bit. At the end of either corridor you more or less stumble upon the marble courtyard. It's a lovely space, but, again, not ideal for exhibitions. A few marble sculptures, especially the seated *Penelope* by Franklin Simmons (1839–1913) and the bust *Caroline Marsh* by Hiram Powers, find an appropriate setting

here. Hiram Powers, the Neoclassical sculptor who shocked and titillated his contemporaries with the oft-copied *Greek Slave* (see Yale), was a childhood friend of George Perkins Marsh, the "father of environmentalism" (see Marsh-Billings-Rockefeller National Historical Park in Woodstock, Vermont). Both were born and grew up in Woodstock, and Powers's bust of Marsh's wife attests to their lifelong relationship. Nineteenth-century Vermont was a small world, indeed.

The spaces on either side of the marble court typically hold temporary exhibits. Upstairs is the permanent collection, set out in an instructive way. A few display cases with well-annotated groups of works in various media lay out art history from the Renaissance to Romanticism. This quick historical survey is followed by a few galleries dedicated to the major subject matters of Western art: portraiture, landscape, genre, still life — in ahistorical groups. In this way, chronological and topical displays make the most of what is actually a relatively small collection of paintings.

The real wealth of the collection is in works on paper, especially early-twentieth-century American art. Here great thanks are due to a major donor to the collection, Henry Schnakenberg (1892–1970). He was an artist himself, studied at and later was president of the Art Students League in New York, and painted mostly New England landscapes. He was also instrumental in establishing the Southern Vermont Arts Center in Manchester (q.v.). He bequeathed to the collection "an exceptional group of paintings, drawings and prints, some European, but mostly by Americans of his own generation." Albert Bierstadt, Paul Cadmus, William Glackens, Winslow Homer (see color insert), Rockwell Kent, Yasuo Kuniyoshi, George Luks, Reginald Marsh, Joseph Pennell, Theodore Robinson, Ben Shahn, Charles Sheeler, John Sloan, Carl Sprinchorn, and James Abbott NcNeill Whistler are among the better-known names, but his collection seems to include almost everyone associated with the Art Students League in the first half of the twentieth century and the circle of painters associated with Manchester and Dorset in Vermont. As part of Vermont's major public university, the Fleming Museum honors this local artistic heritage. Usually, there is a selection of Vermont-associated art exhibited in the balcony gallery of the marble courtyard.

The collection of Ancient art includes examples from Assyria, Sumer, Egypt, Greece, and Rome, and is particularly strong in Egyptian objects. Supplementing them is a set of large-scale engravings made to record the Egyptian expedition of Napoleon, 1798–1801. Here are the beginnings of serious Egyptology.

+ PLUS

Billings Student Center by H. H. Richardson
The UVM Green Historic District is the heart of the college campus and ringed by twenty-nine historic buildings, fourteen of which are listed on the National Register. The green is the legacy of Ira Allen, brother of the famous Ethan Allen of the colonial Green Mountain Boys. Burlington itself has several historic districts; one particularly lovely way of reaching the campus is by walking up College Street from the waterfront. Various stately nineteenth-century homes and fraternity buildings give way to the open vista of the green, and an ensemble of imposing brick and stone buildings.

The boldly asymmetrical building with the large arch is Billings Student Center, formerly Billings Library, designed by Henry Hobson Richardson. As with any Richardson building (see New London railroad station, Trinity Church in Boston, North Easton), one is struck by the power of the overall effect and the delicacy and imagination of the detail. Luckily, since it is a student center, the building is open to the public and you should not miss the beautifully carved balustrades, the imposing fireplace, and many more details for you to discover. The donor, Frederick Billings, was a Woodstock, Vermont, lawyer who had become wealthy in the West, in railroads (the town of Billings, Montana, is named for him). He bought the twelve-thousand-volume library of George Perkins Marsh (having bought Marsh's farm earlier) from his widow (see Marsh-Billings-Rockefeller National Historical Park), and donated the library as well as funds for a building to the University of Vermont. His full-length portrait over the fireplace was painted by fellow Vermonter Thomas Waterman Wood (see T. W. Wood Gallery in Montpelier, Vermont).

Manchester

SOUTHERN VERMONT ARTS CENTER

West Road, Manchester, VT 05254; Tel. 802-362-1405; www
.svac.org.

Directions: From Manchester Center (intersection of Routes 11
and 30 with Route 7A) drive south on 7A through a small
rotary. Immediately after the rotary, turn right onto Ways
Lane and then right onto West Road. The entrance to the
SVAC will be shortly on your left.

Hours: Tuesday through Saturday, 10 A.M. to 5 P.M.; Sunday 12
to 5 P.M., year-round.

Admission: Adults $8, students $3, children under 13 free.

Catalog: none, but there is a historical account, *Art and Soul:
The History of the Southern Vermont Arts Center,* by Mary
Hard Bort (2000). SVAC publishes a lavishly illustrated an-
nual program, available for free.

This is barely a museum by our definition: a permanent collection
of about seven hundred pieces, usually not on view and of dis-
tinctly regional character, hardly qualifies. But I would not want
to deny the reader an opportunity to experience this gorgeously
located, architecturally attractive, and highly ambitious and ac-
complished art center. "Art center" is the operative term; several
distinct functions are accommodated in a group of buildings that
form a veritable arts campus.

To start with the newest (opened in 2000) and most impos-
ing of these buildings: the Elizabeth de C. Wilson Museum, self-
described as "arguably the East Coast's finest exhibition space not
set in a major urban center," is a venue for major traveling exhi-
bitions. The white clapboard-covered, modern vernacular–style
building (see color insert), which mounts about six major shows
annually, boasts soaring exhibition spaces, smaller galleries, and
a gift shop.

Close by is the Madeira Education Center, a simple, one-storey

modern "shed" that features two well-equipped art studios, with floor-to-ceiling windows that frame the hills and meadows of the campus. Here, week-long art workshops in oil painting, water-color, sculpture, and photography are offered to serious amateurs and professionals, taught by a distinguished roster of visiting faculty. The beautiful setting on the slope of Mt. Equinox, with vistas of the Green Mountains, lends itself to plein-air painting, which is included in the course offerings.

The Yester House Gallery is housed in a twenty-eight-room Georgian mansion, acquired in 1950 as the permanent home for the Association of Southern Vermont Artists. This organization had evolved from a group of five painters who in 1922 showed their work together in the nearby Dorset Town Hall. The "Dorset Painters" and others arranged annual shows in various locations as more—and more famous—artists (Luigi Lucioni, Ogden Pleissner, Reginald Marsh, Norman Rockwell) joined over the years. Meanwhile, wealthy summer people and Manchester town worthies got together to provide the organizational and financial undergirding for what became the Southern Vermont Arts Center. The 1918 mansion today hosts a plethora of member, juried, and solo invitational exhibitions, with all works for sale. Expect six to eight concurrent exhibitions, which change monthly. Once a year, artworks by local area schoolchildren are exhibited; the SVAC has an extensive outreach program to area schools. The gracious Garden Café evokes the elegance of the former mansion. Large pieces of sculpture are installed throughout the grounds from May to October. Again, except for a few pieces belonging to the SVAC's permanent collection, these are all for sale, with price tags attached.

Lastly, the performing arts are given a home in the four-hundred-seat Arkell Pavilion. Lectures, song, dance, jazz, and classical music all are offered, sponsored by SVAC, by the Manchester Music Festival, and by Northshire Performing Arts.

+ PLUS

Equinox hiking trails
The 407 acres of SVAC are connected to the extensive trail system of the Equinox Preserve via the Maidenhair Trail. The Equinox

Preserve maintains 850 acres on the slopes of Mt. Equinox, with most trails originating near the Equinox Resort in Manchester. A detailed trail map is available at the information booth behind the Equinox Resort, 3567 Main Street (Route 7A), at SVAC, and at local inns and stores. Suggested routes for one-, two-, three-hour or all-day hikes allow you to custom-tailor your hiking experience.

Equinox Preservation Trust, P.O. Box 46, Historic Route 7A; Manchester, VT 05254; Tel. 802-362-4700; www.equinox preservationtrust.org.

Middlebury

MIDDLEBURY COLLEGE MUSEUM OF ART

Center for the Arts (South Main Street), Middlebury, VT 05753; Tel. 802-443-5007; www.middlebury.edu/museum.

Directions: Middlebury is located on Route 7, midway between Rutland and Burlington, Vermont. Once in Middlebury, follow signs for Route 30 (South Main Street); the Center for the Arts is about a half mile from the center of town, on the left.

Hours: Tuesday through Friday, 10 A.M. to 5 P.M.; Saturday and Sunday, 12 to 5 P.M.

Admission: Free.

Catalog: None, but a free handout, *Art in Public Places*, provides a guide to outdoor sculpture on the campus.

The museum received its name and home in 1992, when Middlebury College built the impressive Center for the Arts, which houses all performing and visual arts functions of the college (architects Hardy, Holzman, Pfeiffer Associates). A fanciful Postmodern take on various New England vernacular forms, using local materials in imaginative ways, this complex includes multiple performance spaces, studios, library, the museum, and a cafeteria. Do take a walk around and through the building to see all its various angles, shapes, and ideas. Most delightful is a varia-

Attributed by J. D. Beazley to the Berlin Painter, *Red-Figure Neck Amphora (Doubleen)*, c. 470 B.C. Greek, Attic, Early Classical period. Terracotta. Collection of the Middlebury College Museum of Art, Vermont. Purchased with funds provided by the Christian A. Johnson Memorial Fund, 2001.019. Photo by Ken Burris.

tion on octagonal barns with spiky mansard windows that catches your eye at the street front.

The museum itself, accessible from the rear, represents only a small portion of the CFA, but has attractive and lucidly laid out galleries for its collection of about 1,500 pieces and a program of three to four traveling exhibitions per year. Basically, selections from the permanent collection are shown in a suite of galleries on the first floor and temporary exhibitions on the second. As you enter, you will see Assyrian reliefs from the same source as those at Wellesley, Amherst, Yale, and Dartmouth (see the last for more detail).

The first gallery on the right contains Ancient art (Egypt through Rome) and the highlights are a quartet of Greek vases by the Rycroft, Berlin, Naples, and (circle of) Antimenes painters, respectively. The label texts for every piece in this exhibit, while long, are superb, locating each piece in historical context,

touching on geography, archaeology, mythology, and everyday usage, and cross-referencing items in enlightening ways. This is a teaching exhibit in the best sense, and it's well worth the time and effort to follow the chronological layout and study both art and labels.

To the left is an assemblage of art from various places, labeled the Age of Devotion; it contains Jewish and Christian art (Eastern and Western) from the fifth to the sixteenth century. Very fine sculpted pieces in ivory, wood, and stone attest to Middlebury's strength in small sculpture.

The next pair of galleries present European art on the right and American on the left. Things could not be clearer, although this layout may, of course, change in the future. Continuing the small-sculpture theme, there are a number of French pieces from the nineteenth century: *Jaguar Devouring a Hare* by Antoine Louis Barye (1796–1875); the very small but powerful *Head of Pierre de Wiessant* by Rodin (a plaster study for his *Burghers of Calais*); and the dramatic *Head of a Gaul* by François Rude (1784–1855), which is a detail from his *Departure of the Volunteers of 1792* on the Arc de Triomphe in Paris. The haunting wax-over-plaster *Bimbo Malato* (Sick Child) by Medardo Rosso (1858–1928) is a rare example of what has been dubbed "Impressionist sculpture." Middlebury has about two hundred small, mostly nineteenth-century sculptures in all, including the bust of the much-copied *Greek Slave* by Hiram Powers (1805–1873), who happens to be a Vermont native (a full-length version is at Yale).

European painting is strongest in the seventeenth through nineteenth centuries; a *Judith with the Head of Holofernes* by Hans von Aachen (1552–1615), painted in the dramatic Italian Baroque style, is a standout. On the American side, we have a number of Hudson River School paintings, most appropriately Frederic Church's *Otter Creek, Middlebury, Vermont* of 1854. Here the Otter Creek is still pristine, before it was harnessed to industrial use and made Middlebury rich. Modern art consists mostly of art on paper and is thus rarely exhibited. Middlebury's collection includes Picasso, Dalí, Miró, de Kooning, Rauschenberg, Warhol, and others. Contemporary photography is another strong holding, but not readily seen. And in the interest of comprehensiveness, there

is also Asian art, notably Chinese ceramics, and Japanese wood-cut prints.

+ PLUS

Campus sculpture
You should not fail to take a tour of the campus, with the above-mentioned *Art in Public Places* as your guide. It contains a foldout map that locates seventeen pieces of (mostly outdoor) sculpture. Note also the new library by Gwathmey, Siegel & Associates, which itself has a handout on the artwork on display within it.

Montpelier

T. W. WOOD GALLERY AND ARTS CENTER, VERMONT COLLEGE

36 College Street, College Hall, Vermont College, Mont-pelier, VT 05602; Tel. 802-828-8743; www.twwoodgallery .org.

Directions: Take I-89 to Exit 8. At fourth light, turn left and cross the river to Main Street. At first light on Main Street, turn right on East State Street. Continue up the hill, then turn right on College Street. College Hall is on the right.
Hours: Tuesday through Sunday, 10 A.M. to 4 P.M.
Admission: Free.
Catalog: Thomas Waterman Wood, 1823–1903—this catalog of an exhibit mounted in the 1970s is for sale.

The simple, white rooms of the T. W. Wood Gallery, on the ground floor of College Hall, befit this modest state capital of fewer than nine thousand residents. The gallery owes its exis-tence to Vermont's foremost nineteenth-century painter, Thomas Waterman Wood (1823–1903), a native of Montpelier, who late in his life founded the gallery and bequeathed his works to its citizens. Largely self-taught, he eventually was able to get some training in Boston, becoming at first a portrait painter—the

bread-and-butter way of life for an artist—and, later, a popular painter of genre scenes.

Having married a Vermont girl, Minerva Robinson, in 1850, he built a summer home and studio in Montpelier; he named the house Athenwood, in honor of his wife, substituting "Athena" for "Minerva" (see PLUS, below). Athenwood would remain his annual link with Montpelier, even though he eventually came to reside and prosper in New York.

As a young painter, he followed a somewhat itinerant mode, staying in Quebec and Toronto, Washington, D.C., and Baltimore, each time exhausting the local opportunities for portrait commissions. In Baltimore he painted his first genre scene, *Moses, The Baltimore News Vendor*, which was accepted for the 1858 exhibition of the National Academy of Design. At the same time he felt ready to go to Europe to travel, study, and copy current and Old Master paintings; the artist was beginning to supersede the mere portrait painter. Upon their return in 1859, the Woods moved to Nashville and in 1862 to Kentucky, where they spent the Civil War years. He commemorated the contribution of African Americans to the war effort in a set of three full-length character portraits—*The Contraband, The Volunteer*, and *The Veteran* (Metropolitan Museum of Art)—which set the tone for his sympathetic and humane depiction of African Americans in many of his subsequent genre paintings.

The success of these paintings convinced him that he could make a living from genre paintings. He settled in New York (with annual summer stays in Montpelier) for the rest of his life, garnering many honors; he was elected president of the National Academy of Design in 1891.

Wood's genre paintings derive from factual observation of neighbors, craftsmen, and farmers, made into prototypical figures and set into an accurately rendered scene for which the title is often the clue. It is narrative, detail-rich painting, as a few titles from the more-than-hundred paintings and sketches at the gallery will convey: *The Drunkard's Wife*; *American Citizens (to the Polls)*; *Gossip*; *A Pinch of Snuff*; *The Auctioneer*; *Crossing [on] the Ferry*; *The Faithful Nurse*; *The Quack Doctor* (which is set on the recognizable corner of State and Main streets in Montpelier).

One gallery of the three shows a selection of Wood's work, including portraits and landscapes. The permanent collection of about eight hundred pieces contains works by some of his contemporaries and is also the repository for works created in Vermont under the auspices of the Federal Art Project of the Works Progress Administration during the Depression era. Among the better-known beneficiaries were Reginald Marsh, Joseph Stella (with an impressive oil, *Skyscrapers*, of 1937), Yasuo Kuniyoshi, Paul Sample, and Henry von Schnakenberg (see Fleming Museum in Burlington). About ten changing exhibitions per year show contemporary works, mostly of Vermont artists.

+ PLUS

Athenwood and the Thomas W. Wood Studio
Athenwood with its adjoining studio still stands, overlooking Montpelier, but has been converted into two private residences. From the street you can see the imaginative, filigreed gables and cornices executed in "Carpenter's Gothic." Wood's father had been a carpenter and Wood was trained in the trade. He presumably made the designs and had a local carpenter help him build it. We know him, because Wood painted his portrait and it's in the Wood Gallery (*Franklin Hoyt*).

Directions: Retrace your way down East State Street, and go left on Main Street. After crossing the bridge, proceed straight ahead, up the hill, on Northfield Street. The house and studio appear soon on your right, Nos. 39 and 41 Northfield Street. It is advisable to park near the bridge and walk up the hill, as the road is narrow and winding.

Shelburne

SHELBURNE MUSEUM 🛒

U.S. Route 7, P.O. Box 10, Shelburne, VT 05482; Tel. 802-985-3346; www.shelburnemuseum.org.

Directions: From I-89 take Exit 13 and proceed south on Route

7. The museum is located on US-7, seven miles south of Burlington.

Hours: Late May to late October: Daily, 10 A.M. to 5 P.M.

Admission: Adults $18, teachers and students with ID $13, children 6–18 $9, children under 6 free. Tickets are valid for two consecutive days. Vermont residents pay half price. Free shuttles with multiple stops run continuously from the visitor center and back.

Catalog: A Souvenir of Shelburne Museum (2005) gives a general overview. Separate publications on the Impressionists, the dolls, and American folk art.

This is not one museum but many museums housed in an array of historic buildings spread over a beautifully landscaped area of forty acres near Lake Champlain. It is the life's work and gift of Electra Havemeyer Webb (1888–1960), who was born to avid collector parents, Louisine and Henry O. Havemeyer (they bequeathed most of their art, about two thousand items, to the Metropolitan Museum in New York). With money no object, she started collecting at age eighteen with the purchase of a cigar-store Indian, much to the dismay of her mother. She celebrated and elevated American folk art to the status it has today. When her multiple estates could no longer hold all the pieces, she founded in 1947 and opened in 1952 what's been called "one of America's great combined repositories of American arts, architecture and artifacts."

The overarching collection consists of over twenty-five historic buildings that were either already in place or brought here. They include barns, inns, private dwellings, a railroad station with a historical locomotive, a covered bridge, a lighthouse, a blacksmith shop, a Shaker shed, a jail, a schoolhouse, a meetinghouse, and the 220-foot Lake Champlain steamboat *Ticonderoga*.

This outdoor museum of mostly eighteenth- and nineteenth-century New England architecture has been supplemented by another fifteen or so buildings that fit harmoniously among the historic buildings and help accommodate what is the largest and most important collection of American folk art. It counts over 150,000 items and the collection keeps growing.

No building here just stands around empty, and while some

are furnished historically (e.g., Dutton House furnished to the period of 1820–30, when it was an inn, and the apothecary and general store seemingly ready for business), others are a bit more eclectic (Stencil House showing original 1830 stenciled walls and diverse eighteenth- and nineteenth-century furnishings of museum quality), or they display specialized collections of, say, high-style European and American Baroque furnishings (Prentis House). The Variety Unit, consisting of an 1835 brick farmhouse with large additions, is home to the decorative arts, with grouped displays of ceramics, glass, pewter, scrimshaw, and wooden food-molds. In the same complex is a collection of antique dolls (its five-hundred-plus dolls deemed among the premier collections in the United States), dollhouses, and toys.

Leaving aside collections of tools, machinery, coaches, and manufactured goods, as interesting as they are, we will concentrate on the collections of handmade folk art, and representational art. Even this subcategory is huge; you should not even try to see everything in a day.

Dorset House, an 1832 Greek Revival clapboard from Dorset, Vermont, houses the Shelburne's collection of bird and fish decoys, "recognized as the finest and most comprehensive of its kind in the United States." Over nine hundred pieces are in the collection, with an emphasis on their aesthetic merit, showing regional styles and including pieces by recognized twentieth-century masters, such as Anthony Elmer Cromwell (1862–1952), one of whose works has recently sold for over $1,000,000 at auction.

More than four hundred American-made, historic quilts form "the largest and finest museum collection in the country." In fact, the Shelburne was the first museum to exhibit quilts as works of art. They are housed in the improbably named Hat and Fragrance Textile Gallery, in a rough-hewn former distillery, hung in pivoting frames to allow for easy viewing of about thirty at a time. Again, aesthetic worth is the operating principle; all specimens are in great condition, so you can concentrate on the simple boldness of Amish quilts, the intricacy of early geometric patterns, the narrative charm of later examples, or the artistry of recent free-form quilts. Even if you are not a quilt connoisseur, you will be captivated. The quilt collection is accompanied by a collection of

Harry Shourdes, *Shorebirds*, ca. 1900. Shelburne Museum, Shelburne, VT.
© Shelburne Museum, Shelburne, Vermont.

decorated hatboxes, hooked rugs, costumes, and herbal sachets used to preserve textiles—hence the gallery name. The abutting Hat and Fragrance Garden grows plants used for dyes and fragrances.

The Stagecoach Inn, built in 1783 in nearby Charlotte, displays such major pieces of folk art as weather vanes, cigar-store figures, ship carvings, and trade signs, in brightly painted period rooms. There's nothing overstuffed here, each piece has breathing space, and one cannot but be impressed by the power of the simplified forms, which speak so well to a twenty-first-century sensibility trained on Modern and African sculpture. Some early "primitive" American paintings are also usually exhibited here (e.g., Erastus Field, Edward Hicks).

The Webb Gallery is the main venue for American painting and important special exhibitions; depending on the size of an exhibit, you will see more or less of the collection of American art. Artists include landscapists (Thomas Cole, John Frederick Kensett, Albert Bierstadt, Fitz Henry Lane, Martin Johnson

Heade), genre painters (Eastman Johnson, Winslow Homer), portraitists (John Singleton Copley), and still life painters (John Peto), but compared to the other collections, this one is modest in numbers and traditional in taste. There are also a few twentieth-century paintings of conservative bent (Grandma Moses, Andrew Wyeth).

The special exhibitions, however, pull out all the stops, showcasing the Shelburne's own riches and complementing them with first-rate loans. In 2007, the main exhibit was "Out of this World: Shaker Design Past, Present, and Future." It not only assembled a fabulous collection of Shaker and Shaker-inspired furniture, but also provided the spiritual and economic background, with Shaker music, clothes, art, contemporary photos, etc. Each season, there is usually a blockbuster show and six to eight smaller exhibitions.

There are two one-man collections: in Vermont House (1790), a rotating selection from John James Audubon's *Birds of America* is always on view. The twentieth-century illustrator and painter Ogden Minton Pleissner (1905–1983) has his own (eponymous) gallery, which shows a selection from over six hundred works owned by the Shelburne. A close friend of Electra's husband, James Watson Webb, Pleissner specialized in landscape and sports, but also worked as an artist–war correspondent in England and France for *Life* magazine. His Manchester, Vermont, studio is completely re-created in one wing of the building (see also Southern Vermont Arts Center).

Electra said of her parents, "[T]hey lived in an age when no one thought of anything American as art, so they collected entirely European art." This is only half true, inasmuch as Louisine Havemeyer was a close friend and patron of Mary Cassatt's, America's great Impressionist. She relied on Cassatt's expertise to guide her art buying, much of it current French art, including paintings and pastels by Degas, Cassatt's mentor and friend. While most of the Havemeyer collection went to the Met, some stayed in the family. Electra's share was hung in the Park Avenue apartment that the Webbs occupied during the winter season. Electra had always wanted to bring her Impressionists and fine English furniture to Shelburne, so after her death in 1960, her children built the white, Greek Revival Electra Havemeyer Webb Me-

morial Building to fulfill her wish. Quite unlike anything else at Shelburne, in this building six rooms of the New York apartment have been recreated, as carpets and lamps, furniture, wood paneling and window treatments, and, of course, the art, were disassembled and then reassembled here. For many visitors, this choice collection, of several paintings each, by Manet, Degas, Monet, and Cassatt, as well as Courbet, Corot, and Daubigny, is the high-point of the visit. One painting in the entry foyer was acquired later and is a summary of the entire Shelburne experience: it is an oil portrait of Louisine Havemeyer holding young Electra in her lap, painted by Mary Cassatt.

+ PLUS

Shelburne Farms 🚼

Virtually next door is Shelburne Farms, the boyhood home of James Watson Webb, Electra's husband. His parents, William Seward and Lila Vanderbilt Webb, had created a 3,800-acre model farm on this beautiful stretch of land along Lake Champlain. Frederick Law Olmsted, the designer of Central Park, did the landscape planning; imaginative, huge barns and stables have the look of Norman castles or fairy-tale concoctions. The 24-bedroom Queen Anne mansion is now a seasonal luxury inn. The grounds, now a mere 480 acres (the Shelburne Museum grounds were sliced off this tract), retain Olmsted's layout of meadows, tree clumps, woodlands, and carefully framed vistas of Lake Champlain and the Adirondacks. You can explore this parkland-farm on 8 miles of meandering walking trails, or on roads in an open-air wagon. The complex is run as a not-for-profit environmental education center and a working dairy farm, which produces delicious aged Vermont cheddar.

Tel. 802-985-8686; www.shelburnefarms.org.

Directions: From the Shelburne Museum go north on Route 7. At the first light turn left on Harbor Road, follow the signs for Shelburne Farms. Open mid-May to mid-October: Daily, 9 A.M. to 5:30 P.M. (welcome center) and 10 A.M. to 4 P.M. for the property itself.

Admission: Adults $6, seniors $5, children 3–17 $4.

St. Johnsbury

ST. JOHNSBURY ATHENAEUM AND ART GALLERY

1171 Main Street, St. Johnsbury, VT 05819; Tel. 802-748-8291;
www.stjathenaeum.org.

Directions: From the south take 1-91 North (or 1-93N, which
merges into 1-91); take Exit 20 to Route 5N, shortly there-
after turn left onto Main Street. The athenaeum is at your
left. Metered parking available on streets.

Hours: Weekdays, 10 A.M. to 5:30 P.M., Monday and Wednes-
day until 8 P.M.; Saturday, 9:30 A.M. to 4 P.M.

Admission: Adults $5, children under 18 free.

Catalog: Mark D. Mitchell, *St. Johnsbury Athenaeum: Hand-
book of the Art Collection*, St. Johnsbury, 2005. Copies of this
model of a gallery guide are available for use during your
visit—indispensable, since there are no labels.

St. Johnsbury was a company town—the company was E. & T.
Fairbanks and Company, founded in 1824, and the product was
platform scales. Brothers Erastus and Thaddeus combined Yan-
kee ingenuity and management skills, so that by midcentury they
dominated the world market for scales of any size and by 1860
employed over a thousand people in St. Johnsbury, with other
manufacturing facilities in England and on the continent. With
wealth came the philanthropic impulse and the endeavor to bring
culture and education to this northern Vermont outpost. In 1842
the family founded St. Johnsbury Academy, a coeducational (!),
comprehensive high school, free to any child in the area. The
school lives on today as a private, well-endowed day and board-
ing school, which also functions (via a voucher program) as the
local high school.

The next generation of Fairbankses included Horace (1820–
1888), who founded the athenaeum in 1871, and Franklin (1828–
1895), who established the Fairbanks Museum and Planetarium,
the most comprehensive natural-history museum north of Boston.

Its Richardsonian Romanesque building, in red sandstone, dominates Main Street, just two blocks away from the Athenaeum.

The Athenaeum is really two institutions: the library, opened in 1871, and the art gallery, which occupies a wing added at the back of the original building two years later. The building was designed in the fashionable French Second Empire style, and Fairbanks enlisted the director of the Boston Athenaeum to acquire nine thousand volumes (and have them bound in imported leather) to cover all areas of study, with "an ideal of completeness." Horace had not gone to college, but joined the family enterprise, which he was to lead until his death. A man of action, who also served as governor of Vermont and was instrumental in bringing rail links to St. Johnsbury, he believed passionately in education and self-improvement and wanted to share his own enjoyment of art. His personal collection was assembled with an eye to a future gallery, and he often bought art directly from the painters.

You enter the gallery through the library and a narrow alcove. Then the almost-square room opens, with natural light streaming from the arched skylights, to reveal—a time capsule. The gallery is, in fact, the oldest art gallery still in its original form in the United States. You see, as on the day of its opening, plum-colored walls, with dark green pilasters ornamented in gold; black-walnut wainscoting and floors; and gilt frames hung salon-style, tightly packed and two or three above each other. White marble statues on black pedestals punctuate the dark décor, and some large potted plants seem the perfect finish. Enter the nineteenth century! The visual centerpiece and the pride of the collection is Albert Bierstadt's monumental *The Domes of the Yosemite*, which, at roughly ten by fifteen feet, fills the entire far wall. (See color insert.) Bierstadt is the master of the dramatic landscape and, having joined various survey expeditions to the Rockies, did a series of Yosemite canvasses. This one is the largest; it came to Horace Fairbanks through a bankruptcy sale at a fifth of the original purchase price—at a mere $5,100.

The rest of the collection represents a good cross section of what was popular and uplifting in the second half of the nineteenth century. American painters dominate, but there is a sprinkling of German (von Kaulbach, others), French (Bouguereau,

Moreau), English, Belgian, and Italian artwork. By far the majority of the canvasses are landscapes, which is, of course, the one genre in which American nineteenth-century art developed a completely autonomous voice. The major Hudson River painters are here: Asher Durand (*Landscape with Rocks*), Thomas Moran (*An Autumn Afternoon*), Sanford R. Gifford (*The View from South Mountain, in the Catskills*), Worthington Whittredge (several), Jasper F. Cropsey (*Autumn on the Ramapo River—Erie Railway*, which despite its title, is pure, luminous landscape, autumn foliage, and a sun shimmering through milky haze). Americans, of course, painted European landscapes when on their study tours. Two fine examples are by Charles Loring Brown (1814–1889), *On the Grand Canal* and *Bay of Naples*.

There are genre scenes, some sentimental, some exotic, some both, with children, especially girls, a favorite subject. As *Handbook of the Art Collection* points out, the depiction of vulnerable young girls possibly reflected "a conservative reassertion of women's dependence on men" against the struggle for women's rights in the suffragist movement. History painting and scenes from foreign countries would bring glimpses of faraway lands and olden times to the woods of Vermont.

Vermont artist Thomas W. Wood (see T. W. Wood Gallery, Montpelier) shows us more than just a genre scene; *The Argument* is a real-life story, with known characters discussing a newspaper article in the general store of Williamstown, Vermont, near Montpelier. This kind of painting, just a few steps away from the art of Norman Rockwell, epitomizes the narrative nature of many of the works here. We are invited to decode the story, identify character types, and take away a message—here, for example, the nature of democracy in action at the grassroots level. Art for Horace Fairbanks certainly had a didactic function; it was to delight and to teach, and ultimately to ennoble.

Which brings us to the oddest part of the collection, the copies of European masterworks. Technically expert oil copies of European art (together with plaster casts of ancient statuary) used to be the mainstay of American museums in the nineteenth century. Before the age of mass travel and color reproductions, this was the only way to experience the best that Europe had to offer, and

Horace Fairbanks made sure there were a few good examples: Fra Angelico, Raphael, Veronese, Guido Reni, Carlo Dolci, Canova, Rembrandt, van Dyck, Velázquez, Murillo are all "reproduced" and interspersed with the original artwork.

Be sure to look for additional artwork in the library, reference room, and staircase, where you will find portraits and busts of Horace and Erastus Fairbanks among many more landscapes and genre scenes. The second-floor Athenaeum Hall with its stenciled ceiling is the home for lectures, readings, and concerts, a significant part of the educational mission of any athenaeum.

+ PLUS

Town Achitecture
St. Johnsbury exhibits the "benefits" of any town that lost its importance in the twentieth century. Buildings, streetscapes, and overall size are preserved, because not much development happened during that century. While this meant economic stagnation, exodus, and deterioration, it also allows for the current rebirth of an amazingly intact nineteenth-century town. As you walk around the small downtown—essentially upper-level Main Street and lower-level Railroad Street—you will notice an abundance of impressive survivors from the nineteenth and early twentieth centuries: five churches of varied architecture, the Fairbanks Museum and Planetarium, many of the buildings on the campus of St. Johnsbury Academy, the courthouse (all on Main Street), the commercial development of Windhorse Commons, which repurposed two octagonal buildings from the midcentury into modern offices, and the Masonic Lodge, now transformed into the Catamount Art Center (on Eastern Avenue, which leads downhill from the Athenaeum to Railroad Street). To get a good sense of the renaissance of St. Johnsbury and for further information, go to www.discoverstjvt.com.

Windsor

CORNISH COLONY MUSEUM

147 Main Street, Windsor, VT 05089; Tel. 802-674-6008; www.cornishcolonymuseum.com.

Directions: From the north: Take I-91 to Exit 9; proceed south on Route 5 into Windsor (7 miles). Route 5 becomes Main Street. From the South: Take I-91 to Exit 8, proceed north for about 7 miles on Route 5, which becomes Main Street. The museum is housed in a redbrick former fire station, on the second floor.

Hours: During summer exhibition (late May to late October): Tuesday through Saturday, 10 A.M. to 5 P.M.; Sunday, 12 to 5 P.M.; during winter exhibition (check dates): Thursday through Sunday, 11 A.M. to 5 P.M.

Admission: Adults $6, seniors and students $4, children under 12 free.

Catalog: Published for each annual summer show. Past issues available in gift shop.

The term "Cornish art colony" describes a trickle and then a wave of artists, writers, and other intellectuals who came to summer in the area of Cornish and Plainfield, New Hampshire, and, just across the river, Windsor, Vermont. The first to come, in 1885, was Augustus Saint-Gaudens, lured by a lawyer friend with the assurance that he would find "plenty of Lincoln-shaped men" to model for his *Standing Lincoln*, now in Lincoln Park, in Chicago (see Saint-Gaudens National Historic Site, Cornish, New Hampshire). The first wave were mostly Paris-trained artists who returned to create an American art that was technically informed by European standards, but would have an American identity. Saint-Gaudens's close friend Thomas Wilmer Dewing (1851–1938), a Luminist in the vein of Whistler, was next.

Stephen Parrish (1846–1938), painter and etcher (again in the Whistler mode), as well as his more famous son, illustrator Max-

field Parrish, followed in short order. The artist and architect Charles Platt (see Addison Gallery in Andover, Massachusetts) joined them in 1889 and actually started his career as an architect by designing many of the summer homes for the "colonists." They were mostly in the style of Italian villas, albeit adapted to the New England environment, with terraces, pergolas, and formal gardens. He in turn attracted as his assistants two noted female landscape architects, who were among the first women in their profession, Rose Standish Nichols (a niece of Saint-Gaudens) and Ellen Biddle Shipman.

Repeat visitors included sculptors Daniel Chester French (see Chesterwood in Sturbridge, Massachusetts), Frederick MacMonnies, Paul Manship, Frederic Remington, and William Zorach. Among painters we should mention American Impressionists Willard Metcalf, Julian Alden Weir, Ernest Lawson, and Realist Everett Shinn, among literally hundreds of lesser-known artists, writers, and musicians. Woodrow Wilson established his summer White House here in 1913, 1914, and 1915, following his artist wife, Ellen Axson Wilson.

The Cornish Colony Museum has the difficult task of bringing this evanescent golden period to life, and it does so through annual themed exhibits that draw on its own collections, the collection of its founder-director, Alma Gilbert-Smith, and loans from public institutions and private collectors. Gilbert-Smith is an authority on Maxfield Parrish, who is, indeed, the major focus of the museum and the exhibitions. His advertising images and book illustrations brought him much fame and money, while his romantic and somewhat sentimental depictions of landscapes and "maidens on rocks" endeared him to a broad public. He is considered the most reproduced artist in the history of art. It is estimated that one in five American homes at the time had a Maxfield Parrish print on the wall.

+ PLUS

Cornish-Windsor Covered Bridge
The link between Windsor, Vermont, the site of the museum, and the actual town of Cornish, New Hampshire, is a landmark

in itself—the longest covered bridge in the United States! The Connecticut River here forms the border between Vermont and New Hampshire. The wooden bridge, with the peacefully flowing water underneath, and Mt. Ascutney looming over it, is a picture-perfect distillation of the beauty that lured so many artists to this corner of New England.

Directions: As you leave the museum, turn left onto Main Street, then turn left at the next light onto River Street. Follow it down to the river and across the Cornish-Windsor Covered Bridge. Immediately after the bridge there is a little parking area on the right. Pull in so you can take a good look or a photograph.

Woodstock

MARSH-BILLINGS-ROCKEFELLER NATIONAL HISTORICAL PARK

54 Elm Street, Woodstock, VT 05091; Tel. 802-457-3368; www.nps.gov/mabi.

Directions: Take I-89 to Exit 1 and proceed on Route 4 West for 13 miles. In downtown Woodstock bear right to take Route 12 North. Cross the iron bridge and bear right onto River Street; take the first right into the parking area at the Billings Farm and Museum. (Note: Billings Farm & Museum is a privately managed model farm and museum of Vermont farming, which operates in partnership with the MBR National Historical Park. Separate admission is charged.)

Hours: Memorial Day Weekend to October 31: Daily. Tours of the mansion and gardens hourly, on the hour, 10 A.M. to 4 P.M.; specialized 90-minute tours, "Conservation Through the Artist's Eye," are offered about every two weeks on an irregular schedule. Call for dates and times. The park, with an extensive trail system, is open year-round.

Admission: Adults $8, seniors $4, children under 15 free.

Catalog: None, but the Web site has a good selection of paintings on view, with excellent background information.

Why is a national historical park listed in a book on art museums? There is history, there is parkland with twenty miles of trails, and there is a farmhouse grown into a mansion with about five hundred works of art in it. It all started with the Marsh family farm and a stately house built in 1805–07 for Charles Marsh, Sr. His son, George Perkins Marsh (1801–1882), saw how Vermont's forests were being denuded due to logging, potash production, sheep farming, and the firewood needs of the railroad (60 percent of Vermont's virgin forest was harvested in the first half of the nineteenth century). On a diplomatic assignment to the Middle East he noted the desolate state of many areas that had been fertile and fruitful under the Romans. His classic *Man and Nature* (1864) is considered the first book to acknowledge man's impact on nature. It influenced the emergent fields of scientific forestry and farming, and led to a heightened awareness of the fragility of natural systems.

Another Woodstock native, Frederick Billings (1823–1890), had made a fortune out West as a lawyer during the Gold Rush, returned to Woodstock, and set out to reverse the decline of the devastated countryside. He bought the Marsh farm in 1869, planted a hundred thousand trees on Mt. Tom (now within the national park), and set up Billings Farm as a model dairy farm. He also expanded the mansion and furnished it lavishly, with elegant wood paneling in teak, mahogany, and maple, with Tiffany windows, and yes, with Hudson River School art, mostly bought directly from the painters. He amassed more than four hundred paintings and etchings. Thomas Cole, Asher Durand, Thomas Moran, Sanford Gifford, John Frederick Kensett, Albert Bierstadt are all well represented, and the subject matter reflects the interests of Frederick and Julia Billings: western and Rocky Mountain scenes (he was also president of the Pacific Railroad; Billings, Montana, is named for him), New England and New York vistas to reflect their ancestral ties, as well as some European and exotic settings. Billings bought well, and the pictures are in excellent shape, never having left their first home. Some highlights are Alfred Bierstadt's *Cathedral Rock, Yosemite*, Sanford Gifford's *Venice* (so luminous, it reminds one of Vermeer), and John Frederick Kensett's beautiful *Lake George*.

The last name in the triumvirate, Laurance Rockefeller (1910–2004), became master of the estate through his marriage in 1954 to Mary French, granddaughter of Frederick Billings. The Rockefellers kept the estate intact, with just minor upgrades, so that it feels today like a lived-in, Victorian grand family home. They added a few more choice pictures, such as Bierstadt's imposing *Scenery in the Grand Tetons* and *Matterhorn*. Dubbed "Mr. Conservation" for his many activities on behalf of the National Park Service (including the expansion of the Grand Tetons National Park) and conservation in general, Laurance Rockefeller bequeathed the entire estate, with 555 acres of forestland, to the National Park Service in 1992.

+ PLUS

Billings Farm & Museum; Woodstock 🍁 🚼

For the National Park Service, the focus of this park is squarely on the history of conservation. There are extensive related exhibits in the visitor center, the former carriage house now furnished with tables and benches made from local trees. A large library of conservation-related titles and comfortable chairs invite lingering. A visit to the Billings Farm & Museum would be an excellent choice if there are children in your party. If you don't know the city of Woodstock, just walk over the iron bridge down Elm Street to the village center. Beautiful houses line this street and the village green, a testament to the wealth accumulated during the lumber heydays.

Maine

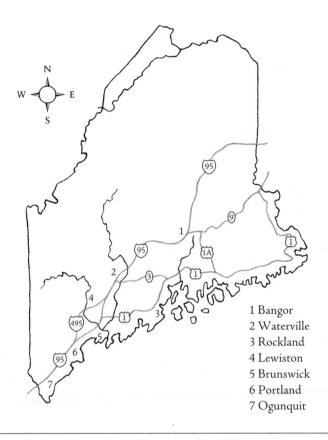

1 Bangor
2 Waterville
3 Rockland
4 Lewiston
5 Brunswick
6 Portland
7 Ogunquit

Bangor

UNIVERSITY OF MAINE MUSEUM OF ART

40 Harlow Street, Bangor, ME 04401; Tel. 207-561-3350; www
.umma.umaine.edu.

Directions: From 1-95 North or South: Take Exit 185 (Broadway),
turn left at light onto Broadway (Route 15). At the fourth
light turn right onto State Street (Route 2). At the light at
the bottom of the hill, turn right onto Harlow Street. Merge
into left lane, turn left into parking lot.
Hours: Monday through Saturday, 9 A.M. to 5 P.M.
Admission: Free.

This northernmost public outpost for fine art in Maine is located
in downtown Bangor, even though the University of Maine cam-
pus is slightly to the north, in Orono. This has the advantage
that the citizens of Bangor—i.e., Maine taxpayers—can easily
visit the collection their money has helped assemble, now over
6,500 pieces, and the richest collection of prints in all of Maine.
Half of the collection is deemed museum quality and is housed
and shown in exhibits in the Bangor galleries. The rest is hung
on campus, comprises portraits, or is part of the Vincent Hartgen
Museum by Mail program, created to reach even more citizens in
this sparsely populated state. Now in its fiftieth year, the program
has nearly fifty "suitcase exhibits" that travel to schools and other
public institutions for a month at a time.

The museum collection is strongest in mid-twentieth-century
American art on paper, and in Maine artists. But European art
is also represented through works by Giovanni Piranesi, Wil-
liam Hogarth, Honoré Daumier, Pablo Picasso, Georges Braque,
Marc Chagall, Robert Delaunay, and Joan Miró. As is often the
case in collections that concentrate on works on paper, there is a
strong German presence: Käthe Kollwitz, Max Beckmann, Erich
Heckel, Otto Mueller, Karl Schmidt-Rottluff, and Josef Albers.
But American art is at the core. Aside from a few nineteenth-

century items (Hudson River School artist Alfred Bricher, Luminist George Inness, Impressionist Mary Cassatt), the collection leans toward twentieth-century Realist and political art: Grant Wood, Reginald Marsh, Charles Burchfield, and John Steuart Curry are represented, and there is a large collection of paintings and political cartoons by William Gropper (1897–1977), as well as over 250 posters from World Wars I and II.

Through a bequest by alumnus Robert Venn Carr, Jr., the museum acquired a good selection of Modern and contemporary prints by artists such as Alexander Calder, Willem de Kooning, Frank Stella, Andy Warhol, Roy Lichtenstein, and David Hockney. This collection of nearly three hundred items has an excellent, specialized Web site (www.library.umaine.edu/Carr) that lets you search for its images by artist, keyword, or style—the last a short lesson in the major schools and movements of the twentieth century. This being Maine, there is a rich variety of Maine artists and artists active in Maine, with John Marin particularly well represented. Others include Winslow Homer, Alex Katz, Louise Nevelson, Andrew Wyeth, Neil Welliver, and photographer Berenice Abbott. In addition to owning a number of works by Carl Sprinchorn (see also Bates College), the university is also the repository of his papers.

UMMA is housed in bright, modern galleries in a former department-store building. (Since the Maine tourism office is located just one floor up, you can help yourself to a large selection of promotional materials, maps, and guides.) There are between eight and ten shows per year; photography and works by contemporary Maine artists receive special consideration. A small selection from the permanent collection is always on view and thematic temporary exhibits often include works from the collection.

+ PLUS

Hudson Museum, Orono Campus

The University of Maine's main campus, in Orono, is home to the Maine Center for the Arts, which combines a 1,600-seat theater/concert hall with facilities for the Hudson Museum, an impressive ethnological and archaeological collection. Comprising

over 8,000 items, it is predominantly devoted to North and Central American Indian artifacts, many of which are of high artistic interest. The museum was closed for renovation as this book went to press, but based on its previous exhibits and displays it is likely to be a very attractive and engaging venue again. The rare fact that a museum and a performance hall occupy the same building has inspired the staff to explore cross-disciplinary events and to make it into a "multidimensional cultural institution."

Directions: From UMMA turn left onto Harlow, turn left again three times until you are on State (US-2), then turn left onto Broadway. Merge onto I-95 North. Take Exit 191 (Kelly Road), turn right onto Kelly for 1 mile, then left onto Main Street (US-2) for 1.6 miles, then left onto College Avenue. The visitor center is at 168 College Avenue. Get a campus map and proceed.

Brunswick

BOWDOIN COLLEGE MUSEUM OF ART

9400 College Station, Brunswick, ME 04011; Tel. 207-725-3275; www.bowdoin.edu/art-museum.

Directions: I-295 to Exit 28, Route 1 North (Pleasant Street). Go through five traffic lights, then turn right onto Maine Street. The campus begins after a half mile, at the intersection of Maine Street and Bath Road. Proceed on Maine. The museum (the Walker Art Building) is the third building on the left. For parking, proceed past the museum on Maine Street, turn left onto College Street. Turn right at the second street and follow the signs "Admissions Visitor Parking."

Hours: Tuesday through Saturday, 10 A.M. to 5 P.M., Thursday until 8:30 P.M.; Sunday, 1 to 5 P.M.

Admission: Free

Bowdoin College's art museum began its life with a superb collection of European master drawings and paintings, bequeathed

in 1811 and 1813, respectively, by James Bowdoin III (1752–1811). He had brought them back from Europe, where he had served as ambassador to France and Spain under President Jefferson. He is the son of James Bowdoin II, the governor of Massachusetts who suppressed Shays's Rebellion, and who also helped found the American Academy of Arts and Sciences. The Bowdoins were among the wealthiest Colonial families, active in Revolutionary circles.

The growing art collection wandered among various buildings until a temple to art, the Walker Art Center, was designed by Charles Follen McKim (completed 1894). The Walker sisters, two art-loving Victorian spinsters from Boston, honored their late uncle and benefactor, Theophilus Wheeler Walker, by commissioning from the leading firm of the day "a building entirely devoted to art. . . . Our idea is a building that shall be not only appropriate as a memorial, but will also show the purpose for which it is to be used." The firm of McKim, Mead and White was already busy with the Neo-Renaissance Boston Public Library (q.v.). The Walker Art Building can be regarded as a miniature cousin to the BPL, as well as a forerunner to the later Morgan Library in New York, especially with regard to the integration of mural painting and sculpture into an artistic whole.

The access from the quadrangle reinforces the temple associations since the building sits on a terrace and you enter (or rather used to) by ascending a set of wide steps and traversing a multi-columned Palladian loggia. The façade boasts two carved lions, copied from those of the Loggia dei Lanzi in Florence; niches set in the walls hold bronze statues of Sophocles and Demosthenes and make you forget that there are no windows in the elegantly detailed façade. There is no mistaking the veneration of high culture, which adulation, upon the museum's opening in 1894, would have been reinforced inside by a large collection of plaster casts of antiquities.

The quite small museum needed to be updated and expanded; with the inspired choice of the team of Machado and Silvetti (see also Provincetown Art Association), Bowdoin was able to keep the exquisite temple intact visually, climatize it, computerize the lighting, and expand the museum space by 63 percent. How did

they do it? Ingeniously. First of all, they gave the building a second façade, toward the street, which consists of an added glass-curtain gallery, its back wall brightly painted in turquoise, which shows off the sturdy Assyrian relief panels extolling the deeds of Ashurnasirpal II (for more details, see Hood Museum, Dartmouth College). The casual passerby gets an enticing glimpse, the building feels open and inviting, and space has been added. In order to gain handicap access and provide visitor amenities, Machado and Silvetti constructed an almost-transparent glass cube. It sits unobtrusively next to the Walker, and is connected to it underground. Lastly, the basement level was extended—downward. Hard to believe, the floor was lowered by four feet, and now yields spacious, bright, airy galleries for temporary exhibits. Of all the expansions and additions that I saw during the research for this book, this one seems to be the boldest and yet the most reverential.

For the grand reopening in 2007, the BCMA reinstalled its permanent collection under sweeping themes. Ancient art at Bowdoin is richly endowed, thanks to the 1926 bequest of Edward Perry Warren, "the leading collector of classical antiquities in the first quarter of the twentieth century" (Faison). The installation is divided into Ancient Art: Immortal Dreams, dealing with the afterlife and funerary culture, and Ars Antiqua: Ancient Pastimes and Passions, which explores "the Mediterranean loves of music, athletic pursuits, theatre and luxury." Among the former you must not miss the marble *Portrait Head of the Emperor Antoninus Pius*, regarded as "perhaps the finest Roman portrait in America" (Faison).

If this is not overarching enough, you will have The Human Figure: 2500 B.C. to 2000 A.D., a display of sculpture in the rotunda that stretches from a Cycladic marble torso to a contemporary work by Joel Shapiro (b. 1941), via a superb Hellenistic nude, Michelangelo's *Dying Slave* (a plaster cast), a Rodin, and a Giacometti. Presiding over this eclectic group are four lunette murals commissioned by McKim. They show allegories of the four major art cities, Athens, Rome, Florence, and Venice, executed by the foremost Classicist mural painters of the day, John La Farge, Elihu Vedder, Abbott Thayer, and Kenyon Cox, respectively.

European art holdings are fairly typical of the teaching collec-

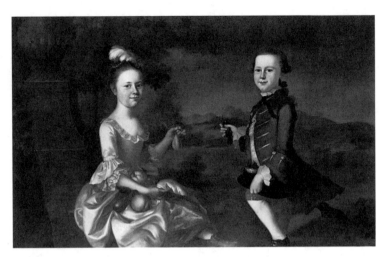

Joseph Blackburn, *Portrait of Elizabeth Bowdoin and James Bowdoin III*, ca. 1760. Oil on canvas, 36⅞ in × 58¹/₁₆ in (93.7 × 147.4 cm). Bowdoin College Museum of Art, Brunswick, Maine. Bequest of Mrs. Sarah Bowdoin Dearborn, 1826.11.

tion of a small college aiming at coverage of the entire history of Western art. The current installation, Seeing and Believing: 600 Years in Europe, is organized by theme rather than chronologically. One of the highpoints is the High Gothic *Head of a King*, which has been shown to belong to a torso at Chartres Cathedral. Another installation, The Walker Sisters and Collecting in Victorian Boston, aims to recreate a Victorian interior in which to display the sisters' bequests to the museum as well as artful decorative items with which upper-class Boston art patrons furnished their homes. The holdings on paper, having grown from the initial Bowdoin bequest to almost six thousand in number, are of high caliber and cover the twentieth century and Europe better than the painting collection.

When we come to American art, the most striking specialty at Bowdoin are Colonial and Federal American portraits; prominent among them in quality and quantity are portraits of Bowdoin family members through the generations. Robert Feke (1707–1751), the major predecessor of Copley, is represented by five works, among them the full-length *General Samuel Waldo* and the elegant *Portrait of James Bowdoin II*, the subject dressed in ivory silk vest

and brown velvet coat. The English-American Joseph Blackburn (ca. 1730–1778) painted James Bowdoin III and his sister as children. A fine Copley, *Portrait of Thomas Flucker*, shows much more psychological penetration than do the works of Copley's forerunners; the sitter was the brother-in-law of James Bowdoin II. There are seven portraits by Gilbert Stuart, including the "classic" seated portraits of Thomas Jefferson and James Madison, commissioned by James Bowdoin III, who also had himself and his wife immortalized by Stuart. Later portraits include likenesses of Henry Wadsworth Longfellow and Nathaniel Hawthorne, both of whom were alumni.

Of later American painters, Bowdoin has substantial collections of works by Maurice Prendergast, Winslow Homer (including personal memorabilia), John Sloan, and Rockwell Kent. The collection drops off in the second half of the twentieth century, although an exhibition presenting works by alumni collectors bodes well for possible future bequests.

+ PLUS

Peary-MacMillan Arctic Museum
Almost adjacent, on the narrow south end of the campus green, is Neo-Gothic Hubbard Hall, which houses the unique Peary-MacMillan Arctic Museum. It is still awaiting modern amenities and ample space, but nevertheless has an intriguing program that combines artifacts relating to natural history, exploration, and native art, all related to Arctic exploration. Peary, the first man to reach the North Pole, was a Bowdoin alumnus; the archives hold extensive materials of his and later expeditions. For specific exhibitions, see www.bowdoin.edu/arctic-museum.

Lewiston

BATES COLLEGE MUSEUM OF ART

75 Russell Street, Lewiston, ME 04240; Tel. 207-786-6158; www.bates.edu/museum.xml.

Directions: Maine Turnpike (I-95) to Exit 80. Take Alfred A. Plourde Parkway until it dead-ends at Webster Street (second stoplight). Left onto Webster to the first stoplight at Farwell. Right on Farwell and go 0.5 miles to stoplight. Go through stoplight; street is now Russell Street. Go through two more stoplights, then turn left onto Bardwell Street into the museum parking lot.

Hours: Tuesday through Saturday, 10 A.M. to 5 P.M.

Admission: Free.

Catalog: None. *Ninety-nine Drawings by Marsden Hartley*, edited by William J. Mitchell and published by the college in 1970, is a complete inventory of the Marsden Hartley drawings owned by the museum.

This small museum essentially came into being through one bequest, around which it developed its identity. The niece of painter and Lewiston native Marsden Hartley (1877–1943) fulfilled his wishes by donating ninety-nine drawings and some early oils, as well as personal belongings, writings, and paintings by friends. This gift occurred in 1955, the centenary of the college's founding; the Treat Gallery was established to house this collection and whatever other art had been on campus.

The focus of the museum was soon sharpened: to collect art "from Maine" and to collect works on paper. The latter include Old Master prints, works by such European artists as Cézanne, Matisse, and Picasso, and twentieth-century American works by Mary Cassatt, John Marin, John Sloan, and George Bellows. There is also a growing photography collection, and acquisition endowments for landscapes, photography, and ceramics.

The Maine focus embraces Hartley, above all, but also his friend Carl Sprinchorn (1887–1971). Both studied in New York, were included in the famous 1913 Armory Show, and painted extensively in Maine. Sprinchorn is supposed to have said to Hartley: "You can be King of the Coast, I will be King of the Woods." As more and more artists make Maine their home, there is a growing number of contemporary Maine art that the museum pursues and possesses. Some better-known names include William Thon, Neil Welliver, Charles Hewitt (born 1946 in Lewis-

ton), and Robert Indiana (born 1928, and a resident of Vinalhaven since 1978).

Vinalhaven, an island just off Rockland, was also the home of Vinalhaven Press from 1984 to 2000. It was a fine-art press and workshop that attracted many artists interested in traditional printing techniques, Indiana and Hewitt among them. Both had recent one-man shows at the museum. "Scrape, Cut, Gouge, Bite, Print . . . The Graphic Work of Charlie Hewitt 1976–2006," was mounted in 2007. Bates is now the repository of Hewitt's graphic work. "Robert Indiana: The Hartley Elegies" took place in 2005 and showcased a series of ten large prints Indiana created in homage to Marsden Hartley. Pop artist Indiana is, of course, most widely known for *LOVE*, the ubiquitous sculpture with the tilted *O*, one copy of which is at the Farnsworth Museum in Rockland.

In 1986, the Olin Art Center was built and the Treat Gallery, greatly expanded and now counting about five thousand items, was renamed the Bates College Museum of Art. Since then the museum has tried to position itself as "the *new* academic museum . . . dedicated to introducing new ideas and questions about how art transcends and reflects history in our current times, and presents the possibilities of what is to come." What this might mean in reality was shown in a recent exhibition that filled the entire museum space, "Green Horizons," an exploration of "the politics and nature of greenness and sustainability" through various media, projects, and cross-disciplinary collaborations. This meant that nothing of the permanent collection was on view, but I was assured that this is exceptional. So be prepared for fairly politicized exhibits, at times, and for a solid coverage of Maine art, and be advised to call ahead to see what of the permanent collection might be on view.

+ PLUS

Lewiston Public Library
Marsden Hartley is indeed something of a patron saint in Lewiston. The public library named a major new annex the Marsden Hartley Cultural Center. One of Robert Indiana's *Hartley Elegies*

is on permanent view there. Indiana took as a springboard Hartley's semiabstract "German officer" paintings, themselves memorials to the death of Hartley's friend Karl von Freyburg in 1915.

Lewiston Public Library, 200 Lisbon Street; Tel. 207-784-0135.
Directions: From the museum turn right onto Russell Street, then right onto Central Avenue, which after 0.2 miles becomes Ash Street. Continue on Ash Street for 0.5 miles, turn left onto Park Street, right onto Spruce and right onto Lisbon.

Ogunquit

OGUNQUIT MUSEUM OF AMERICAN ART ✻

543 Shore Road, Ogunquit, ME 03907; Tel. 207-646-4909; www.ogunquitmuseum.org.

Directions: From I-95 take Exit 7 to Route 1. Take Route 1 North for about 7 miles. Take right onto Bourne Lane (just past Ogunquit Playhouse). Continue on Bourne until it ends, turn right onto Shore Road, go for about 0.75 miles. Museum is on the left. Parking available.
Hours: July through October only: Monday through Saturday, 10:30 A.M. to 5 P.M.; Sunday, 2 to 5 P.M.; closed Labor Day and four days in mid-August for rehanging.
Admission: $5 adults, $4 seniors, $3 students; free for members and children under 12.

Location, location, location . . . Low-slung, airy pavilion, 7,500 square feet, on picturesque rocky cove, ocean views, three acres of lovely landscaped grounds with reflecting pool, outdoor sculptures, in desirable Maine resort town. . . .

Who would not want to move in? Fortunately, you are free to visit. Upon entering you will be struck by the gorgeous view of shore and ocean visible through the glass wall at the far end: the effect is as of a superscaled landscape painting. You are free to walk through the glass doors into the garden, where stone and metal sculptures are placed sensitively amid flowers, shrubs, and

trees. Bird and fish motifs and natural materials characterize the three-dimensional works both outside and in the interior central sculpture court, and seem to respond to the tender preaching of the bronze *Man of Assisi* (by John Dirks, b. 1917), who guards the entrance to the museum. Antique wooden benches salvaged from sleds and carriages are scattered throughout, while the heavy granite lintels capping all doors, and the rugged pine columns on granite pedestals, which support the rear portico, embody quintessential Maine elements without overpowering the intimate, light-filled atmosphere.

The Ogunquit Museum of American Art owes its existence to one painter's love for this rugged stretch of Maine coast and to Ogunquit's rich history as an art colony. The first artist to attract summer students was Charles H. Woodbury (1865–1940, active in Boston), who opened his summer school in 1898 and led it until 1940. A rival enterprise, the Summer School of Graphic Arts, was founded in 1911 by Hamilton Easter Field (1873–1922, active in New York). They were located on and near Perkins Cove, then a little fisherman's wharf with cheap shacks that served as studios for the aspiring artists.

Henry H. Strater (1895–1987) first arrived in 1919 to study with Field, having already spent years at the Académie Julian in Paris and the Art Students League in New York. After more years of study and travel in Europe (where he consorted with Hemingway and his old Princeton pal F. Scott Fitzgerald), he returned to Ogunquit, built a house, and from 1928 onward spent part of each year there. In the forties, he decided that Ogunquit should have its own museum to reflect its rich artistic history. He bought land at Narrow Cove, which had been a favorite spot for generations of aspiring painters, from the son of Charles Woodbury. He founded, endowed, and built the Museum of Art of Ogunquit, which opened in 1953. He was its director for thirty-four years, during which time the narrow focus of its original name grew to encompass American art of the twentieth century, albeit with an East Coast slant. The museum was renamed the Ogunquit Museum of American Art in 1992.

Typically, four exhibits, two at a time, are shown during the summer months; the museum is closed for a few days in August to

allow for the hanging of the second set. They include solo shows of new and established artists, as well as group shows and topical exhibits. I think it's fair to say that the OMAA favors the realistic strain in Modern art, landscapes, figurative painting, and smaller formats. These exhibits may or may not include objects from the permanent collection, which numbers about 1,500 items and includes such established early- and mid-twentieth-century painters as Thomas Hart Benton, Charles Burchfield, Charles Demuth, Marsden Hartley, Childe Hassam, Robert Henri, Winslow Homer, Edward Hopper, Rockwell Kent, Walt Kuhn, George Luks, John Marin, Reginald Marsh, Louise Nevelson, Mark Tobey, and Andrew Wyeth.

Only a few items from the permanent collection will be on view at any given time, about evenly divided between paintings and sculpture. There is, however, a room dedicated to the memory of Henry H. Strater and the history of the museum and it will typically have a goodly number of Strater's paintings on view. OMAA owns the two portraits Strater painted of Hemingway in 1922 during a joint vacation in Rapallo, which also included Ezra Pound.

+ PLUS

Marginal Walk 🛒

Unlike many other beach communities, Ogunquit has long stretches of public waterfront. The famous Marginal Walk is about a mile long and connects the town center with Perkins Cove on a winding path that hugs the coves and rocky outcroppings of the coastline. At various points, steps lead down to tiny beaches, there are benches to take in the view, and you will invariably see artists and amateurs with easel and paint trying to capture the rugged beauty and clear light of this picturesque stretch of coastline. If you love beach walks on fine sand (or a dip in the cold ocean), Ogunquit also obliges you with 3.5 miles of public beach—mostly unencumbered by the trappings of tourism—just north of the Marginal Walk (pedestrian access via Beach Street).

Portland

PORTLAND MUSEUM OF ART

7 Congress Square, Portland, ME 04101; Tel. 207-775-6148;
www.portlandmuseum.org.

Directions: I-95 to I-295 North. Take Exit 6A (Forest Avenue
 South). At the first light bear right onto State Street. At the
 second light turn left onto Congress Street. The museum is
 on the right after the next light. Several public parking ga-
 rages nearby.

Hours: Tuesday through Sunday, 10 A.M. to 5 P.M., Friday until
 9 P.M.; during summer months also open Monday, 10 A.M.
 to 5 P.M.

Admission: Adults $10, seniors and students $8, children 6–17
 $4, under 6 free.

Catalog: None, but there are many museum publications re-
 lated to previous exhibitions that featured works from the
 permanent collection.

Would it be too bold to say that the Portland Museum of Art
drove the city's rejuvenation? It certainly played a major role,
when, in 1983, the Charles Shipman Payson Wing, designed by
I. M. Pei & Partners, took its commanding position at one of the
highest points on one of the busiest intersections of Portland. The
assertive yet elegant Postmodern building, with its large circles
and semicircles cut into the brick façade, has become emblem-
atic of Portland. It ushered in a period of gentrification and eco-
nomic revival and is the anchor for the Art District, which also
includes the Maine College of Art in a former Beaux Arts depart-
ment store nearby at 522 Congress Street, many commercial gal-
leries (as well as some beautiful Federal and nineteenth-century
mansions). The Payson Building forms the entrance and is the
core of the modern museum. It took another two decades for the
two predecessor buildings to be refurbished and integrated into a
sequence of spaces that constitute a trip back in time. The "His-
toric Grand Reopening" of the McLellan House and the L. D. M.

Sweat Memorial Galleries took place in 2002 amid much civic celebration. The three buildings, each distinguished in its own right, encapsulate the history of both the city and its art museum.

The McLellan (1801) epitomizes the post-Revolutionary wealth and importance of Portland. The McLellan family owned the largest shipping fleet, the first bank, and the first insurance company chartered in Maine. An elegant, three-storey Federal-style brick mansion, it abounds in exquisite period detail. A large Palladian window above the stylish entrance on Spring Street looks out onto the waters of the harbor. In 1880 the house was acquired by Colonel Lorenzo de Medici Sweat, and nomen was certainly omen. His wife was an advocate of historic preservation and an early member of the Portland Society of Art, founded in 1882 and the predecessor of today's museum. Upon her death in 1908, her estate deeded the McLellan House to the society, stipulating its preservation, and gave funds for the construction of an adjoining gallery in honor of her husband.

The L. D. M. Sweat Memorial Galleries (1911) also boast one grand Palladian window, this one overlooking High Street; otherwise the exterior is simple. The interior galleries cluster around a severe rotunda with arched niches set into the masonry walls. Another rotunda, the light-filled, more intimate Unum Gallery, forms the transition from the Payson Building to the Sweat Galleries. These spaces are devoted to nineteenth-century American art. The two rotundas feature Neoclassical marbles, such as the sweetly romantic *Dead Pearlfisher* by local sculptor Benjamin Paul Akers (1825–1861), the first work to enter the museum. The seated *Penelope* and the full-length *Ulysses S. Grant* are by Franklin B. Simmons (1839–1913), another son of Maine, who also created two outdoor sculptures, *Henry Wadsworth Longfellow* (whose birthplace is just a few blocks down Congress Street), and Portland's Civil War memorial, both in walking distance.

The five galleries are organized by theme, such as The National and the Exotic, and Beauty Pictured and Possessed, the latter covering the Gilded Age and the Aesthetic movement. This gallery includes *Portrait of Mrs. Charles Pelham Curtis* by John Singer Sargent, which, incidentally, he painted in Isabella Stewart Gardner's Gothic Room (q.v.). Landscape in America features works

by Thomas Cole, Fitz Henry Lane, Frederick Church, and Albert Bierstadt, and, acquired in 2007, Thomas Moran's *The Lotus Eaters*, a Turner-like evocation of an imaginary sea-and-mountain locale from *The Odyssey*. The larger Palladian Gallery is dedicated to Arts of the New Republic and showcases some of the museum's extensive collection of furniture, glass, and silver, as well as paintings in roomlike settings. Many pieces are of local manufacture or importance, including some charming depictions of Portland scenes.

One whole gallery is given over to Winslow Homer (1836–1910); this collection was largely the gift of Charles Shipman Payson, who then followed it with the eponymous building. Homer (as well as Akers and Simmons) was a mainstay of the Portland art scene, assisted in the founding of the Portland Art Society, and spent the last twenty-seven years of his life on nearby Prout's Neck, on Cape Elizabeth. His studio-residence there has recently been acquired by the museum and will eventually be accessible to the public in some yet-to-be-resolved way. Payson's gift included such memorable oils as *Weatherbeaten* of 1894, a powerful study of coastal rocks being pounded by waves; and the gloomily lit and disturbing *Wild Geese in Flight*. A selection of watercolors and some of the nearly four hundred print illustrations in the museum's possession are always on view, making Portland an important center for the study of Winslow Homer.

The Payson building, with open, multistorey spaces, is the perfect venue for contemporary art, and it does indeed house American and European art from the late nineteenth century to the present. The ground floor has a large, flexible space for changing exhibitions; smaller exhibitions are mounted on other levels, as well. In all, there are about twelve exhibitions a year.

The permanent collection of this, Maine's largest museum, has truly exploded in recent years. Upon the opening of the Payson building the object count was given as 7,500 pieces, while the Web site in 2007 announced a collection of 18,000 items! But not just the quantity—the quality of the additions is extraordinary. There are four major collectors who transformed the PMA from a regional museum collecting mostly Maine-related American decorative and fine arts into the foremost outpost of European art north of Boston.

In 1991, the Joan Whitney Payson Collection was given or promised to the Portland Museum by her son in her memory (she was the wife of Charles Shipman Payson). The outstanding piece in this collection is Renoir's *Confidences*, showing a couple in a sun-dappled garden setting, reading a newspaper. Others include *The Dancing Lesson* by Degas, and landscapes by Courbet, Sisley, and Whistler. (The collection regularly moves to Colby College for one semester every two years.)

The Scott M. Black Collection, or parts thereof, are frequently on loan at the PMA. Considered one of the finest collections assembled in the last twenty years, it contains about forty masterpieces of Impressionism, Postimpressionism, and Surrealism. Many exhibitions launched in the past decade have taken selections from the Black Collection as their starting points.

German art is supported by two collectors associated with the PMA. The Bradford Collection of German Expressionism contains over two hundred works on paper by all the great names (Max Beckmann, Erich Heckel, Ernst Ludwig Kirchner, Max Pechstein, Emil Nolde, Karl Schmidt-Rottluff). Fifty of these works have already been given to the PMA, the rest is a promised gift. The Albert Otten Collection, on loan, covers the period from the late nineteenth to the mid-twentieth century, with an emphasis on art from Germany. It includes painting, sculpture, and works on paper by Klee, Kandinsky, and Pechstein, but also French art. Since most of the German art at Portland consists of prints, pieces are exhibited for short period of times, in various thematic constellations.

Elizabeth B. Noyce, former wife of Intel founder Robert Noyce, moved to Maine in the 1970s and became Maine's foremost philanthropist, as well as a collector of mostly Maine-related art. Upon her death in 1996, her art collection was divided between the Farnsworth and Portland museums, the principal museums that seriously collect Maine art. Portland received sixty-six items and owes to her largesse important seascapes by Fitz Henry Lane, Robert Henri, and Marsden Hartley, as well as its first George Bellows, *Matinicus*, a harbor scene of his beloved eponymous island; examples from the three generations of the Wyeth family; Childe Hassam, Rockwell Kent, and many lesser-known and contemporary artists.

Stuart Davis, *New York–Paris No. 2*, February 1931. Oil on canvas, 30¼ ×
40¼ in. Portland Museum of Art, Maine. Hamilton Easter Field Foundation
Collection. Gift of Barn Gallery Associates, Inc., Ogunquit, Maine, 1979.13.10.
Art © Estate of Stuart Davis/Licensed by VAGA, New York, NY.

The second floor is essentially given to European and American Impressionism and Postimpressionism; Cubism, Modernism, Surrealism, and contemporary art are on the third floor. Do not miss the balcony level above the third floor, which, in addition to small exhibits, combines porthole vistas over the Portland harbor with interesting visual angles onto the contemporary artwork below. Lastly, the souterrain level has an auditorium, and a pleasant cafeteria surrounded by lit glass-cases showing off nineteenth-century American pressed glass in imaginative and eccentric hues and shapes.

+ PLUS

*The Art Gallery at the University of New England
(Westbrook College Campus)*
While Portland has many interesting sites near the museum, they are well advertised by promotional materials. More out of the way and less known is the small campus of the former Westbrook

Seminary, founded in 1831, which has morphed into the Westbrook College Campus of the University of New England. The quaint and peaceful campus houses, at its far end, a Bauhaus-inspired white two-storey cube, built in 1977 by the Architects' Collaborative, the firm of Walter Gropius in Cambridge. The initiative and funding came from John Whitney Payson to house the collection of his mother, Joan Whitney Payson, consisting of twenty-eight remarkable works, mostly French Impressionism. With several pieces being sold off, and amid strained relationships between the paintings' owner and Westbrook College, in 1991 the remaining paintings were transferred to the Portland Museum of Art, where a portion are still on loan (see above).

The gallery was closed and had to find a new purpose. Reopened in 1998 as the Art Gallery at UNE, it takes advantage of its woodsy setting by holding an annual invitational exhibition of outdoor sculpture. The gallery itself mounts six exhibitions annually, with an emphasis on photography, contemporary art, works by women, and international artists. Sometimes the themes converge, as in the exhibition "Maine Women Art Pioneers," and "Contemporary Artists from Africa." A small, permanent collection of works on paper, photography, and some sculpture is occasionally on view in the lower gallery and in various venues on campus.

Directions: From the Portland Museum of Art follow High Street; merge onto Forest Avenue and cross 1-295 via an underpass. At the fifth light take a left onto Walton Street, then turn right onto Stevens and park on the street. The campus is on the left. (Limited campus parking near the gallery.) Open Wednesday through Sunday, 1 to 4 P.M., Thursday to 7 P.M. Tel. 207-602-2626; www.une.edu/artgallery.

Rockland

FARNSWORTH MUSEUM AND WYETH CENTER

16 Museum Street Rockland, ME 04841; Tel. 207-596-6457; www.farnsworthmuseum.org.

Directions: From the south: take I-95 North to Brunswick, then coastal US-I North to Rockland. From the north: take Route I South to Rockland. Within Rockland follow signs. Several parking lots around the museum.

Hours: Memorial Day through Columbus Day: Daily, 10 A.M. to 5 P.M., Wednesday until 7 P.M. Winter hours: Tuesday through Sunday, 10 A.M. to 5 P.M.

Admission: Adults $12, seniors and students $10, children under 16 free. Sunday, 10 A.M. to 1 P.M. free for all. Ticket includes admission to the Farnsworth Homestead and to the Olson House in Cushing, Maine, any day within a week. The two houses are open only from Memorial Day through Columbus Day.

Catalog: Pamela J. Belanger, *Maine in America: American Art at the Farnsworth Art Museum*, Rockland, 2000.

"Celebrating Maine's role in American Art" is how the museum describes its mission. To the uninitiated it might seem a bit preposterous. Is Maine's role really that large? As it turns out, it is large enough to fill a museum with a number of distinct collections that adhere—mostly—to the mission. Let's take them one by one.

First, there is the permanent exhibit, Maine in America, which draws on an extensive collection and periodically changes focus to bring out new pieces and retire others (and may include major non-Maine items). The exhibit covers Maine as the subject matter for visiting artists, and art by Maine-born or Maine-based artists. Ocean waves bashing the rocky shore, ships of every kind in all weather, tall firs, lakes ringed by rugged mountains, the wild beauty of the island of Monhegan, Mt. Desert Island, pretty harbors such as Camden and Rockport, fishing shacks and quiet coves, not to forget rugged fishermen and lumberjacks—there was and is an abundance of subject matter that has attracted painters from the early nineteenth century to this day.

The earliest landscape painters were in search of the sublime and picturesque, much as were the Hudson River School painters. By midcentury Fitz Henry Lane had made several trips to Maine; the Farnsworth has five important works in his distinct

Luminist style, showing, for example, fully rigged sailboats near Camden or Rockland. Martin Johnson Heade, Sanford Robinson Gifford, John Joseph Enneking continue the romantic land- and seascapes. Eastman Johnson introduced a more realistic note in his genre paintings, and Winslow Homer is represented by several watercolors of shore scenes. Among American Impressionists, Willard Leroy Metcalf (1858–1925) visited his friend Frank W. Benson (1862–1951) on the island of North Haven; Metcalf's *Ebbing Tide, Version Two* of 1907 records a vista from the island, while Benson charms with *Laddie*, his light-drenched portrait of a young boy.

Robert Henri, George Bellows (five works), Rockwell Kent, Leon Kroll, Marsden Hartley, John Marin, Edward Hopper (four works), Walt Kuhn all painted in Maine and are represented in the Farnsworth with scenes from Maine, or, in the case of Marsden Hartley, nearby Nova Scotia. Their vigorous brushwork and pronounced outlines seem particularly suited to the clarity of the Maine atmosphere and the power of the ocean.

The next wave of twentieth-century painters availed themselves of the Modern idiom of flat color fields and expressive use of color, while adhering to the representational mode of art: Fairfield Porter, Will Barnet, Alex Katz, Neil Welliver show us yet another take on the Maine landscape, a seemingly cooler, more detached stance. The Farnsworth continues to collect Maine art of the present and is committed to showcasing it in dedicated galleries and exhibitions.

We have skipped the big name of the Farnsworth: the Wyeth dynasty. The Wyeth presence at the museum is overwhelming: the works of Newell Convers Wyeth, his son Andrew Newell Wyeth (b. 1917), and the latter's son James Browning Wyeth (b. 1946) are shown separately in dedicated galleries and buildings. The Wyeth Center in the museum's name consists of "several discrete components dedicated to collecting, research, exhibitions and interpretive programs related to three generations of Wyeths in Maine." The white church building at the edge of the museum campus has been converted into galleries that show the work of N. C. Wyeth downstairs and James Wyeth upstairs, unless a major Wyeth-related show takes over the entire building. A new wing

Newell Convers Wyeth, *Bright and Fair—Eight Bells*, 1936. Oil on canvas,
42³⁄₈ × 52¼ in. Farnsworth Art Museum. Museum purchase, 89.13.

of the original museum building houses an extensive collection
of works by Andrew Wyeth; rotating, thematic exhibits that draw
from this trove are always on view. Other facilities are dedicated
to Wyeth-related research, bibliographical support, and interac-
tive database programs.

The Wyeths' connection with Maine goes far and deep: N. C.
Wyeth bought a summerhouse in Port Clyde in 1920, named it
Eight Bells after the famous painting by Winslow Homer (now at
the Addison Gallery in Andover, Massachusetts), and summered
there for most of his life. This move helped N. C. Wyeth tran-
scend his role as illustrator to become what he wanted to be—a
painter. Son Andrew met his wife in nearby Cushing, Maine; she
introduced him to the Olson family and their farm, which be-
came the topic and inspiration for many drawings, watercolors,
and paintings, including the famous *Christina's World*, now in the
New York Museum of Modern Art. Andrew summers in Cushing
to this day. James Wyeth grew up summering in Maine and even-
tually bought the house of painter Rockwell Kent on Monhegan

Island. In the early 1990s he gave it up to gain more seclusion on Southern Island, Maine. The phenomenon of a three-generation family of outstanding painters (which includes a number of female members as well) is astounding, and the opportunity to see much of their work in close proximity is a gift to the art lover and connoisseur.

It will come as a surprise to many that noted and notorious twentieth-century sculptor Louise Nevelson (1899–1988) grew up in Rockland, the daughter of immigrants from the Ukraine, under the name of Leah Berliavsky. She married a shipowner from New York, Charles Nevelson, and moved at age twenty-one to New York, where she studied art. In 1932 she went to Germany to study with Hans Hofmann, whom she credits with introducing her to Cubism; he seems to have facilitated her transition to Abstract, Cubist sculpture. Major donations by herself and her family make the Farnsworth the second-largest holder of works by Nevelson (after the Whitney in New York City), particularly works of her early career. The collection, housed on the top floor in bright, spacious quarters, includes paintings, works on paper, jewelry, and examples of her later sculptures, constructed of found wood painted all black or all white.

The Farnsworth component of the museum's name has its own building, too; namely, the Farnsworth family home, a mid-nineteenth-century Greek Revival structure, fully furnished in High Victorian style. It was bequeathed by the last survivor, ninety-seven-year-old Lucy Farnsworth, in 1935, together with a sizable endowment to establish a library and museum in her father's memory. It is therefore the nucleus of the entire museum complex. The house is on the National Register of Historic Places and is open for touring during the summer months.

+ PLUS

Olson House
The Olson House in Cushing, Maine, about twenty minutes by car, is a must-see for anybody interested in Andrew Wyeth or in the creative process. The weather-beaten farmhouse, tall and with a high-pitched roofline, stands on a hill, in firm isolation,

a magnificent presence. Andrew Wyeth was first introduced to the house and its occupants, crippled Christina and her reserved brother, Alvaro, in 1939, and kept painting them and their surroundings until 1969, the year after both occupants had died. The house is mostly empty of furniture, but filled with the haunting presence of Christina and the harsh, simple lifestyle of a bygone era on a lonely saltwater farm. Reproductions of Wyeth's relevant paintings are hung right where he painted them, allowing the visitor to compare the reality of the subject and its transformation into art. It's magical! Despite Andrew Wyeth's clear, realistic style, you realize that he willed the physical environment to yield the essence of what he was after, and cleansed reality of the extraneous.

Directions: Take US-1 South to Thomaston (4.8 miles). In Thomaston turn left onto Wadsworth Street, which becomes River Road. Go for 6.2 miles, then turn left on Pleasant Point Road. After 1.5 miles turn left onto Hathorn Point Road. The house is at the end, after 1.9 miles. (The museum also provides printed directions.)

Waterville

COLBY COLLEGE MUSEUM OF ART

5600 Mayflower Hill, Waterville, ME 04901; Tel. 207-859-5600; www.colby.edu/museum.

Directions: From the south: take I-95 to Exit 127 (Waterville/ Oakland). Turn right onto Kennedy Memorial Drive. Go through two sets of lights and turn left at the third light, onto First Rangeway (opposite Inland Hospital). Turn left at the T-intersection onto Mayflower Hill Drive. The admissions office (for campus maps and information) is at the right, the museum a little further on the left.

Hours: Tuesday through Saturday, 10 A.M. to 4:30 P.M.; Sunday, 12 to 4:30 P.M.

Admission: Free.

Colby has been extremely lucky in its donors, alumni, archi-tects, and, particularly, its museum director. Founded in 1959, the Colby College Museum of Art grew, under the inspired thirty-six-year leadership of Hugh Gourley III, from two rooms in the Art and Music Center in 1966, to one of the largest art exhibition spaces in the state of Maine. This is astounding in itself, but more impressive is the high quality and sharp focus of the collection. Small in numbers (just over five thousand items) and focused on American art, the museum is really a collection of collections, each assembled by an inspired art lover or artist and bequeathed or promised to Colby en bloc.

The most recent and important bequest, a promised gift of over five hundred objects—mostly American art of the nine-teenth and twentieth centuries—forms the backbone of the mu-seum. Some eighty pieces are on view now. By 2009, for the fiftieth anniversary, about two hundred will be shown; addi-tionally, a new wing is to be completed by 2013 to make even more of the collection continuously accessible. The donors, Peter and Paula Lunder, have assembled one of the finest collections of American art. From Hudson River School artist Sanford Robin-son Gifford, to George Inness, Winslow Homer, William Merritt Chase, Mary Cassatt, and John Singer Sargent, many of the major figures of the nineteenth century make an appearance, often with multiple works. James Abbott McNeill Whistler is represented by over two hundred prints, as well as oils and watercolors. This makes Colby a major center for Whistler studies, and the planned wing will have a dedicated space for his works. The Lunder col-lection continues into the twentieth century with Edward Hop-per and Georgia O'Keeffe; sculpture is especially well covered, with multiple works by Augustus Saint-Gaudens, Paul Manship, Elie Nadelman, and Alexander Calder, as well as contemporary sculptors.

Let me just list some other major donations in chronological order:

Mr. and Mrs. Ellerton Jetté, in 1956, donated seventy-six American Primitive paintings, watercolors, and drawings, mostly portraits in the somber fashion of early itinerant

painters; they later bequeathed a collection of American Impressionists.

In 1957, Helen Warren and Willard Howe Cummings bequeathed American paintings, watercolors, and folk sculpture, especially some striking weather vanes.

Twenty-four works by John Marin (1870–1953), who was closely associated with Maine, were given in 1973 by his son and his wife; over the years they added more works, including twenty-nine etchings and photographs of Marin by the likes of Alfred Stieglitz and Paul Strand; a portrait bust of Marin by Gaston Lachaise is on lan from the Lachaise Foundation. There is a dedicated Marin gallery, where the works reveal how he transformed New York cityscapes and Maine landscapes into exuberant, Cubism-inspired vibrating images. This is the largest Marin collection outside the National Gallery in Washington.

Louise Nevelson, the flamboyant sculptress known for her intricate assemblages of black-painted wood, gave twelve early sculptures and twenty drawings. She grew up in nearby Rockland (see also Farnsworth Museum).

In 1992, the Joan Whitney Payson Collection of French Impressionist and Postimpressionist Art came to the Colby Museum for one semester and continues to do so every second year (the Portland Museum houses the collection for the remaining eighteen months). This small but exquisite collection includes major works by Courbet, Ingres, Renoir, Sisley, Chagall, and Reynolds.

Finally, the museum boasts nearly seven hundred works by contemporary artist Alex Katz (b. 1927), housed in the Paul J. Schupf Wing, built for the express purpose of showcasing this vast trove. Katz paints big and bold—people, landscapes and even still lifes—in posterlike, flat colors and always in enormous dimensions. He gave this very large gift (including complete sets of his prints), because "I wanted to see my paintings in the perfect situation. Colby

provided the place. . . . I conceived the donation as the kind that holds a lot of exhibitions within it." Katz was involved in the selection of the architects and worked closely with them to get the open, simple spaces, clear light, and industrial-style surfaces that match his work so well.

Jere Abbott, first associate director of MoMA and director of the Smith College Art Museum (1932–46), gave the Colby College Art Museum a $4.3 million acquisition fund. With this endowment, the museum has been and is still steadily buying American art of the twentieth and twenty-first centuries.

In addition to artists mentioned above, the Colby has excellent examples by John Singleton Copley (four; see color insert), Gilbert Stuart (three), Charles Willson Peale, Albert Bierstadt, Childe Hassam, Robert Henri (*La Reina Mora*, a dashing, full-length portrait of a Spanish dancer). George Bellows, Maurice Prendergast, Marsden Hartley, and Rockwell Kent mostly depict Maine scenes.

Colby also has sizable holdings in Chinese art and ceramics, making it "the most important resource for the study of early Chinese art and culture in Maine."

What the above list does not convey is the pleasant environment the museum creates for its art and for the visitor. Though the museum was built and expanded over half a century, the flow from gallery to gallery, on two levels, is smooth. Spaces are calibrated to their holdings: domestic early American art is in intimate rooms with intense, warm wall colors; the delicate watercolors and etchings by Marin and Whistler have visitor-activated lighting to minimize their exposure to light; Modern art is in stark white, high-ceilinged spaces. Lighting is mostly natural and on a bright Maine summer day, almost crystalline.

The architecture is an interesting example of modern architects coming to terms with the redbrick, Neo-Georgian-style campus, without any false historicism. The Lunder Wing, by Frederick Fisher, resembles a simple barn, albeit in brick, while the Schupf Wing (Max Gordon and, after his death, Scott Teas) delineates on the outside, in faint brick patterns, the large-scale dimensions

of the interior spaces. The forecourt of the main building is conceived as a sculpture park, and holds Richard Serra's *4-5-6*, three cubes in those dimensions, set on different sides and oxidizing into a warm, dark rust color.

+ PLUS

Skowhegan Lecture Archive
A famous neighbor of Colby College is the Skowhegan School of Painting and Sculpture. Founded in 1946 by Willard Cummings (and three artist friends) on farmland belonging to his family, the school has been a meeting and working place for selected artists each summer. From 1952 onward, the teaching staff has delivered public lectures, which have been recorded. This collection of over five hundred lectures "represents the depth and breadth of postwar American art," and includes Ben Shahn, William Zorach, David Smith, Jacob Lawrence, Helen Frankenthaler, George Grosz, Roy Lichtenstein, Louise Nevelson, and many others famous in the art world. Saved onto CD-ROMs, these lectures are accessible at only nine locations nationwide, one of which is Colby College. Access is through the multimedia desk at the Bixler Art and Music Library, which adjoins the museum.

WEBSITES

Societies and organizations
Connecticut Art Trail: www.arttrail.org

Historic New England, administers historic houses:
www.historicnewengland.org

Maine Art Museum Trail: www.maineartmuseums.org

The New England Museum Association: www.nemanet.org

Ten museums in central Massachusetts: www.museums10.org

The Trustees of Reservations, preserves open spaces and
historical sites: www.thetrustees.org

Cultural travel
B&Bs that are on the National Register of Historic Places:
www.bbonline.com/historic.html

Cultural events and sites in New Hampshire and southern
Maine: www.goseacoast.com

Cultural sites in Essex County, north of Boston:
www.essexheritage.org

Historic artists' homes and studios open to the public:
www.preservationnation.org/travel-and-sites/sites/artists-homes
.html

Historic house museums, by state: www.vpa.org/museums

Illustrated blog on Connecticut historic buildings:
www.historicbuildingsct.blogspot.com

Links to hundreds of New England towns by state, category,
interest: www.newenglandtowns.org

Literature, architecture, and art north of Boston:
www.escapesnorth.com

Monthly review of exhibitions at galleries and museums in Rhode
Island, Connecticut, Massachusetts, and New York:
www.theartguideonline.com

New England cultural travel: www.gonewengland.about.com

Sites and artists of the White Mountains (New Hampshire):
www.whitemountainart.com

National museum portals
American Association of Museums: www.aam-us.org

Art Museum Network: www.amn.org

Daily compilation of art-related news: www.artdaily.org

Listing of commercial and not-for-profit art galleries, art fairs, and
auctions: www.art-collecting.com

Listing of U.S. art museums, by name, state, or city:
www.artcom.com

Massive listing of fine arts organizations, including museums:
www.tfaoi.com

Museums and museum events in United States:
www.museumsusa.org

Portals to art, history, and science museums worldwide:
www.museumstuff.com, www.museumlink.com,
www.museumspot.com

Web image-galleries, virtual museums
Comprehensive site on American artists: www.askart.com

An index of online museum image archives, covering 8,000 artists:
www.artcyclopedia.com

Major architecture worldwide: www.greatbuildings.com

Virtual museum and database of European painting and sculpture
from the twelfth through nineteenth century:
www.wga.hu/index1.html

BOOKS

Belander, Pamela J., editor. *Envisioning New England.* Treasures from Community Art Museums, Hanover, N.H.: University Press of New England, 2004.

Citro, Joseph A., and Diane E. Foulds. *Curious New England.* Hanover, N.H.: University Press of New England, 2003.

Faison, S. Lane, Jr. *The Art Museums of New England.* Boston: David R. Godine, 1982.

Faison, S. Lane, Jr. *The New England Eye: Master American Paintings from New England School, College, and University Collections.* Exhibition catalog. Williamstown, Mass.: Williams College Museum of Art, 1983.

Harding, Anneliese. *German Sculpture in New England Museums.* Boston: Goethe Institute Boston, 1972.

Harris, Jean C. *Collegiate Collections, 1778–1876.* Exhibition catalog. Mount Holyoke College Art Museum, June 15–December 15, 1976.

Harrison, Marina, and Lucy D. Rosenfeld. *Art on Site: Country Artwalks from Maine to Maryland.* New York: Michael Kesend Publishing Ltd., 1994.

Hunisak, John M. *Carvings, Casts and Replicas: Nineteenth-Century Sculptures from Europe and America in New England Collections.* Middlebury, Vt.: Middlebury College Museum of Art, 1994.

Riess, Jana. *The Spiritual Traveler: Boston and New England; A Guide to Sacred Sites and Peaceful Places.* Mahwah, N.J.: Hidden Spring, 2001.

Numbers set in italic indicate illustrations.

American Abstract Artists, 181
Aarons, George, 174
Aarons, Jules, 166
Abbey, Edwin Austin, 130
Abbott, Berenice, 318
Abstract art, 181
Abstract Expressionism, 34, 61, 102, 152, 188, 209, 236
Adam, Robert, 76
Adams, John Quincy, 81
African art, 46, 86, 98,124,162, 214, 240,289
African sculpture, 16, 95
Akers, Benjamin Paul, 330, 331
Albers, Josef, 102, 140, 281, 317
Alcott, Bronson A., 176
Alcott, Louisa May, 176
Aldrich, Larry, 70
Allen & Collins, 170
Allston, Washington, 101, 120
American Academy of Arts, 44
American Illustrators Gallery, 74
American Impressionism, 38, 58, 60, 68, 69, 157, 172, 173
American Indian art, *see* Native American art
Ancient glass, 45
Ando, Tadao, 244
Angelico, Fra, 29, 112
Ann Beha Architects, 35, 38, 278

Antimenes painter (circle of), 295
Archipenko, Alexander, 16, 48, 97
Architects Collaborative, 334
Aretino, Spinello, 136
Armory Show, 47, 208, 324
Aronson, David, 165
Arp, Jean, 201
Art Deco, 38, 226, 235, 258
Arts and Crafts, 20, 179
Ashcan School, 30, 34, 38, 96, 102, 182
Asian art, 34, 142, 156, 157, 214, 217, 218, 251, 262, 289, 297
Assyrian reliefs, 46, 54, 94, 95, 250, 273, 295, 321
Audubon, John James, 303
Austin, Jr., A. Everett "Chick," 28, 29, 30, 31
Averbuch, Ilan, *color insert*
Avery, Milton, 16, 61, 173, 253

Bacon, Henry, 230
Bakst, Leon, 97
Balanchine, George, 29
Ballets Russes, 31, 97
Barbizon School, 18, 57, 58, 123, 246
Barlach, Ernst, 33, 51, 139
Barnet, Will, 336
Barnum, Phineas Taylor, 16, 17
Baroque art, 26, 29
Barye, Antoine Louis, 296

Batoni, Pompeo, 42
Bauhaus, 28, 102, 140, 181, 186
Baziotes, William, 209
Beardsley, Aubrey, 135, 137
Beaux, Cecilia, 169
Beckmann, Max, 33, 139, 165,
 317, 332
Beecher, Henry Ward, 94
Bellini, Gentile, 112
Bellini, Giovanni, 112, 136
Bellotto, Bernardo, 227
Bellows, George, 30, 38, 45, 78,
 96, 97, 101, 157, 226, 236, 253,
 324, 332, 336, 342
Benedetto da Maiano, 279
Benson, Frank W., 121, 151, 191,
 264, 280
Benton, Thomas Hart, 38, 63,
 157, 328
Benton, William, 63, 64
Berenson, Bernard, 110
Berlin Painter, 46, 295
Bernini, Gianlorenzo, 137
Beuys, Joseph, 140, 197
Bierstadt, Albert, 37, 50, 67, 98,
 101, 157, 165, 177, 217, 220,
 225, 264, 281, 290, 302, 306,
 312, 313, 331, 342, color insert
Bill, Hans, 140
Blackburn, Joseph, 225, 322
Blake, William, 41, 135, 136, 137
Blake, Quentin, 91, 92
Blashfield, Edwin Howland, 253
Bloom, Hyman, 165, 166, color
 insert
Boit, Edward Darley, 78
Bol, Ferdinand, 227
Bollingen Foundation, 41
Bologna, Giovanni da, 241
Bonnard, Pierre, 145, 201
Bontecou, Lee, 16
Bordone, Paris, 112

Borglum, Gutzon, 61
Borglum, Solon, 37
Bosch, Hieronymus, 46
Boston Expressionism, 165
Botero, Fernando, 85
Botticelli, Sandro, 112
Botticelli, studio of, 136
Boucher, François, 51, 136, 227
Bouguereau, Adolphe, 245, 306
Bourgeois, Louise, 253
Bourke-White, Margaret, 102
Bouts, Dirck, 137
Brancusi, Constantin, 48, 138,
 181
Braque, Georges, 181, 182, 317
Bray, Jan de, 64
Brewster, John, Jr., 160
Bricher, Alfred, 318
Brown, Charles Loring, 307
Brueghel, Jan, 259
Brueghel, Pieter, 136
Brutalism, 48
Bulfinch, Charles, 163
Bunker, Dennis Miller, 113
Bunshaft, Gordon, 49
Burchfield, Charles, 38, 318, 328
Burne-Jones, Edward, 127
Buttersworth, James, 151
Byzantine art, 142

Cadmus, Paul, 290
Cahoon, Martha Farham, 149
Cahoon, Ralph, 149
Caillebotte, Gustave, 227
Calder, Alexander, 205
Calder, Alexander, 29, 67, 138,
 145, 242, 281, 318, 340
Calder, Alexander Sterling, 205
Callot, Jacques, 157
Cambio, Arnolfo di, 137
Canaletto (Giovanni Antonio
 Canal), 42, 227

Capitol (Washington, D.C.), 27, 44

Caponigro, Paul, 198

Caravaggio, Michelangelo Merisi da, 29, 263

Carlsen, Emil, 21, 66

Carolus-Duran, 085

Carrère & Hastings, 73

Casado, José del Alisal, 81

Cassatt, Mary, 19, 37, 63, 101, 156, 246, 264, 303, 304, 318, 324, 340

Cellini, Benvenuto, 112

Centerbrook Architects, 59, 272

Cesar Pelli and Associates, 66

Cézanne, Paul, 85, 123, 137, 200, 236, 242, 245, 263, 324, *color insert*

Chadwick, William, 50, 58

Chaet, Bernard, 16

Chagall, Marc, 16, 97, 145, 317, 341

Champney, Benjamin, 151, 256

Champney, Edwin, 256

Chandler, Joseph Everett, 103

Chandler, Winthrop, 50, 160

Chardin, Jean Baptiste Siméon, 227

Chase, William Merritt, 22, 101, 161, 162, 200, 224, 280, 340

Chavannes, Puvis de, 129

Chernow, Burt, 15, 16

Chinese art, 55, 86, 119, 137, 142, 214, 262, 297, 342

Chinese cloisonné, 224

Chinese export ware, 55

Chinese furniture, 78

Chinese jade, 137, 224

Chinese porcelain, 18

Chirico, Giorgio de, 16

Christo, 16

Church, Frederic, 27, 28, 37, 39, 50, 59, 66, 98, 101, 177, 204, 224, 296, 331

Cimabue, 136

Clark, Stephen C., 45, 47

Clark, Sterling, 45

Cleve, Joos van, 137, 279

Codman, Charles, 177

Cole, Thomas, 27, 31, 37, 50, 59, 97, 224, 264, 302

Collins, Charles, 220

Colonial furniture, 26, 29, 54, 159

Colonial Revival, 103, 188

Color Field Painting, 34, 188, 236

Connecticut College, 24, 25

Connecticut Impressionism, 63

Constable, John, 41, 247, 279

Copley, John Singleton, 37, 45, 84, 95, 101, 116, 120, 136, 162, 204, 215, 241, 252, 263, 273, 303, 322, 323, 342, *color insert*

Cornish art colony, 230, 271, 308

Corot, Camille, 33, 112, 136, 157, 279, 304

Cos Cob art colony, 21, 23, 69

Cosimo, Piero di, 29

Costa, Lorenzo, 279

Courbet, Gustave, 112, 200, 227, 263, 304, 332, 341

Cox, Kenyon, 321

Cranach, Lucas (the Elder), 46, 112

Crocker, John Denison, 54

Cropsey, Jasper, 50, 67, 157, 165, 177, 241, 281, 307

Cruikshank, George, 91

Cubism, 181, 182, 333, 338

Currier & Ives, 226

Curry, John Steuart, 318

Cushing, John Gardiner, 78

Dada, 47
Dalí, Salvador, 29, 145, 296
Dallin, Cyrus E., 104, 125, 209, color insert
Daubigny, Charles, 304
Daumier, Honoré, 33, 91, 137, 317
David, Jacques Louis, 135, 136, 137, 208, 245
Davis, Stuart, 30, 38, 121, 173, 208, 333
Degas, Edgar, 19, 85, 112, 123, 137, 201, 227, 246, 263, 303, 304, 332
Delacroix, Eugène, 112, 137
Delaunay, Robert, 317
Demetrios, George, 171, 174
Demuth, Charles, 208, 253, 328
Derain, André, 36
Dewing, Thomas Wilmer, 113, 309
Dickinson, Edwin, 208
Diebenkorn, Richard, 39
Diller Scofidio + Renfro, 108
Dine, Jim, 34, 39, 236, 242
Dirks, John, 327
Donatello, 122
Doughty, Thomas, 177
Dove, Arthur, 101, 121, 281
Dow, Arthur Wesley, 179, 180
Dreier, Katherine, 47, 48
Dublin art colony, 163
Duccio di Buoninsegna, 136, 218
Duchamp, Marcel, 47
Duchamp-Villon, Raymond, 242
DuMond, Frank Vincent, 58
Duran, Carolus, 247
Durand, Asher C., 37, 98, 101, 241, 307
Dürer, Albrecht, 33, 112, 136, 157, 247, 275

Duveneck, Frank, 173
Dyck, Anthony van, 29, 42, 112, 129

Eakins, Thomas, 30, 37, 45, 98, 101, 199, 264
Earl, Ralph, 37, 50, 59, 225, 286
Ebert, Charles, 50, 58
Egyptian art, 45, 54, 86, 116, 117, 142, 163, 262, 291, 295
El Greco (Doménikos Theoto-kopoulos), 122, 123, 162, 263
Enneking, John J., 151, 336
Epstein, Sir Jacob, 205
Etching revival, 34
Etruscan art, 117, 142
Evans, Walker, 102
Ewell, William S., 191
Expressionism, 16, 139

Fabriano, Gentile da, 46
Faison, Jr., S. Lane, 64, 83, 95, 118, 143, 172, 204, 227, 250, 251, 321
Feininger, Lyonel, 140, 226, 281
Feke, Robert, 215, 322
Fichter, Joseph, color insert
Field, Erastus Salisbury, 66, 220, 225, 286, 302
Field, Hamilton Easter, 327
Fisher, Alvan, 177
Floyd, Chad, 59, 272
Fontana, Lavinia, 241
Foote, Will Howe, 58, 58
Foster and Partners, 116
Fragonard, Jean Honoré, 136
Francavilla, Pietro, 29
Francesca, Piero della, 245
Frank, Mary, 226
Frankenthaler, Helen, 202, 226, 343
French porcelain, 28

French, Daniel Chester, 98, 127, 129, 203, 205, 229, 232, 310

Frick Collection, 73

Frishmuth, Harriet Whitney, 279

Gabo, Naum, 67, 97

Gainsborough, Thomas, 41, 42, 129, 136, 245, 247, 263

Gauguin, Paul, 85, 124, 129, 137, 261, 263, *264*

Geissbuhler, Arnold, 153

Géricault, Théodore, 135

German Expressionism, 276

German porcelain, 28

Gérôme, Jean-Léon, 245

Ghiberti, Lorenzo, 46

Ghirlandaio, Domenico, 245

Ghirlandaio, Ridolfo, 46

Giacometti, Alberto, 153, 321

Gifford, Sanford R., 157, 177, 224, 252, 307, 312, 336, 340

Gilbert, Cass, 67, 231

Gilded Age, 27, 42, 76, 234, 269, 330

Giorgione, 112

Giverny, 22

Glackens William, 38, 290

Glass, ancient, 45

Glass, Venetian, 28

Gogh, Vincent van, 4, 124, 137, 245

Goncharova, Natalia, 97

Gorky, Arshile, 67

Gossaert, Jan "Mabuse," 279, *280*

Gottlieb, Adolph, 39, 173, 209, 236, 281

Goya, Francisco de Goya y Lucentes, 33, 91, 136, 145, 226, 245

Goyen, Jan van, 227

Grafly, Charles, 174

Grandma Moses, 150, 233, 287, 303

Greacen, Edmund, 50

Greek art, 83, 117, 142, 163, 218, 262, 295

Greenwich Society of Artists, 21

Griffin, Arthur, 254

Gris, Juan, 182

Griswold, Florence, 57

Gropius, Walter, 140, 186, 334

Gropper, William, 318

Grosz, George, 61, 102, 165, 343

Guardi, Francesco, 112, 227

Guercino (Giovanni Francesco Barbieri), 122

Guggenbichler, Meinrad, 137, 241

Gullagher, Christian, 160

Gund, Graham, 237

Guston, Philip, 16, 236, 237

Gwathmey Siegel & Associates, 141, 297

Gwathmey, Charles, 49

Haberle, John, 37

Hafftka, Michael, 16

Hals, Frans, 29, 47, 137

Hancock, Walker, 174

Hans von Aachen, 296

Harding, Chester, 252

Hardy, Holzman, Pfeiffer Associates, 278, 294

Harnett, William M., 37, 162, 225

Harrison, Wallace K., 277

Hartley, Marsden, 30, 38, 101, 173, 208, 253, 265, 281, 324, 325, 326, 328, 332, 336, 342

Hassam, Childe, 22, 30, 37, 50, 60, 63, 69, 101, 162, 173, 199, 264, 280, 281, 328, 332, 342, *color insert*

Hathaway, Rufus, 160
Hawthorne, Charles, 207
Heade, Martin Johnson, 50, 59, 64, 121, 172, 303, 336
Heckel, Erich, 139, 317, 332
Hendee, Stephen, 38
Henri, Robert, 38, 96, 101, 328, 332, 336, 342
Hesse, Eva, 39
Hewitt, Charles, 324, 325
Hicks, Edward, 302
Hiroshige, Utagawa, 98, 275
Hockney, David, 318
Hoffmann, Josef, 140
Hofmann, Hans, 102, 152, 209, 338, *color insert*
Hogarth, William, 42, 237, 261, 263, 317
Hokusai, Katsushika, 98
Holbein, Hans (the Younger), 112, 136
Holyoke Painter, 218
Homer, Winslow, 30, 37, 45, 98, 101, 121, 135, 137, 172, 225, 247, 264, 290, 303, 318, 323, 328, 331, 336, 337, 340, *color insert*
Honthorst, Gerrit van, 80
Hooch, Pieter de, 204
Hopper, Edward, 45, 64, 101, 102, 173, 208, 253, 281, 328, 336, 340
Hudson River School, 37, 38, 39, 55, 157, 177, 312, 335, 340
Hunt, Richard Morris, 67, 77, 123, 134
Hunt, William Morris, 120, 123, 172, 180, 191, 199, 252
Huntington, Henry E., 42

I.M. Pei & Partners, 329
Icons, Russian, 147

Illustration, 16, 36, 38, 75, 91, 166, 167, 233, 310, 337
Impressionism, 18, 37, 68, 85, 123, 208, 246, 332, 333
Indian art, 86, 119, 143, 214, 262
Indiana, Robert, 236, 325
Ingres, Jean Auguste Dominique, 51, 135, 134, 137, 341
Inman, Henry, 281
Inness, George, 50, 67, 78, 98, 101, 157, 177, 217, 224, 225, 241, 252, 264, 318, 340
Isenbrant, Adriaen, 204
Islamic art, 143

Japanese arms and armor, 223
Japanese art, 55, 86, 116, 119, 155, 214, 224, 262
Japanese prints, 18, 32, 95, 98, 118, 142, 157, 226, 237, 262, 297
Jawlensky, Alexej, 140
Jeanne-Claude (wife of Christo), 16
Jennys, William, 50, 225, 252, 286
Johns, Jasper, 103, 236
Johnson, Eastman, 80, 303, 336
Johnson, Philip, 49
Judd, Donald, 103
Jung, Carl Gustav, 41

Kahn, Louis, 43, 44, 46, 75
Kallmann, McKinnell & Wood, 185, 212
Kandinsky, Wassily, 33, 48, 140, 263, 332
Katz, Alex, 236, 318, 336, 341
Kauffman, Angelica, 81, 156, 241
Kaufman, Mico, 191
Kaulbach, Wilhelm von, 306
Kelly, Ellsworth, 103, 109, 236

Kensett, John Frederick, 22, 50, 59, 66, 177, 241, 252, 264, 302, 312

Kent, Rockwell, 154, 162, 200, 233, 290, 323, 328, 332, 336, 337, 342

Kevin Roche, John Dinkeloo and Associates, 32

Kirchner, Ernst Ludwig, 139, *201*, 332

Kirkland, Douglas, 198

Klee, Paul, 48, 140, 201, 332

Klimt, Gustav, 16, 140

Kline, Franz, 202

Knaths, Karl, 208

Kokoschka, Oskar, 33, 140, 165, 242

Kolbe, Max, 139

Kollwitz, Käthe, 63, 145, 165, 317

Kooning, Elaine de, 16, *color insert*

Kooning, Willem de, 236, 242, 296, 318

Korean art, 55, 119, 213

Krasner, Lee, 39, 209, 242

Kroll, Leon, 173, 336

Kronberg, Louis, 113, 191

Kuhn, Walt, 281, 328, 336

Kuniyoshi, Yasuo, 290, 290

La Farge, John, 78, 113, 123, 126, 232, 256, 321

Lachaise, Gaston, 61, 138, 341

Lane, Fitz Henry (formerly Hugh), 37, 78, 121, 172, 174, 302, 331, 332, 335

Lawrence, Jacob, 38, 136, 343, *color insert*

Lawrence, Thomas, 42

Lawson Ernest, 22, 310

Le Corbusier, 48, 138

Léger, Fernand, 48, 181, 236

Lehmbruck, Wilhelm, 51, 139, 202

Lely, Sir Peter, 42, 136

Leonardo, portrait of, 55

Levine, Jack, 165, 166

LeWitt, Sol, 25, 27, 36, 37, 242, 250

Leyendecker, Joseph Christian, 74

Lichtenstein, Roy, 236, 318, 343

Lifar, Serge, 31

Lippi, Fra Filippo, 136

Lissitzky, El, 97

Lombardi, Giovanni-Battista, 61

Longfellow, Henry Wadsworth, 76

Loos, Adolf, 140

Lorenzetti, Pietro, 136

Lorrain, Claude, 29, 41, 51, 122, 245

Louis, Morris, 236

Low, Sanford B.D. (Sandy), 36, 39

Lucioni, Luigi, 293

Luks, George, 38, 290, 328

Luminism, 157, 172, 173, 336

Mabuse (Jan Gossaert), 279, *280*

Macbeth Gallery, 36

Machado and Silvetti, 208, 320

Mack Scoggin Merrill Elam architects, 239

Macknight, Dodge, 113, 114

MacMonnies, Frederick, 128, *128*, 234, 310

MacRae, Elmer, 22

Maginnis and Walsh, 194

Magritte, René, 29, 236

Maillol, Aristide, 138

Maisel, Jay, 198

Majolica, Italian, 28

Manet, 19, 33, 97, 112, 137, 145, 157, 201, 304

Manship, Paul, 38, 61, 100, 173, 174, 310, 340

Marc, Franz, 140

Marcks, Gerhard, 139, 140

Maril, Herman, *color insert*

Marin, John, 253, 318, 324, 328, 336, 341, 342

Marsh, Reginald, 16, 38, 61, 63, 226, 236, 290, 293, 299, 318, 328

Martini, Simone, 112, 136

Massys, Quentin, 263

Master of the Osservanza, 46

Matisse, Henri, 36, 112, 137, 245, 263, 279, 324

Mattá, Robert, 85

Maurer, Alfred, 61

McGhee, Barry, 237

McIntire, Samuel, 216

McKim, Charles Follen, 127, 128, 231, 320

McKim, Mead and White, 67, 79, 94, 234, 277, 289, 320

Mead, William R., 94

Memling, Hans, 245

Metcalf, Willard, 37, 50, 58, 173, 174, 310, 336

Metropolitan Museum of Art, New York, 36, 45, 60

Michelangelo (plaster cast), 321

Michelangelo Buonarroti, 54, 112, 113, 136

Michelangelo, portrait of, 55

Middle Eastern art, 224

Millet, Jean-François, 123, 145, 227

Minimal Art, 188

Miró, Joan, 16, 29, 48, 145, 182, 296, 317

Modernism, 34, 48, 121, 162, 173, 201, 242, 333

Modernism, Russian, 95, 97

Modernists, 30, 34

Modigliani, Amadeo, 36, 236

Moffett, Ross, 208

Moholy-Nagy, László, 102, 140

Mondrian, Piet, 29, 48

Moneo, Rafael, 83, 239, 240

Monet, Claude, 18, 19, 85, 98, 123, 137, 201, 227, 246, 261, 263, 279, 304

Moore, Charles, 138, 249, 272

Moran, Thomas, 98, 204, 312

Moreau Gustave, 136, 306

Moreno, José, 250

Morgan, John Pierpont, 28

Morisot, Berthe, 85, 246

Moroni, Giovanni Battista, 112

Morris, Robert, 242

Morris, William, 127

Morse, Samuel, 96, 101

Mosaics, Roman, 261

Moser, Koloman, 140

Motherwell, Robert, 39, 202, 209, 236

Mueller, Otto, 139, 317

Mural, 33, 39, 74, 154, 276

Murillo, Bartolomé Esteban, 136

Museum of Modern Art, 48, 61

Nadelman, Elie, 340

Nakian, Reuben, 61, 62

Naples painter, 295

National Gallery, Washington, D.C., 40, 51

Native American art, 143, 214, 289

Near-Eastern art, 142

Netscher, Caspar, 219

Neue Galerie, New York, 73

Nevelson, Louise, 25, 39, 138, 202, 242, 281, 318, 328, 341, 343

New York City Ballet, 29

Newman, Barnett, 173
Noguchi, Isamu, 16, 39
Noland, Kenneth, 103, 242
Nolde, Emil, 140, 332
Nubian art, 117
Nutting, Wallace, 29, 30

O'Keeffe, Georgia, 30, 38, 121,
 180, 226, 253, 281, 340
O'Neill, Eugene, 52
Oceanic art, 124, 214, 289
Old Lyme art colony, 50, 57, 58
Oldenburg, Claes, 236
Olitski, Jules, 242, 281
Olmsted, Frederick Law, 39, 74,
 125, 238, 304
Op Art, 188
Orozco, José Clemente, 39, 202,
 276
Ozenfant, Amédée, 102, 181

Pacheco, Francisco, 250
Pan Painter, 117
Panini, Giovanni Paolo, 227
Paolo, Giovanni di, 136
Parrish, Maxfield, 38, 74, 310,
 color insert
Parrish, Stephen, 309
Paul Mellon Centre for Studies
 in British Art, 42
Paxton, William, 121
Peabody Museum of Natural
 History, Yale University, 45
Peale dynasty, 37, 95
Peale, Charles Willson, 95, 342
Peale, Raphaelle, 225
Peale, Rembrandt, 95
Pechstein, Max, 140, 332
Pei, Cobb & Partners, 109
Pei, I.M., 116
Pène du Bois, Guy, 61
Pennell, Joseph, 290

Persian art, 262
Perugino, 245, 279
Peterdi, Gabor, 16
Peto, John, 37
Phelps, William Preston, 191
Phillips, Ammi, 59, 66, 160, 241,
 280, 286
Photography, 33, 102, 138, 140,
 166, 179, 198, 247, 296, 324
Photogravure, 34
Piano, Renzo, 114, 135
Picasso, Pablo, 16, 29, 33, 36, 47,
 91, 137, 181, 182, 201, 245,
 275, 279, 296, 317, 324
Piero della Francesca, 112, 246
Pinturicchio (Bernardino Betti),
 241
Piranesi, Giovanni, 33, 317
Pissarro, Camille, 85, 137, 227,
 246
Plaster casts, 53, 54, 199, 204,
 217, 223, color insert
Platt, Charles A., 49, 59, 100, 310
Pleissner, Ogden, 293, 303
Pollaiuolo, Antonio del, 46
Pollock, Jackson, 209, 242
Polshek Partnership Architects,
 202
Polykleitos, Roman copy after,
 240
Pons, Juan, 204
Pop Art, 236
Pope, Theodate, 18, 20
Porcelain figurines, 85
Porcelain, French, 28
Porcelain, German, 28
Porter, Fairfield, 336
Postimpressionism, 123, 332, 333
Potthast, Edward Henry, 21
Poussin, Nicolas, 51, 122, 136
Powers, Hiram, 289, 290, 296
Pratt, Bela L., 127

Praxiteles, 118
Praxiteles, Roman copy after, 241
Pre-Columbian art, 55, 86, 116, 124, 143, 163, 240, 241, 261, 265, 289
Prendergast Charles, 253
Prendergast, Maurice, 63, 101, 173, 253, 323, 342
Pre-Raphaelites, 135, 136, 137
Pyle, Howard, 38, 167

Quilts, 301, *color insert*

Raeburn, Sir Henry, 136, 279
Ranger, Henry Ward, 57, 66
Raphael, 111, 112
Rauschenberg, Robert, 16, 236, 296
Ray, Man, 47
Redon, Odilon, 33
Regionalism, Regionalists, 38, 157, 182
Reiter, Willington, 183
Rembrandt van Rijn, 33, 112, 122, 136, 137, 157, 237, 247, 263, 275
Remington, Frederic, 98, 101, 145, 247, 310
Renoir, Pierre Auguste, 16, 51, 98, 123, 137, 145, 200, 227, 236, 246, 332, 341
Revere, Paul, 50, 103, 105, 164
Reynolds, Sir Joshua, 42, 95, 96, 136, 341
Ribera, Jusepe, 29, 80, 136, 250
Richards, William Trost, 78, 173
Richardson, Henry Hobson, 52, 76, 79, 126, 132, 222, 228, 238, 256, 291
Riemenschneider, Tilman, 137
Rigaud, Hyacinthe, 51

Rivera, Diego, 85
Robinson, Theodore, 22, 69, 290
Rockwell, Norman, 38, 74, 203, 232, 233, 293, 307
Rodin, Auguste, 138, 202, 242, 296, 321
Roman art, 83, 142, 163, 218, 262
Romney, George, 42, 129, 136, 220
Rosenquist, James, 236
Rosenstock, Ron, 198
Rosso, Medardo, 296
Rothko, Mark, 103, 173
Rouault, Georges, 33, 236, 280
Rowlandson, Thomas, 91
Royal Academy, 41
Rubens, Peter Paul, 42, 98, 112, 122, 137, 247
Rude, François, 296
Rudolph, Paul, 44, 48, 49, 239
Ruisdael, Jacob van, 137, 227, 245, 263, 279
Rungius, Carl, 21
Russian art, 97, 146
Rycroft painter, 293
Rycroft Painter, attributed to, 262
Ryder, Albert Pinkham, 69, 200
Ryder, Chauncey, 191

Saarinen, Eero, 49
Safdie, Moshe, 213, 228
Sage, Kay, 67
Saint-Gaudens, Augustus, 98, 105, 127, 199, 201, 222, 269, 270, 309, 340
Salgado, Sebastião, 255
Sample, Paul, 299
Sánchez Coello, Alonzo, 64
Sansovino, Jacopo, 241
Santoro, Nick, *color insert*
Sargent, John Singer, 30, 37, 67,

69, 78, 101, 105, 110, 113, 114, 120, 122, 129, 135, 137, 157, 162, 204, 225, 247, 263, 280, 330, 340

Sarto, Andrea del, 80, 263
Schlemmer, Oskar, 140
Schlippe, Alexey von, 24
Schmidt-Rottluff, Karl, 139, 317, 332
Schnakenberg, Henry, 290, 299
Schongauer, Martin, 136
Seiter, Daniel, 219
Serra, Richard, 343
Seurat, Georges, 129, 137, 201
Shahn, Ben, 208, 290, 343
Shaker artifacts, furniture, 155, 156, 157, 177, 178, 303, *color insert*
Shaker community of Harvard, 176
Shapiro, Joel, 321
Shapleigh, Frank, 165
Sheeler, Charles, 102, 121, 226, 281, 290
Shingle style, 76, 79, 234, 238
Shinn, Everett, 310
Signac, Paul, 145
Simmons, Franklin B., 289, 330, 331
Siqueiros, Alfaro, 85
Sisley, Alfred, 332, 341
Skopas of Pharos, 143
Sloan, John, 30, 38, 101, 102, 173, 290, 323, 324
Smibert, John, 37, 215
Smith, David, 138, 343
Smith, Joseph Lindon, 163
Snyders, Frans, 98
Société Anonyme, 47, 48
Soyer, Raphael, 61
Sprinchorn, Carl, 290, 318, 324
Steele, Fletcher, 234, *color insert*

Steen, Jan, 263
Stein, Gertrude, 29
Stella, Frank, 102, 237, 318
Stella, Joseph, 253, 299
Stern, Robert, A. M., 234
Stick style, 77
Stieglitz, Alfred, 341
Stirling, James, 142
Stowe, Harriet Beecher, 94
Strand, Paul, 341
Strater, Henry H., 327, 328
Strozzi, Bernardo, 29, 263
Stuart, Gilbert, 37, 50, 84, 95, 120, 166, 215, 225, 252, 263, 323, 342
Stubbs, George, 41
Sully, Thomas, 96
Surrealism, 25, 29, 30, 194, 332
Suvero, Mark di, 273
Swartwout, Egerton, 44

Tamayo, Rufino, 202
Tanguy, Yves, 67, 236
Tappé Associates of Boston, 70
Tarbell, Edmund, 121, 280
Tefft, Thomas Alexander, 249
Ter Borch, Gerard, 137
Thayer, Abbott, 321
Thomson, Virgil, 29
Thon, William, 324
Tiepolo, Giovanni Domenico, 51, 112, 227
Tiffany, Louis Comfort, 12 , 232, 312
Tilton, Edward L., 278
Tintoretto, Jacopo, 29, 51, 112, 279
Titian (Tiziano Vecelli), 111, 112
Titian, after, 126
Tobey, Mark, 328
Tonalism, 57
Torres-Garcia, Joaquín, 85

Toulouse-Lautrec, Henri de, 98, 129, 137, *274*

Trompe l'oeil, 37, 210

Trumbull, John, 27, 44, 45, 50, 66, 96

Tryon, Dwight, 151, 199

Turner, Joseph Mallard William, 41, 112, 145, 157, 245, 247

Twachtman, John H., 22, 59, 69, 173

Tworkov, Jack, 208

Utamaro, Kitagawa, 98

Valkenburgh, Michael Van, 215

Vasari, Giorgio, 241

Vedder, Elihu, 252, 321

Velázquez, Diego, 97, 112, 122

Velde, Willem van de (The Younger), 227, *228*

Venetian glass, 28

Vermeer, Jan, 112

Veronese, Paolo, 111, 112, 136

Victorian furniture, 54

Vinton, Frederick Porter, 191

Vuillard, Edouard, 145, 162, 201

Wadsworth, Daniel, 27

Wadsworth, Jeremiah, 27

Ward, John Quincy Adams, 94

Warhol, Andy, 39, 145, 242, 236, 296, 318

Warner, Olin Levi, 50

Washington, George, 18, 27, 44

Watteau, Antoine, 136

Weber, Max, 61, 180, 253

Webster, Noah, 94

Weeks, Edwin Lord, 81

Weir, Julian Alden, 50, 59, 67, 68, 310

Weiss/Manfredi Architects, 203

Welliver, Neil, 281, 318, 324, 336

Wertmüller, Adolf Ulric, 241

West, Benjamin, 42, 45, 64, 96, 100, 101, 220

Wetmore Print Collection, 25

Weyden, Rogier van der, 122

Wheatley, Francis, 220

Whistler, James Abbott McNeill, 19, 37, 78, 101, 113, 135, 137, 145, 157, 190, 191, 199, 290, 332, 340, 342

White, Stanford, 127, 270

Whitney Museum of American Art, 38, 39, 188

Whittredge, Worthington, 307

Wiggins, Guy, 58, 66

William Rawn Associates, 247

Wilson, Richard, 41

Wilson, Woodrow, 58

Windsor chair, 30

Wood, Grant, 38, 299, 307, 318

Wood, Thomas Waterman, 291, 297

Woodbury, Charles H., 327

Wright, Frank Lloyd, 118, 133, 240, 281

Wright, Joseph (Wright of Derby), 41, 162

Wyeth family, 332, 336

Wyeth Newell Convers, 38, 74, 167, 336, *337*

Wyeth, Andrew, 281, 303, 318, 328, 336, 337, *338*, 339

Wyeth, James, 336, 337

Yale Painter, 46

Young, Brigham, 69

Young, Mahonri, 69

Zorach, Maguerite, 208, 253

Zorach, William, 55, 208, 310, 343

Zurbarán, Francisco de, 29, *30*, 112

blindspotthenovel.com